MEN
AND MONUMENTS

MEN
AND MONU-
MENTS

by Janet Flanner

Essay Index Reprint Series

 BOOKS FOR LIBRARIES PRESS
FREEPORT, NEW YORK

All of the material in this book except the
Preface appeared originally in *The New Yorker*

INTERNATIONAL STANDARD BOOK NUMBER:

0-8369-1876-2

LIBRARY OF CONGRESS CATALOG CARD NUMBER:

73-121468

PRINTED IN THE UNITED STATES OF AMERICA

To the memory of Harold Ross,
creator of *The New Yorker,*
for whom over years we wrote,
and for whom we still write.

CONTENTS

ILLUSTRATIONS

PREFACE

THERE are no permanent criteria for declaring what art is and what it is not. Art began remotely as what was not necessary. Nor has it changed over time from that superior and remarkable status. It began in the original civilized gesture of savage man, who started adding and repeating something useless, which in some way pleased him, to the article of need which he was fabricating. His first contribution may have consisted of making some rude decoration on a clay pot which in no way improved that vessel's capacity to function. It was of no aid, but in its own terms it was art. Nothing could be done with it except notice it. Being extraneous, it attracted the eyes. Later this decoration became connected with magic, and, as the world ripened, with religion. Over the ages it developed that gratuitous things like these persistent creations, the miraculously extra, the unneeded, began having a life of their own. They afforded pleasure to bystanders. This was and remains the only utility of art. It is something to be looked at with aesthetic enjoyment and in a way to be deeply thought about, though it remains inexplicable. Words and language do not explain it. What artists say about it usually casts little light. They prove their knowledge of it by creating it.

Artists should be the surest judges of art since they should have the most measured, significant standards. Yet they are often unreliable. Even during their own lifetimes they change their opinions, and over centuries former styles of art lose credit with subsequent

artists, while some other styles rise in appreciation for reasons which may be valid only for a short time.

According to André Malraux the Greeks had no word for art, but what we call Greek art enjoyed the exceptionally uninterrupted popularity of almost half a millennium. The Romans stole it as booty from conquered Greece, and, transferring it with admiration to Rome, left it in a geographical position to survive the first changes from paganism to Christianity. Nevertheless, when original sin came to have organized significance—with the symbolism of the apple, the serpent and naked Adam and Eve in the Garden of Eden—the innocent nudity of Greek statues of male athletes and of firm-bosomed Venuses soon fell into disrepute. So the nude remained hidden under theology for a thousand years until Michelangelo's teacher, Luca Signorelli, painted the first notable nudes of the Renaissance, in a large, bold, crepuscular scene featuring a shaggy-limbed youthful Pan. But even then the nudity of the full-figured nymph and companion shepherd, standing and piping his praise, were seen obscurely and modestly by the light of a pale crescent moon, crowning the god's head. Later Titian gave to radiant nude Venuses social popularity and Greek sculpture was restored to favor through the collections of the Popes, who were then at the height of their worldly taste and their temporal power and glory. The Renaissance artists of France, in their turn, disdained the Gothic art of the sculptors who had carved the draped figures on the west portal of the Cathedral of Chartres, those exquisite elongated deformations which, to the Renaissance eye, did not represent a high voluntary style but merely a medieval ineptitude, the result of backward technique. The pure imitation of nature in its realistic human form, amid suitable silks and architectural perspectives, was everywhere the Renaissance artist's ardent aim.

Today Georges Braque considers that Italian Renaissance painting is not art at all but mere decadence and frivolity of decoration. On the other hand, African Negro sculpture, which had never been esteemed by European artists, became art in the eyes of the Ecole de Paris, to which Braque belonged, and Picasso declared

of a certain female African statuette that it was "more beautiful than the Venus de Milo." One of the greatest difficulties encountered by the layman in his pursuit of art is that throughout history artist's opinions on art have not offered any permanent authority.

French professional art criticism, which began functioning widely around the mid-nineteenth century, rendered yeoman service to the many new styles of modern art successively and exclusively created in Paris because the Parisian critics could be counted on, almost to a man, to be perfectly wrong about all of them, which was in itself a guideline. Then the new Third Republic's bourgeoisie, as a sign of rising dominance and prosperity, also began to influence art inversely by expensively buying the wrong species of it, such as Bouguereau nudes, which they preferred. Furthermore, Parisians gathered in crowds to sneer at and to shout against the epoch's valid new art, such as the work of the Impressionists and later the Fauves. Aside from showing the poverty of popular taste, these near riots furnished admirable proof of how vitally important art ideas were to the wide Parisian public, already accustomed by 1867—and the only public in Europe that was—to periodic Salons. Salons were, in fact, a French innovation; the first Paris Salon was inaugurated in 1667. Parisians were thus an educated people, familiar with opining on art: the typical volatile, argumentative French citizenry, which not only knew what it liked in the way of painting but was infuriated when any other Frenchmen, such as the Impressionists, dared believe in anything new, different and contrary, whose existence was categorically proved by their having painted it. The Parisian public had always expressed its anger partly by contemptuous jeering laughter—earlier it had even laughed at Delacroix's "Dante and Virgil in Hades." Charles Baudelaire was the soundest of all reporters on the lamentable mediocrity of the generally admired Salon of 1846 and, in his spirited defense of that "unjustly treated artist," Delacroix, declared: "The criticism he has received has been bitter and ignorant. . . . For most people, to name Eugène Delacroix is to trouble their spirits with vague ideas of

ill-directed ardour, of turbulence as if inspired by an adventurer, of disorderliness, even." This was because Delacroix had traveled to, and had romantically painted, unfamiliar, exotic Morocco, seeking unclassically vivid colors and oriental figures, as Matisse was to do later on.

Art must be the most precious portable property man has ever invented because it is always the first thing civilized man steals and sends home during a war. The Romans set the notable example. When Napoleon Bonaparte became a conqueror he also became a tremendous admirer of other peoples' art. His victorious campaigns through Europe with the Republican armies resulted in the capture of such a gigantic accumulation of art booty, including some of the most famous paintings then known, that they were exhibited in Paris in the Musée de la République, inaugurated in 1793, one of the first acts of the new Republic after beheading the King. This constituted the first French museum, of which the unfortunate Louis XVI could be called an accidental founder, since it contained that decapitated monarch's art collection, among others. Bonaparte's campaigns in Italy, that treasure trove of beauty, had been followed for months by the greatest overland migration and transportation of European art ever seen until his time. There was a steady procession, made up of relays of pack horses, mules and carts loaded with looted Italian masterpieces of all varieties, carefully wrapped against the weather, which the animals finally footed through the gates of Paris for the greater glory of France. After his defeat at Waterloo the victorious allies ordered that all the art he had stolen be returned by the French government to its former owners, thus inaugurating art's second great trek in modern history, its homeward journey of restitution. One of the most awkwardly impressive of the art objects he had appropriated and carried to Paris was the antique bronze quadriga, those four fabulous gilded horses which originally adorned Nero's Arch of Triumph in Rome, although when they excited Napoleon's covetousness they had long ornamented the Byzantine façade of St. Mark's in Venice. In brief imitative imperial enjoyment Napoleon placed them atop the little Arch of

Triumph he built beside the Louvre to honor his victories of 1805. Captured Italian artisans had set up the quadriga for him in Paris, but after Waterloo French workers were unable to take it down, so Italian experts had to be sent for to dismantle it again and pack it back to Venice—a double humiliation for Paris.

The second and even greater looting of Europe's art belongs in recent history, and was the organized work of the Nazis, who had also laid Europe under the conqueror's heel in their mad dream of hegemony which was to include a thousand years of occupation. Owing to Adolf Hitler's provincial horror of modern French art, it alone was officially excluded from the Nazi looting list for France. However, the more worldly-minded Marshal Göring, who had an art taste superior to his Führer's, managed to filch a few modern gems, including a brilliant van Gogh, although a giant Picasso slipped through his fingers at the last moment, just before the liberation of Paris.

In André Malraux's tome *The Voices of Silence,* his vast recent work on the philosophy and metamorphosis of art, he discusses universal art in detail over past thousands of years, but says little about contemporary art, precisely the period on which its admirers or detractors wanted an opinion from a mind so encyclopedically familiar with the art forms and values that had come before. In one of his few references to it he says: "Ignorance may partially explain the masses' dislike for modern art, but there is also a vague distaste for something in it which they feel to be betrayal." He further mentions *"the negative qualities"*—he italicizes them for emphasis—which, bulking large in our present civilization and art, have come to the fore. "Our art is becoming an uneasy questioning of the scheme of things. . . . Thus it is that Picasso steps into the place of Cézanne, and the sense of conquest, of man triumphant, is replaced by a spirit of questioning, sometimes serene, but usually anxious and perplexed."

A European psychiatrist, recently asked to give his explanation of why modern art had so angered the public when it was first exhibited, said that human beings en masse cannot enjoy having

the integrity of their formalities, which represent security, shaken by new interpretations. Accepted and known forms are the comforting, protecting elements in civilizations; over the ages, man has found his defense and surety in religions, ceremonies, costumes and iconography. The unfamiliar is alarming and the public recoils at identifying with it because it represents the unknown. (Hitler, not only as a bumpkin but as a dictator, feared *Entartetekunstbolschewismus*, or decadent Bolshevik art, as he called the modern, because it was to him a symbol of revolution, which he feared as the unknown that could destroy him.) The least balanced and most susceptible elements of the hostile French public had even wanted to destroy modern art when they first saw it—had tried to riddle the Impressionist canvases with their canes and parasols—to such an extent had it seemed to them painted in false symbols. Although they could not have analyzed or named it as such, it represented the unknown and thus unconscious fear, and was therefore hideous to their eyes. Only exceptional individuals are stimulated rather than irritated by what is importantly new and offers unexplored identifications, imagined or real. Art is not only a question of opinion, as many intellectuals suppose, but is a mysterious matter of instinctive emotion and feeling, old as the childhood of civilization. The reason Baudelaire was one of the most penetrating art critics of his time was that he analyzed less what he thought than how he felt about art. It is difficult to say what Picasso makes us feel. Braque, on the other hand, makes for a positive feeling of security and serenity; among the modern master painters he least rouses the so-called worry complex, the psychiatrist stated. He went on to generalize that great art in the past not only reproduced nature and illustrated objects and emotions, but also interpreted the meaning of things—both for the artist and the viewer, who at that time shared similar feelings. Modern art established a chasm, a cleavage between the artist and his public, until familiarity with it in turn made a bridge across the void for some viewers, although not for all. There are those who, accustomed to Picasso's whole repertory of more extreme styles, have never grown used to what

seems to them ugliness and cruelty of line, to which they still react as strangers.

To the layman it would seem that in creating contemporary art the artist was at first too precipitate in his peculiar genius, which placed him too far in advance of the public. Discarding his traditions, beauty symbols, formalities and inherited aesthetic myths as well as his human experiences previously shared with the rest of society, he very suddenly created an art preponderantly composed of the fetishes of his personal style. These were his discoveries, his substitutes for the old dissolving human and religious values in a changing world which he had been the first to sense and then to visualize. In France he illustrated his prescience in paint and form not only before the French public was ready for what he offered but before the French writers and thinkers of his generation, and even the Paris philosophers, saw that a new, and in a way an emptied, world was coming in and had already partially arrived, through art.

The American experience with art has naturally been unlike that of any other country's in the North Atlantic group. When the early Puritan settlers first arrived on these wild shores, they shared nothing in common with the Indian tribal art they found flourishing there, static in its savage folkloric form. The white newcomers, fugitives from England's opulent seventeenth century, had disembarked carrying elements of their own high civilization, such as religious conviction on matters of conscience and the use of muskets. They were separated by aeons of time and human experience from the Indians' pantheistic art, which they considered barbaric, ungodly and so no art at all, yet at the same time they enforcedly lived cut off from the mature art of the peoples they had left behind across the ocean. As for creating it for themselves, even had their Puritanism permitted, they had no time left over from their struggle with raw nature. Nor did their descendants have leisure for the useless and beautiful, engaged as they were in the trek of progress across the continent. Art and the appreciation of it were thus not included in a true sense in the early growth of the United States' indigenous civilization. We entered the twentieth century in a state of superior

material perfection which contained an established aesthetic void. Then, as a result of the Western internationalism which followed the First World War, we Americans found ourselves in connection with England and Europe once more. In the countries from which most of our ancestors came, American tourists, who were going abroad in crowds for the first time, saw freshly both the relics of history and the full scale of art—new, exciting, influential experiences.

The United States has had to import its great art. Everything else we make for ourselves. It would appear that the greatest impediment to our obtaining any initial national notion of the cultural and civilizing pleasure of art was probably the ubiquitous American husband who too good-naturedly left art to the females of his family —as if Giotto, Rembrandt, Goya, Manet and Matisse were like embroidery or some sort of fancy housewifely decoration, unsuitable as virile concerns. Though European art was bought around the turn of the century by certain rare collectors or on a lower level by big spenders like the Vanderbilts, on the whole art was thought by most American men to be an emasculating refinement until it began to be purchased in fairly considerable quantity by rich businessmen after the First World War. They frequently knew nothing more about the matter than what their art merchant said and how much it would cost, but they accidentally served the national interest by putting what amounted to their O.K. on art as a privately held choice commodity, and in this way it gained its first influential, respectable ranking. Since the second war, private art collecting on an enormous costly scale by American multimillionaires living in magnificent new houses, from Hollywood to Texas, in refurbished old Virginia mansions or deep in Manhattan and out on Long Island, has become the next step in art appreciation in the United States. It has placed pictures in a new social context as necessary luxuries, colorful symbols of prestige culled from a preciously limited market, as marks of power and superior position. This second wave of generally richer art buyers has included much bigger purchasers, especially of modern art, which they have favored. There was among

them a new type in American wealth, almost baronial in style, multi-millionaires of trained imagination, bold inventiveness and large gestures, endowments which often enough had been responsible for their creation of their huge fortunes. These qualities led them to synchronize easily with the aesthetic inventors, the modern European artists of the highest rank. Owning French art became their vogue. Possibly the blueprint quality of early Cubism seemed to ally it with the mechanical elements of contemporary American life; at any rate, it became a collectors' favorite. Matisse's idle houris in colored pantaloons symbolized a costly and exotic romanticism, satisfying through its strangeness to the energetic American scene, and in a similar vein the Impressionists' poetic woodland-and-river realism afforded the new pleasures of gentler landscapes, framed and visible indoors. Renoir's bourgeois parlors and cozy-corner furnishings, his buxom matrons and processions of children —boys in gardens and long-haired little girls in gleaming sunlight— seemed to us Americans like friendly middle-class citizens, although not of our generation or neighborhood, to whom we had been introduced by his painting genius and whom we could affectionately understand and enjoy.

Ironically enough, French art, which was especially favored and bought by wealthy postwar Americans, has made them even wealthier, as their canvases, no matter what color, have taken on the yellow sheen of gold in their constantly increasing values of the past few years. The unprecedentedly high prices paid today, whether for old or new art, show art to be a munificently rewarding investment. Under the weight of heavy taxes and death duties, the government has now provided the final movement of art in the United States—out of private hands and into public holdings in museums. Here, too, the collector profits doubly, insofar as he has first enjoyed his pictures on his own walls. Afterward, turned donor, with his pictures ornamenting a museum, he receives his first implication of immortality by the preservation and coupling of his humble name with that of the great artists, whose works, by chance, he had bought.

To give an idea of the excessive financial appreciation recently given to art, a great museum-type Renoir, the dominant American preference among French painters, lately fetched a reported $180,-000 in New York, the subject being that galaxy of nudes called "The Bathers." In 1890 the Paris art merchant Ambroise Vollard vainly tried to sell a sumptuous Renoir nude for 250 francs, then $50, "not that anyone deigned even to look at her," as he later reported. A museum Cézanne lately changed hands in New York for about the same price as the Renoir. And again, in that same earlier year of 1890, Père Tanguy, a Montmartre paint seller who befriended artists, sold small Cézannes, when he could find a buyer, at 40 francs, then $8. Cézanne, that most unappreciated painter even by other painters at first, who, through his new notion of composing on "the cylinder, the sphere and the cone," was posthumously to govern the modern painting world—Malraux calls him "a king"—was sixty-five years old when the artists of the Salon d'Automne finally honored him with a room for his own works. Of these pictures one of the Paris critics, still mistaken in his judgments as was their professional habit, brutally wrote, "His paintings look like those designs that schoolboys obtain by squashing flies in a piece of folded paper." When Matisse was already thirty-six years old and still so poor and unsuccessful that he was forced to send his children to live with his parents, Miss Gertrude Stein and her brother, Leo Stein, paid the equivalent of $100, which seemed a fortune to him at the time, and to them, too, for his portrait of Mme. Matisse, in an immoderately large hat. A big, perfect 1912 Cubist Braque of serene colors such as anyone could have bought when new for $80, but which few purchased, today is valued at from $30,-000 to $50,000. Picasso's "Young Girl with a Basket of Flowers," the Steins' first Picasso, was bought by them for $30. Now still in Paris, in the possession of Miss Alice B. Toklas, Miss Stein's friend and survivor, this untroubling adolescent nude has assumed incalculable value, because of its fame, its beauty and its early creation. As a unique piece with a private history, at auction it might well fetch the highest price of any portrait of this century.

Art, whose intimate value lies in the pleasure it gives to the eye, has now developed its own usufruct, growing richer of itself as it hangs on the collector's wall or in the merchant's back room or, newly finished, on the famous artist's easel. Often enough painted in poverty, it has come to symbolize wealth. Aimed at contemplative appreciation, it has attracted the shouts of bidders and auctioneers. Except for those little rarities made by nature such as diamonds and rubies and gold nuggets, nothing so small in size as a masterpiece painting, with its gemlike or dark colors lying on a fragile stretch of destructible canvas, has achieved such a reputation of value or can sell for such a price. Inch for inch, a Cézanne landscape is the highest-priced newly discovered land known in the Western world. This is a recent way of appreciating art.

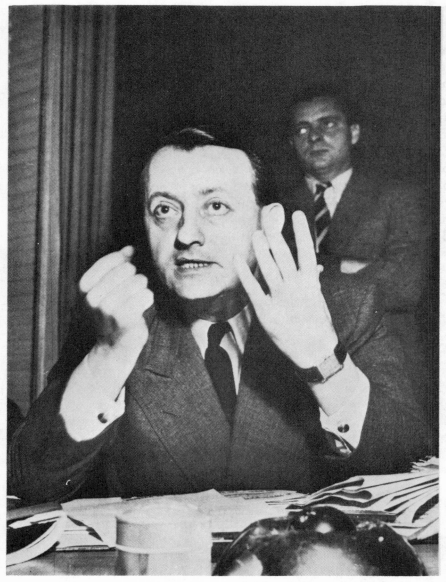

Yale Joel—Life Magazine © 1948 Time, Inc.

André Malraux

I

THE HUMAN CONDITION

THE French look upon André Malraux as a remarkably multiple man. He is invariably classified first as *un haut aventurier*—a high adventurer being to the French a heroic fugitive from the commonplace, a modern romantic who is at home only at the altitude of dangerous events. In second place comes the Malraux who is internationally the best known—the writer and Goncourt Prize winner who created a virile and violent type of novel about modern man's fate and the tragic heroes who defy it, which remains unique in French literature. The third Malraux is *l'homme engagé*, the intellectual obsessed with action, who took part in a revolution on the other side of the globe, flew a plane in a neighboring civil war and fought under a *nom de guerre* in the French Resistance— all of them like engagements with current history which must not be missed. Fourth is Malraux the political agnostic, who, long since having lost hope in yesterday's experimental Communism, after the Liberation believed in the Social renovation of France under General Charles de Gaulle. Fifth, and most recent, is the Malraux who, in some fashion combining the four others, along with the voyages made, the remote temples penetrated, the art museums absorbed in

thirty years of travel and contemplation during and between wars, has summed up the experiences of his senses and his creative intellect in *Les Voix du Silence* ("The Voices of Silence"), a book on his theories of art which has established him on both sides of the Atlantic as a new interpreter of universal humanism. A sixth Malraux is the legendary one who lives in an atmosphere of obscurity— a Malraux magnified, mysterious, evasive, even more lavishly endowed and more consequential than the five others. Off and on, and for various reasons, French literary circles have been discussing the complexities of *le cas Malraux* over the past thirty years, during which they have pinned him down at least to the extent of identifying these half-dozen exceptional figures united under the single name.

Now, in his fifties, Malraux is nerve-racked, intense, slender, elegant and slightly bent, as if from too much reading. His hair is dark and his eyes are deep green; he has an impressive head and, with its dramatic lines and shadows, the cold, impassioned face of a Renaissance *condottiere*. He is a phenomenal peripatetic talker if the room is large enough. No other French writer is so rapid, compulsive, fascinating and rewarding a monologist. Malraux paces the floor as if he were propelled by the jerking energy of his speech. As he walks, words and ideas rush from his brain and out of his mouth in extemporaneous creation, as though they were long quotations from books he has not yet written, and they flow at a rate that is almost the speed of thought, and sometimes faster than the ear can catch. His extravagant memory accompanies him as he paces back and forth, bringing reminiscences out into the air, along with history, art and man's dangerous destiny—whatever he needs at the moment. From time to time, for punctuation, he lifts his right hand, his long, apostolic forefinger erect, and says *"Mais attention!"* as if to warn the dazed listener about the paragraph to come, which passes in a revelatory gust. It is a concentrated talking style, which often includes interpolations of *"Primo"* and *"Secundo"* to keep matters straight; a low-voiced style, with a hurried coherence about it, and an occasional anguished straining for an ultimate exactitude; a style

that displays immense general intelligence and erudition, expressed in particularities of reference, hypotheses and hopes, as his thoughts develop audibly, through ellipses, into cogent conclusions—an astonishing creative production, which even some of his literary friends, professionally accustomed to ideas and vocabulary, have been unable to follow. André Gide wrote in his *Journal* that Malraux "talks with that extraordinary volubility which makes him so hard for me to follow . . . in awe before his dazzling and staggering flow of words," and went on to compare him with another friend of his who was a conversational trial—the poet Paul Valéry, who also did not notice whether the listener could keep up. Mme. Théo van Rysselberghe, who was also a friend of Gide's, records that once, on the way to Pontigny, where in the late 1920's the intellectual cream of Europe sojourned as if attending a series of scholarly country house parties, she picked up Malraux, who had just returned to Paris from Teheran, to take him along in her car, and that he said *"Bon jour,"* and then went right on, "In Persia . . ."

A few years ago, at a luncheon given in Paris for Malraux, who speaks almost no English, and a *Life* editor from New York, who spoke no French at all but whose aim was to obtain an interview for an article on General Charles de Gaulle, three bilingual Paris correspondents of *Time,* invited so that they might translate Malraux's French, failed to manage anything comprehensible as he obligingly rushed on with staccato information, accompanied by the *Life* man's reiterated "What did he say?" Forewarned, another American writer with some questions to ask him was recently permitted to take along a stenotypist and machine to his home, in Boulogne-sur-Seine, just outside Paris, to record the answers. The result, as Malraux gathered momentum in his large studio, was prodigious. In a two-hour interview, he talked what turned out to be fifty-two typewritten pages, or a total of fifteen thousand words— the equivalent of seventeen columns of the *New York Times,* and more diverse in topic. In reply to an opening question about Lawrence of Arabia, known to be the tragic adventurer who interested him most (this was before the spate of books and arguments on the

Colonel), he talked for ten pages on several facets of the subject, including Lawrence's disappointment in his own writings, plus a side reference to Rimbaud. There were eight pages about a long conversation with Trotsky years ago, on the French bathing beach of Royan, when, Malraux said, Trotsky looked "like an old eagle with his feathers awry." Among other things, Trotsky said that the villagers did not know who he was, and took him for a White Russian, and that the village mayor had kindly offered to explain local politics to him. The conversation lasted a whole day, while the two men "tramped the sand, talking, talking over the sound of the sea." Malraux seemed to recall the entire conversation verbatim. He then recalled some odd things that the elder of Chiang Kai-shek's two sons, when held as a hostage in Moscow, had said about his father; talked about the difficulty of making a film in Spain during the Spanish civil war; and talked an introductory paragraph about his escape from a German prisoner-of-war camp when France fell in 1940 ("quite easy—nothing serious at all") and then a page about a friendly, casual cat that almost made serious trouble by accompanying him as, under the German guards' eyes, he walked, in the cap and overalls of a carpenter, across the line into Unoccupied France. He gave a five-page analysis of the essential difference between the actual thoughts of Nietzsche (one of the dominant philosophical influences of his life) and the modern interpretations of them, and he devoted one page to his first meeting with William Faulkner, in Paris, in the summer of 1948. He talked about a Bible he had seen in Dostoevski's home in Russia, which Dostoevski had consulted when in exile in Siberia; it seems he had used it as a fortune telling book, each evening taking the first text that met his eye as a forecast of whether he would be freed the next day, and then writing in the word "No" beside the text after each disappointment. Malraux talked of some little-known sculptural masterpieces in the Baghdad Museum of Antiquities, and added a paragraph on the also little-known thirteenth-century Japanese painter Takanobu, and a paragraph on semi-tones in Chinese music and the fact that the Japanese attitude toward love is more Western than that of the

Chinese, who regard love as a soul-sickness, and then talked several pages on his own metaphysics of art. The interview ended with his saying, with abrupt sadness, that, what with Iron Curtains and difficult visas—especially difficult for him—the world had become small to travel in.

Georges-André Malraux was born on November 3, 1901, in Paris, on the Rue Damrémont, in Montmartre. This is one of the few simple facts known about his life. There is no official biography. The history of his family is obscure. In Paris, the accepted composite version of his background says that he came from a ruined bourgeois family, that his father's family was from Dunkirk and was in marine business of some sort, that his grandfather was a ship's outfitter who was or was not also the mayor of Dunkirk, and that his great-grand-father was lost at sea. It says that Malraux's father, Fernand-Georges Malraux, was a businessman in the Paris suburb of Suresnes—or, on second thought, maybe a banker. On being divorced from his wife, he married a second time and had two more sons—Roland and Claude. The name Malraux is unknown in France except in connection with this single family from Dunkirk; according to a family legend that André Malraux himself does not seem to take much stock in, they were originally Flemish, came to France in the eighteenth century, and, whatever their patronymic, were nick-named and became known as Mauvaise Charrue, meaning they were bad with the plow because they loved not the land but the sea. Mauvais Charrue was in time compressed into their new name —Malraux. Of the five or six French books and several dozen major critical French essays on Malraux, only two include any biographical notes, and each of these states only that Malraux's father and grandfather both committed suicide, the second report being perhaps not true but merely assumed, because Malraux wrote in one of his novels about somebody's grandfather who tragically did away with himself. Malraux himself is hermetic where his private life is concerned. The confusing legends about him have swelled like balloons to fill in his silence. He assumes the position

that his private life is actually his and actually private—a large, exclusive territory. It is taken for granted in Paris press circles that if a question of a biographical nature is inadvertently asked in an interview, Malraux will reply by saying *"Vie privée"* and nothing more. In his view, which is aloof, his *vie publique* lies in his books. To someone doing research on them, or on him as a writer only, he makes gifts of time, patience, bibliographical information and counsel that are generous, even princely. The few friends who will discuss him at all outside their own strictly limited circle carefully speak of him without intimacy, as if he were a statue. Aside from what he has reported in his major novels—which are almost all autobiographical—about certain parts of his life of action, mostly in foreign settings and nearly always at bloody, acute angles of current history, little that is specific is generally known about Malraux the individual, except, as he pertinently says, for what he thinks, and about that he has been explicit for years.

He ranks as one of the three or four famous living authors of France and, since the death a few years ago of his aviator-writer companion Antoine de Saint-Exupéry, the nation's only *haut aventurier*. On the whole, Malraux remains like a djinni in his own ink bottle, as far as anybody who is trying to sketch a personal portrait of him now is concerned. Owing to his striking personality, however, he has left certain records in people's memories. According to one recollection, it was in 1919, when he was eighteen, that he formed his first professional connection with books. Already "distinguished, dressed modestly but very correctly, and reserved in manner," he presented himself, out of the blue, as a "procurer of rare books" to a minor literary character named René-Louis Doyon, who at that time ran a small Paris bookselling business and was also editor of the monthly magazine *La Connaissance*. Malraux, whom Doyon arranged to buy books from on a regular basis, added a note of prosperity to the enterprise by bringing in first editions that attracted collectors. He picked his material perspicaciously from the bookstalls on the *quais*, was businesslike and punctual, and knew what things were worth. Doyon thought that Malraux had a

vocation to be an artist of some sort, though he also seemed worldly and ambitious, and that he showed a developed taste for good printing and an all-round talent for publishing. By 1920, when he was nineteen, Malraux began to write for Paris *avant-garde* magazines like *Signaux* and *Action*. His first book, published in 1921 and dedicated to the poet Max Jacob, was *Lunes en Papier*, a slim extravaganza, part Dada, part Hieronymus Bosch, about midget monsters who turned into the seven deadly sins.

By this time, backed by Kra, the Paris publishing house, Malraux was bringing out a series of small de luxe books named Les Aldes, after the famous fifteenth-century Venetian printer, Aldus Manutius. Presently, he began working for Kra as editor of their literary series called "Editions du Sagittaire." Then, as later, literary work, including writing, was of strictly secondary interest to him. His dominant intellectual occupations were with art; with archaeology, an extension of art that could lead afield into foreign adventures; and with anthropology, a natural third element in his curiosity about civilizations as a key to the meaning of man. According to the Malraux legend, he had attended the Lycée Condorcet, and, after receiving his *baccalauréat*, had studied at the famous Ecole des Langues Orientales Vivantes, founded in 1669 under Louis XIV, and perhaps even at the Sorbonne. If so, he even then was leaving no footprints or records. In any event, with his swift precocity, he would have found classrooms only an exasperating delay in the carrying out of his remarkably adult, far-reaching early program. It was apparently as a feverish reader and a haunter of museums and libraries that Malraux gave himself his special education in his three favorite subjects, establishing, in his passionate interest, his own curriculum and being his own harsh schoolmaster and, in a way, his own roaming university. Since Orientalism was his chosen specialty even then, he apparently attended lectures at the Louvre and the Paris Musée Guimet of Oriental art, concentrating, by means of books and photographs, on the greatest honeycomb of Khmer art in France's colonial empire—the ruined temples on the abandoned Royal Road of Cambodia. He decided that the area

around Bantay Srei, the dilapidated, exquisite little temple forty-five kilometers from Angkor Wat, would be the place to hunt for valuable Khmer statues. As fantastic as anything else in connection with Malraux is the fact that the French government—reportedly prodded by the Guimet, though the Guimet has denied this—gave him, at the age of twenty-two, the official mission of going out and making a search there. While at Kra, he had married Clara Gold-schmidt, attractive and intellectually inclined. They set out together for Indo-China in 1923. The trip occupied nearly a year.

Suffering from fever, Malraux and his wife pushed into the Cambodian brush on horseback, preceded by natives who hacked a path through the jungle growth and followed by natives with ox-carts to transport the hunted statues when they were found. Most impressive and most repugnant to the fastidious, city-bred Malraux in this search for jungle art was the accompanying insect life— "spiders held by their grasshopperlike feet to the center of webs four metres across . . . phosphorescent and geometric," and under-foot a crawling myriad of unnamable little creatures "with the sick-ening virulence of life seen under a microscope" (so he later wrote in *La Voie Royale*, a novel about this journey). He found the statues where he had supposed they would be. This was his only triumph, however, for they lay in jungle territory designated by a French government research institute in Indo-China called the Ecole Fran-çaise d'Extrême-Orient, on the basis of rulings made back in Paris, as *classé*, meaning that its art, lost, recumbent and decaying under creepers, was still a historical monument, not to be removed for salvation even by a daring young man sent by the home government for the express purpose of finding it. Malraux's differences with the colonial administration over the question of whether he was merely to report on the location of the statues or take them away with him led to his being brought to court at Pnom-Penh, the capital of Cam-bodia, and sentenced to three years in the local jail.

From here on the tale becomes even more *farfelu* (or bizarre), as Malraux recently called it, in recounting the details to a friend. Though he had received a jail sentence, he had not been arrested,

owing to the laxity of colonial procedure. However, the court had arrested his statues and put them in the city museum. While he was supposed to be in jail, he was living in style at the Grand Hotel. Evidently, the hornet's nest he had run into was really the *amour-propre* of the French colonial archaeological service, outraged that Paris had sent in this young outsider to dig out their very own statues—which they had never laid eyes on before but whose general location they knew of, from military maps made some years earlier by the French colonial army, which had stumbled over them—and, on claim of discovery, to try to get them out of their country. From the Grand Hotel, Malraux haughtily appealed his case. Then the court made an embarrassing discovery: the Paris authorities had never had the legal right to give the Extrême-Orient art men jurisdiction over undiscovered Cambodian statues, because Cambodia was only a protectorate, not French territory. Thus, the real owner of the disputed Bantay Srei statues was the King of Cambodia, the only proper plaintiff who could have sued Malraux. The last act of the Pnom-Penh court was to grant Malraux's appeal, dismiss the case, and try to forget it all.

A lot of gossip had been stirred up, however. Various stories circulated at the time went to make up the beginning of the Malraux legend. The Belgian Prime Minister, who had gone out to look at Angkor Wat, related when he got back to Europe that Malraux had sent his oxcarts filled with art, as though it were his private luggage, to the French governor's mansion at Pnom-Penh, where he was expected as a guest, and that they had been inhospitably impounded there. There was gossip in Paris, too. It was said that according to a private dossier on *l'affaire des statues* assembled in Paris for the Colonial Minister, Albert Sarraut, the native police were only hunting for opium in the carts when they discovered the art. Another story was that the statesman Philippe Berthelot, who esteemed young Malraux's brains and perhaps was the government figure who had endorsed the expedition in the first place, had the private dossier of supposed facts suppressed. The most sensible Paris rumor was that the charge against Malraux was rigged up by the colonial

authorities because he had established contact with the Jeune-
Annam political group, who wanted dominion status, which was
at that time regarded by the French as a wildly rebellious notion,
and that the threat of the jail sentence was to cool him off. Late in
July, 1924, Paris papers printed the statue story, calling Malraux,
of whom the public had then never heard, the Pilgrim of Angkor
Wat, and reporting that he had been carrying statues worth a mil-
lion francs (about fifty thousand dollars at the time) in his oxcarts
when he was stopped en route to the Indo-Chinese-Siamese border.

Early in August of that year, a rousing open letter headed
"Plaidoyer pour André Malraux" and written by the bookseller-
editor Doyan appeared in the Paris daily *Eclair*. Could not pardon
be given, he pleaded, for "audacity marked by courage," so that this
youth "of strong cerebral activity, with an impassioned taste in
art" might not "perish in a land and a prison of doubtful hygiene."
By this time, Mme. Malraux, apparently ignorant of the fact that
the case had been dismissed in Pnom-Penh—this had taken place
while she was on the sea—had come back from the East to find help
for her husband. A month later, the weekly *Nouvelles Littéraires*
printed a petition from a galaxy of Paris writers offering to testify
to Malraux's value to literature and declaring that a three-year im-
prisonment could prevent the achievement that they had the right
—as they sternly put it, as if warning the absent Malraux himself
—to expect of him. Among the signers were the noted Catholic
novelist François Mauriac (who seemed to be the guiding hand
in the drafting of the petition), André Gide, André Breton, Louis
Aragon, André Maurois, Roger Martin du Gard and Max Jacob
as well as Gaston Gallimard, the big Paris publisher. One of the
signers said recently that at the time he had never heard of Mal-
raux, and that he thought many of the others had not, either. But
the young man's *bel exploit*, his haughty, lawless courage and his
admirable taste in Khmer sculpture provided him with an identity
that was strongly appealing. This friendly pressure to liberate him
from a prison he had never seen the inside of only added confusion
to the whole Malraux situation and legend. With his case dismissed,

he reappeared in France in the autumn, but by the beginning of
1925 he had set out once more for the East. He stopped off in
Saigon, where he founded a Jeune-Annam newspaper called *L'-
Indochine*. Then he went to China.

Malraux's expatriation from postwar France was the typically
more vigorous expression of a malaise also experienced by other
young intellectuals, who felt homeless there, too, but stayed on in
Paris to say so. The year Malraux left for what proved to be his
longest Eastern stay marked the climax of the young French intellec-
tuals' dissatisfaction with the moral, artistic and social leftovers of
prewar bourgeois France, which many of them had been old
enough to risk dying for in the war but which they now felt they
could not live with. The war, in destroying the familiar old values,
had created a vacuum, which the younger generation of talent had
started furnishing with Cubist paintings and Dadaist and Surrealist
writings. On both sides of the Atlantic, youngish men with some-
thing new to say were restless; the twentieth-century era was evi-
dently coming in at last, and already there had been a hegira to
Paris of unknown Middle Western writers who were to found a
new American school of literature, ruggedly dropping its first roots
in the Left Bank. For certain young French writers, so violent was
the sense of cleavage with the literary past that at the state funeral
of Anatole France in 1924, as the procession, an autumnal flower
parade of chrysanthemums, passed along the Left Bank *quais*, his
remains were jeered at by a sidewalk crowd of Surrealist poets,
armed with a pamphlet they had written called *Un Cadavre*, which
identified him with all they considered dead in prewar writing. In
that year, too, the intellectuals' bellwether, the monthly *Nouvelle
Revue Française* (or *NRF*), published a diagnostic essay by Marcel
Arland, a close friend of Malraux, called "Sur un Nouveau Mal du
Siècle." (The first sick century had been discovered a hundred years
before by Chateaubriand, Alfred de Musset and others.) Among
the symptoms of his generation's malaise, Arland solemnly cited its
loss of belief in the international supremacy of the French novel—

in the superior national genius of their nineteenth-century bourgeois novelists. A new vogue had sprung up for the novels of Dostoevski, which, with their more analytical, spiritualized tragedies, seemed irresistibly modern to the youthful French of the 1920's, for whom—and in particular for young Malraux—he became the master European novelist.

The one book Malraux himself wrote while in the East was not a novel but a short contribution to this youthful chorus of denunciation of what was wrong with France. This was published in 1926, when he was still out in China, and it was mockingly called *La Tentation de l'Occident*, since at the time the West held out to him no temptation whatever. In general, his complaint, melancholy in tone—he referred to Europe as a great cemetery of dead conquerors—flayed the soullessness, the destructive materialist energy, the anxiety neuroses and the masochism of the West's "metal civilization," which he compared to the East's detached, contemplative spirit, consciously occupied through the ages with its unconscious. The book was in the form of letters exchanged by two overeducated young men, one Chinese, Ling W. Y., and one French, Monsieur A. D., each of whom was visiting the other's continent for the first time, inspecting its culture, its art, its civilization and its philosophy as if through a microscope lens in the guise of a monocle. Because of his pro-Orientalism, Malraux not only gave Ling more than half the letters but let him announce in italics, to show its importance in his creator's mind, what turned out to be the most famous of all Malraux's formulas, even though it was later associated with another author. This formula was *"At the very center of European man, dominating the great movements of his life, there lies an essential absurdity."* This philosophical reference to the meaninglessness and non-sense of modern life (that vanity of vanities denounced in Ecclesiastes) Malraux repeated as one of his dark fundamental assumptions in all his subsequent books, but it was not until after the Second World War that the idea of the Absurd became popular in France, as a feature of Jean-Paul Sartre's existentialism.

In 1927, right after his return from China, Malraux wrote a

provocative essay, "D'une Jeunesse Européenne," which appeared
in Paris in a volume of the noted Cahiers Verts series. Malraux
did not choose to squeeze this brief, rich essay, as he did the mystic
La Tentation de l'Occident, into the one-volume de luxe edition of
his novels published in 1951 by Gallimard, but it is considered the
basic expression of his life's program, and is still an up-to-date
critique on the continuous crises of European civilization. It dealt
strongly and penetratingly with what educated young twentieth-
century minds then thought modern reality consisted of—soulless
emptiness. Malraux stated that youth was out of step with the doc-
trinally Catholic civilization of France, since "we are no longer
Christians"; this was his first announcement of his agnosticism,
from which position he has never retired. He described "the con-
stellation of despair" developed by his generation, suspended be-
tween its empty longing for faith in something and its lack of
capacity for belief in anything (a dilemma from which Existential-
ism later leaped off, via Malraux's doctrine of the Absurd, into the
Néant, or Nothingness). He said that in modern civilization there
was no home for spiritual values, and "that youth can be moved
only by a better world than it is living in," adding, in a typical sweep
of imagery, that now that God had gone, man had nothing to place
his hope in but "man, the sole object left." Though Malraux was
only in his mid-twenties when he wrote *The Temptation of the
Occident* and "On European Youth," they contained practically all
the germinal thinking for his future works. They exhibited his in-
telligent despair, and his lucid, humanistic and "splendidly un-
conquerable" man, set down among somber philosophic guidelines;
later, he would add war and international groups of men, and turn
them into his special type of novel, but already he had established
the passionate assumption he would build the novels on—the as-
sumption of the heroic and its risk of death, of virile fraternity,
of defiance of what was classically called fate, joined to the rebellious
contemporary ethic that man must struggle against men's injustice
and that civilization must be saved, with a love of art and a dignified
disdain for defeat as the golden instruments of salvation—all major,

adult romantic postulates, thought out and written down with genius by a young Frenchman who had strayed far from home and was preoccupied with the Chinese revolution. The China he had lived in had been a state of revolution and counter-revolution since 1911, and in active ferment since 1924.

Malraux was young enough just to miss being a soldier in the First World War. In any case, private wars were more to his taste, with his adventurous, undisciplined character. *L'affaire des statues* had given him the vulnerable standing of an *hors la loi*, a man outside the law—a standing that, years later, with various mature qualifications, Malraux termed the adventurer's foundation. Embedded in his talent and dominant in the range of his human curiosity was his special interest in the mentality and philosophies of the East, and in the events to which they gave rise. There at hand, in the bloody Chinese seesawing for power, which was now at its peak, lay unlimited exotic, reckless adventure and the male heroic material, confused but still on the discernible individual scale, that was to be the special subject of both his action and his writing—man's fate in his struggle with the meaning of modern history. Germany had recently given the world its first lesson on the subject, but the young Malraux had missed it.

Malraux was the first of the postwar intellectual generation to come into contact with China's revolution. By this time, the original aim of the founder of the Kuomintang, or Nationalist People's party, Dr. Sun Yat-sen—to set up a Chinese republic without foreign influence—had been altered by the Doctor's having been influenced himself, shortly before he died, by the Comintern's well-known Russian delegate in those parts, Mikhail Borodin, whom he appointed political counselor to the Kuomintang in Canton and who promptly created a Chinese Communist party within the Kuomintang. In the summer of 1925, the Nationalists in Canton organized a general strike, in an attempt to starve out the great British shipping trade on the island settlement of Hong Kong, at the mouth of the Canton River. Not unexpectedly, the strike flared into bloodshed; the local Nationalist army was routed by Chinese mercenary

forces of the British, and the Kuomintang won the day only by begging help from Borodin's new Chinese Red Army. Malraux used this uprising, including Borodin, as the theme of *Les Conquérants* (*The Conquerors*), his first novel. Nearly two years later, in the spring of 1927, when the Red workers were ousting a pro-foreign police regime from Shanghai, General Chiang Kai-shek, who until then had been accepting Communist backing, arrived in the city with his army, and there found financial help more to his political taste—from the Right. His switch made the Nationalist revolution two-headed, with him in charge of the Right head. Malraux used the Shanghai incident, with Chiang Kai-shek as a real-life character, never seen but often referred to, in *La Condition Humaine* (published in the United States as *Man's Fate*), his third novel, which ranks as his greatest. (His second novel was *La Voie Royale* dealing with his experiences in Indo-China.)

The Malraux legend that later grew up said he had been a dashing cloak-and-dagger agent in China, and even a member of the Kuomintang's Committee of Twelve, sitting with Chiang Kai-shek himself. Actually, Malraux's official position in China is one of the rare personal items concerning his revolutionary period on which he has ever volunteered information. In 1933, in a letter he wrote to Edmund Wilson, then a contributing editor to the *New Republic*, Malraux stated that he "organized the Jeune-Annam movement, then became a *commissaire* [in charge of propaganda and information] of the Kuomintang in Indo-China and finally in Canton," adding dryly, as if to place himself with even further precision, "There were in Canton in 1927 singularly more revolutionary adventurers than Marxists."

In 1928, *Les Conquérants* was published in Paris. It was a success. It was hailed, with some confusion, as an epic chronicle that movingly created viable mythical heroes in the present century; as an autobiographical story of an adventure in political violence; as a novel concentrating on male psychology, since there were no women in it; and as a book obviously written by a talented, febrile

intellectual who was also an astonishing interpretive reporter of
revolution as a current event, and who possessed, as a form of imagi-
nation, his own philosophy—something altogether new in French
novels. Most French critics—some, though, were only irritated or
alarmed—saw in it an intense, original and brilliant formula for
modern writing, with visual images as clear as a movie camera's,
and an almost telegraphic style that provided both immediacy and
rapidity of report on physical action. Together, the immediacy and
the rapidity cut the distance between the reader and what was
happening until he seemed close enough to see, overhear and scent
—to be intimately, physically informed. It was this powerful sense
of reader participation that gave the Malraux style its effect of
authenticity, which became part of his legend and his fame.

The material of *Les Conquérants* was certainly new to the times.
Starting merely as an account of a Canton general strike, it swelled
into an account of a confused struggle in power politics between
East and West—a book dripping blood and violence as it portrayed
a new form of political tactics, in which remorseless men stabbed,
shot or poisoned each other by way of presenting political argu-
ments, plotted an assassination as carefully as a political speech,
or used torture as an encouragement to political conversions. All
this was recorded as taking place in a strange corner of the world,
where colonial affairs had become a desperate matter, and where
modern politics were producing a private war of a kind Europe had
not yet dreamed of. Malraux's novel read like sanguinary living
history. It was news to Paris, relaxing at its glittering postwar en-
tertainments.

The leading figures of *Les Conquérants* are Chinese, Europeans
and Russians—all revolutionaries, all with different national psy-
chologies but similar reasons for taking part, more or less united,
in a heroic struggle for change. Malraux has used this same epic
theme of struggle for change in all his war novels, and the dominant
figure in *The Conquerors,* Pierre Garine, is the prototype of all
the Malraux adventurers to come, who always reflect Malraux
himself, tyrannically tied to his own image. Garine-Malraux is rep-

resented as a Swiss-born international adventurer, intellectual, disillusioned, romantically illogical, but lucid in imagination and talented in intrigue; a duel-minded skeptic, constantly seeing the defeat of some elements of ideals in physical victory, as well as the victory of ideas in physical defeat; sensitive to man's hopes, yet bored by any planned political utopia; an individualistic rebel against Marxist doctrine, yet a man who is attached as a paid propaganda chief to the Communist wing of the Chinese revolution, having chosen it, he says, for its dangers and *hautes actions* and for the chance it gives him to gain power, which he craves. As *The Conquerors* opens, this expatriate is carelessly dying of tropical fever. The only important Frenchman in the group is an unnamed novice adventurer, who is really the young and reckless Malraux as he was when he wrote the book, rather than the flashing Garine-Malraux he perhaps longed to be and, as an artist, already understood well enough to create perfectly on paper. The Russians are the Comintern agent Borodin, the only real-life personage, who was by legend also the original for a part of the Garine-Malraux character, even though Borodin represents Marxist indifference to the survival of any individualism, including his own; and Nicolaïeff, a former Cheka policeman and current torturer, whose specialty is slow strangulation, during which he uses incense to revive the victim, so can prolong the treatment. The Mandarin Tcheng-Daï represents the Kuomintang's anti-Communist wing and nonviolence, and was modeled on Gandhi. The terrorist Hong, who assassinates him and is later killed for the killing, represents the impoverished coolies and their class hatred of the rich, and has a quotation from Lenin, whom Hong has come to hate also, tattooed on his arm. Rebecci is a queasy, talkative old Italian Anarchist shopkeeper. The German Klein—Malraux groups are always carefully internationalized—is an ex-Trotskyite, tortured to death by terrorists, who cut away his eyelids and slice his face. (The growing sadism of our century's politics, ending in the Nazi crematories, was to be the subject, in his novels, of one of Malraux's continuing rages against today's so-called modern civilization.) In the swift

action of the novel, in the presentation of the fighting itself, in the intrigues of Russian against Chinese and Communist against Republicans, in the street battles, the propaganda coups, the funerals, the speeches, in the anguish of men's heroism and hopes, and in the piling up of visual details, Mauraux reproduces that frenzied sense of haste with which a revolution spins its history. It is a technique of speed that he has made his own. Because thoughts are as important to him as action, his main characters relax between moments of danger by talking in brilliant aphorisms—another device that he uses in all his novels, creating a unique conversational style. The French critics immediately recognized these aphorisms of *Les Conquérants* as pungent social definitions. One was Hong's bitter maxim: "There are only two races, the poor and the others." An aphorism of Garine's established him—and young Malraux—as a strange, cerebral type of modern French adventurer. "I don't like mankind," Garine starkly muses. "I don't even like the poor, for whom, after all, I am going to fight." He adds that he does, however, prefer them to the European bourgeois class he himself (and Malraux) comes from and despises. Still quoted today is Garine's mockery of Borodin for his Bolshevik exaltation of discipline: "He wants to manufacture revolutionaries the way Ford manufactures autos!" *Les Conquérants* ends with the victorious Red Army tractors rumbling into Canton and the apolitical, asocial Garine, the most intellectual, inappropriate and *démodé* of the conquerors, who is symbolically doomed to defeat and death by his tropical fever, taking ship for the Europe he will never live to see. In all the Malraux novels, defeat of one sort or another falls on most of the heroes like a transfiguration.

Back from China as a debutante novelist, Malraux's curiously youthful appearance, after his years of tough adventure, surprised Paris literary circles. One press photograph showed him dressed in a sophomoric sweater and boldly holding a cigarette to his lips, seeming almost too adolescent to smoke, let alone to have written a revolutionary novel—a handsome, reckless-looking prodigy with

intense, watchful eyes and a mop of dark hair. (Malraux looked so boyish that apparently he had run into difficulties when taking over responsibilities out in the East; at any rate, in his next novel, *La Voie Royale*, the young statue-hunting French archaeologist in it takes pains to state that he is several years older than he appears to be.)

Soon after Malraux arrived in Paris, he began his long editorial career (it is still going on) in the influential Left Bank publishing house of Gallimard. As the publisher of a choice list of important prewar and postwar writers and of the monthly NRF, it was considered the chief molder of French literary trends and discoverer of talent. Malraux's first position at Gallimard was as the editor in charge of the firm's art books. Paris was seething with an interest in art, ultramodern or antique. Malraux also put on recherché art shows on the Gallimard premises, one of them consisting of sculpture from Gandhara and Afghanistan, which was then new to the public, and caused considerable talk pro and con. His having been invited to work at Gallimard showed that he had arrived as a literary personality and, more important, was expected to go further. In his new position, he came in contact with a famous trio of senior editors and writers—Gide, Jean Schlumberger and the poet Valéry. It was probably not all beer and skittles for the young newcomer. He still remembers with shock that Valéry, who then ranked as France's greatest poet, began their acquaintance by asking why on earth he had gone to Asia, as if travel for the sake of either the eyes or the imagination was youthful folly. Malraux made his usual strong first impression on the staff. One of its members recently reminisced about the feeling of isolation that already surrounded Malraux, giving him the air of "a young man living outside any coterie [which is precisely what the Gallimard circle was]; of having a haunted need for something off the regular path of young men, even young men of talent, of being always in search, in flight; of talking so fast that he sounded pursued." The reminiscence continued, "He seemed to have made up a universe for himself, based on choice, on what he chose to put in it, and ignoring the rest. He

obviously had his own system of weights and balances for ideas, duties, and activities, his own fashion of measuring life and man's values, or participation in it. He had a horror of the mediocre. He was *chevaleresque*. Basically, there was something noble about him. His education was uneven. He had been preoccupied with writers rather than with their writings. He seemed to have the disorganization of genius, and its neurasthenia. He fitted into no formula. You could never hold on to him. He was Byronic—his Greece was to be China and Spain. He was not intimate." At this time, too, Gide's friend Mme. van Rysselberghe remarked semi-jokingly of Malraux that even to say to him, in greeting, "How are you, Malraux?" seemed an intrusion. It was already clear that his life was to be concentrated on a public study of himself. In the eyes of exceptionally observant men and women who knew him then and know him still, he has never changed. He is difficult to assess, because of the magnetic qualities of his personality and of his writing; he has a glamour that is more than style. In his writing, he uses words and thoughts that seem to mean even more than they state. This special margin between what the reader does and does not understand is accepted as another dimension of Malraux himself. He conveys something profound in what is already difficult and indefinite. His writing has a triple potential: first, in his ideas, which are always intelligent; second, in his use of them, which gives them the echoing effect of poetry; and, third, in the fact that they perfectly support his personality. What early conferred upon him his high *classement littéraire* was his real need for physical action that risked and tried to prove all, coupled with his equally real necessity for writing, for the self-expression of the artist on the written page.

Historically, the most interesting book review of Les Conquérants was one that was three years late. It was written by Trotsky, and came out of a clear sky, since the two men had not yet had their long, single meeting, and, as far as Malraux knew, Trotsky had not been aware he existed. The review was published early in 1931, in the NRF, and was entitled "La Révolution Etranglée" ("The

Strangled Revolution"). Trotsky was then living in exile on the
island of Prinkipo, near the Golden Horn, and had doubtless just
come on the book. In his review, he noted admiringly that Malraux
had "the precise eye of the artist, the original and bold observation."
He called it "a remarkable book . . . of exceptional importance . . .
[as a] romanticized chronicle of a part of the Chinese revolution,"
adding firmly that this was "the greatest subject of the past five
years." Malraux was the only French novelist who had used this
subject, and it was certainly what had attracted Trotsky's attention.
Then, for thirteen pages, written for the most part with surprising
elegance, he discussed Malraux's treatment of the revolution, saying,
among other things, that "a good dose of Marxism" for Garine and
Malraux, whom he took to be one and the same, would have saved
the book from mistakes like Malraux's "aesthetic caprices" and
Garine's scorn of "revolutionary doctrine," this scorn being obviously
a black heresy. (Twenty years later, professionals in art history were
to make the same reproach of heresy and "mistakes" to Malraux,
the poet of art history.) An old doctrinaire himself, Trotsky thought
that the pages dealing with Hong, whose aim was to assassinate as
many of the proletariat's enemies as he could get his knife into,
were the only real revolutionary stuff in the book. Trotsky deplored
the fact that the agent Borodin, whom he recalled as a third-string
operator once used by the Communists in America, had been de-
picted as an important representative of his calling. Trotsky's biting
disapproval of Malraux's picture of the Chinese revolution clearly
stemmed for the most part from the fact that the revolution was
being run by the wrong people in Moscow, meaning Stalin, whom
he was too proud to mention. Malraux's answer to Trotsky, printed
in the same number of the NRF, was candid and probably reason-
ably effective, considering that as an amateur revolutionary he had
been rather caught in a forked stick by one of the greatest profes-
sionals. In the correct dialectic jargon, Malraux replied that as a
novelist he had put the accent in Les Conquérants on "the relation
between individuals and collective action, not on the collective
action only"; that is, he said, he had been writing not about a revolu-

tion but solely about tragic heroes operating in a revolution—heroes who, it might have seemed to the NRF readers, were perhaps not such tragic revolutionary figures as Trotsky himself, writing a belated book review in exile on Prinkipo. By the time Les Conquérants reached its thirteenth edition (it was published by Grasset, who had published Malraux's Tentation in 1926 and Jeunesse in 1927), Stalin had reportedly heard of it and banned it in Russia as anti-Communist, and Mussolini had heard of it and banned it in Itatly as pro-Communist. At any rate, Grasset put a band around the book, announcing, in large letters, INTERDIT EN RUSSIE ET EN ITALIE, which automatically increased its sales in France.

Soon after Malraux began working as art-book editor at Gallimard, he also began functioning as a manuscript reader and editor, when he was not traveling to the ends of the earth. From the first, the pattern of his journeys had been determined by his art interests; they were planned so that he could see museums or private collections, temples, cathedrals, palaces, or maybe just one particular Romanesque fresco or statue in a remote, dilapidated chapel in an obscure European village. "Archaeology was my first study; it formed me," he has said. "Art was my most constant preoccupation, then literature. It is my obsession with other civilizations that has given my own civilization and probably my life their special accent." He always traveled swiftly but intensely, seeing everything and forgetting practically nothing. He is gifted with a photographic memory for art, and says that he is able to come out of a room containing twenty pictures and list the pictures in the order of their hanging. In his earliest travels, he repeatedly covered Western and Central Europe, and later he classically viewed Greece and Egypt. He traveled all over North Africa, but never penetrated savage Central Africa. He visited Abyssinia, the Near East, parts of Arabia, and Persia, living occasionally in a little palace in Isfahan. In the course of even longer journeys, he traveled around Central Asia and engaged in a brief archaeological exploit in Afghanistan. In 1930 or thereabouts, he went to Japan and, on his way back, traveled extensively in India; he once returned to France from Indonesia via

the United States, in order to see the American museums. And, for
a European, he knew Indo-China and China well, making the most
recent of a number of voyages out there in 1931, to see more temple
paintings and carvings, and to visit mandarins who still possessed
collections of art to be contemplated privately. To his regret, he has
never been to Latin America or Oceania. He feels that the aesthetic
high points of his journeys were the works of Michelangelo (in
Florence, not those in Rome); his first sight of the temples and
shrines of Nara, a Buddhist center in Japan; the tomb of Jahangir,
in Lahore; the Sphinx, seen for the first time under the best condi-
tions; and the art excavations from Mari, now in the Damascus
Museum, and the Parthian art excavations in Iraq, which he con-
siders two of the archaeological achievements of the century. The
vast range of art he has seen in all these places seems to have re-
mained like a private collection in his memory, but the dates when
he saw the things, and what year this voyage was sandwiched in
between others, have always been unimportant to him, and are in a
state of confusion in his mind. Besides, during the last war the
Gestapo seized some of his papers, making gaps in his records. Ex-
cept for art or history, dates do not catch his attention; as for the
events of his own life, he does not recall or much care which year
was which, and says that in a general way he knows how old he is
only once a year, on his birthday.

In 1930, La Voie Royale, the novel based on Malraux's statue-
hunting exploit in Cambodia, was published. The dramatis personae
and certain facts were somewhat changed in his account. Mme.
Malraux, who had made the journey with him, was not in his book.
(Several years later, she gave her own interpretation of the trip in
a novel called Portrait de Grisélidis—a reference to Griselda, the
fabled patient wife.) In La Voie Royale, he reduced the company
to two versions of himself—one an overwrought young French
archaeologist in the East for the first time, the other an old colonial
professional adventurer, tarnished by his struggle for survival there,
such as Malraux might in time have come to be. The story of La

Voie Royale, which either frankly reveals the lawlessness of the Cambodian escapade or else cynically uses what others said about it, as an arrogant spoof, has the young archaeologist taking a gamble on making a quick fortune out of the only thing he knows, which is art, by hunting Buddhist statues to sell on the European antiquities market. Politically speaking—since all Malraux's early novels contain acute and prophetic political insights—the old adventurer, a Nordic named Perken, represents a privileged colonialism that is already perishing. He runs a kind of private kingdom of tribesmen somewhere in Siam, and wants his share of the money—assuming that his knowledge of the jungle can lead the expedition to certain lost temple sites in Cambodia—to buy guns with which he plans to fight off other white men's more progressive civilization, already creeping toward his precious kingdom with railroads and bad brandy. (A few elements of the situation vaguely remind the reader of Joseph Conrad's *The Heart of Darkness.*) When, after repeated disappointments, the pair finally discover a ruin, richly complete with dancing-girl statues, Perken's only response to the temple's beauty is to calculate how many carbines and machine guns it may be worth to him. In a fight with hostile natives, he cuts himself on a piece of bamboo, the gangrene of the jungle sets in, the statues are abandoned and, in "a desperate fraternity," the young Frenchman vainly tries to transport him back to his own domain. Perken dies in agony en route, killed by the dangerous life he has proudly made for himself. His last words are "There is no death. There is only me . . . me . . . going to die," ringing the rebellious, lonely Malrauvian cry against mortality as the final defeat of man.

This is Malraux's one novel in the old-fashioned romantic sense of the word, being the story of a treasure hunt, a drama of male comradeship, a superb tableau of counterpoised male psychologies, with no distracting overtones of world politics—all handled with beauty and a rush of fresh, ornamented writing, filigreed like jungle ferns and colored like the alarming jungle flowers. It is a tour de force of young, masculine literary brilliance. Malraux's gift for visual images, stimulated by these first experiences of his with

rampant and devouring nature in the brush and jungle, resulted in descriptive passages of sensuous beauty—or horror—that rustle like poetry through his prose, yet behind his lyric eye lay the detached, materialistic intelligence, its comments affording the separate and second level of observation which French critics feel always gives his work its special dual quality. Unfortunately, Malraux, who is a harsh critic of his own works, thinks *La Voie Royale* is adolescent (he also thinks that of *Les Conquérants*), because both its old and young adventurer are too romantic to have any sense of humor, and so he did not include the jungle story in the 1947 Pléiade edition of his novels.

Malraux's marriage with Clara Goldschmidt failed sometime in the middle thirties, shortly after the birth of their only child, Florence. In the early thirties, they lived on the Rue du Bac, not far from the Gallimard office. The apartment was described by one visitor as "sombre, nude, with whitewashed walls. Against this whiteness stood out a divan, a few furnishings, simple in their silhouettes, some colored Oriental objects d'art, and two or three pictures and pieces of sculpture, all very modern." Malraux's capacity for reading, writing, concentration, endurance and isolation was extraordinary. His strength for work was cyclonic. He could work at his publishing job by day and at his writing more than half the night at home, on a sustained schedule of eighteen hours out of twenty-four. It was in these circumstances that he wrote *La Condition Humaine*, considered his masterpiece as a novelist. Upon its publication, in 1933, it made one of those rare sensations in Paris that start a new book's entry into the body of a nation's literature. Not only was it given the Goncourt Prize that December, but at the same time it was generally acknowledged to be the finest recipient of the award since its most opposite laureate number, Marcel Proust's *A l'Ombre des Jeunes Filles en Fleurs*, the Goncourt's choice back in 1918. (The difference between the two prize winners' methods was immediately commented on by the literary critics. Malraux had felt impelled to leave home and seek insurrection, gun-

fire and carnage in the political upheaval of China in order to find
themes that would feed his talent, whereas Proust had found his
genius only by staying quietly at home and remembering, in a cork-
lined room.) One of the Goncourt jury members, the writer Roland
Dorgelès, was so enthusiastic about *La Condition Humaine* that, in
violation of the jury's practice of maintaining secrecy, he announced
to a Paris newspaper two days before the voting took place that
Malraux would be his choice. In addition, having heard that one
juryman wanted above all to give his vote to a young writer, and
was hesitating between a pair of authors he had never laid eyes on
but assumed to be young enough, Dorgelès hastened to call on him
and point out that one of those authors was past forty and the other
was fifty-eight, whereas Malraux was only thirty-two. A few days
later, Malraux received the Goncourt Prize, thus becoming one of
the youngest winners who had ever been crowned. In the course
of the winter, he was the most talked-of literary figure in Paris, and
the most feted, dazzling the dinner parties and salons of fashionable
Parisians with his conversation and adulated as "the most intelligent
Frenchman of the century" until his social patience, of which he
never had any great supply, gave out.

Whereas in Malraux's first two novels he had created male types
who were memorably exceptional men, in *La Condition Humaine*
—and this was the basis of its profound popularity with and mean-
ing for the French and the world of readers at large (it was soon
translated into sixteen languages)—he not only stabilized his charac-
ters' heroism by means of the pressure of revolution but also ag-
grandized their normal human qualities of pity, tenderness, patriot-
ism and sacrifice. For the first and only time, too, he included
domestic relationships—of husband and wife, of father and son, of
lover and mistress—so his new book seemed a mature novel on the
grand classic European scale, seen against an exotic Chinese back-
ground. Moreover, its main theme was essentially simple; it was the
doom, as Malraux saw it, of the Shanghai revolutionaries after
Chiang Kai-shek's issuance of an order to turn in their arms, which
meant their massacre—an order given by Stalin, it became known

in the recent de-Stalinization accusations, a command that the Communists in the Shanghai Kuomintang resigned themselves to because Moscow was not yet ready for an open struggle with the General for control of the now two-headed Chinese revolution. Led on first by hope, then by heroism, all the major fighting figures of *La Condition Humaine* came to a tragic end, only the less active characters being allowed a sad survival, to continue in their unimportance.

The book opens in absolute silence, with the quiet assassination of an unidentified man who is sleeping in a bed in an unidentified hotel (he possesses a document that would procure for him a shipful of arms the revolutionaries must get for themselves to set off their uprising)—a stabbing by the intellectual Tchen as his first awful moral sacrifice to the revolution. Old Gisors, a former Peking professor, art expert and mentor, survives by turning again to his opium pipe for forgetfulness after the torture and suicide of his beloved son Kyo. Kyo and his German doctor wife, May, are the only married couple that Malraux has ever attempted (except on a reduced scale in his later novelette, *Le Temps du Mépris*), and seem unconvincing: he cannot successfully imagine himself into being a wife, and since his characters are usually parts of him, when he tries to be a married woman he signally fails as a writer. The Russian Katow, the rarest hero of them all, gives his cyanide pellets to two fellow-prisoners who have lost courage before the waiting horror of their execution—to be thrown alive into the firebox of a locomotive whistling nearby—so he meets his end exaltedly facing the torture for all three of them. Among the survivors who flee the revolution is the French Baron de Clappique, shrewd clown, whoremonger, arms merchant and mythomaniac. There is also Valérie, the feminist French cocotte, who leaves her lover in order to teach him that a woman is a human being, not merely a body in bed. There is her lover, Ferral, a French representative of big business, whom Malraux uses as the novel's *deus ex machina*; to beat the revolutionaries, he scrapes up the fortune in Chinese dollars from the Rightists as backing for Chiang Kai-shek, to enable Chiang to

break with the Left. This time, nearly all the important characters —Katow, the old professor, the comic and careless Clappique, the erotic, tough-minded Ferral and, especially, the two ultramodern, intellectualized women, the cocotte and the German lady doctor, despite his failure to make her marital psychology sound convincing —seem to be projections, clear or opaque or even reversed, of some part of Malraux himself, as if he were an actor playing many different roles with intuitive understanding. The novel ends with what has turned out to be a weighty prophecy to white men with investments in the East: with Ferral back in Paris at a meeting in the office of the Minister of Finance with a group of elderly, candy-nibbling financiers, who are so avariciously shortsighted, politically, that they refuse him money for the Chinese Right to use in fighting the Chinese Communists—a decision which, he warns them, will mean, in a changing East, the financial doom of every European in Shanghai and eventually the loss of the white man's China to Moscow.

In Paris, the book critic of *Le Temps* said of *La Condition Humaine,* "The material is of an inexpressible richness . . . a great book. Two-thirds of its pages are worthy of a master"—a high percentage for that conservative paper to concede to a young author whose subject was revolution. A more worried view was taken by the ultra-Catholic François Mauriac, who wrote in his diary, in an anxious analysis of Malraux, "We live in a strange society, old, bored, that pardons anyone who entertains it, even with fear. . . . Here is a youth who since adolescence has been moving against society, a dagger in his hand, and who to stab it has sought out its most vulnerable point, in Asia. . . . But look at the facts! He has talent; he has more talent than any other youth of his age. And whether one is indignant or whether one approves, it is a fact that in the year of grace 1933 a fine book excuses anything."

The phrase "la condition humaine" immediately entered the French language, where it has remained. It has become a stock expression in serious French conversation, in editorials, in essays and in Parliamentary speeches, and it is frequently used in sermons

from the pulpit to mean the Christian's sufferings here below. It is the only novel title in modern French writing that has become an everyday idiom. The Malraux legend has it that he took the title from the *Pensées* of Pascal—specifically, from the famous tragic reflection that said, in part, "Imagine a number of men in chains, and all condemned to death, of which some each day had their throats cut within view of the others, those who remained seeing their own plight in that of their fellows. . . . This is the likeness of man's estate—*C'est l'image de la condition des hommes.*" In one of Montaigne's essays there is the phrase "*l'humaine condition,*" and the legend has also cited this as Malraux's source. However, in some fairly minor correspondence of Mme. de Maintenon with her father confessor, she used the actual phrase: "*Il y a une vide affreuse dans toutes les conditions humaines* [There is a horrible emptiness in all man's estate]," which somehow escaped the attention of the legend-makers. Malraux recently said that the title of his novel could be taken as a souvenir of the writings and the thoughts of all three—Pascal, Montaigne and the lady. Because of today's nostalgic interest in China, lost to Moscow, *La Condition Humaine,* in the autumn of 1954, twenty-one years after it was first published, was presented in Paris in play form, dramatized by the playwright Thierry Maulnier. At an auction of books and art held in the Galerie Charpentier in Paris in the spring of 1956, the highest price paid for any item was for the original handwritten manuscript of *La Condition Humaine,* beautifully bound and boxed in leather and the former property of M. Gallimard, its publisher. It was sold for 3,020,000 francs (over $8,000). A first edition of the book, enriched by two autograph unpublished chapters, fetched 455,000 francs ($1,300).

In an American book on Malraux, called *André Malraux and the Tragic Imagination,* published in 1953, Professor W. M. Frohock, Professor of French at Wesleyan University, in Connecticut, offers evidence that Malraux was not in Canton during the events of the June, 1925, Canton uprising reported on in *Les Conquérants,* and

regards it as unlikely—on what basis he does not make clear—that Malraux ever went to Shanghai, the scene of the events of the 1927 political struggle, made bloodier, that he used in *La Condition Humaine,* until several years after the events had taken place. Checking French colonial newspapers in the branch of the Bibliothèque Nationale in Versailles, Professor Frohock found Malraux's signature on a series of daily articles on Franco-Annamite political relations that appeared in his Saigon newspaper during most of the three weeks when the Canton uprising was taking place. According to several American journalists who were in China at the time, Malraux may have been in Canton a week or so later; being a gifted reporter, with hypersensitive perceptions, in their opinion he could have found his story still vibratingly alive. As for his Shanghai experiences, whenever he had them, everything he wrote about them, an American Far East correspondent recently said, "rings as true as a Chinese gong." In a recent review of Frohock's book in the British *New Statesman & Nation,* the critic says, "During the thirties it was commonly thought that he [Malraux] was an unusual kind of reporter who recorded in brilliant imitation-fiction actions he had himself taken part in . . . [but whether he actually did take] part or not in the actions described is irrelevant. . . . Malraux, in his Chinese novels, at all events was not writing disguised autobiography . . . [but] a vision that demands for its complete embodiment the extreme situations of war and revolution." The Frohock book has not been translated into French or commented much on in Paris, but in any case, such careful research is little appreciated there, and as soon as Malraux's Chinese books appeared, French literary critics concluded that whether or not the author had physically participated in what he wrote about, its authenticity lay in his having made the material his own, as any great novelist does, by the authority of his artistry.

Shortly after Malraux won the Goncourt award, which amounts to 5,000 francs, he informed a friend that he intended to use the prize money to discover the long-lost capital city of the Queen of Sheba, which someone had told him was beyond the desert of

Yemen. In 1896, when Edmond de Goncourt established the prize, its gold francs were worth $1,000. But the paper money of France had fallen in value until in 1933 it was worth only about $200. Because Malraux had a reputation for extravagance, his project was taken to be one of his occasional mordant jokes, until he explained that his plan was to explore the desert modestly, passing himself off as a Persian. However, his royalties from the large sales of a Goncourt winner had already brought him 300,000 francs, or about $12,000. By the time *Les Nouvelles Littéraires* for March 17, 1934, announced as a quasi-literary note that the Goncourt winner was using his prize to search for the Old Testament queen's city, Malraux had been off on his adventure for a month, having flown out to it in a specially outfitted, borrowed private airplane.

It was characteristic of him that he should have decided to use his prize money and some of his royalties on one more adventure. It seems that some years earlier, when returning from China to France by a zigzag route that led through Afghanistan, Persia, Arabia and French Somaliland, he had met a stranger in a Djibouti hotel who told him, "The Arabs say that somewhere beyond the Yemen desert, half hidden by sand, the real capital of the Queen of Sheba still stands"—in other words, the capital city of the Sabaean civilization, popularly cloaked under the legendary queen's name. From that moment on, Malraux apparently had a rendezvous with the secret city. In 1934, his idea was to make his search of Arabia Felix alone, posing as a Persian. He confided his plan to an adventurous friend who was a famous record-breaking airplane pilot, Reserve Captain Edouard Corniglion-Molinier (now a general, he was a Minister of State, from a Gaullist splinter party, in the Laniel government), and the Captain pointed out that the Bedouins were as hostile to Persians as to any other outsiders, and said he would surely be massacred if he traveled on the ground; therefore, he suggested using a plane. There was some talk of Malraux's being flown in by another pilot-adventurer friend, Antoine de Saint-Exupéry, but he had just been married and his wife would not let him go. Then a rich French aviation enthusiast

lent Corniglion-Molinier a small single-engine plane for the expedi-
tion. Malraux figured on a ten-hour, nonstop flight of two thousand
kilometers over Bedouin territory. The plane was fitted with extra
gas tanks and a good deal of other special equipment, and, though
Malraux himself was to pay for the gasoline and for the salary of a
mechanic, who was the third in the party, the expedition's con-
siderable expenses were also partly paid by the afternoon Paris
newspaper *L'Intransigeant,* whose editor signed up both Malraux
and the Captain to write articles about Sheba's city if they got back
alive. On February 22, 1934, after Malraux had given the surprised
editor an extract of what Gustave Flaubert had written on the
Queen of Sheba in *La Tentation de Saint Antoine,* the two ad-
venturers and the like-minded mechanic took off from Le Bourget.

On March 10, *L'Intransigeant* published on its front page a
telegram from Djibouti announcing, HAVE DISCOVERED LEGENDARY
CITY OF QUEEN OF SHEBA; TWENTY TOWERS OR TEMPLES STILL
STANDING. IS IN NORTH OF RUB' AL KHALI. HAVE TAKEN PHOTO-
GRAPHS FOR INTRANSIGEANT. GREETINGS. CORNIGLION–MALRAUX.
Paris, London and New York newspapers featured the Malraux
news, plus a spate of opinions by archaeologists, who proved them-
selves to be experts by their disagreement over what the French
fliers had discovered or failed to discover. The New York *Herald
Tribune* quoted the French Orientalist Jules Barthoux, then in
town, as saying that Malraux had consulted with him about Sheba's
city in 1930 but that what he had just flown over was unfortunately
only a ruin called Wabar, the Arabic name for some large rodents
that lived in its rocks. The University of Pennsylvania's Professor
of Assyriology said, also in the *Herald Tribune,* that Malraux had
undoubtedly found somebody's ruined city, but not Sheba's, which
was authoritatively believed to be in the south of Arabia Felix, at
Marib—a well-known theory, which, for some reason, Malraux
refused to subscribe to; though in his flight, he passed over Marib
to take a peek at it, out of curiosity, and later reported that he
thought it small. In addition, the *Herald Tribune* printed the
Biblical story, from the First Book of Kings, of the Queen of Sheba's

visit to King Solomon, and illustrated it with paintings depicting the royal meeting amid nude slaves, peacock fans and tame lions. The *New York Times* cited a Columbia University professor of Semitic languages as saying, "A nice story about Solomon and the Queen of Sheba. But as far as we know there never was such a queen," and hence no city to hunt for. In the Paris papers the Musée du Louvre's curator of Oriental antiquities stated flatly that Sheba's capital had long since been discovered at Marib, but added that what Malraux had discovered might prove archaeologically more interesting. In London, Bertram Thomas, who was famous as the first Western Orientalist to cross the Rub' al Khali, hailed Malraux's claim to have finally found Sheba's capital as consistent with scientific theory and "more of a thrill than a surprise."

Because of bad weather on the return trip, the Malraux party did not reach Le Bourget until late in March. Malraux and Cornig-lion-Molinier then wrote a series of ten articles—seven by Mal-raux, three by Corniglion—which did not begin to appear in *L'Intransigeant* until May, and, after all the professorial hullabaloo over what the two men had or had not found, they seemed a belated narrative of what they had merely seen. They had flown so low over the mysterious city, one Malraux article declared, that Bedouins had fired muskets at the plane; and the city was "like an enormous monument, like the towers of Notre Dame . . . blind towers . . . trapezoid towers . . . vast terraces . . . propylaea . . . walls forty metres high . . . broken statues . . ." Malraux's photographs, blurred by desert dust, indistinctly showed a pillared metropolitan ruin. The Corniglion-Molinier articles related that in their excitement on the great day they had imprudently flown eleven hours on their esti-mated ten-hour gasoline supply, that a lucky wind had helped take them back to Djibouti and that they had been given a palace re-ception at Addis Ababa by the Emperor of Ethiopia, Haile Selassie, "because the city we discovered was that of his ancestress, his dynasty traditionally claiming its origin in Sheba's son by Solomon." Shortly after the last article appeared, a French government official reprimanded the Captain for having flown across Yemen without

Yemenite authority, because it might have provoked an international incident. That was the last that was heard of Malraux's flight over a majestic archaeological ruin in Arabia Felix that was, after all, apparently not Sheba's city. In Paris, Malraux was much criticized for having made this flight. Some people felt that it was useless and dangerous, as well as spectacular to the point of exhibitionism. But, as a more recent Paris critic has remarked, it seems logical that Malraux's life as an adventurer should have contained "*plus de tentatives que d'accomplissements*." Sheba's capital was one of his *tentatives*.

In 1933, the events of history shifted Malraux into the European period of his writings and political experiences. Hitler's ascent to power that year roused many French intellectuals, if not the French government, to the dangers of German Fascism. As the French intelligentsia had generally done over 150 years whenever liberty seemed threatened, they swung, in the main, to the left. No novice as an *homme engagé* on that side, Malraux entered the growing conflict between twentieth-century political faiths in Europe with a medieval crusader's zeal for participation and his own feverish physical need for the tonic of danger. In the next dozen years, while the preliminaries to the Second World War were turning into the war itself and while it was being fought and militarily concluded, Malraux was to be, successively, a Communist-backed spokesman for the Left; an aviator on the Loyalist side in the Spanish civil war; an enlisted private in the French Army; a prisoner of war and *rescapé*; a colonel fighting under a *nom de guerre* in the French Maquis and badly wounded, captured by the Germans, freed and awarded the highest medals and citations for bravery; a brigade commander in General Leclerc's Army of Liberation in Alsace; a fighter with the French First Army in Germany and a recipient of the Croix de la Libération, the Croix de Guerre with four citations; and, in a surprising postwar sequence, a Cabinet Minister in General Charles de Gaulle's provisional government of France. One of Malraux's most startling gifts had always been his Cassandralike

sense of how and where history was getting ready to be made. What he wrote was, to an unhappily large extent, what history turned out to be. Indo-China and China were his earliest fields, where today's history was then only breaking ground and sprouting. The French now credit him with having been the first man to recognize that the 1920's were not Europe's postwar but its prewar period. When he was barely out of his teens, he had written that European republicanism, the nineteenth century's great social experiment, was sliding downhill in a crisis of Western civilization, and by his subsequent actions he showed that he believed it was not possible to weigh the twentieth century without willy-nilly weighing Marxism as the next great social experiment. In his Gaullist period, before the Cold War was generally regarded as serious, Malraux, delivering a lecture entitled "An Appeal to Intellectuals," was one of the first Frenchmen to call attention to the menacing problem of world Communism to the West.

Because his two novels on the Chinese revolution of the 1920's (before *La Condition Humaine* there had been *Les Conquérants*) had read like the autobiography of a Communist sympathizer, in the 1933 Paris Leftward swing he was automatically regarded as the most authentic pro-Communist literary French voice by nearly everybody but the French Communist party. For one thing, according to him and to a statement by the party chief, Jacques Duclos, front-paged years later in the Communist paper *L'Humanité*, Malraux never belonged to it. For another, while he had presented the Shanghai uprising as a tragic epic of Communists dying for the sake of a better life for other men, his characters (who, whether Chinese or German or Russian or French, were usually begotten in his own image and frequently talked like him) had also aphorized in dialectical heresies that described their author's cold, impartial lucidity. Although his novels showed his humane enthusiasm for the idea of the fraternal man, and his impatient sympathy with the Communists' stated plan to rid the world of the injustice and indignity of poverty, in the eyes of trained French Communists his novels also showed that he was as agnostic about Marxism as he

was about Christianity, that he thought Communist doctrine *fatras* (or balderdash) and that although he was an exasperated *révolté* against the cultured bourgeois class that he sprang from, he only proved his unfortunate origin by not becoming an avowed champion of the proletariat. Furthermore, being an indigenous French skeptic, he preserved his deep individual pessimism as a novelist and artist instead of taking on the bright collective optimism of the Sovietized Comrade. According to one candid Communist interpreter, Malraux lacked "the *joie de vivre* of the true revolutionary" and remained politically deformed by "the sombre dilettantism" of the literary artist, who, as if with double lenses, saw in the Marxists' planned utopia the familiar revolutionary mirage of men's bright earthly hopes but also the classic tragedy of their lost liberties.

In 1933, when the French Communists and the French intellectuals were coming to feel a common fear and hatred of German Fascism, not only the Paris Communist party but Moscow as well began an intensive open-house period of hospitality for the intelligentsia. Apparently, Malraux's basic position by this time was what party men today disdainfully call that of a negativist—one who is for something, within limits, because he is totally against something else. Malraux, being a violent anti-Fascist, entered into a mutually pragmatic relationship with the French party, and was built up as a star literary orator for the Left, despite his bad physical nerves and his unreliability in Marxist dialectic. Undisciplined and freethinking, and thus useless as party material, he was nevertheless invaluable as a passionately anti-Fascist ornament at Paris Communist rallies, and his name was printed in big type on the posters, like Picasso's in more recent years. At that time, serious French thinkers traveled east in considerable numbers to see Red Square, and Malraux went to Moscow several times. He was officially invited to attend the All-Union Congress of Soviet Writers, held there in August, 1934, at a former nobles' gambling club; listed in the program as a humanist, since he could not be listed as a Marxist, he caused a dustup among the Comrades with a speech in which he told them that they seemed to have a lack of confidence in their

writers—"based on your misunderstanding of culture, it seems to me"—and that Tolstoy's characters were psychologically richer than those of Soviet authors. If Malraux accomplished nothing more at the meeting, he made a friend of old Maxim Gorki. The year before, in 1933, Malraux and André Gide, who was then going through his brief Muscovite period, were sent by the French Communists to Berlin to present to Hitler, who refused to receive them, a petition for the liberation of the Bulgarian Communist Georgi Dimitrov, accused of firing the Reichstag. Malraux was one of the founders of the World League Against Anti-Semitism and one of the members of the Comité International d'Aide aux Victimes du Nazisme. The Left Wing became an accepted, respectable political habitat in France, even before the establishment of the Front Populaire government, which united the Communists, the Socialists and the anti-clerical Radical Socialists. Indeed, in certain aristocratic intellectual Paris circles, Communism became fashionable, rather like a new form of caviar. Jean Cocteau said of one viscountess that she had ordered her hammer-and-sickle emblem in diamonds and rubies from Cartier's. In the summer of 1935, the International Congress of Writers in Defense of Culture held a meeting in Paris, in the Palais de la Mutualité, that even the Rightest Paris press regarded as the international intelligentsia event of the year, and both Gide and Malraux, who were leaders of the organization, were on the speakers' list, along with Heinrich Mann, Aldous Huxley, E. M. Forster and John Strachey. Again, Malraux's speech was far from being devoted to the materialist dialectic. He talked about the artist's need to learn to create as an individual before he could record any "world version," or any international propaganda. Like Malraux's formidably cogent and brilliant conversations, his speeches at party rallies—at the old Bal Bullier, the outdoor Stade Buffalo and the Grande Salle de la Mutualité—consisted of floods of ideas that were personal, not general, and thus they had the strange impact of private communications on the thousands of proletarian listeners crowding the tribunes. Unlike any other Left speaker, he also invariably drew some of the *gratin,* or upper crust, who came to hear his mind work.

Dipping his pen into current events again after his trip to Germany with Gide, Malraux wrote *Le Temps du Mépris* (*Days of Wrath*), which was published in 1935. This was less a novel than a de Maupassant *idée-surprise* short story, set, oddly, in a Nazi prison camp. Its plot, up to the point where it dissolves into dream and claustrophobia sequences, is technically perfect. It tells how an important Communist agent named Kassner is arrested somewhere in Germany and denies his identity to the S.A. prison officers. If they could be sure who he was, they would torture him to obtain information, and then, if he was still alive, they surely would shoot him. However, they release him after nine days, because some heroic lesser agent has falsely given his name as Kassner and, presumably, has taken over his fate. Kassner has no idea who the substitute Kassner is. At the end, Kassner goes home to bid farewell to his wife and son, knowing that the next time he is caught no one can save him. *Le Temps du Mépris* was the first noteworthy French report on the Nazi peacetime concentration camps, with their beatings, tortures and other physical inhumanities, which few Europeans could then believe in or had even heard of. (In the middle 1930's, the wartime crematories still lay beyond the reach of even the German imagination.) The book was dedicated to the anti-Nazi Comrades who had given Malraux accounts of what they had suffered. It is his only straight propaganda novel, and the only one to tell a story he had not lived or at least seen firsthand.

On July 18, 1936, the Spanish civil war broke out. Two days later, Malraux was in Spain. This move began the most highly organized of his European political adventures and led to two of his finest creative works—his epic novel *L'Espoir* and the film he made of it. He started out by founding an international air squadron called the Escadre España (later, it was renamed by its men the Escadre Malraux, after he was injured in a crash), which was stationed on its own airfield outside Madrid and, of course, fought on the Loyalist side. Like all Malraux's exploits, this one was soon surrounded by a vast muddle of hearsay. One story had it that the Front

Populaire's Socialist Premier, Léon Blum, with tears of regret in his eyes, refused to give Malraux's unit any French planes, because France had already determined upon a policy of nonintervention. Another story had it that Blum slipped the Squadron a dozen secondhand French Army planes, and a third that the Spanish Republic paid for the planes, through its Paris ambassador, after Malraux and his friends had bought them "practically on the flea market." One thing seems sure; according to eyewitnesses in Spain, they were mostly "slow old crocks—pursuit planes left over from the First World War." One reporter said that the only way the men could drop their homemade bombs from some of them was to toss them overboard, like boys throwing rocks. Malraux was the titular chief of the Squadron; the technical chiefs were two pilots who were reserve officers in the French Air Force. Malraux flew on sixty-five missions and, though he had no pilot's license, occasionally piloted anyhow, while everybody held his breath. Half the members of the Squadron were French; the others were mostly Americans, English, and German and Italian anti-Fascists, and there were even some White Russians, plus some reckless pilot mercenaries, who were paid sixty thousand pesetas a month for risking their necks—a fortune if they lived to spend it. The first important engagement for Malraux and the Squadron was an August attack on Franco's forces at Medellín, when they flew low enough to use their pistols. They also fought at Toledo, Madrid and Guadalajara, among other places. By November, the Escadre was on its last wings, after a gallant private battle with Nazi Heinkels near Teruel, where there was a new hidden airfield. By the first week in November, when Franco attacked Madrid, even the Republican Army air force was so depleted that its chief was forced to give the famous order "Bring out the pursuit plane," there being only one left.

In March, 1937, Malraux crossed the Atlantic to crusade for the Loyalists and raise money for medical supplies in the United States and Canada. He raised his first big sum in New York, speaking a few words of English that rapidly turned to French, at a luncheon at the Hotel Biltmore, which was backed by rich committee ladies.

After giving talks in some other Eastern cities, he flew to Hollywood, where he stepped from the plane carrying a copy of Dashiell Hammett's *The Maltese Falcon*, with which he had been trying to brush up on his English en route. (A few years before, as a young editor for the Parisian publishing house of Gallimard, which was interested in American novels, Malraux had written the preface to its edition of *Sanctuary*, the first of William Faulkner's novels to be translated into French, and in it he had mentioned the literary influence of our detective stories on our modern fiction.) Malraux had arranged to have an American friend of his—Haakon Chevalier, who was an instructor in the French Department of the University of California at Berkeley, and who had translated *La Condition Humaine* and *Le Temps du Mépris* into English—make a translation of his speeches and parlor conversations. The system worked out in some confusion but with excellent financial results, such as the raising of twenty thousand dollars at one mass meeting at the Shrine Civic Auditorium. At several of the elegant Hollywood parties that were given in Malraux's honor, where stars donated ambulances to the cause and in return asked his opinion of their pictures, people were taken aback by his voluble, encyclopedic familiarity with American movies. He was asked at one party why in the world he, one of France's famous novelists, had risked his life in Spain, and answered, in English, "Because I do not like myself"—a truly revolutionary idea in Hollywood circles. At a Sunday breakfast at the University of California Faculty Club, where Malraux talked on art, he laid the groundwork for one of his typical mnemonic feats. Notes were taken on what he said, and pages of them turned out to be germinal ideas on art that appeared verbatim and entire ten years later, in his three-volume *La Psychologie de l'Art*.

L'Espoir (*Man's Hope*), Malraux's reportorial novel about the Loyalist side of the Spanish Civil War, was published by Gallimard in 1937. It made an immediate and powerful impression in France. Of all his current-history novels, this, naturally, was the one that ordinary French readers were most intimately interested in (and nearly twenty years later it still remains a best-seller among students

in the Sorbonne neighborhood), for what he told about was next door and was still happening at the time the book came out. It was the first notable novel about the first modern, mechanized civil war —the first revolution in which the working class used airplanes in its fight. Malraux, a participating flier with a lyrical gift for conveying the carnal *élan* of men fighting, was the first writer ever to treat air combat in epic style, describing enemy planes "turning like planets" to bomb cities below—still a novelty then. Written in the typical Malrauvian martial-and-cerebral style, the book reads basically like a combat diary of the war, complete with national and international combatants, from its opening in Madrid through the fall of Toledo and the Battle of Teruel early in 1937, the last engagement of the Escadre Malraux and of Malraux himself. Among its leading characters are a middle-class Spaniard who had worked as a sound expert for a film company, an American newspaperman from Iowa City, Malraux's inevitable art experts (one of them worried about saving some El Grecos from incendiary bombs), a mature French airline administrator turned squadron chief, who, though obviously Malraux, is, for once, little like him, and a dozen other men without women. (It has often been remarked of Malraux's soldiers in any land that they are a special *chevaleresque* crew, who never complain about the absence of females and never wonder when they are going to eat next; they are like men who are fed by and embrace only courage.) *L'Espoir*, which is Malraux's last novel written from the Left side, also contains a new, disillusioned subsidiary theme: the struggle between haphazard heroism and disciplinarianism, between desiring victory and organizing it, between the Western world's final flareup of romantic, rebellious Leftist individualism—it was this individualism of which Malraux was an apostle—and a newly visible totalitarian power policy, the Communist "organization of the Apocalypse." "I grant you economic servitude's a dreary state of affairs," the father of one Loyalist Spanish fighter, in *L'Espoir*, says bitterly, looking into the future, "but if, to do away with it, they're obliged to enforce a political, military, or religious servitude, why should I take sides?"

"The age of [political] parties has begun," warns another Leftist character. However, in this novel the most famous of the philosophical and psychological maxims that Malraux's characters always express for him is not concerned with politics; it is "What can man best do in his life? Translate into consciousness the largest possible experience, *mon bon ami.*" The title of the book was taken from an aphorism voiced by another of its characters: "There is within man a terrible and profound hope." The noted French novelist Henry de Montherlant said that "of all books in the last twenty years it is the one to wish most that one had lived and written."

In 1938, with the help of his friend Corniglion-Molinier, who had also been in Spain during the early part of the civil war, and then had returned to Paris to his work as a film producer, Malraux made a motion picture of the last part of *L'Espoir* in Spain, while the fighting was still going on, mostly using Spanish peasants and Loyalist soldiers as actors. The difficulties were constant. Film had to be flown down from France, flown back to be developed and flown down again so that Malraux and his colleagues could see the rushes. In Barcelona, streets and houses used in yesterday's unfinished scene would be changed by bombing overnight or would disappear entirely. Two dramatic, photogenic incidents near the end of the novel were the main reason for making the film and gave it its extraordinary quality. The first was an incident involving an old peasant who has come to warn the Squadron of the existence near his village of a new, hidden airfield for Heinkels. The old man agrees to guide them to it in a plane, but, unable to read a map, and never having flown before, he is, at first, ironically unable to recognize from the air the roads and landscape he has trudged over since infancy. This air search, as photographed from a little plane, when translated onto film became a hair-raising, cinematographic chef-d'oeuvre—a twitching kaleidoscope of views as the plane tilted like a kite a few feet above mountain peaks or skimmed over trees to give the disorientated old man a closer, more dangerous view. The second incident was the aftermath of the Squadron's bold attack on the discovered enemy field and the crash of one of its planes

—the descent from the mountainside, "in austere triumph," of the Squadron's international dead and wounded, carried on litters made of branches, and with a coffin lurching on a donkey's back, the whole procession moving between a black hedge of respectfully mourning Spanish villagers, to whom the foreigners had been, and remained, unknown, except during that brief passage of fraternity. The film ends with a view from the valley below of the victims and villagers tracing a descending, dark processional pattern, like a line of tragic poetry, on the bleak landscape. It was principally these scenes of rare beauty and emotion that eventually won the film the Louis Delluc Prize, which is the French film critics' award. But in 1939, when the film, with background music by Darius Milhaud, was ready for showing, the Spanish war was just over and political feeling was running high; permission was given by the French government for the film to be shown but the conditions in Paris just after the declaration of war by Germany led to postponing the public presentation, and it was shown privately. By the summer of 1940, the Germans were swarming into Paris. Just before they overran the movie studios centered at Joinville, near Paris, someone, in the confusion, mistakenly switched the one existing print of *L'Espoir* to a box marked with the name of another Corniglion-Molinier film, *Drôle de Drame,* well titled for the circumstance; the Germans seized and destroyed what they thought was *L'Espoir* but was really a print of *Drôle de Drame,* and thus the film was accidentally saved. It was not shown publicly in Paris until after the Liberation, and it was then that it won its prize.

The Moscow trials and the Stalin-Hitler pact gave Malraux, like many other members of the French Left, the final justification for breaking with the Communists, and upon the outbreak of the war with the Nazis, he joined the French tank corps as a volunteer, with the rank of private. Thus, at the age of thirty-eight, Malraux, a Frenchman obsessed with the cult of action, was fighting for the first time for his own country, in its struggle against its old enemy. At the fall of France, in June, 1940, he was captured in the Yonne,

and sent to a prisoner-of-war camp in the cathedral town of Sens; in November, he escaped, in civilian clothes, including shoes a size too small for him, in which he had to make a long cross-country trek. Wearing a carpenter's work suit, and carrying planks on his shoulders, he crossed into France's Free Zone. There was some lamp-black, for staining wood, in the pocket of the jacket he had been lent, and this somehow got onto his hands and from there onto his face. When he was safe across the line, he hurried into a café to change his clothes and saw a semi-minstrel face in a mirror; for an instant, he did not recognize himself. In December, he made his first contact with the Resistance, which was then loosely organized. Parts of the next two years he spent in Switzerland, in the French Corrèze and the Dordogne, and in the Midi, where he read and wrote in the house of a friend of André Gide's. The man had left his butler as caretaker, and although the butler and Malraux had nothing to eat but boiled rutabaga, the butler served Malraux his meals in style. In 1942, Malraux became connected with the Gaullist Resistance apparatus, and the next year he began carrying out Allied Etat-Major operations in the Free Zone, including liaison work with British parachutists who were bringing arms to the Resistance. By the spring of 1944, Malraux, under the *nom de guerre* of Colonel Berger, had been made *chef du Maquis,* and commander of fifteen hundred men, for three *départements*—the Lot, the Dordogne and the Corrèze. There were a good many outstanding French writers in the Resistance, but of them all Malraux was the most influential, partly because he had had experience with organized revolt in China and Spain and in China had seen torture made a political practice—something that most other Maquis commanders and their men had to learn about from the Nazis and Pétainists.

Malraux's Maquis campaign was characteristically fantastic and fortunate. It began in December, 1940, when he took part in the dynamiting of some locomotives near Toulouse; thereafter, the Maquis action was intermittent, until 1943, when the Resistance was sufficiently organized to carry out a continuous program. By May, 1944, his group's main task for the Supreme Allied Com-

mand was to harry the S.S. Division, Das Reich, which was the Free Zone's special scourge (its most horrifying exploit was to herd the villagers of Oradour into their church and burn them alive), and impede it in its push north to meet the coming Allied invasion of Normandy. In June, though, a detail from the Reich Division had captured Malraux. While he was a prisoner in the Lot, his men, in their turn, captured a unit of Wehrmacht soldiers in the Corrèze —this was the first surrender of Nazi men and arms made to a Resistance group in the Free Zone, and it turned his theretofore ill-equipped Maquis group into of the best heeled in the territory, with excellent German arms to use against the Germans. As absentee commander of the group that laid hands on the booty, Malraux was later awarded one of the four hundred Croix de la Libération given out in all of France. His capture had been what he calls *farfelu* (or bizarre); a unit of the Reich Division for which he had laid a road trap near the town of Gramat trapped him instead, while he was riding in a car with some English parachutists. Malraux ran across a field to draw fire from the Britons and let them escape, which they did. He was shot in the thigh, but he ran on, until further shots brought him down, badly injured. For this, he was awarded the British Distinguished Service Order by King George, presented to Malraux in Paris at the British Embassy by Ambassador Alfred Duff Cooper.

Malraux's experiences as a prisoner of the Reich Division were equally dramatic and, again, lucky. Since his Colonel Berger identity papers were patently false, he gave the German interrogation officers, established in one of the Gramat hotels, his real name, to save time. Lying bleeding on the floor of the hotel office, he still had the strength to involve himself in an intellectual argument about Saint Augustine, on whom he is an authority, with an S.S. officer who had offered him spiritual comfort, claiming to be a priest—falsely, Malraux decided, since he turned out to have so little knowledge of the Saint. A few days after, he was taken out for what proved to be a mock execution—"the same trick that was played on Dostoevski," he has since remarked, with literary satisfac-

tion. His Nazi captors had him stand facing a wall, with his arms raised, but he quickly wheeled about to see what was going on—if it was truly death—and they did not fire. Later, he was taken to a French villa elegant enough to contain a bathtub used for torture, but he was not tortured. One afternoon, he was driven to a superb château, where cars flying the flags of German generals were assembled in the garden. Knowing that, as a colonel, he could be court-martialed only by a group of officers that included generals— Malraux at any time is competent on such military niceties—he thought that the presence of so many generals, and himself, indicated a *conseil de guerre* to be held over him, after which, this time, he would surely be shot. At the end of a half hour of unexplained waiting, he was taken back to the Gramat jail, where the Nazis by then had put him. Next day, his French jailer told him that the Reich Division band had given a Wagner concert at the château, and that the general who had ordered him to be brought there for interrogation had decided that the music was too fine to miss. Shortly after, Malraux was handed over to the Gestapo and transferred to St. Michel Prison, in Toulouse. Paris was liberated on August 25, and a fortnight later the Paris Resistance newspaper *Combat* published an official denial that Malraux had been killed. What had happened was that as the Nazis began fleeing east before the invading Allied troops, Malraux was left forgotten in prison, was liberated, like everybody, by prisoners' wives, and began fighting again, around Limoges.

The Dordogne, where Malraux was soon once again in command, had been a refugee center since 1940, when a large population of Alsatians and Lorrainers had been evacuated so that they could not be impressed into fighting with the German Army when it poured into France, and now the evacuees' Maquis chiefs chose Malraux to command their volunteer Brigade Alsace-Lorraine, eventually attached to General Philippe Leclerc's Second Armored Division, which was engaged in liberating their home region. Guerrillas without uniforms, but rugged fighters, the Brigade was called on to help out the regulars in some difficult spots—notably

in the Haut-Rhin and the Vosges. When Malraux, who with his
men had been lending a hand to the Premier Corps d'Armée, and
had then gone on his way, heard that a certain colonel was planning
to liberate Dannemarie, he went back and asked if they could help
again. Yes, the colonel said, especially if before the attack they
could give him some young fellow who would blow up the loco-
motive of a Nazi armored train in the region which had been
giving them special trouble. "I'll do it, if you want," said Malraux.
("*Un guerrier magnifique*," the colonel, now a general, recently
declared.) In combat, Malraux, though still suffering from severe
leg wounds, persisted in thinking that he was invulnerable. (It
is his conviction that "meditation upon death⌐has no connection
with the fear of being killed.") He was reportedly aloof in his
dealings with his men, most of whom had no idea who he was
but recognized in their Colonel Berger an instinctive leader. Ac-
cording to his outfit's padre, Abbé Pierre Böckel, he was a "luminous
realist." During the liberation of Strasbourg, on November 24,
1944, Colonel Berger, suddenly operating as Malraux the art
lover, was the first liberator to enter the nave of the city's eleventh-
to-fifteenth-century Romanesque-and-Gothic cathedral, closed be-
cause of bomb damage. (For some reason, his being the first
Frenchman-at-arms to penetrate the cathedral was considered so
important that news of it was sent to Washington in code.) After
the Germans were driven out of France, he pushed on into Germany
with the French First Army, which took part in the capture of
Stuttgart in April, 1945. Its commander-in-chief was General Jean
de Lattre de Tassigny, a fine talker whom Malraux impressed by
easily outtalking him at the officers' mess. In Stuttgart, the General
called a *prise d'armes* in a rubble-strewn city *Platz*, where Malraux
received the fourth citation to his Croix de Guerre, for his part in
the Strasbourg liberation, the first having been given for his being
captured by the Reich Division, the second for his pre-invasion
action against that division, and the third for his part in the battle
at Dannemarie.

After the war ended, Malraux was still bothered by his leg

wounds. (Even now they make it difficult for him to sit quiet very long, but that is something he has never liked to do anyhow.) He was also badly in need of money. The Gestapo had destroyed some, but not all, of his private papers, which he had stowed in various places around France, and to raise cash he vainly tried to sell the holograph manuscript of *L'Espoir*, written in his small, angular, legible script, which looks oddly like hieroglyphic incisions in stone. He had married for a second time early in the war. His second wife, Josette Clotis, a young writer, was killed in a railway accident during the Liberation. Malraux was given the belated news of her death when he was fighting in the Vosges. One reason he needed money in 1945 was that they had had two sons —Pierre-Gauthier, by then four years old, and Vincent, an infant.

According to the Malraux legend, his relationship with General de Gaulle, which was to reorientate his life for the next eight years, began at their meeting during the war in Alsace, with the General declaring, *"Enfin, j'ai vu un homme."* Malraux himself says he was first presented to the General at the Ministry of War, in Paris, after the war's end, in 1945, as were many writers who had fought in the Resistance. According to French opinion afterward—at the time, Paris intellectual and political circles found it nearly incomprehensible when Leftist Malraux, animated by French patriotism, joined the General, even if he did not yet represent the Right he later came to symbolize—the attraction between the two men at that point in French history must have been irresistible, and not even one of opposites, despite their diametrically different pasts. Both loved action and were contemptuous of politics; both were fascinated by the phenomenon of power; both were exalted, impractical and highly educated; both were convinced that France had a new European destiny; and—like millions of other Frenchmen, after all—both believed that de Gaulle had started saving France during the war and that its salvation could not be continued unless the General carried on the glorious burden. Malraux says he became Minister of Information in de Gaulle's

provisional government—he was the second man to hold the post, and was in office briefly, from November 21, 1945, to January 20, 1946—only after warning the General that he would work "not as a politician but as a technician," as he had done in 1927, when he was in charge of propaganda and information in Canton for the Communist wing of the Chinese revolution. At de Gaulle's investiture as President, in November, 1945, Parliament had unanimously acclaimed the General, and France was at his feet. Within a fortnight, it had come to seem to the press that de Gaulle was an extraordinarily remote chief of state, and in like manner Malraux became a somewhat distant Minister of Information. He devoted himself principally to one special preoccupation—his program for Maisons de la Culture. This was a farsighted educational-propaganda project for France, which was to start with the full-scale reproduction, by an excellent technical process, of some of the most famous paintings by Manet, Watteau, Poussin and other French artists. These were to be placed in French schools, for the children to learn to appreciate, and in provincial museums, partly to help revive national pride after the humiliation of the Occupation. They were also to be offered for sale to museum print rooms, colleges and schools in other countries—some American and English institutions subscribed very promptly. (Malraux's real educational *dada* was to have French school children taught by means of movies, used as basic pedagogy, but he never got around to that.)

One of the American deputy directors of the United States Information Service in Paris recalled afterward that when he went to see Malraux that winter, in his unheated office near the Etoile, the Paris newspapers were being printed on single sheets, editors were moaning about the scant paper supply, and the Franco-American information exchanges were still at sixes and sevens. All this was what he had come to talk about, but what Malraux talked about, with burning excitement, was his art project. "The strength of his feelings was nearly unbearable," this man said. "You thought he'd explode. His eyes were bleak, sad, and intense,

and he didn't look at you much when he talked. It was as if he were mostly talking to himself, though he'd flash glances at you occasionally, in detached observation. He was really hypnotic when he talked. You'd come about a piece of business that never got finished, or really even started, and you felt richly rewarded by his telling you about something else that was absolutely no use to you." January 20, 1946, the day de Gaulle renounced his effort to form a "national union" government, allowing his existing government to fall, and his Ministers with it, was also the day that the first—and last—of Malraux's several Maisons de la Culture art reproductions came off the press. One copy—it is Renoir's "Moulin de la Galette," with its waltzing couples—hangs, as a souvenir, on the wall of Malraux's study, in his home outside Paris.

In April, 1947, when the noble notions left over from the Liberation had bogged down in the old swamp of French Parliamentary politics, admirers of General de Gaulle founded the Rassemblement du Peuple Français, or R.P.F., making him the rare gift of a political party so that he could be its leader. Their eventual object was to elect him back to the salvational office from which he had resigned fifteen months before. Malraux was one of the five charter signers of the R.P.F., and, by presenting its ideas to the nation, he became its dominant catalyst and the main focuser of the Gothic personality of de Gaulle, as well as his most intimate cerebral adviser and, once again, his propaganda technician. Malraux's official title was the R.P.F. Director of National Propaganda. At the party's inception, Malraux said, prophetically, "The Rassemblement is either a revolution or it is nothing." One postwar explanation of Malraux is that when young he was a *révolutionnaire mystique* not because he was pro-Moscow but because he could not abide the way the world was going; backing the R.P.F., he was still a mystical revolutionary but one who could not abide the way France was going and also could not abide Communism, which he now saw as an organized threat to Western Europe. De Gaulle called the Communists *les séparatistes*, since their intention was to separate France from Europe and give it to Moscow. Ac-

cording to Gaullist leaders, Malraux's influence on the General
was stronger than any other man's, because he represented what
the General regarded as a pinnacle: a highly intellectualized,
fiercely impassioned Frenchman who believed in France's "voca-
tion for greatness" and who had already been a volunteer warrior
in various causes—the perfect combination of arms and the man.
Many French felt only misgivings about the relationship. "What
Malraux admires in the General is his silence; what the General
admires in Malraux is his words" was one comment. Unfortunately,
along with the millions of Gaullist patriots who wanted the Fourth
Republic re-formed, thousands of anti-republican ex-Vichyites
rushed to the General's banner merely to use it as an umbrella
against Communism. France's democratic core hardened against
the R.P.F., especially after the municipal elections of October,
1947, when, at its opening peak, it won 40 per cent of the vote
throughout the country.

This time, Malraux was dynamic as a propaganda director. He
put his interest in art into R.P.F. posters. All along the Paris
boulevards, walls came alive with his enormous, magnificent re-
productions of the aroused Republic as "France," sculptured by
Rodin, with the Gaullist Cross of Lorraine added for identifica-
tion, and of a superb, little-known sketch (it was in the Musée de
Dijon) by the sculptor François Rude of "La Marseillaise," with
head aloft and draperies flying, which as a statue is now the most
famous of any adorning the Arc de Triomphe. The Malraux Christ-
mastime poster showed a Gaullist Lorraine Cross woven of con-
centration-camp barbed wire, which, recalling Jesus's crown of
thorns, became in Parisian eyes an emotional symbol of France
crucified. "We have to set a high tone," Malraux said of his
aesthetic publicity. "We cannot use the style of a grocer selling
pickles, for they are not what the General has to offer." Malraux's
office was on one of the Grands Boulevards, and, to furnish more
propaganda, his stenographers were pretty Gaullist Resistance
heroines.

As a speaker at R.P.F. mass meetings, Malraux was second

in attraction only to the General, and the effect of his speeches on his hearers was as remarkable as it had been in the days of his anti-Fascist speeches at Communist mass meetings. "He had the rare gift of being able to make his hearers comprehend what he wanted them to believe," an R.P.F. leader said afterward. A colleague of his at Gallimard, where, between adventures, he has worked since 1928 as art-book editor and, more recently, as literary editor, has remarked, "He dominated crowds in the mysterious manner sometimes given to concentrated, solitary personalities, intimate with nobody." After hearing him cheered by thousands at the Vélodrome d'Hiver, a British Embassy observer of French affairs sent back word to London that as a speaker Malraux was tremendous, "talking with the fervor of the Jacobins and the rhetoric of Bossuet." In April, 1948, Malraux and the General spoke at the R.P.F.'s First National Congress—held outdoors at Marseille, where the party wished to test its new strength against the Communists, who are traditionally strong in that city. "We fight with bare hands," Malraux shouted, raising both his hands in the air. This became the popular R.P.F. slogan, for, though it was a Rightist party, it certainly lacked moneybag backing—perhaps because Malraux himself was advertised as representing "the revolutionary virtues of the Rassemblement," or perhaps because of his stand in favor of better conditions for the French working class. (The General's association-of-capital-and-labor idea, aimed at a so-called reform of collective bargaining, was so obscure that nobody was ever quite sure where he stood—"except the hard-shell capitalists," Malraux not long ago said, pungently. "They were completely against it. So they understood it.") At lunch with some American journalists in the spring of 1948, Malraux said, "If six months after we come to power we have not given the workers so much better a life that even the Communists cannot deny it, then the General and I will probably be shot—and deserve to be," he added with grim satisfaction. After the crucial 1951 national elections, in which the R.P.F. won more seats in the Assembly than any other party but fewer votes than the Communists, the

General possibly could have seized power had he been the man on a white horse his enemies still hoped he was. A Paris quip current then was "Without de Gaulle, Gaullism might have succeeded." The General's retirement from his party, its split and its decline are matters of strangely minor subsequent history, considering its incandescent beginnings, when Malraux's fiery appeals and the hopes that haloed the General kindled close to half of France. Gaullism is the first, and so far the last, adventure on a potentially grand scale that has made history in postwar France. As some Parisians said of Malraux's part in it, an *haut aventurier* unfortunately has no place to go except into another adventure.

In June, 1950, the international press reported that Malraux had a grave illness, which doctors were unable to diagnose. He had by then married for the third time, and his wife was suffering from the same condition. The doctors finally determined that the disease was Queensland fever, which is rare in Europe. Malraux's third wife, whom he had married in March, 1948, is Mme. Marie-Madeleine Malraux, the widow of his half-brother Roland. According to the legend, Roland Malraux, who was captured by the Gestapo just before the Liberation, left André his wife and small son, Alain, as a desperate fraternal legacy, in case he never came back from wherever the Gestapo was taking him. Actually, while he was temporarily imprisoned in Toulouse, he sensibly sent word, via the underground, to his wife, who was then expecting their child, that she should find André, who would somehow take care of her and the baby. After France fell, Roland Malraux, who was a film director in peacetime Paris, had been offered refuge, with his wife, by their friend Mme. Colette de Jouvenal, daughter of the celebrated Colette, in her small château in the Corrèze, one of the three departments that eventually came under André Malraux's Maquis command. Roland joined him in the Resistance. Soon after Roland Malraux was taken prisoner, he was sent to a concentration camp (reportedly on the North Sea, although the family never was sure), where he perished. André's other half-brother,

Claude Malraux, was killed in the Resistance, which left André the only survivor of the three fighters. André Malraux's third, and last, marriage was celebrated at the town hall of Riquewihr, one of the picturesque wine villages in Alsace, and former members of the Alsace-Lorraine Brigade made up the wedding party.

The Malraux live in a duplex apartment in a big house among the elegant mansions, gardens and *démodé* forest trees of Boulogne-sur-Seine, a Paris suburb. Theirs is a curiously overlapping dynasty, since the boys are at once, in due proportion, their parents' sons, nephews and stepsons. Malraux is a prodigal, inventive and stimulating father, lavish with gifts and with private jokes that suit all their age levels, and his own as well. "I suppose I am really a sad type," he recently wrote to an acquaintance about a gloomy photograph of him that neither liked, "yet I recognize myself only in pictures where I look gay"—his rarest expression. In casual conversation, his humor consists of raillery, paradox, astringent French wit and occasional extravagances, created all of a piece and like exaggerated baroque. He has always drawn amusing, skillful little animal grotesques—like one recently published in *Malraux par Lui-Même*, which resembles a cross-eyed donkey and is captioned "Le Dyable de la Critique d'Art"—and quantities of spare, hightailed cats (cats are his favorite creatures, though he says they will not often have anything to do with him), and he invariably draws something of the sort in books he gives to children, and sometimes in those volumes of his own works he presents to adults—for he is a steady book giver. His daughter Florence was only six when the war started, during which he did not see her, but a few years ago they came together again. Attractive and extremely intelligent, she is now his confidante in his literary projects, and has been working in the art department at Gallimard. Malraux plays the piano—not well, he insists, but well enough to play two-part pieces on a grand piano with two keyboards, specially made by Pleyel, with Mme. Malraux, who is expert, having formerly been a concert pianist.

The family's studio-salon, built from Malraux's own design, is

two stories high, large, white, handsome, chic and modern. It contains few, but choice, furnishings and ornaments, such as a Khmer sculptured head wedged in among his books, a New Hebrides helmet, a lamp base (on Malraux's desk) made from a Sassanid jar, a mantel composed partly of chased-wood columns from an old British man-of-war, a Dubuffet painting, also a painting by Jean Fautrier, and a small collection, unusual in Europe, of American Hopi Indian katchina dolls, which are ranged like Picassoesque statuettes against one wall. Working at his desk or pacing the floor as he talks, Malraux is a constant cigarette smoker. While he was sitting at his desk, which puts his back to the window, one day during his Gaullist period, someone shot at him from the avenue below, hitting the shutter, and the bullet hole is still visible.

Several years ago, his various wounds and fevers having left his health shattered, Malraux gave up the habit he had since youth of writing only at night, and carefully reorganized his life for overworking by day. His nervous tics, which at moments afflict his composure like cracks in a refined mask, are now less manifest than they used to be. (They are the result of acute sinusitis, long neglected, from which he has suffered for the last twenty years.) He has luxurious tastes, and enjoys good French food and wines when he can keep his mind on them, but at table he is usually preoccupied with thinking or talking, and anyhow he eats little and rapidly. He has no mechanical sense or facility. When he is alone, he reads, thinks and speculates as his normal employment of time. There is a story that years ago, during vacations on the Mediterranean, he used to set the sail on his skiff when far from shore and plunge overboard, the game being to catch up with the boat by fast swimming before it was everlastingly too late. He seems to have no pastimes now. His relaxation takes the form of talking with individuals who are interested in the same problems he is. When he is with such a person, their exchange of speculations presumably makes up one half of a dialogue with his own thoughts. "You have the feeling that personally you are not present," one of his European friends said recently. "You are sitting in the chair

as a brain, a mind. André is not interested in a man; he is interested in Man."

In France, Malraux is regarded, along with Lord Byron, D'Annunzio and with what now remains of the once glamorous figure of Lawrence of Arabia, as one of the flashing company of great modern literary adventurers who made tours of personal destiny, were deliberate participants in nations' crises and wrote parts of their own legends. Of this aspect of his life, Malraux says mordantly, "There are no heroes without auditors. Adventurers are assumed to be impostors. Most of the letters I receive from strangers are slightly inquisitorial in tone." Those who are acquainted with him even a little think that he knows himself by heart. In leading his life, he is both actor and spectator. His relations with Eastern philosophies, religions and art have given him the base for his metaphysical positions. As a twentieth-century thinker, he has illuminated his way through his investigations with his own intense, blazing light; his aim from youth has been to apply a half-dozen key ideas he selected at the start to the decoding of civilization and what he calls its great myths, meaning all its dominant invisibles, such as religions, systems of ethics and political faiths, and to make his report on man—on his singularity, his scope, the condition and the meaning of his life, and his tragedy (happiness has not been one of his studies)—using himself as creator, artist, fighter, witness, critic and microcosm. For the French, his genius lies in his rare intelligence, in his quintessentially French gift for complex ideas, in his capacity for formulation, for creative, unconventional deduction, and in the subtle perceptiveness of his thinking, often more lucid than logical. They feel that, unlike those of most creative thinkers, his intelligence and his emotions are equal—and both present in almost superfluous quantities. He has arrived at his eclectic erudition by a private way, choosing and studying, as he has proceeded through life, only what has fascinated him. His mind, now richly overloaded, seems to be divided into compartments, in each of which he functions separately. His novels are built on a world scale, achieved in part by the omission of women,

since his male characters, depicted in fatal international, martial or political crises, are elevated above the domestic, the daily and the ordinary, and thus above the interferences of love.

Malraux is a recluse. Most of the people he sees are writers. Among the large figures now gone, Gide was a constant friend, though he complained that Malraux was "too intelligent for me." Saint-Exupéry, who was Malraux's only adventurer-writer friend, composed an affectionate essay on him in which he said, "Malraux offers and devotes himself without bargaining." He goes beyond what are regarded as the usual limits of loyalty to friends, they say, moving heaven and earth to find a job or fix things for someone in trouble, with a gust of personal concern that always surprises and impresses them. All his friends have always said he has few friends.

Since Gide's death, Malraux has been increasingly accepted as the most important literary personality of France. There is, however, no Malrauvian school of writing or thinking; he has admirers, even aficionados, but no literary imitators. Though his major novels appeared between the wars, and their author made his first sensational impact on the literary scene about twenty-five years ago, it is only since the Second World War that the mass of French critical articles on him have been published, in what seems to be a delayed, cumulative reaction. According to the files of the Bibliothèque Nationale in Paris, articles about him have appeared in religious magazines, dealing with his non-Christianism; in a philosophical collection that treated him as a world figure, along with Keyserling, Spengler and Thomas Mann; and in a philosophical volume that compared his philosophy with those of Nietzsche (Malraux is always being cited as a Nietzsche-made Frenchman) and Kierkegaard, relating him to them through Anarchism and Existentialism, respectively. The Russian writer Ilya Ehrenburg includes him in a series of disparaging portraits of Frenchmen, together with Duhamel, Gide, Romains and the churchly Mauriac. In some Polish essays, he is discussed in connection with Stendhal, Conrad and Surrealism. He has been written about extensively in the British

and American intelligentsia magazines, from *Horizon* to *Partisan Review*. In Parisian articles on Western writing, he and Ernest Hemingway have been looked upon as the epoch's only heroic writers, the major distinction between them being, the French feel, that "Hemingway makes his heroes live, but Malraux makes his live and meditate." In Pierre-Henri Simon's important volume of essays entitled *L'Homme en Procès*, which deals with the cultural process that has created the new, postwar Frenchman, Malraux is discussed, along with his junior, Albert Camus, as a member and leader of the younger generation. Malraux's algophilia, or love of pain, is mentioned in this book, and also his heroes' morbid fascination with death, oddly courted, since they do not believe in immortality and therefore regard death almost angrily, as if it were the final personal injustice, which human intelligence cannot alter by rebellion. The book of essays *Portrait de l'Aventurier*, by Roger Stéphane, has a notable, severe preface by Jean-Paul Sartre, who says, "Heroism has to have a pretext; otherwise it would be only suicide," and calls the Lawrence of Arabia brand of adventurer-writer and the Malraux hero, risking his skin in foreign combat, "heroic parasites." In *Malraux, ou le Mal du Héros*, Claude Mauriac, son of the Catholic leader François Mauriac, treats Malraux psychoanalytically under two headings so similar (at least in young Mauriac's mind) as to be separated by only one letter—*"héros"* and *"éros."* Claude Mauriac analyzes Malraux's masculine despair (repeated, like all his ideas, in all his novels and invariably mentioned by French writers dealing with him) at the realization that love informs the necessarily curious lover only of what he, nor what she, feels, whereas mere passion, or eroticism, conveniently leaves him egotistically free of that unsatisfiable curiosity. More than half the October, 1948, number of the Paris intelligentsia magazine *Esprit* was given over to him, in a symposium entitled "Interrogation à Malraux." It is now the rarest of any Malraux collector's item. In it, various first-rate writers authoritatively discuss what is called *"le cas Malraux,"* meaning his transfer from an early peripheral position in Chinese and French Communist circles to a place by de Gaulle's side in the R.P.F.

For three years, this had been the most baffling postwar political evolutionary puzzle to French intellectuals, provoking a storm of consternation, insult and confusion, which *Esprit's* analysis, much of it very critical of Malraux, brought to an end.

The French consider Malraux the most difficult of all their modern writers to write about. Since he has, with passionate determination, used his unique, complex personal experiences as tests for his inquiries, hypotheses and conclusions about life, the novels resulting from these experiences are an anthology of his answers, or maxims, which critics are constantly forced to quote in their attempts to elucidate him, and in the end Malraux seems the only proper authority on himself. Two critics have made a special study of him. One is Pierre de Boisdeffre, whose book *Métamorphose de la Littérature: de Barrés à Malraux* won the 1950 Grand Prix de la Critique. He begins another book, called *André Malraux*, by saying that "his works and personality are too complex and too moving not to discourage any résumé, even the most honest, or any analysis, even the most minute," and forthwith achieves an honest analysis. The other Malraux scholar, the experienced Gaëtan Picon, has produced the most recent work on the subject —*Malraux par Lui-Même*. It is his second lengthy analysis of Malraux. In an illuminating summing-up, he states that "Malraux's life has been a methodical organization of courage," and he continues, "The language he lends to his personages is his own, that of his conversations, filtered, magnified. . . . One finds in the dialogues of his characters a rhythm which is that of his words and his thoughts: the same rapidity, the same brusquerie of attack —a trembling rush by leaps and bounds—the same syncopated pathos, the same alliance of lyric eloquence and sober ellipses. There are the same aphorisms that cannot be gainsaid, the same impassioned formulations, the same fulguration of a flamboyant phrase . . . extinguishing its own light in the fire of a contrary formula. . . . For him, writing is a form of solitude." Other comments have been, "The life and works of André Malraux suggest a man restricted to the heights of experience." "It is possible," said another literary

appreciator, "that his life, and not his writings, is his chef-d'oeuvre."
"He has so far had the most successful life of any intellectual of
our epoch," still another writer has commented. The latest French
book on Malraux opens with a thoughtful analysis: "Neither his
work, if we measure it in terms of literature, nor his life, if we meas-
ure it in terms of action, alone suffices to explain him; Malraux
owes the rather singular rank of his greatness to their conjunction
and confusion. . . . He writes with his life. . . . It is his actions that
have paid for his books."

As art-book director and literary editor at Gallimard, Malraux
still has great influence, even though nowadays he usually func-
tions at long range, by letter. It is considered an event when he
appears at the establishment in the Rue Sébastien-Bottin, and the
place becomes aflutter. It was not for nothing that one essay on
him was called "Malraux le Fascinateur"; he is a magnet for
curiosity. Gallimard gives him an open purse to draw from, as the
firm's star writer. His ideas for new books and his discoveries of
new talent are automatically accepted; among the latter was his
discovery, in prison camp during the war, of the extraordinary
social reformer and former priest, the poet Jean Grosjean, whose
works the Gallimard monthly NRF published to considerable
acclaim. Malraux is an expert on printing matters—his taste in
typography is considered superlative—and he can handle books
from the inception of their idea, which he has often furnished,
and the manuscripts of their writers, whom he has often selected,
on through the printing process, the choice of papers and the bind-
ing. One of his valuable literary-collection ideas was the *Tableau
de la Littérature Française, XVII*ᵉ*-XVIII*ᵉ *Siècles*, which contained
thirty-five essays on French literary figures written by thirty-five
modern littérateurs and was published just before the war. The
Montesquieu essay was written by the poet Valéry, the essay on
the memoirist the Duc de Saint-Simon by the moralist Alain, the
essay on Diderot by Drieu La Rochelle, the essay on the play-
wright Racine by the playwright Giraudoux, the essay on Pascal
by François Mauriac, and the essay on Laclos and his eroticized

Les Liaisons Dangereuses by Malraux himself—a collection so typically unconventional in its choice of authors to write on such hackneyed classics that it has run to thirty-four editions. Malraux has also been responsible for a series of art books knows as "La Galerie de la Pléiade." The first volume in the series, *Saturne*, contains his own essay on the little-known last years of Goya, after the artist had grown deaf, so could hear no gaiety, feared blindness, in which he could see no more beautiful women, and created his violent, tragic series called "Disasters of War," which Malraux's volume features. In his Pléiade volume on da Vinci, he not only reproduced all the artist's paintings in color and some of his drawings but also included comments on him by Goethe, Stendhal, Walter Pater, the historian Jules Michelet, Oscar Wilde, Henry James, Odilon Redon, Delacroix and so on, and had the whole printed by Draeger Frères, the Paris *maîtres-imprimeurs*, making a resplendent and, of course, costly volume.

In 1954 Doubleday & Company published the American edition of Malraux's *Les Voix du Silence* (*The Voices of Silence*), and found it an exceptionally complicated piece of publishing, since the book was printed in English in Paris and contained more than four hundred art reproductions, but the former Paris representative of Doubleday said, with an air of pleased surprise, that Malraux had been one of the hardest working and easiest authors Doubleday had ever dealt with. People enjoy working with him, in spite of his exhausting dynamism; projecting his own intelligence, he has confidence in them. To the perspicacious translator of *The Voices of Silence*—Stuart Gilbert, who, earlier, was one of the men who translated Joyce's *Ulysses* into French—Malraux said disarmingly, since the job of putting his book into another language was likewise no sinecure, "You'll find my lyric passages frequent and fatiguing; just do the best you can with them." Probably because his forte is so invincibly the French language, Malraux has never been able to speak any other usefully. He reads Greek, having kept up with it since his schooldays, and says he knows English well enough to read Shakespeare but not well enough

to talk English to a London taxi driver. In relation to work or even in simple discussion, Malraux is notorious for not answering a direct question, which would seem a fragmentary response to his encyclopedic mind, and is also known for never giving the limited answer desired. As one of the twenty-five members of the Conseil Artistique de la Réunion des Musées Nationaux (he inherited Gide's seat), who meet with the directors of the Louvre to give their opinions on, among other things, purchases of art the museum has in mind, he once favored buying a small canvas by Petrus Christus, a follower of the van Eycks, which some of the other members did not admire, for stated reasons. Thereupon, Malraux reportedly said, "But as you well know . . ." and courteously deluged them with a cascade of information that no one without his heterogeneous mind could possibly know and that had nothing to do with what they disliked in the canvas. It was subsequently purchased.

In 1941 he wrote *Les Noyers de l'Altenburg* (*The Walnut Trees of Altenburg*), dedicated to his son Pierre-Gauthier, first volume of a projected trilogy which he has as yet not completed. It was published in Switzerland in 1943, under the title Malraux chose for the entire three-volume novel, when completed, *La Lutte avec l'Ange.* (*The Struggle with the Angel*). *Les Noyers,* as it is usually called for brevity, was not published in France until 1948. As a book it is less than half of what he originally wrote, the Gestapo having destroyed the rest. It is unlike any of the other Malraux novels. In rhythm it is musical, almost symphonic; it is by no means always easy to follow; and it uses the familiar Malraux material in such different forms and proportions as to show a new Malraux— the anxious veteran of his previous wars and his triumphant younger thoughts. It is, however, like all his other novels in being nearly impossible to summarize. The work falls into five parts in time and in stages in the lives of a family of Alsatians named Berger (from which came Colonel Malraux's *nom de guerre* of Colonel Berger, given him by Maquis friends who had read the

book). The principal figure in the first part is the young French-
man Berger, a wounded prisoner who is being sheltered in Chartres
Cathedral after the German break-through in 1940. In the second
part, set in 1908, his professorial father, then a German Alsatian,
is on a strange propaganda mission for Enver Pasha, who had a
vain dream of a Turkish blood alliance; this mission takes him
among the wild khans of Central Asia, where he becomes a legend
among those tribes, much as Lawrence later became among the
Arabs. Included in the third part is what is sometimes a serious
account and sometimes a broad takeoff of a philosophers' conclave
held back home in Altenburg, where the elder Berger and his
brother are visited by a famous philosopher; this man's ideas are
probably caricatures of the ideas of Oswald Spengler (whose view
of a discontinuity in man's civilization Malraux does not share).
The fourth part contains the father's experiences on the Vistula
front in the First World War, where he is trying to rescue some
stricken Russians, against whom the Germans were first using the
horror of poison gas. Part five gets back to the younger Berger,
recalling the time his tank—another modern cruelty Malraux
wanted to include in his record of man—was caught in a tank trap
(an experience Malraux's father had had in 1918, in the First
World War), from which, after his anguish, he emerged as if
newborn, with new hope, into the miracle of being alive again:
an optimistic end for a Malraux hero, since his heroes usually die.
The book is filled with symbols. It is interpreted as a study of
man's obstinate, tragic search for understanding between men,
in which the old Altenburg walnut trees—persistent Nature her-
self—stand as the most encouraging symbol of all.

 In January, 1953, Malraux, accompanied by his wife, paid his
third visit to New York, as a delegate to the International Congress
on Art History and Museology, which helped celebrate the opening
of some of the Metropolitan Museum's recently rearranged galleries.
Asked by reporters if he agreed with Miss Rebecca West that
America's railroad stations were its cathedrals, he said no, its mu-

seums were. An American college president who sat next to him at one of several gala New York dinners he attended reported afterward that Malraux had no small talk.

The guest on Malraux's other side reported that the college president had opened the conversation by saying jocularly, "You Europeans give us a lot of trouble."

"The Balkans used to give us trouble, too," Malraux replied.

"But we haven't got any Balkans," the president protested.

"You have us Europeans," Malraux said, in what the Quai d'Orsay would consider very good table talk indeed.

"How long have you worked on your art books?" an acquaintance asked Malraux recently.

"All my life," he answered.

He worked from 1935 to 1957 at actually writing down the opening eight or ten volumes, some combined or rewritten in parts (as new), making it difficult to count them exactly. Together they present a period of twenty years' labor, with time off for his participation in two wars. *Les Voix du Silence*, published in 1951 by Gallimard in Paris, with its 465 art illustrations, is a thick, one-volume revision and expansion of his *La Psychologie de l'Art*, which consisted of three volumes. The most astonishing of these in its thesis was *Le Musée Imaginaire*, and the two others were *La Création Artistique*, and *La Monnaie de l'Absolu*. *Les Voix du Silence* has been followed by three more volumes, under the overall heading of *Le Musée Imaginaire de la Sculpture Mondiale*, consisting of *La Statuaire*, published in 1953, *Des Bas-Reliefs aux Grottes Sacrées*, published in 1954, and *Le Monde Chrétien*, also published in 1954. Each of the three volumes opens with a brief Malraux essay on its special subject, terminates with notes on all the illustrations, supplied by museum experts from around the world, and features several hundred reproductions—remarkable in selection and often of art items that are not generally known. A fifth and final volume, which will resemble *Les Voix du Silence* in that theories and text will be extensive, is to be called *La Métamorphose des Dieux* and should be published early in 1957.

Originally Malraux stated that this list of art books would finish a project he has aimed at since youth—an interpretative psychology and history of art—and in a way this will be true. However, he has since involved himself as director of a gigantic literary enterprise at Gallimard's of a universal history of art in forty volumes, with M. Georges Salles, head of the National Museums of France. There is no telling how long this vast undertaking may take.

According to Doubleday, *The Voices of Silence* in English translation ran 10 per cent longer than it had in French, and represented an investment of close to two hundred thousand dollars by the time it was published, in the autumn of 1953, in an edition of thirty thousand. Its price was twenty-five dollars a copy, and nearly half the edition was sold by Christmas, providing Malraux with the richest immediate royalties he has ever known. In both the American edition and the Gallimard de luxe edition, its sale has been phenomenal.

Les Voix du Silence, which is dedicated to Malraux's wife Madeleine, was begun in 1950, when, he said, being ill and housebound, he could concentrate on the kind of work it entailed. Its publication in Paris the next year was a literary event and the vast volume was saluted as the summit of his works. The book's myriad illustrations serve as continued proof of his main thesis in *Le Musée Imaginaire*, a startling and sensible idea of such validity that the phrase itself, "the imaginary museum," immediately entered the French language and has remained there. His idea is that, through photography and the modern printing press, we of this century have become the first-generation heirs to a ubiquitous imaginary museum, which contains art from the cave men on down and gives us more knowledge of art, its styles and its significance in man's development than any actual museum ever on earth could supply. This available new familiarity with art makes art, for Malraux, the starting point for a modern universal humanism which is the general theme of the 650 pages of *The Voices of Silence*, a polyphonic orchestration of his many accompanying themes and creative thinking, at various tempi. In it he creates, by means of his

special mentation and ideas, and his unconventional choice and use of reproductions, a prodigious combined history, psychology, interpretation and philosophy of art—and, in a way, a philosophy of man, too, not only because of the vast ground his volume covers but because it poses, in Edmund Wilson's phrase, "profound inquiries into mankind's position and purpose." To the above-average reader that the book demands, much of its stimulation and value lie in Malraux's dynamic gift for putting important elements of aesthetic inheritance into new relations for observation, freshly placing them in a perspective that stretches back over five thousand years. Thus he starts by informing the surprised reader that the museum as an institution is only less than two hundred years old, a European invention; that the Greeks who created such great "art" had no word for it and would not have known what we mean by the idea; and that if modern visitors to the Louvre felt the same emotions while looking at any famous crucifixion that its medieval appreciators felt, it would have to be removed from the museum, where it serves as art, and replaced in a church, where it would enjoy its special function. He informs the reader that only when opulent Renaissance christendom chose to acquire beautiful forms that had been created for service to other gods and to other men did there emerge the notion of specific value, which we now call art, with oldness suddenly conceived as part of its richness, and with objects torn out of time, to be appreciated, coveted, priced, collected, bought and sold.

It is physically and cerebrally a tremendous book to read and well-nigh impossible in its richness to report on, since digestion, not comment, is what it demands. His text is alternately weighty with the gravity of his ideas and buoyant with the intimate flight of his imagination. His major thesis is "the metamorphosis of art," meaning that art takes successive forms in remaining itself, over time. "Metamorphosis is not a matter of chance; it is a law governing the life of every work of art," he states. Art itself he defines as "that whereby forms are transmuted into style." As for the painter, "It is against a style"—that of his teacher, his epoch or the past—

"that every genius has to struggle" in order to create style of his own. Malraux also states that "By the mere fact of its birth, every great art" modifies those great art styles "that arose before it . . . After van Gogh, Rembrandt has never been quite the same as he was before Delacroix" (a two-way metamorphosis idea that runs in the opposite direction to orthodox art historians' staid view, which is that great styles affect only the styles that follow). His definition of beauty is more tame: "Beauty is that which everyone prefers to see in real life." Though art has reflected God and gods, Malraux supposes that art has mirrored the volition of the artist to create his own autonomous world, as God and the gods had, the artist thus being the godlike man who makes form and variety as his own creation. "As against representation of the visible world," only artists have tried "to create another world," their own.

Malraux's Gallic pertinence of comment, no less than the power of his thought and the lyric of his expression, are what make this long, over-rich and often elliptical book fascinating and brilliant reading, on the whole. Art treated by Malraux is no dull subject. With a kind of mordant wit he points out that "Hercules' mutilated torso is the symbol of all the world's museums"; that "The loss of the head of Nike [the Winged Victory of the Louvre] is regrettable, no more than that; the loss of her wings would have been the end of her"; and says, "That fortunate mutilation which contributes to the glory of the Venus de Melos might be the work of some inspired antiquary; for mutilations, too, have a style." He points out that Athens' statues were never white but brightly painted; their being blanched by time when Europe's eyes found them conditioned Europe's sensibilities, and today the whiteness of Greek art remains an obstinate, false and precious classic ideal. He says with characteristic penetration that "the Greek nude came into its own without heredity and without blemish"; that after the Greeks, Christian art was not in need of anatomy but of theology. He celebrates the glory of Greek art, whose great contribution had been "its tireless cult of man." "All Roman portraits . . . are biographies," he later adds, relevantly.

As if tortured by his own ambivalent relation to Christianity, on moving forward over time from "all that vast incantation which is Byzantine" into the Gothic, that carved and arched essence of Mariolatry, and the then vivid living faith of the New Testament, he gives repeated, insistent and varied analyses of the change in art from the pagan torsos to the martyred faces of the Christian saints. This was the new period of portraiture in which "The features of each Christian were stamped with his personal imprint of original sin. . . . Each Christian's face bears the marks of a great tragedy, and the finest Gothic mouths seem like scars that life has made," mentioning "the brief and timid Gothic smile," which also was new. He adds, as a double-edged comment, "There has been on earth only one Christian people without sin—the people of the statues," since they were of stone. "Seldom is a Gothic head more beautiful than when broken," he notes cruelly, with his own sense of martyrdom and style in mutilation; but says also and more soberly that "in Gothic art we seem to be meeting living men for the first time" and that, compared to any Minerva or Juno of antiquity, "even the queenliest of Madonnas is a real woman."

Malraux's intentions in his book are profound and transcendental. His is a superior purpose. In filling what he describes as his imaginary Museum Without Walls, he gives it complete eclecticism. In this written art tour around the world and through the centuries, such as he had himself traveled over in his own life, *The Voices of Silence* treats extensively with one of his special intimacies and pleasures, the contemplative art of China; with Khmer art, with Buddhist and Egyptian temple art (and long before them the rupestrian prehistoric art so belatedly come to light in our time). He explores the great marriage of color in Byzantium's artistic effulgence, and its result in Romanesque stained-glass fenestration; and the movement of the barbaric East in Romanesque sculpture. He deals with twelfth-century Japanese painting, carefully analyzes the early period of Giotto, whom he considers the greatest Christian painter. As he moves toward and through the Renaissance,

and beyond, he includes essays on his favorite artist giants, such as
Michelangelo, Rembrandt, whom he likens to "the tremendous
glow of a far-off conflagration," Vermeer, Caravaggio, Tintoretto,
El Greco and Goya, the first painter to give "his particular accent
to modern painting." In a kind of calendar of growth, he shows
the artist moving away from the early seasons of the gods, or even
God, and into his own anthropomorphic concerns—matters like
taste and conscious style—till, through the Renaissance and the
convention of perspective, the artist solved the problem of simu-
lating reality on canvas, a likeness now left to the camera. For
Malraux it was only after the Renaissance that art finally began
freeing itself from the fiction of verisimilitude, even of fiction it-
self, of the need to tell any story, holy or unholy; until, in the mid-
nineteenth century, modern Western art finally emerged in France,
at last setting the artist completely free for the philosophy and
practice of his own individualism. Malraux thinks Manet was the
first true modern, though Cézanne "is still a king." Toward the
end of the book (and it might well have been its final character-
istic sentence), Malraux cries, as if from a peak of observation, "All
art is a revolt against man's fate."

It is a book whose excitement, enriched information and inspira-
tion for average intelligent laymen can probably be measured also
by certain dissatisfactions it has given to many professional museum
men. To them even his notion of the Imaginary Museum, founded
upon photography and the modern practice of reproductions,
proved to be offensive, their concern being art's originals, of which
they are the guardians. In France, to some churchly minds, it
seemed that, in Malraux's lonely agnosticism, he attributed to art
the exaltation and comfort of religion, and thus found the divine
in the creative visual works of man—a heresy of aesthetics. To
intellectual French readers, drawn by experience or his reputation
to whatever Malraux might write, the satisfaction given by the
book lay in their appreciation of what he once again so specially
offered, this time in treating of art—his personal discoveries of
thought, struck like coins with new value by the incisive force of

his brain, his poetic imagination and literary genius of expression. To the French literary world generally, to its philosophers and to its thoughtful readers, *Les Voix du Silence* represented a major step forward in Malraux's desperate search for man's immortality as an answer to man's fate, the persistent problem which Malraux has uniquely posed as his essential concern. Of all he has written, this book emerges as perhaps the most extraordinary monologue that any modern man has carried on in his relentless quest for an answer to his solitude. As Malraux has said of himself, *"Je suis en art comme on est en religion."*

He has been more concerned than any other Frenchman of his generation with man and *la condition humaine*, which man creates and against which man rebels, and he has also been, more than other Frenchmen, an adventurer, with his mind and body, into the temples, churches and museums, the politics, hopes and frenzied courage, the revolutions and wars of his time. Thus, Malraux, more than any other contemporary writer and thinker, ranks for France as a unique witness to and recorder of history by having made parts of it his own in the first half of our century.

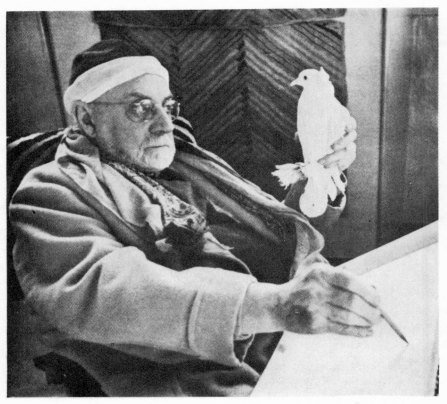

Matisse

2

KING OF THE WILD BEASTS

IN THE 1905 Salon d'Automne in Paris, assembled beneath the genteel glass domes of the Grand Palais, there was displayed an unpopular, violent and important roomful of new art. It consisted of feral, tropical-colored canvases with ordinary, insular French themes—a painting of the Seine but running with water as red as hibiscus flowers or a leopard's tongue, a portrait of "Woman with Hat" but with her face as yellow as a lion's ruff and with shadows on her cheek as green as jungle vines. They were canvases by a still nameless new company of color-minded Paris painters. Surrounded by their ferocious and pure hues stood some nonentity's faintly Florentine bust of a pleasant child, a circumstance that led Louis Vauxcelles, the art critic of the Paris daily *Gil Blas*, to jeer, "*Un Donatello parmi les fauves* [a Donatello among the wild beasts]," which carried the implication of a Daniel in the lions' den. The tendentious group of painters he thus inadvertently and historically nicknamed Fauves included André Derain, Maurice de Vlaminck, Kees van Dongen, Othon Friesz, Albert Marquet, Henri Manguin, Charles Camoin and Georges Rouault, mostly in their talented late twenties, and their leader,

Henri Matisse, already thirty-five. This was his first notable emergence, and first unreassuring experience with fame. At the 1905 Salon, in consequence of the *Gil Blas* critic's remark, Matisse, then nearly a stranger to the public and only just acquainted with himself in his delayed evolution from a copyist of Louvre paintings into a creator of a new genus of French art, was given the sarcastic sobriquet of *Le Roi des Fauves*, King of the Wild Beasts. Broad-shouldered, red-bearded, married; myopic, with thick glasses; bourgeois rather than bohemian; son of a very modest northern grain merchant; an indefatigable, well-balanced, well-organized worker, whose clinical interest in his research for his art formula was as passionate as if it were to be his elixir, Matisse had already been nicknamed by other artists, with a sharp eye for genre, *le Docteur*.

At the debuts of all the revolutionary styles of painting that now seem merely to make up the lovely late-nineteenth-century phenomenon of modern French art, from Monet's Impressionism, in the 1870's, to Seurat's neo-Impressionism and Gauguin's and van Gogh's Expressionism, the Paris art critics performed an invaluable service. They were nearly always wrong in their judgments. Thus they sustained the conviction of each emerging contingent of artists, usually upheld by little else (being poor, visionary and worried), that their imaginations, palettes and paintings were set on one more right, immortal track. Fauvism, at its birth, was distinguished by the insults that customarily greeted the arrival of something vital and unfamiliar; it was termed a monster, and Paris critics called it aberrant, repellent, sensational and unnecessary. Derain's painting of vermilion sailboats was considered "fit for a child's bedroom"; the bedroom would have to be a rich child's now, for this painting *de l'époque* would fetch around eight thousand dollars in the market. Rouault's barkers and fat ladies in a Montmartre street fair (he was then far from his crucifixions and Christ heads, now to be seen in museums) earned him the gibe of "caricaturist, misogynist." Matisse, for his "Woman with Hat," a portrait of his wife, was termed "robustly gifted but gone astray in eccentric color." At the Salon, someone tried to stab the portrait.

Encouraged by the opprobrious critiques and dazzled by Matisse's dominating Salon performance, other young artists were converted to Fauvism, including Raoul Dufy and Georges Braque. Dufy, already a colorist, was at first so affected by Matisse's new approach to composition that he temporarily gave up his bright colors—and Matisse's, too. Braque, essentially a serious temperament, painted a dozen Fauvist landscapes with trees the color and shape of oranges. Derain had already made even London's Westminster Bridge and Hyde Park look lurid. He and Vlaminck had been experimenting with pure color before they met their future chief and became the leading junior Wild Beasts. The pair of them—they had become acquainted during a slight accident on a commuter train outside Paris in 1899—had set up their pre-Fauve practice in a riverside shack near the suburb of Chatou, painting cabbage fields and the Seine, because they cost nothing as models. Vlaminck, who had been a professional bicycle racer, a violinist, a leader of a bogus gypsy orchestra and a novelist, but never, before the railway accident, a serious painter, came to seem, because of his energy and precocity, a conspicuous and flashing figure among the Fauves. In a tentative gesture, the two young men and Matisse, not long after they met—drawn together by their common belief in the theory of violently pure colors—sent canvases in their new style of painting, like brilliant samples, to the 1905 spring Salon des Indépendants. To their pride and astonishment, each of them sold one picture for a hundred francs (then twenty dollars) to a Le Havre art patron known to dislike modern art. The humiliating explanation was that he had decided to buy what seemed to him the ugliest pictures in the show for his son-in-law, whom he also disliked.

In the spring of 1907, Matisse sent to the Salon des Indépendants a fulgent picture entitled "Le Bonheur de Vivre," now regarded as the apogee and masterpiece of the Fauve movement. From behind his thick glasses he had envisioned "The Joy of Living" as a small, almost knotted composition of male and female nudes rejoicing in the colored hyperbole of an eternal primeval garden. This time,

it was mainly the public that greeted him with a fury of disapprobation. Parisians who can still remember the event say that from the doorway, as they arrived at the Salon, they heard shouts and were guided by them to an uproar of jeers, angry babble and screaming laughter rising from the crowd that was milling in derision around the painter's passionate vision of joy. With the closing of the Salon, no subsequent crowds had an opportunity to discover how they would react to its timeless aphrodisia, because the picture, which Matisse sold for twelve hundred francs, became one of the early treasures of the recently deceased Dr. Albert C. Barnes, of Merion, Pennsylvania, and was there sequestered in his Barnes Foundation museum, where visitors have never been welcome.

Since Fauvism was still fresh enough after three years of functioning to inflame the public eye, the 1908 Salon d'Automne cautiously refused to house representatives of the next violent art invention—some paintings by Braque, who by this time had abandoned Fauvist orange-colored trees. The unacceptable pictures included Braque's historic painting of the Midi village of L'Estaque, composed, according to Matisse, who was by now a Salon jury member, *"avec les petits cubes."* Having an eclectic's interest in any new formula, Matisse voted for the picture's inclusion. He illustrated its novel principle in a little pencil sketch the next year, for that same *Gil Blas* art critic, who, after the bolder 1909 Indépendants accepted *"les bizarreries cubiques,"* derisively nicknamed the style Cubism. Unlike Fauvism, Cubism (it is difficult to imagine what else it could have been called, even in affection) had a permanent influence on modern French art. But a year before the advent of Cubism, which fell like an avalanche of precise, studio-cut, four-sided stones upon the friable shapes and colors of contemporary French painting, Fauvism as a group had already come to its end. During the movement's brief French life, it penetrated the art circles of most European countries. It was the starting point for German Expressionism as first practiced by the Dresden Brücke group and was an initial source for the Munich Blaue Reiter, furnished an opening liberating impulse for Italian Futurism, and, in

prerevolutionary Russia, for the groups called Bubnovy Valet (Jack of Diamonds) and Oslinyi Khvost (Donkey's Tail).

There are many elaborate definitions of Fauvism, some of which take up only a page or so and others entire books. One of the younger Fauves said, after he lost faith, "Color seemed to us a savior." This defines what it had meant. Around the same time, a French cook said of a Matisse female portrait her mistress had bought, "Imagine making a thing like that out of a pretty woman!" Fauvism was partly inspired by the sharply illuminating gossip of the great rebels against academicism who had just preceded it and whose voices were still intimate echoes in studios, such as Gauguin's remark to Cézanne that "a kilo of blue is bluer than a half kilo," van Gogh's comment that "I am trying to exaggerate the essential," Cézanne's worry lest any of his green apples, for instance, should look "horribly resemblant" to life, and Toulouse-Lautrec's relief that "at last I have forgotten how to draw." The Impressionists' revolution of thirty years before had consisted largely of painting what they saw in terms of what they had just learned was scientifically true—that light was not white, as everyone had been painting it in the innocence of genius over the centuries, but made up of all colors, mixed. (This superior truth had so enraged the Paris public that it tried to hit early Impressionist paintings with its umbrellas and canes, as if to punish the idea.) The Fauves' revolution was mostly against the Impressionists' poeticized realism and against their paling, speckling colors as their theory and their painters grew old. The Fauves developed their new style, and made it half sensual, half factual, using only loud colors, the way a musician might compose only for loud instruments. Such a startling mixture of principles and tastes naturally angered many people, among them other painters. The Montmartre Lapin à Gill group dipped a donkey's tail in Fauve colors, switched it against a canvas, and contemptuously sent it to the Indépendants as true Wild Beast art. Stickers were pasted up on walls in the Place du Terte stating, *Matisse rend fou* [Matisse drives people mad]." Actually, all French painting had been in an intelligent color

ferment ever since it began practicing the theory of color vision
put forth by the German physicist Dr. Hermann von Helmholtz
early in the century—the theory of primary and complementary
colors, according to which blue looks bluer next to orange, red looks
redder next to green, *und so weiter* across the rainbow. Matisse said
the Fauves' aim was to use pure color straight from the paint tubes,
so that, on top of the ocular refreshment and shock, color itself
would add plastic form and composition to the subject. This last
was their principal revolutionary technique. Uninterested in the
third dimension, Fauvists omitted shadows if they chose or, if not,
used heavy black outlines to promote form; consciously employed
distortion, rather than reality; and used a perspective that also
looked unfamiliar. A Fauve work is so flat that (by a law of optics)
it seems to pull the observer toward it instead of receding humbly
away from him into the distance, in the old Renaissance academic
manner. By a new act of genesis, Fauvism re-created all nature as
brilliant—as red, lavender, blue, orange and succulent green. On
the other hand, its portraits were done without romance, like vivid
still lifes of faces. Fauvism is now tardily regarded as the last major
coherent expansion of nineteenth-century French painting.

The younger painters who destroyed the Fauve movement by
deserting it left for what seemed to them earnest, important reasons;
they were men getting down to the vital business of learning how
to paint again. Derain had early feared that all their pure color
would become only "a theory for dyers." Vlaminck declared in-
dignantly, "Pure color is another form of slavery." Partly by means
of Matisse's superior reach toward the exaltation of color as his
natural zenith, Fauvism had temporarily united strongly differen-
tiated talents—Braque, Rouault, Derain, Vlaminck, Dufy, Friesz,
van Dongen—some of whom never painted so well again but all
of whom became notables in their own subsequent styles. These
artists, in a rare, brief, spirited moment, painted within the same
experiment, started an epoch, and then ended it. Matisse, who had
been the first Fauve, remained, in a way, the only Fauve.

Thereafter he was to occupy a small, personal, uninfluential zone

of absolute and first-ranking importance, where he applied the
uncompromising fever of his talent and the cool, burnishing
organization of his intelligence to his versions of reality—of the
female form, and of the meander of vine tendrils, flowers and textile
arabesques, which his prodigious colors and phenomenal plastic
gifts turned into unique aesthetic properties. Matisse's isolated,
concentrated labor, his increasingly cloistered existence, as his life
and career progressed, and his expert, almost impersonal concern
with the synthesis of decoration and beauty—he was the only
major man in the profession still using either word—preserved him
over almost the next half century, as though he were an academy
in himself. The concatenation of changing art events, toward
Cubism, then toward abstractionism and nonrepresentational paint-
ing, curiously put this man, once denounced as the King of the
Wild Beasts, in the way of becoming the classic French artist
of his time, because he was still attached to nature.

Matisse was born in the village of Le Cateau, in the Départe-
ment du Nord, on December 31, 1869. He was thus old enough
to have lived through three Franco-German wars, and he lived
through them all more or less undisturbed. He was an infant
during the Franco-Prussian War, his faulty eyesight relieved him
of military service in 1914, and he lived in Unoccupied France
during the Nazi Occupation. Early in this last war, however, at
the age of seventy-one, he suffered the first grave physical interrup-
tion to his career, a serious intestinal operation. It did not halt his
painting, but he could be up and about for only a few hours each
day. He spent most of the year in Nice, in the interior, residential
quarter called Cimiez. There, in a fantastic six-story Victorian hotel,
Le Régina, ornate with glass porches and elegant façades, where
the old Queen herself used to stay, he both worked and lived. Di-
rectly before the war, the upper floors of the hotel had been turned
into apartments, and Matisse, who had previously lived in smaller
quarters down in the heat and wind of Nice's ocean promenade,
took a large suite, on the third floor, for his studio and living

quarters. A small public garden faces the front of the Régina and its ghostly foyer, in Matisse's day a vast, glassed-in emptiness of unfurnished, depopulated marble halls, has a regal white staircase on which royalty no longer tread. To avoid the summer heat of the South, he went north for a month to a flat he had in Paris, on the Boulevard du Montparnasse. It was comfortable, bourgeoise and unindicative of anything in particular.

In his eighty-second year, three years before his death, Matisse was still an impressive figure. When he stood by his easel or rose from his easy chair to greet a visitor, he looked like a massive, well-preserved ruin, like an important structure that had been undermined mostly by the weight of time, but the upper and lower stories—his heavy torso, his dwindling limbs—maintained a precarious, majestic balance, with some inner girders of will power holding the whole together. From the drapery of his pale silk painting jacket and the winding woolen scarf around his throat emerged his ovoid head, with its short white trimming of hair and beard, its amazingly lively pink skin, its shadowed, harsh, straight crease of mouth above a full, sensitive lower lip, with the watchful blue-gray eyes visible only as blurs behind the thick fenestration of his spectacles. His hands were still alert, and carefully tended. He still looked like a doctor, or maybe some outmoded type of European scientist who in his expertism had discovered, among other things, how to prolong his years.

Matisse's painting career began with the only other serious illness of his life. He had been brought up near Le Cateau, in the hamlet of Bohain-en-Vermandois, where his father plied his small grain business amid the textile-factory towns and the flat, dull sugar-beet fields of the north. When Henri was nearly eighteen, the family managed to send him to Paris to study law—which was the father's idea. A fortunate attack of appendicitis sent the son back home, where a kind neighbor woman gave him an art copybook as something suitable for an invalid. He began drawing and painting in bed, where toward the end of his invalid

life he was forced again, as his refuge for work, and signed his first picture, which was of his bedside table with old books on it, with his name backward "essitaM." His mother liked to paint china. On the strength of this fragile connection with art, she encouraged him to return to Paris to study painting at the Académie Julian. He soon left the Académie and became a nonpaying student at the Beaux-Arts under the painter Gustave Moreau. In 1898, at the age of twenty-nine, Matisse married Mlle. Amélie Noëlie Parayre, a dignified brunette from Toulouse, and, after several months of travel, took her to live in his apartment at the top of an old building on the Quai St. Michel, with a fine view of Notre Dame. Eventually, there were three children—Marguerite, Pierre and Jean.

An exceptional, broad-minded professor in the rigid Beaux-Arts, which lived on tradition and on plaster casts of the past, Moreau had told his students to "work for the coming generations," had correctly forecast that Matisse would "simplify painting," and had advised the class not only to copy in the Louvre but to sketch in the Paris streets and cafés. In the Petit Casino, Matisse sketched Mistinguett in one of her first music-hall appearances. He also made copies of Louvre paintings, to try to earn a little money, because the State sometimes bought copies for provincial museums and because, as a future innovator, he was attracted first to the traditional, as if to measure its limitations. The State bought several Matisse copies, including a not very interesting one he made of Poussin's "Echo et Narcisse." The first original picture he painted—a girl reading—looked so much like a conventional museum piece that the State bought that, too. He began exhibiting at the Salon de la Société Nationale, that powerful Paris cul-de-sac of semiofficial academic art. Along with earnest naturalism and some symbolism, the Nationale showed virile idealism in its popular annual supply of full-hipped, high-busted *nues* of such unmistakable refinement that it was a wonder the models had consented to pose with their corsets off. The Bouguereau nudes were especially

satisfactory and famous. Bouguereau was Matisse's first professor, at the Académie Julian, but the young painter stayed with him only a few days and then fled to Moreau.

It was Moreau who, in 1897, pointed out to Matisse that in five years of unceasing work he had not so much as cracked his chrysalis to let his own style break forth. So that year Matisse painted "La Desserte," a boldly colored study of a maid in the act of arranging fruit on a dinner table. It took him all winter to paint it, and the fruit, which had to be renewed from time to time, was expensive. It was easy to keep one room on the windy *quai* extra cold, to make the fruit last longer, but then Matisse had to paint clumsily in his overcoat, gloves and hat. The picture's new manner shocked the Nationale jury, which had been keeping their eye on him as their reliable academic type of artist and had cunningly made him an associate member of the Society. But he had hatched the beginnings of his own style and he was through with theirs.

A few years later, his emancipation was, in a single act, completed. Looking back on this event some thirty years afterward, he said, "I was married. I had three children, and I had an arrangement with a dealer who took all the still lifes I painted in the academic style at four hundred francs apiece. It was not very much as things are now, but it meant a livelihood for all of us. One day, I had just finished one of these pictures. It was as good as the previous one and very much like it. I knew that on delivery I would get the money that I sorely needed. There was a temptation to deliver it, but I knew that if I yielded it would be my artistic death. Looking back, I realize that it required courage to destroy that picture, particularly since the hands of the butcher and baker were outstretched waiting for the money. But I did destroy it. I count my emancipation from that day."

Forty years after the event, he was still emancipated, and, though famous, was still searching. To a visitor in Nice, he said, "Each picture, as I finish it, seems like the best thing I have ever done, and yet after a while I am not so sure. It is like taking a train to Marseille. One knows where one wants to go. Each paint-

ing completed is like a station—just so much nearer the goal. The time comes when the painter is apt to feel he has at last arrived. Then, if he is honest, he realizes one of two things—either that he has not arrived, after all, or that Marseille is not where he wanted to go anyway, and he must push farther on."

Back in 1897, when his emancipation was beginning, he started to meet, for the first time, unofficial, independent painters, like Camille Pissarro, Pierre Bonnard and Edouard Vuillard. Through them, he met, also for the first time, at art dealers' galleries and museums, the canvases of Degas, Manet, Toulouse-Lautrec, Renoir and Cézanne. On Pissarro's advice, he managed a trip to London, to see the sunset Turners. (English critics had insultingly described them as looking like addled eggs.) Back in Paris, he saw his first Japanese prints, which influenced him, as they had earlier Paris moderns, by their unapologetic lack of shadow and perspective. Then, in 1898, after his marriage, he and his wife went to Corsica on their honeymoon. This journey deeply influenced him. He found there what was not indigenous to the Ile-de-France or the Nord and what he had longed for—blue sky and blazing sun. They did not alter his disciplined mentality, but they swelled his imagination. The sun and its scintillating colors gave him his painting climate, which thereafter he carried with him on his palette.

Matisse's next venture into modernism was the purchase, in 1899, of a treasure he could not afford, a small Cézanne of three female bathers. Mme. Matisse paid for it by selling her only bit of jewelry, a small brooch. Cézanne was not yet appreciated or costly—indeed, he had just left Paris in discouragement, to settle down, and to teach unimportant pupils, in his native Aix—and even Matisse's radical artist friends prophesied that he would never retrieve the family money thrown away on those Cézanne females. He could have, however, in 1930, when an American collector offered him a million francs for it; he refused the offer. In 1936, Matisse presented the painting to the city of Paris, which placed it in the picture collection of the Petit Palais. It had been his dearest possession

for thirty-seven years. In his touching letter of presentation, he said, "This work of Cézanne has upheld me morally in critical moments as an artist; from it I have drawn my faith and perseverance."

Matisse most needed perseverance right after he bought the Cézanne. Nobody was interested in Matisse's new style of painting. (It is a family legend that after the Cézanne had been hanging in the flat for several years, Mme. Matisse naïvely said to her husband, apropos of it, that she was beginning to understand modern painting at last, as if his own paintings had taught her nothing.) Around 1900, in desperation, Matisse gave himself a year to start selling his pictures; he resolved that if he failed, he would go into his father's grain business. He even started making sculpture as a sideline. Mme. Matisse made hats to help out with their pitiful budget. His family, back in Bohain, sent him a hundred francs (twenty dollars) and a sack of rice monthly. At that time, both Matisse and Marquet, who had a studio in the same *quai* building, were so poor that they had to accept work as artisans, tinting meters of laurel leaves to decorate the Grand Palais for the Paris Exposition Universelle, in celebration of the millennium.

Matisse had already had his first exhibition by a dealer in 1902, in the bric-a-brac shop of Mlle. Berthe Weill, an eccentric who could infallibly recognize coming painters but could never sell them. In 1904, Matisse hit his mark, in a sense. He was given his first one-man show (forty-six pictures) by the famous art dealer Ambroise Vollard, that aesthetic and financial wizard who had taken on Cézanne—of whom he had so far sold precious few (including the one to Matisse). But Vollard's cachet meant that Matisse had arrived—artistically, at least. Vollard sold just one Matisse from the exhibition—a picture of some phlox, for 150 francs, minus a commission of 50 francs.

The stormy Salon d'Automne of the next year had a silver lining for Matisse. *Les Stein,* as Paris art circles called the notable quintet of Californians that consisted of Miss Gertrude Stein, her brother Leo Stein, their brother and sister-in-law Mr. and Mrs. Michael

Stein, and Gertrude's friend and secretary, Miss Alice B. Toklas, had been characteristically interested in the Salon public's special dislike of the Fauve "Woman with Hat." *Les Stein,* who at first did their purchasing of pictures as a group, were then starting out on their art adventures. Matisse, along with Cézanne and Picasso, was part of their first plunge; they bought the "Woman with Hat" at the official Salon price of five hundred francs (one hundred dollars). When he met them afterward, at their celebrated Rue de Fleurus apartment, it was his first entry into a *salon artistique et littéraire international;* this one was frequented by, among others, Juan Gris, Guillaume Apollinaire, Max Jacob and Marie Laurencin. There in 1905, Miss Stein introduced him to Picasso. In her extraordinary *Autobiography of Alice B. Toklas* she reported that "they became friends, but they were also enemies." Later they were neither friends nor even enemies, she added, meaning that they became literally nothing to each other; Matisse and Picasso had also been described, at the moment of their meeting, as North Pole and South, or perfect opposites. The Steins were Matisse's first buyers in quantity. They could not pay much for his art, but they could talk about it a great deal. Besides buying him, they launched him.

Les Matisse and *les Stein* were friends for several years. The friendship began being strained, however, even before the First World War. The conflicting stories of what caused the schism, as well as the conflicting stories told by the Steins and by Matisse as to which Stein had discovered him first or had chosen which picture first, constituted a first-class artistic-literary explosion when the whole thing finally became public, in the Paris of the 1930's when the Toklas autobiography—written by Miss Stein, of course—was published in French, causing dissension among everybody. All that anybody can be sure of today is that in old photographs of the Rue de Fleurus salon and of the Michael Stein collection in Paris there were visible, on the various Stein walls, about forty Matisses, of which at least half were of prime significance and of increasingly enormous value as time went on. Among these unerring choices

were the hundred-dollar "Woman with Hat," purchased in the early 1950's by Mr. and Mrs. Walter A. Haas, of San Francisco, for twenty thousand dollars; another superb, violent 1905 picture of Mme. Matisse, "Portrait with the Green Stripe," now in the Copenhagen Royal Museum of Fine Art; "The Gypsy," an old bawd with a green nose and green breasts, from that isolated, brief period in which he painted ugly women, now in the Musée de l'Annonciade, in St. Tropez; from 1906 "The Young Sailor, No 1" (there was also an almost identical "Sailor No. 2"), at present in a Norwegian collection; the fabulous 1905 "Le Bonheur de Vivre" from the Salon of that year which is in the Barnes Foundation collection; and "The Blue Nude," now in the Baltimore Museum of Art. The Steins also had some of his gigantic still lifes of fruits and flowers. These were canvases of such huge size that Matisse painted imitation frames on them of stars and crescents in a border, since nobody could have afforded to frame them in the regular manner. They also owned "Margot," a portrait of his daughter Marguerite; and, above all, they possessed his 1906 informative self-portrait (now in Copenhagen), "Portrait of the Artist in a Striped Sweater"—a man with a face like a bearded mask, composed in tense discipline to serve the restless, imaginative brain behind it and the affiliated, dexterous hand that is invisibly painting below. All these portraits were the great early Matisses. Owing to their quarrel, long before Miss Gertrude Stein died, in 1946, no Matisse paintings remained in her collection.

The second, and more lasting, good result of the Rue de Fleurus connection was Matisse's meeting there with the Misses Cone—Dr. Claribel and her sister Miss Etta—Baltimorean relations, by marriage, of the Steins. These sisters became the first great buyers of Matisse in America; they continued to buy over the years, and never quarreled with him. When they could not journey to France to see his work, he sent them selections of it to choose from, as well as Christmas cards every year. Dr. Claribel died in 1929, and upon the death of Miss Etta, in 1949, their modern collection, which

ranked as the best in the country in respect to Matisse drawings and sculptures, went to the Baltimore Museum of Art.

The years from 1901 to 1906 were decisive in Matisse's life—for his embittering first failures and small, gleaming successes, for what he saw of new art and created in new art, and also for what happened, like a combined warning and prophecy, to the works of the three trail-blazing artists who had come just before him. In 1901, the Paris Galerie Bernheim Jeune held the first retrospective exhibition of van Gogh, who had sold exactly one picture in his lifetime. His colors, for the first time seen in their full range at this comprehensive showing, had a volcanic effect on avant-garde Paris artists. At the exhibition, Vlaminck said to Matisse, "Today I love van Gogh more than my father." In 1903, Gauguin, penniless, died in the Marquesas Islands, a couple of job-lot Paris auctions of his paintings having been his only financial reward. In 1904, the Salon d'Automne devoted an entire room to Cézannes; the big portraits still did not sell. In 1906, the Salon honored Gauguin with his first retrospective and Cézanne died. Mostly posthumously, these three artists had finally started losing their odium and were fully influencing the younger painters, including Matisse. Van Gogh was a suicide before Matisse went to Paris to study painting, and so Matisse never knew him; Gauguin's last Paris visit was in 1895, and Matisse, an obscure student, never tried to know him; Cézanne—whom Matisse must have loved as his stylistic father, at least—he could have met in Paris or at Aix, but, as he said later, "It never occurred to me to visit him. It was his painting that interested me, not the man." The only one of the three he took a journey for was Gauguin, and that was long after Gauguin was dead. With the years, Matisse grew more and more fascinated by the problem of painting the vibration of light as it looked to him on his Mediterranean, just as Gauguin had been on his archipelago, and at the age of sixty-one Matisse voyaged out to Tahiti all alone to see with his own eyes what Gauguin's South Sea light looked like.

When Matisse sold his first pictures, after the Fauve Salon, his immediate reaction was to move where he could paint more pictures more comfortably. For years, he had painted in his Quai St. Michel flat—it was cheaper than a studio—while the children played nearby, and his wife posed as a Spaniard with a shawl, as a guitar player with a guitar, as whatever had to be posed, and made hats in between. In 1906, in order to have more room, he moved his studio to a former convent, the Couvent des Oiseaux, on the Rue de Sèvres, and two years later moved both his work and his family to even larger quarters in another former convent, the Couvent du Sacré-Coeur, near the Invalides. Emptied of nuns and monks by the recent enforcement of the separation of Church and State in France, their austere cubicles and refectories turned out to be perfect, ironically enough, for artists and for studio life. At the sugggestion of Mrs. Michael Stein, he began teaching while still at the Couvent des Oiseaux, and continued in the Sacré-Coeur. The surviving importance of these classes lies in the famous dry advice he gave his students—some of them Americans—who began enthusiastically painting in his manner. With his trenchant gift of analogy, he informed them that before they could balance on a tightrope (i.e., paint in terms of distortion), they would have to learn to walk on the ground (i.e., learn classical drawing). In 1908, the *Grande Revue* of Paris, which had laughed at Matisse's 1905 Fauve Salon works, found him important enough to justify printing his lengthy, lucid "Notes d'un Peintre," which exercised considerable influence in European painting circles. It still ranks with the best of the rare modern examples of coherently written thought about painting by a painter. Shortly afterward, he moved his family and his work again, this time to the suburb of Clamart, where he had bought a small bourgeois house. Behind it was the added luxury of a garden; it came equipped with an alfresco relic of earlier French aesthetic taste, an absurd lead statue of the romantic lovers Paul and Virginia posed beneath a metal umbrella.

Soon after that occurred the change in locale that shaped the rest of his artistic life. In 1911, Matisse and his wife spent the first of

two winters in Morocco. On his honeymoon journey to Sicily, the sight of the Mediterranean had already given him a solar-yellow southern climate. Morocco filled this climate with a costumed Oriental civilization appropriate to it and to his imagination. Other French painters of his generation traveled in North Africa and, despite their ocular excitement, were still French tourists when they left. Through his North African visits, Matisse, as an artist, became artificially colonialized. He instinctively invented a voluptuous, colorful female population, sequestered in the confines of his own mind, to inhabit this nonexistent ideal colonial Morocco, which his painting demanded. To serve it, his cool northern intelligence organized the picturesque, and even the tawdry, for his sumptuous colors and his undulating, controlled, unsentimental line, which was at home there tracing full-blown women and flowers. He began suitably applying his scarlets, madders and cobalts to Arab scarves, striped robes and billowing harem trousers; he invested his inspiration with the bazaar's glittering furnishings and trinkets, all placed with a patient, immutable precision, which made a pattern in itself, against the background of arabesqued textiles that enriched his compositions' crowded seclusion. Most important of all was his populating his canvases with those remarkable odalisques he invented—less portraits than semi-sensual female objects, with legs and arms that could assume perspective—who perfectly inhabited his indoor scenes, where half-shuttered windows admitted masculine sunlight and even the exterior flash of the oases' rare greens. Women, being decorative, were Matisse's natural choice for models. Aside from his early portraits and few figures, he rarely painted men. The harem formula supplied the false realism his decorative *élan* demanded. By character, Matisse was a complex mixture of hot and cold—a mélange of his dominant, stabilizing intelligence and the flaming, luminous sensibilities of his genius as a colorist—and the quasi-Orientalisms of Tangier and Marrakech gave his brain and eyes what he needed for his balanced excess. His mastery of this controlled extravagance became his typical style.

One discovery that Matisse made in North Africa could be said

to have affected French contemporary painting in general. He discovered that, as he phrased it, "black is also a color." He used it like one. It gave his paintings a rich, voluptuous, almost fashionable touch, adding elegance to their modernism. Black had been used by European academicians for centuries as the absence of color—as shadow, where color was lost to sight. The Impressionists had even categorically declared that in nature black did not exist, and had, at some inconvenience, tried to do without it in their paintings. During the First World War, when Matisse met Renoir, then elderly and crippled but still laboriously painting on the Riviera (he was the one great figure in modern art of the preceding generation whom Matisse ever met and became friendly with), the old gentleman, at their first interview, quarreled spiritedly with Matisse for his use of black in the painting he had brought with him for criticism. It was the 1917 Matisse masterpiece "Interior at Nice," which sixty years later he still regarded, with detached satisfaction, as "one of my most beautiful paintings" (and it is probably the most highly valued of his many works in the Copenhagen museum). It is lonelier, more nostalgic, more emotional than most of his other major compositions. It offers the black and blue motif of black southern shutters striping the blue of the Mediterranean outdoors, and, inside, in the bold, black-paneled room, the black, brown and blue motif of an opened violin case and its idle instrument, with no person present to make music or to view the sea.

About ten years before Matisse painted "Interior at Nice," while Picasso was still working in Paris on what had not yet quite become Cubism, the Spaniard invited Matisse to his Montmartre studio to see a certain picture. Picasso asked his visitor what it represented, and, when he could not guess, Picasso whipped a false mustache from his pocket and placed it in the middle of the painting. With this hirsute aid, the rudiments of a Cubist portrait of a man sprang into focus. Matisse was shocked by the mustache rather than by the cubes. During the First World War, he himself painted what some art experts call his Cubist-influenced pictures. Other authorities, including many of the Cubist painters themselves,

loudly denied he showed any of this influence. (The war, though
it spared the myopic artist from soldiering, was hard on the rest
of the grain dealer's family. Their northern village was overrun
by the Germans. Auguste, the painter's younger brother, was seized
as a hostage, and eventually the terrible seesaw battle for Château-
Thierry cut Bohain-en-Vermandois off from communication with
the rest of France.) It was early in "this ridiculous war," as old
Renoir furiously called it, that Matisse—perhaps because of the
war's introduction of mechanization, the first Europe had known—
produced the paintings that supposedly show Cubist influences.
Actually, what he worked out in these paintings was a kind of
angularity in space, a sharp-edged, flat, decorative style in which
he used the cube's corners rather than its three dimensions. It was
a new style for him, and unlike anybody else's. Instead of grouping
objects in his composition, he dispersed them, like oases on the
desert of the canvas. He had in these cases indeed "simplified paint-
ing," as his teacher Moreau had prophesied. One of the outstanding
examples of this angular simplification was the "Piano Lesson,"
of 1916. This is now in the New York Museum of Modern Art,
one of his most famous paintings, and was considered a local gem
in the great Matisse retrospective exhibition, collected from pretty
well all over the Western world, held in that museum in 1951.
The 1916 picture "Painter in His Studio," which Matisse liked so
much that he kept it for his own collection until 1945, when it
was acquired by the Musée National d'Art Moderne, in Paris, and
the 1917 "Bathers by a River," in which the women's bosoms seem
to have been drawn with a compass held in the hands of a mathe-
matician, are other noted examples of this so-called Cubistic period.

As a matter of fact, Matisse had tried out simplicity before. In
1913, in his seated, hatted "Portrait of Mme. Matisse" (later in
Moscow, in the Museum of Modern Western Art), he made a
personal eclectic experiment—using his wife as subject and having
her green-hatted head turned toward the right—based on the
1900–1904 Cézanne portrait "Woman in Blue," also hatted but
looking toward the left (and now also in Moscow). Neither the

style of the ladies' neat *tailleurs* nor their small, chic Paris hats nor their portraitists' studied, simple compositional lines varied much, despite the span of years. Until Matisse's own styles, of which he developed perhaps half a dozen, were perfected over the initial twenty years of his career, he tested, reused, incorporated or discarded the painting theories of other painters with the same implacable conscientiousness and labor that he accorded his own prodigious variations.

Matisse had no general Paris popularity until around 1920. Whereas his early Fauve style had made his visions of beauty seem ugly to most people's eyes, the euphoria of his Moroccan experience gave his paintings a strong exotic appeal. It was his second great period of painting (pure Fauvism had been his first), and he knew it. Even so, few French people with a big pocketbook for art bought his pictures. Years later, when any major characteristic Matisse of this period normally fetched around fifteen thousand dollars, he said dispassionately, "One likes one's paintings less when they are worth money than when they are worth none—when they are like poor children." Instead of highly rewarding financial popularity during those years, he had special, almost private recognition from art dealers, collectors and other *cognoscenti*—a kind of international grapevine on which his paintings burgeoned, highly prized but not very costly. In 1917, he made his last geographic move. He left Paris permanently, for Nice and the Mediterranean, where he went to live in withdrawal, as if in one of his own bright-colored paintings.

Matisse had experienced an early, and discouraging, start in New York in 1908, when examples of his works were shown there. By that time, the Fauve movement, which he had dominated in Paris three years before, was dwindling away so rapidly that there was practically nothing left of it except himself, its lonely leader. The Manhattan reception of his violent art style was more serene but no more enlightened than the reception it had had at the 1905 Salon d'Automne, when, as so-called King of the Wild Beasts, or Fauves, he heard his feral-colored paintings jeered at and hissed, as

if they were dangerous. Paris critics had disliked the Fauves so much that they had unjustly spread their dislike over other Salon items, such as the naïve leafy canvas of the old Douanier Henri Rouseau, who had been given the Salon's *place d'honneur* for his "The Lion, Being Hungry, Throws Itself Upon the Antelope," and who had nothing to do with wild beasts except that he actually painted them. The unappreciative calm that greeted this first Matisse exhibit in New York was the result of the fact that it contained none of his oils. It consisted of only his drawings, water colors, etchings and lithographs, which were less irritating to the retina. Edward Steichen had met Matisse in Paris in 1907 and had taken a bundle of his drawings and water colors—the paintings seemed too big a proposition to undertake then—to Alfred Steiglitz, who showed them the following April at his Fifth Avenue Little Galleries of the Photo-Secession, known for their strong modern bias. The *Evening Mail* critic declared with heavy humor that since Matisse's art might "contain a new revelation for somebody," it should be "treated with respect, like Adventism, Eddyism . . . and other forms of religious fanaticism." The *Times* critic oddly declared the drawings "spontaneously blithe . . . with a Gothic fancy for the ugly and distorted." But the monthly art magazine *Scrip's* critic, with more time on his hands, solemnly concluded, "The purely normal person wonders a good deal about it all."

It was in 1913 that the first full-throated roar rose from America in opposition to modern European art. In February of that year, New York saw the International Exhibit of Modern Art at the 69th Regiment Armory. Matisse had thirteen paintings in the show. "I assert that Matisse is an impostor!" cried one New York critic. Outrage was general. Advised by newspaper headlines that the foreign art was degenerate, a hundred thousand eager visitors swarmed into the Armory in the next four weeks to make sure. Henry McBride, art critic of the *Sun*, valiantly defended the new art, including "Matisse pink," a color that Americans had never objected to in their watermelons. Chicago, which was determined to miss nothing cultural, demanded to see the exhibit, which was

moved into the Art Institute there and was stampeded by nearly half a million sightseers. Chicago school authorities denounced the art as lewd, schoolteachers took their classes to see it so that the young folks would know what not to paint (for example Marcel Duchamp's elaborate and highly unphysical Cubist example, "Nude Descending a Staircase"), and the Illinois senatorial vice commission bellowed into an investigation of "foreign fourflushers." Matisse, almost forty-four years old and by that time a major avant-garde figure, gave a Paris interview to an American journalist in which he said, "Please tell the American people that I am a devoted husband and father, with a comfortable home and a fine garden, just like any man," and added that he also rode horseback. One of his pictures in the exhibit, which American critics thought must have been painted by the Matisse children, was "Red Studio," in which, owing to his having discarded the third dimension, the studio furnishings (the work was mainly a picture of his pictures in his studio at Clamart, outside Paris) seemed to be in a state of levitation. This famous canvas, painted in 1911, was acquired in 1949 by the New York Museum of Modern Art and is regarded as one of its most significant and unusual Matisse treasures.

Between his art's first two American journeys, Matisse himself journeyed to Russia, in 1911. Few Europeans at that time were interested in Russia for any reason, but French modern painters were an exception, for there was a Moscow collector who was buying their works, something most rich French collectors were still failing to do. He was Sergei Shchukin, a wealthy middle-aged importer with a talented perception for contemporary Western art; by 1914 he possessed a tremendous and magnificent collection of it, then the greatest in the world, installed in his Moscow palace, which had been built for the baroque pleasure of the Trubetskoi princes in the reign of Catherine the Great. An elegant, almond-faced Slav (Matisse did a portrait drawing of him in 1912, which remained in Matisse's own collection), he was the artist's original patron; he discovered and bought Matisse around 1903, two years in advance of the famous American Stein family. But Shchukin

was primarily concerned at that time with acquiring Gauguins—mostly of coffee-colored Tahitians; he eventually bought fourteen. He also bought four van Goghs, eight Cézannes, five Degases, four Redons, thirteen Monets, seven Rousseaus, three Renoirs and, among the new painters, not only Matisses but a wealth of Derains and Picassos. After the 1917 Revolution, Shchukin's collection, which was seized by the Soviet State, provided the biggest aggregation of French pictures for Moscow's Museum of Modern Western Art. By the time the First World War cut him off, in 1914, he owned thirty-nine Matisses, then the largest collection of this artist's work in the world, but he had acquired only four of them—including two 1902 Paris woodland beauties, "Le Bois de Boulogne" and "Le Jardin du Luxembourg"—before 1905, the year the Steins began to purchase Matisses, as a result of the Fauve Salon. Shchukin later also bought one of Matisse's rare Venice paintings. The Matisses had gone to Italy in 1907, to please Mme. Matisse, and after they got there, Matisse became probably the only painter ever to say, without enthusiasm or explanation, "What of it?"

Shchukin invited Matisse to Moscow in 1911 to hang a pair of decorative wall panels, "La Danse" and "La Musique," that he had commissioned from Matisse a year or two before as added ornaments for the rococo plastered walls of the grand staircase of his palace. "Music" depicts male figures, one playing a flute and one a violin and three perhaps listening, and "The Dance" features leaping nude female figures, for which Isadora Duncan, who had been performing at the Châtelet in Paris, served as the rhythmic model, according to Leo Stein. The females are in a neo-Renaissance style, the males in a neo-primitive one; this difference in period seems to put the sexes ages apart. In "Music," as a daring equation in optics, Matisse aimed at absolutes in blue, green and vermilion in composition so balanced that the human eye could see all of them and it at a glance—"a colored surface grasped by the spectator in its entirety," he said. It is "rather monotonous," one of the leading Soviet art critics, Alexander Romm, declared. A book by Romm, *Matisse, a Social Critique,* is one of the most curious items in the

enormous library of books written about the artist, not only for its Marxist aesthetics but for its exegesis of what is still the largest state collection of Matisses in Europe. After Matisse, who was a precise, if infrequent, writer about his own views on art, published his 1908 "Notes d'un Peintre" in the *Grande Revue*, the most cited passage, unfortunately, defined exactly what his art had failed to give the French—comfort and relaxation. For Romm, this passage defined exactly what Communists do not want in their propaganda art at any price, and he therefore quotes it at the beginning of his book. "What I dream of," Matisse stated in this transcendental passage, "is an art that is equilibrated, pure, and calm, free of disturbing subject matter—an art that for any intellectual worker or businessman or writer can be a means of soothing the soul, something like a comfortable armchair in which one can recover from physical fatigue." This was probably Matisse's version of Michelangelo's dictum, "The best painting is that which gives the greatest relief." To Romm, the Matissean armchair idea outlined only what Romm refers to as "principles of a certain bourgeois stratum in the epoch of imperialism, the hedonist view of art without ideas. In Matisse's pictures one finds neither the city, with its traffic and factories and machines, nor the real man of our day . . . but a fanciful world illumined by a bright and even light . . . where there are no events and no catastrophes . . . not even bad weather." Having deduced by Marxian dialectic Matisse's well-known omission from his paintings of interest in humanity—this was also easily spotted by a capitalist writer on Matisse, the late Dr. Albert C. Barnes—the Russian then gives nearly a hundred pages to a remarkably incisive analysis and appreciation of the Frenchman. In his book, written in Russian a few years before the Second World War and translated into English for world consumption in the early 1950's, Romm doubtless voiced the official Soviet view of art, at least at that time. If so, Moscow has regarded Matisse ever since Renoir's death as "the great master of color and plastic form and the leading representative of French painting." "We cannot accept his hedonistic outlook," Romm insists again, in conclusion, after heartily admiring

its painted result throughout the artist's long career, "[but] Soviet art, which is now facing the problem of monumental painting, cannot ignore the heritage from Matisse." It did, however. Not only were Soviet painters not permitted to paint anything like him, being restricted by ideological directive to painting patriotic naturalism and Stalin's portraits, but the vast collection of modern Western art, in which Matisse's paintings were a dominant, disappeared from sight after the last war. It had been condemned to reclusion as "artistic bourgeois servility." For years no Western art authorities could say where it had gone. In 1954 a non-Communist naturalized Frenchwoman, who had been born Russian and was editor of the best-known Paris women's magazine, with her husband, equally noted editor of the biggest evening Paris newspaper, were given special privileges for visiting the Soviet and, once back home, printed their findings. One of the wife's was the discovery in the attic of the Hermitage Museum in Leningrad of the lost French pictures, which she was permitted to photograph as proof, and later printed. They had been brought there for safekeeping during the war and the Russian public was not allowed to see them. Her photos showed them to be in perfect condition, stretched on sliding wooden racks, rather like washing hung up to dry. There was the portrait of Mme. Mattisse in the green hat, among the many other canvases which Mattisse had considered among his best, ordered from him between 1911 and 1913 by Shchukin. Matisse's name was not mentioned in the Hermitage catalogue.

It was after the First World War, in the halcyon, fancy-free Paris of the 1920's, when hard times or another war were nowhere in sight, that modern French painting, and Matisse with it, finally became a popular attraction—part of the varied civilized entertainment then animating Paris. For once, the visual was enjoying top importance. It was through the eye, that basic educational organ, that people first learned they were living in a new, altered postwar style, and it was modern painting, after prophetically waiting for years, that gave them the first, revealing outline of it. All the arts,

as they were annually focused in the June *Saisons* of the twenties
—painting, music, ballet and even writing, in the latest poems,
manifestoes and printed reports on life or love—seemed suddenly
to have the same age; they were all new and all modern together.
It was brilliant, it was brief, it was the first twentieth-century
French epoch. There has been none since. Cocteau, Diaghilev,
Stravinsky, the young composers called Les Six, and Picasso, Derain,
Braque and Matisse, to name a leading few, were united in a
vertiginous production of modernity, of which the public—a heady,
variegated mixture of fashionable Parisians, internationals, intel-
lectuals and practiced tourists—with equal concord acted as the
enthusiastic recipient. At the Russian ballet premières in the Gaîté-
Lyrique or the Théâtre des Champs-Elysées, the painter's part—
the sets and costumes—was a major factor in the triumphs, along
with the dancers, the choreography and the music. Matisse designed
costumes and sets for the Diaghilev ballet *Le Chant du Rossignol*,
with music by Stravinsky and danced by Massine. It was never a
popular success. Throughout these years, any exhibition by one of
the three *maîtres modernes*—Matisse, Picasso and Braque—in the
Paris galleries of the powerful art dealers was a crowded social
event. Twentieth-century modern art had finally arrived; it was the
thing to look at, to appreciate, to own if you could afford it. The
prices paid by rich American and English collectors for new paint-
ings by these three masters were running between four and five
thousand dollars (the French paid a family price, which was
slightly lower). Actually these were poor prices compared to the
ones paid by international collectors of the generation before.
Nacreous, titillating nudes by Bouguereau, who was Matisse's
teacher for a few days in 1892, had incited appreciators to pay
twenty thousand dollars. The only memorable classroom art advice
the prosperous Bouguereau had given the young Matisse, then poor
and unknown, was to tell him, while laboring at his drawing board,
"Stop rubbing out your charcoal with your finger. It denotes a
careless character. Use a rag. You will never learn how to draw."
In the 1920's, Matisse was making, as he had made for years,

drawings of such perfected limpidity that even his art-critic son-in-law, George Duthuit, who sometimes referred to him with the sharp voice of an outsider, has described them as "mirrors on which the artist's breath is barely perceptible—*bel canto,* without dissonance."

According to Paris art dealers, Matisse, even in the heyday 1920's, when he was enjoying his first real popularity, was harder to sell than Picasso or Braque. Picasso had demiurgic periods—blue, pink, saltimbanque, Cubist, Surrealist, neo-Surrealist, antique—and periods of women with feet like Greek giants, or with artful faces like silk patchwork quilts, and when he finished a period, its paintings had the value of scarcity, like a unique invention that, just when people have found out what to do with it, is taken off the production line. Braque, after his Cubism, maintained a grave geometry of manner, popular because of its nobility and its Euclidean nonnaturalism. By that time, the nonmimetic had become a signature of the modern art vogue, and those who had at first fought it, because it was not factual or familiar, now valued it, as if in relief, for showing them how life did not look. Compared to Picasso and Braque, Matisse was the fleshly, sensuous modern French classic. His style in the 1920's was a superlatively colorful improvement on the visible world, created mostly in terms of women (and some flowers), whom, through an encyclopedic, masculine series of studied repetitions, he lifted to his own artistic perfection. His refinements in style, which made for his perfections, were less à la mode than the other artists' distortions, which made for their variety. On these three artists (Matisse, Picasso and Braque) and on two styles (Cubism and Matisse's plasticism, graced by his inextinguishable rainbow of colors) was founded the Ecole de Paris, which for forty years represented new painting for the whole Western world. On the three artists, Paris art dealers say, was established, around 1920, the obvious saleability and money value of contempory French art, which at this time took its place on the expensive international picture market as the successor to Impressionism.

Undoubtedly the most popular female figure of Matisse's career was his respectable, completely clothed young girl in white, with ostrich feathers loading her hat—"The White Plumes," of 1919. She appears in various versions, some of them now in Scandinavia, and others in the United States, including one in the New York Museum of Modern Art, one in the Minneapolis Institute of Arts, and one in the Cone Collection in the Baltimore Museum of Art. Two winters he spent in Morocco, in 1911 and 1912, supplied his canvases with color and light and intricate designs of the Moslem world, where he lived, in his paintings, for a long time to come, but it was not till around 1920, in Nice, that he began his painted population of odalisques. He painted "Odalisque in Red Trousers" in 1921, "Odalisque in the Hindu Pose" in 1923, and "Odalisque with Magnolias" in 1924; then added odalisques in green trousers, in a mirror, with a chessboard, on a zebra skin, with lifted arms, upright, recumbent and tatooed, and—one of the most admired, with an ovoid head and a curious posture undeniably reminiscent of Cubism—"Odalisque with Straight Back." And there were long, epicurean years of odalisques on couches, beds and Moroccan *poufs,* and in a Bourbon *bergère* and all kinds of multihued chairs, seating accommodations being a regular part of the furnishings his compositions afforded the relaxed art lover. All the odalisques are as different from one another as Matisse said he had found the leaves of a fig tree. "No two leaves are alike, yet each one cries 'Fig tree!' " he said. Each of his odalisques cries "Matisse!"

Dr. Albert Barnes, who collaborated with Miss Violette de Mazia, of his Foundation's teaching staff, on *The Art of Henri Matisse,* one of the biggest of all books on the artist, declared in it that in 1923 he painted a greater number of important canvases than at any other time except between 1905 and 1910, the years of his pure Fauvism. In his supreme 1920's style, no longer savage, as in the Wild Beast days, but grown superbly ripe indoors, Matisse, throughout his harem series, unremittingly observed woman as an artistic value and used her as a decorative fact, without passion or drama. "It is not a woman," he announced in explanation of his

attitude. "It is a picture." He also once said, "If I met a woman on the street who looked like my paintings, I would faint," a terse explanation of his theory of style.

In 1921, twenty-nine years after Matisse had started painting as a free student in the Beaux-Arts, the French government discovered him. The State bought "Odalisque in Red Trousers" for the Musée du Luxembourg. In 1928, it was ready for another canvas, "The Sideboard," decked with humble fruits, a water glass and a mussed blue napkin. For this picture, which he had just finished, he had received an offer of three hundred thousand francs (twelve thousand dollars). Matisse offered it to the Luxembourg as a gift. Because the museum had a rule, designed for the protection of the better living painters, that their works had to be purchased, not accepted as a gift, by which inferior painters could have placed their works there, the museum accepted Matisse's picture and pressed upon him one franc in payment. The year before, he had been awarded the first prize at the Carnegie International Exhibition, in Pittsburg, for his still life "Fruit and Flowers." In this period, his paintings were selling for as much as ten thousand dollars apiece. Homer St.-Gaudens, Director of Fine Arts at the Carnegie Institute, had asked Matisse why he had never visited America and he had replied, because he had never been invited. St.-Gaudens invited him to serve as a juror for the 1930 show. Matisse came and immediately made the observation that the light of New York was like crystal. He gallantly voted for Picasso to get the first prize, and then left for Tahiti, to see what the light Gauguin had painted was like. Later, passing through the United States on his return again, he stopped off in Merion to see his old friend Dr. Barnes. Barnes, who had met him, through Leo Stein, back in the days when Matisse was still living in Paris, had sixty-five Matisses—by that time the biggest and probably the finest collection of his work in the world—but he had bought nothing since 1924, seven long years before. He was now about to make one final purchase. He suddenly announced to Matisse that he was the only artist on earth who could do a mural the Doctor envisioned for his Foundation. As Matisse

later commented caustically, "It is curious that if I was the one artist on earth to do it, he hadn't thought of me before." Still, he agreed to do it, and arranged to work on it after his return to Nice. The mural, which was to be "on whatever subject you choose, just as if you were making it for yourself" and was to be gigantic—fifty-two square meters—would decorate the three lunettes in the central gallery of the Foundation. Matisse once more chose to do dancing females. His first production for Dr. Barnes turned out to be more than a year's lost labor. Ordinarily the most precise of artists, in computing the vast surface of the Barnes area he somehow miscalculated, allowing one square meter too little on his canvas, which he had set up in a large empty garage in Nice. For the second mural's eight dancing females—in slightly different poses—he made, as he had the first time, his many preliminary sketches, in this case thirty, and had them all photographed for convenient comparison—one of his patient methods of getting inspiration. The second mural was set up in the Barnes Foundation in 1933, without a hitch, over a weekend, above the two treasures it had been designed to shelter—Matisse's "The Riffian" and Picasso's "Composition." The project was ill starred. Not only did it cost him more than an extra year's work at the age of sixty-three but few art lovers have ever seen the mural because of Barnes' distaste for visitors. The too-small original finally went to the Musée d'Art Moderne de la Ville de Paris, but it is still invisible, unhung for lack of space.

In 1936, his publisher, E. Tériade, made an elaborate aesthetic statement about Matisse, printed in the de luxe Paris art magazine *Minotaure*, under the title "Constance du Fauvisme" ("The Constancy of Fauvism"). The vivid blues, blacks and reds of Fauvism, at least, he had really never deserted. In the later 1930's, however, he altered his style repeatedly, and the favor he had enjoyed diminished. His houris changed to what looked like mannequins, with broad, chic shoulders and empty faces. Then, in the war years, he burst, with the vigor of a young man and the brilliance of an old master, into an amazing poster style, in which women in bathing suits, without any faces at all—and, indeed, without

anything but magnificent color and bulk—perhaps indicated, in their simplified strength, the weakness his hand was still suffering. For this was shortly after his operation, before he had fully recovered his strength. He declared, at the time, that he had been given a new life (actually, about ten years had been taken off his old life, his household said, no less astonished by his rejuvenation than by his survival) and that he meant to use it to the full. With amazing concentration and application, he returned to his drawing and painting. Thereafter he always said he was not an ill man—though he was obviously invalided for life—but a man who had merely been *mutilé,* or wounded.

For the next thirteen years, until his death, Matisse mostly lived in bed and worked there, generally in one or another of his three studios, two of which faced south and one (with a Moorish black-and-white tile floor) on the north, in his apartment in the venerable hotel Le Régina, in the tree- and garden-filled Cimiez residential quarter of Nice. He worked on small sketches in bed, because he could be up and on his feet only a few hours each day. When he worked on very large designs, he stood up or sat in a wheelchair; he used a ten-foot bamboo pole that had a crayon attached to its tip, manipulating this giant pencil across paper tacked on the wall. It was a heroic performance. In bed, Matisse sat like a man at a desk. A table fitted over his knees and held his papers and drawing materials. He was always fully dressed and looked impressive. Indeed, he allowed no invalid disarray in his attire or around the studios. He set the household standard of neatness and organization. His white beard was clipped to a precise degree of shortness. He wore clothes that matched. If he had on a green sweater in bed and his bald head was chilly, he added a green wool cap. He drew constantly, even while talking to visitors. Drawing had become his language. He could not sit and do nothing with his strong, well-kept old hands. In this invalided man, even in his eighties, a chain of energy was still operating between the artist's hand at work and, behind thick glasses, the flickering of the myopic blue-gray, artist's eyes, set with startling color in the pink, obstinate, intelligent

head. By his bed was a combination bookcase and chest of drawers he had designed. In a kind of artist's shorthand, he had painted on the drawers little pictures of what was inside, his watch, pencils and crayons, his medicine bottles, and so on. The first painter of his generation who preferred sunlight to paint in, he ordinarily worked in the biggest of his south sunny studios. He early arrived at the conviction that what he called "luminous generation" in a composition was successful if it still maintained its strength "when placed in shadow, or if when placed in the sun withstands its light." In the summer of 1950, to avoid the Midi heat, he moved temporarily into the north studio, already filled with his winter woolens, his woolen carpets, and the like, in mothballs, and started to work at once, without breaking his rhythm. He could work anywhere. He worked, slept and ate in any one of the studios, moving around like a tidy gypsy. His studios were furnished sparsely with some of the familiar objects that had crammed his paintings—the blue Persian scarf, the low onyx table, the red-and-white potpourri jar, an armchair covered in zebra skin, and the Louis XV *bergère* on which his models posed, in series, as houris. On the walls were pinned some of his drawings, mostly of girls, like pinups everywhere.

Work protected him during the day, but at night he had to set up other defenses. He suffered from insomnia, yet he kept his light and his radio on, as if he were afraid to sleep. Beside his bed he had a powerful, mobile studio lamp. By its strong light, he could study his drawings on the walls during sleepless hours. He sometimes read at night, especially poetry, because it is short—moderns like Pierre Reverdy, Jacques Prévert, Paul Eluard and his friend Louis Aragon. He also took to rereading the French classics, among them Jean Jacques Rousseau. He had a night nurse, whose main task was to keep him company in his wakefulness and to read novels to him. When he dozed off, she would tell him, after he wakened, what happened in the book while he was asleep and would go on from there, for he did not really care about it. He no longer wanted to listen to his big collection of phonograph records, which were of two kinds, like the reading

matter—classical music for him, and the popular kind for the nurse. He was driven by his feeling that there was little time for all the work he still wanted to do, and he was interested in nothing else.

For many years, Matisse had lived apart from his wife, though he maintained friendly relations with her. His only interest on earth had long since been his work and its organization. For this he had established a household composed of young women employees, who respectfully called him Monsieur Matisse (he did not like to be called Maître), usually modeled for him, helped with studio chores and, in general, did what they were told. They were managed, and to some degree so was he, by a former model who became his remarkable secretary—Mme. Lydia Delectorskaya, a handsome blonde Russian recognizable in pictures and drawings of 1935 and thereafter, such as "Blue Eyes," "Standing Nude with Ornamental Plant," the "Embroidered Peasant Blouse" series, "The White Jabot" and "Lydia" (one of the few complimentary likenesses he had done in late years). The household said it was thanks to her that he was still alive. She set the discipline that the others observed and on which, through her tactful persuasion (for he resisted open interference, even salvational), he actually survived. Except for his work, life came from the outside only. Mme. Delectorskaya filtered and arranged it, acted as buffer or bridge and ran the household. It consisted of a model named Kathia, Russian-speaking and of the Lydia type; Paule, a dark French model and studio helper, who fixed his paints, erased, prepared fresh papers and so on; a good cook (after ten years, his famous cook Mme. Céline had finally retired), for he still liked to eat well; a kitchenmaid; and the night nurse. There was also a feline matriarchy ruled by the mother of three ordinary cats; the youngest, a tiger, by day sat in bed on the Master's knees. In the old days, to escape the Midi summer heat, Matisse had always gone to Paris for a month or so, to his studio in Montparnasse, and the entire household had always gone with him, including his cats. The transfer used even to include a big cageful of exotic birds, but he had

given them up during the war, when it became almost impossible to find grain to feed them.

It was Mme. Lydia and his models, together with Matisse's own tenacity of will, his lifelong fanatical habit of organization, and his vigorous acceptance of a challenge to undertake a new kind of art at the age of almost seventy-eight, that made it possible for this bedridden old artist to begin, and in four years carry out, the plan and the construction of the Dominican nursing nuns' small Chapelle du Rosaire in the hill town of Vence, behind Nice. Its consecration and first service, in June 1950, constituted an international art event. The building of La Chapelle du Rosaire is the unique instance of a modernist European master's having designed for the Catholic Church an entire ecclesiastical structure and everything inside it and outside it, including the pattern of succulents and ivy planted in the chapel garden. For Matisse, whose nude art and earthy colors certainly had no reputation for holiness, it was an odd enterprise. Both the public and the press were early fascinated by the peculiarity of the association; fashion magazines, newspapers, newsreels and art gazettes followed the development of his plans and maquettes; and the chapel was famous long before it was finished.

The chapel's inception was a story—or, rather, two stories—in itself. The first story, and the factual one, was that during a long convalescence in Nice, after his operation in Lyon, Matisse had employed a nurse, a pleasant, young, devoutly Catholic Midi girl, who by chance possessed magnificent arms and occasionally modeled for him, usually in a yellow evening gown, as in "Robes Jaune Citron et Ecossaise." A year or so later, her father, an officer in the French Army, to whom she was devoted, died; she had already lost her mother and, being alone in the world, entered the Dominican nursing order. As Soeur Jacques, she subsequently took up her duties at the Foyer Lacordaire, a little Dominican convalescent home in Vence. Like many of the Niçois during the war, Matisse, cut off from Paris, summered in the higher altitude of Vence to avoid the heat in Nice. Then, in March, 1943, to get away from

the increasing difficulties of city life, he returned to Vence and to a small house he had previously rented, across the street from the Foyer. Soeur Jacques used to run over to give him nursing help and to talk art, for she was herself an amateur artist, in miniature style. For his seventy-seventh birthday, she gave him a postage-stamp-size album of miniature seascapes, and later she showed him some sketches she had made for stained-glass windows in a new chapel the Lacordaire nuns were dreaming of. Here the second story, the legendary one, began. According to the other sisters, in gratitude to Providence for having saved his life, *le ressuscité*, as they always called Matisse, then designed the windows for Soeur Jacques, and eventually took over the designing of the whole chapel in the grateful spirit of an ex-voto. The true story of the windows, according to Matisse, was considerably more worldly. He said that after offering Soeur Jacques some suggestions on her designs, he became so interested in the color problems presented by fenestration that he designed dozens of hypothetical windows of his own. Then, at Eastertime in 1947, there came by chance to Lacordaire a convalescent young Dominican brother, Frère L.-B. Rayssiguier, a former student of architecture and an admirer of Matisse. Frère Rayssiguier called on the artist, and artfully, persistently talked windows and chapel. Briskly, Matisse offered to work on the chapel on one condition—he would design all or nothing. Since the end of the war, he had already developed a *passe-temps* into a new technique that he called "carving in color." It consisted of creating, with scissors, cutouts of colored paper—convenient and stimulating for a semi-invalid—and he had even made a series of these cutouts for a book of art and philosophical reflections, queerly called *Jazz*. The prospect of working with cutouts on the chapel's windows and architectural perspective irresistibly appealed to him. Furthermore—and this was the basic worldly attraction—designing an entire modernist ecclesiastical building (which no other master modern European artist had ever been privileged to do), on the basis of a personal aesthetic demonstrating his theories of color and light, was a fascinating, ambitious project

that, as Matisse perfectly realized, offered a unique chance for his art to be preserved in a form far more permanent than canvas. Matisse's offer was enthusiastically accepted and thereafter seconded by the Church's leader in such projects, the late Dominican Père M. A. Couturier.

Handsome, white-haired, white-robed, himself an artist, a distinguished figure who operated as something of a missionary in Paris intellectual circles, Père Couturier led the movement in France to use contemporary artists in the beautification of contemporary churches, as the Church did in the grand old days of its grand art. Père Couturier, who had stated that it was a miracle to find amid today's paganism any art of religious inspiration, had already been responsible for the first famous modernist Catholic church in France, which is at Assy, in the Haute-Savoie, and has religious decorations by Georges Rouault, Fernand Léger, Georges Braque and Jacques Lipchitz. The Matisse chapel was Père Couturier's second remarkable, and eventually much more famous, modern church project, and he himself as a proper tribute became part of its *décor*. Matisse used him as the model for the fifteen-and-a-half-foot-high, black-outlined figure of Saint Dominic that decorates part of one wall of the chapel, as well as for a head of the Saint over the entrance door.

Frère Rayssiguier remained in Vence to act as foreman during the building of the edifice, which at top level was supervised by Auguste Perret, president of the Order of Architects and a member of the Institut de France. To organize the work in its designing stage, Matisse moved back to his studios at Cimiez, and throughout the construction stage he kept an eye on the progress at Vence by making constant trips up the hill in an old hired Rolls-Royce, his customary transportation. Of several chapel details that were contrary to tradition but were sanctioned, like artistic dispensations, by the Dominican order, the most noticeable even to laymen, after the chapel was opened, was the position of the altar, a simple stone slab. Matisse placed it on a diagonal in the L-shaped little chapel. Also, in accordance with his plans, the priest must serve behind

he altar, as in primitive churches, so he half faces the Dominican
sisters—for whom, after all, the place was built—when they are
seated for Mass in the few carved wooden choir stalls, ranged in
a shallow alcove on one side of the priest. He also half faces the
congregation when there is any, which is rare. (The laity must
stand, there being no pews to ruin the chapel's exquisite propor-
tions.) The chapel's three wall decorations are of white glazed tiles
with black decorations. On the right wall, as the visitor enters, are
the figure of Saint Dominic and a ten-foot-high representation of
the Madonna and Child; all three are faceless, in heavy, smooth,
black, modernist outline. By the entrance door, in the back wall,
are the fourteen Stations of the Cross, pell-mell in one large com-
position, done in what looks to many visitors like impious, unim-
pressive, mostly unrecognizable ultra-simplifications. Station Num-
ber VII, which always pictures the Catholic legend of Saint Ver-
onica, shows an unexpectedly beardless Christ's face imprinted on
her handkerchief. (The Vence youth who posed for it was actually
the only bearded young man in the village.) The Stations of the
Cross have given the least satisfaction to most visitors, whether
they are local or international, and whether their interest is re-
ligious or aesthetic. "What does that mean?" peasants repeatedly
ask, pointing to the Stations in bafflement. "It means modern,"
the white-robed Dominican nun in charge repeatedly replies, with
firm authority. Matisse designed literally everything in the place—
the confessional door, the choir stalls, the candlesticks, the ciborium
and the rest. His slender altar crucifix depicts a Christ so low on
the Cross that his head is below the crossbar, to which his arms
rise in the outline of a stirrup, an astonishing and aesthetically
beautiful new conception. The most notable innovation are Ma-
tisse's stained-glass windows, with which his whole chapel project
had begun. His windows, showing lovely vegetal patterns instead
of traditional sacred history, are of ultramarine blue, lemon yellow
and emerald green, and devoid of red. It was his inspired omission
of red as a color, which in glass always results in a refraction of
light that becomes fiery and medieval, that donated to his windows

their special gift of shedding a new modern, serene, ethereal atmosphere. It filters into the calm, bare white chapel in a magical, almost unearthly Mediterranean effulgence. The priests' five chasubles for the five liturgical colors repeat in black and in colors the windows' trident leaves, Matisse's formalization of the mesembryanthemum, that wayside Midi succulent that has Matisse-colored yellow or pink flowers, which he also used in the chapel's parterre garden. The chapel's outside walls are white and the roof is gay—of sky blue, which gives way irregularly to white that looks like clouds. Some natives have been troubled by its slender *fer forgé* cross trimmed with crescents. "Why did he make a Jewish cross?" one countrywoman asked indignantly. Informed that the crescent is, if anything, Mohammedan, she crossed herself hastily and said, "*Mon Dieu*, it's even worse than I thought." Mostly, however, the countryside people are proud of La Chapelle du Rosaire. They loyally declared that Matisse was the best painter in the Alpes-Maritimes, the Département in which Vence lies. Since the *vernissage*, as the chapel's opening day was called by the Parisians present, the villagers have been increasingly impressed over the years by the crowds of visitors who have arrived in tourist charabancs, which come to show the chapel as one of the new sights of the Riviera, or who have rolled up in luxurious cars or come on bicycles, or even on foot. At first open to the public only on Sunday afternoon, at Matisse's insistence it was visible daily from three to six in the afternoon, rather like a small art museum. Since his death, it has been opened only on Tuesdays and Thursdays.

There was acute curiosity in Midi artistic circles as to whether Matisse, theretofore definitely known as no churchgoer, would attend the consecration in June, 1950, of his chapel, which was blessed by the Bishop of Nice. Matisse did not appear. Instead, he sent to the prelate an amazing, stately letter, indited as if from some great, artistic, secular height. "Your Excellency," it began, "I present to you in all humility the Chapel of the Rosary of the Dominicans of Vence. I pray that you excuse this work's not being presented to you by me in person, which the state of my health

prevents." Obviously, Matisse, who had at one time been openly anticlerical, was no longer as anticlerical as he used to be, but he was known to be not a practicing Catholic. The French are always interested in probing into spiritual details about each other, and Vence rumor said, at the time, that the Dominican nuns, who regarded him as the most illustrious wayward sheep of their acquaintance, vainly offered to let him be buried in his own chapel if he would only come back into the fold. But no one who knew him well thought he would go as far as that, even for the privilege of lying till Judgment Day amid his own modern art. He was of that generation of French youth for whom—and especially for the intelligent and poor or modest members to which classification he had belonged—the French Left, with its rigid tenet of separation from the Church, was the natural political direction. He never changed his position.

In 1945, after the Liberation, the Salon d'Automne, which was where Matisse had started from, amid jeers, in 1905, honored him with a large retrospective, afterward repeated in the Victoria and Albert Museum, in London. His pictures were not satisfying to the people of either nation, emotionally depleted by war and by then overflowing with dreams of peace. A Picasso exhibition held simultaneously at the Victoria and Albert provoked a landslide of angry letters in the London newspapers. Matisse's women, as decoratively distant from reality as ever, seemed too far from the physical struggles people had been through, and Picasso's jagged lines too close to what looked like the debris of bombing. In a sharp, brief swing away from the modern times, which had almost extinguished them, bomb-exhausted, ill-fed people, in their survival, on both sides of the Channel, yearned for older, more emotional art, with inspiration in it, and nobility, and faith, and possibly even angels. It was not till 1947 that Matisse's popularity returned, and then it was redoubled. He became—and to his death remained, so museum men and art dealers said—on both sides of the Atlantic the most popular French artist. Their explanation

was simple. They said that people who cared about modern art were looking at his and buying it again because they again loved what he painted and had always painted, which gave them notions of beauty, with sensuous, exquisite color, in his own specific palette. He knew success early and late, with little in between, and, at the latest time of all, he was at his zenith. Art dealers often take a one-third commission on pictures, and the facts of life in the painting profession are mercenary indeed. In the early 1950's, a forty-by-fifty-inch Matisse sold for from twelve thousand to twenty thousand dollars—and for even more if it was a canvas particularly characteristic of a special year or period. Matisse had sometimes been short of sales, and of money, in years even when his fame was high. Pictures that were not valued at what he thought they should fetch he kept, as illustrations of stages in his career. Furthermore, he refused to sell certain of his pictures that especially pleased him. As early as 1926, in his Clamart studio when he still badly needed funds, he declined to sell one of his pictures to a rich American lady. Baffled, she asked why. "Because," he answered concisely, "if I sold the painting I would have only the money. And you would have my picture." Matisse is believed to have painted two thousand pictures (as against the twelve thousand pictures that Renoir is believed to have painted in his long lifetime). Because he would not sell himself short, Matisse had a large collection of Matisses. He kept most of them in a bank vault in Nice. As he said of them, *"Ce sont des valeurs."* He also owned a small collection of good pictures by other artists who failed at one time or another to sell. He possessed a fine Soutine landscape and several Cézannes and Renoirs. He always regretted a Gauguin he missed when he was poor. He had asked his younger brother, in the family grain business up north, to lend him the cash to buy it. The sum was exactly equal to the price of a good, new bicycle, which his brother bought instead.

In 1951, Matisse began painting pictures again after his four years of work on the Vence chapel. He started by painting his

brunette model Paule in a chair, still using a china plate for a palette, as he always had. His only complaint was that he had to fight against the facility that comes with age. Work continued to be the only thing that interested him. "It has never amused me to amuse myself," he often stated. He had the dry speaking voice of the northern French, which, with its special intonation, makes its own scale. In describing what he had aimed at in his painting, he mostly used music as a metaphor—chords, singing colors, and so on. He was an explicit, logical talker, who also, when painting, enjoyed listening to gossip, which he did not repeat. He talked rapidly, and when he became absorbed—especially in talking art with somebody he knew well—almost telegraphically, omitting verbs and reducing his sentences to ellipses of his thoughts; these ellipses were marked by precision and lucidity, and were always perfectly intelligible. With outsiders, he was reserved, punctilious and didactic, for they always asked questions. Not long before his death he succinctly said to a visitor, with the usual curiosities, "Modern is a style. Style is what explains why painters today don't paint in the manner of Titian, for example. They don't see things the way Titian did. The way enough painters—or a dominantly talented painter—see things is what makes for style."

Those who knew Matisse intimately said that only to slight acquaintances did his formal, measured, bourgeois personality seem inappropriate to his sensuous art. They said that the more a student or a critic studied his painting, the more he realized that it represents the fundamental, organized construction that was characteristic of the man. Friends admired him as a heroic, Olympian figure; they were aware that, although he maintained friendships, he made no sacrifices for them, because he preferred making sacrifices only for work. His manner was never intimate. One friend said with admiration that he was *dur comme un tigre*, that his truths were complex, and that he had fought implacably to preserve them even in solitude and during his unpopularity. His maxims about painting were wise, if alarming. To a student who came asking advice, he said, "You want to paint? Start by cutting your tongue out, for

you ought to express yourself only with your brushes." "Everything not useful in a composition is harmful to it," he told someone else. His loneliness and philosophy he summed up by saying, "An artist's only enemies are his bad paintings." He rarely talked of his career. He knew his worth early, but his fame came late, and when it arrived, it was as if he had become quite accustomed to its weight in advance. He had an incredible visual memory for his work of the last twenty years, and could recall the multiple stages of any given composition, and where each was painted. When important visitors from the outside world would call, he always asked the news of other famous elderly figures, such as Benedetto Croce, of Naples, or Arturo Toscanini, of New York: How are they holding up? Exactly how do they look now?

During his last years he always received a few local friends and acquaintances in his studios from time to time. He enjoyed the visits of several handsome, privileged young women from among the musicians and writers of Nice and St. Paul, the intellectuals' hill town near Vence. He often saw his art publisher, Tériade, who lived close by on the coast. He saw Mrs. Dorothy Bussy, sister of Lytton Strachey and a translator of André Gide. He used to see Gide, who, he said, was a prisoner of his professional personality, his cape, his big hat and his books. Matisse's bright eyes always sparkled when he was amused by his own malice. With familiars, he had the unvarnished candor of old people and children. He was not witty but Frenchily apropos. His most quoted shaft was directed toward a lady who had asked him where modern art was going. "Can't you ask me a *little* question about art, Madame?" he ventured. He reserved a special, formal manner for his neighbor Picasso, who then was living in the town of Vallauris, not far from Nice. They called back and forth occasionally, and after nearly half a century still saluted each other by their last names.

Of Matisse's three children, the daughter, Mme. Marguerite Duthuit, is married to the art critic, and earlier was herself a

painter; Jean Matisse is a sculptor; and Pierre Matisse is the New York art dealer. He also had five grandchildren, all of whom met at Cimiez at Easter in 1950 for their first united reunion with him: his two French grandsons—one, Claude, the son of Mme. Duthuit, and the other, Gérard, the son of Jean Matisse—and his three American grandchildren, Pierre Matisse's two teen-age sons and one daughter, who was recently married to a young French banker. They arrived in Matisse's studio late at night. The next morning, there was a portrait of the granddaughter, Jacqueline—she was then twenty, red-haired (as he used to be), and his favorite—which Matisse had drawn on the wall, as he sat in bed, with the aid of the giant bamboo pole and charcoal, during his sleepless hours. He was the kind of grandfather who teased to show his fondness. Jacqueline, who the year before had been hopefully studying literature at the Sorbonne, he affectionately tormented by saying she could never write and she was certain to grow up into one of those outdoor American women, interested in nothing but large horses. He assured the then twenty-year-old Duthuit grandson that the classical university education he had planned on was nothing but folly. He still treated them as children; he told them travel stories, drawing sketches and verbally supplying colors to bring to them this port in Tahiti or that Russian church with silver pillars, recalled from his voyages. He retraced family anecdotes, such as how he was tempted, when he was at his poorest, by a rug merchant who offered him work dyeing wools because his color sense was so true—and then he sold his first picture and was saved. He recalled his hobbies; for three times in his life he had thought a hard-working man should have a hobby, so he methodically rode horseback, learned to play the violin (it figures, along with its case, in his chef-d'oeuvre "Interior at Nice"), and, past middle age, took to rowing a skiff round the harbor of Nice. To his grandchildren, he furnished the phenomenon of genius seen at close range. With positive pride, whenever any of their young friends complained of a crochety grandfather, the Matisse descendants would brag that *their* grandfather in a temper was really fierce, a

positive treat to hear and see. With the analytical facility of the new generation, they said they realized he had never been a bo-hemian, even when young—that he had wanted a bourgeois life with wife and children, like any man, then discovered too late that he was only, as they put it, an egocentric great artist, which was difficult for everybody. As Jacqueline declared, "It is wonder-ful having him for a grandfather. It showed me from the first what quality was."

Jacqueline also gave a striking intimate account of the final stage in her grandfather's making of a drawing—a few brief moments of catching the essence, which he himself had described as "drawing with my eyes shut." "His concentration then is terrifying," she said, shortly after that Easter reunion. "He acts stone-deaf. His talent is a physical thing, which lies in his hand. But to make it function perfectly in these special moments demands a kind of intense co-ordination, which does or does not work. If it doesn't, he has to wait and start all over again. His hand leads him after he has absorbed the object, and he doesn't look at it any more. He just draws the result of it that is in him, like a film negative." He told her that once he vaguely realized in the midst of this con-centrated state while making a nude drawing that he was drawing the model with only four toes on one foot. It was too late to change the motion of his hand, and four-toed she remained. Père Couturier also gave a similar description of Matisse's fixedness. In his white robe, he had posed for two hours in the Nice studio, walking, talk-ing or sitting still, while Matisse made repeated preliminary sketches for a head of Saint Dominic for the Vence chapel. Then, as if the ripe moment was approaching, Matisse called in Mme. Lydia. She arrived with what he would need already in her hands —ink, pen, paper. "*Allez*, M. Matisse," she said, almost as if speaking to a magician whose turn it was to perform. She stood by him without moving. "*J'ai le trac* [I have stagefright]," he mut-tered. In silence, he picked up the pen and inked it. He did not look up. Père Couturier said he could hear a fly buzzing and was afraid that its infinitely small activity and sound could disturb

and destroy the tension. Then Matisse, in one completely unin-
terrupted rhythm of his hand, like a man in a magic spell of crea-
tion, made the drawing.

An American woman living in Paris, old enough to have known
Matisse well since the Fauve Salon days, several years before his
death said of him reflectively, "His life has been himself and his
painting, and nothing else. He did not easily make friends or
enemies. He was not affable or good-looking; he was just a great
painter. He was not a genius, in my estimation, but a man with
a great endowment. God gave it to him and he made more of it.
What has prevented him from being a genius is that he has had
no interest except painting."

It is a tribute to Matisse's long preoccupation with beauty that
even those French writings—there is a whole literature on him—
that deal comprehensively with his limitations are as beautifully
phrased as the ones, more vast, that compile his excellences. Even
the unfavorable critiques of the last thirty years are only like the
strong, acrid spices that preserve rose petals in the kind of Oriental
potpourri he was fond of placing in his paintings. Such a potpourri,
layer by layer, would include statements like these: "His paintings
rouse more marvel than emotion. . . . In his meditated freshness
of touch is the cold, intelligent sumptuousness of a man who never
loses his head. . . . His odalisques contain nothing of the legendary
but are models and contemporaries, unrelated to Venus. . . . From
his paintings, we know him less than we admire him. . . . He is
the greatest French painter to have had no sense of great subjects.
. . . In his creations there is nothing melancholy—no doubt coming
at dusk; there are no children, no broken old people. . . . His
art has been concerted and perfected by his minute, incessant love
of the visible universe of flesh, of the leaf, blossom, and branch,
of things without the intrusion of humanity. . . . His passion has
been not for inspiration but for perfection."

The loftiest French appreciation of Matisse during his lifetime
sublimely treated him as if he were not an artist at all, though the

tribute came from one of the leading art critics of France: "Henri Matisse is one of the highest examples of French thought." Quintessential French appreciations of him were as picturesque and sensuous as his own compositions. In praise, the French wrote of him: "In his paintings of women, serenity attains grandeur. . . . He paints among the fields of his senses, intelligence, and vision. . . . Exalted by, and in light, he has made the harmony of pure colors his language. . . . To nature he gives the ceaseless questioning of detail, from which he draws in the meander of a vine or the leaf of a palm a general final answer in his art. . . . Under the appearance of facility, he is a classic. . . . His color has of itself all the intelligence that can be expected of color." In America, even the difficult Dr. Barnes wrote, "Of vigorous intelligence and enormous erudition, from his fecund imagination have come achievements unequalled by any other painter of his generation." From the painter's son-in-law, Duthuit, came one of the most curiously exact, elaborate and valuable appreciations: "On the highest level this painter took part in common life with an extraordinary tension of all his being, with the total participation of his will, with the unsparing conviction and ruinous outpouring of energy required for the accomplishment of the obscure purpose that was to enable him to bring together, in a minimum of gay and lively spots of color, the essence of his character."

An indefatigable perfectionist, he once made (or so he said) three thousand sketches for one painting. Art became the unfaltering technique of his hand, variety a calculated part of his restricted, disciplined pattern, and only pure color remained free. M. Matisse died on November 4, 1954. He had painted steadily for half a century as one of the greatest productive art creators of contemporary France, a painter of concentrated genius, color and labors. A few years before, he himself had spoken what could have served as his own epitaph and of his artist's conception of immortality. "Work," he had said, "is paradise."

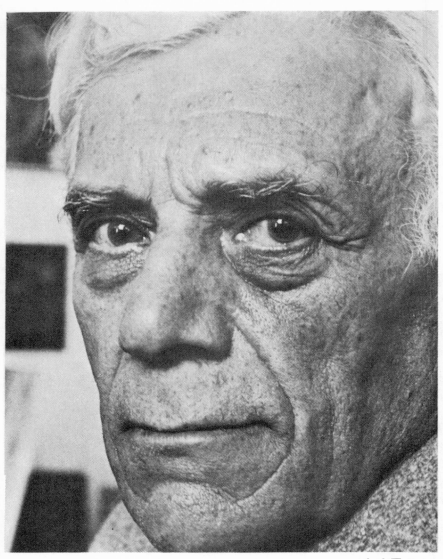

Sanford H. Roth

Braque

3

MASTER

THREE artists of Paris, painting from 1905 through 1908—the dates have financial as well as historical values and are therefore quite precise—discovered what today, fifty years later, is still known as modern art. The three were Henri Matisse, already in his middle thirties, and Pablo Picasso and Georges Braque, in their mid-twenties. They all shared the convenience of having been born at exactly the right time to begin producing their separate contributions—in each case unlikely and strange—just after the opening of a new century destined to be full of world-shaking innovations, some benign, some terrible, among which contemporary art was at first regarded as one of the most unpleasant and destructive. During the major part of these three signal years, the three artists were unacquainted with one another. Matisse, son of a Picardy grain merchant, was already old enough to look like a doctor, with his beard and gold-rimmed spectacles, and, in truth, he passed much of the rest of his life painting housebound women—feverish nude or semi-dressed odalisque types, leaning in languor on pillows, beds or chaise longues. Picasso, son of a bourgeois

Spanish drawing teacher, looked like a young day laborer, his appearance being already as much of a travesty as the many disguises in form that his art was to take. Only Braque, the youngest, who was the son of a small-town house painter, looked what he was—a robust, handsome artisan. He was a big young Frenchman, splendidly proportioned, seductive to the eye and affable; was inclined to bouts of solitude but, in company, was a fine waltzer with the girls and a lively and tuneful singer with the men; and loved to box, to sail, to ride a bicycle, and to play the flute, the accordion and the concertina.

Now in his seventies, as he sits in his Paris studio he looks—in color, precision and dignity—like one of his own compositions. The marks of time on his face, together with his angular, thinned body and his concentrated air of detachment, give him a refined, abstract quality. His hair is as white as white paint and his skin a ruddy brown; his cotton painting jacket, invariably freshly ironed, is usually a light blue; and his scarf is often a pale yellow—all his own colors, which he wears carefully co-ordinated. He has always adhered to that dandified swagger style of dress that is sometimes seen on good-looking, natty European workmen—a combination of pride of class, blue cotton shirts and bright foulards. When younger, he used to have his shoes made to order with square toes, in imitation of workmen's shoes, but with a seigniorial elegance of soft leather and costly workmanship, the mélange affording him some sort of dual satisfaction. When he was young and a cyclist in Paris, he bought a ready-made three-piece suit at one of the department stores each spring, the third piece being bicycle breeches, then regarded as very ultra. He had the trained strength of an athlete and the body of a Greek statue. There is an old snapshot that shows him as a young man in white bathing trunks on a rock by the sea; the strong male grace of his posture, the beauty and proportion of his torso and limbs, rounded as if in marble, his small, shapely head and its tight, carved, dark curls make a figure that looks Apollonian. He was the handsomest and strongest of his circle of painters, and he perhaps unconsciously transferred his superior

physical endowments into the sensuous plasticity that marks his art. A friend has the theory that Braque's handsomeness early relieved him of useless doubts about himself—that, as in the case of Raphael, his masculine good looks afforded him assurance, accompanied as they were by the talent that gave him authority.

Braque was born on May 13, 1882, in Argenteuil, a picturesque town on the Seine, thirteen kilometers downstream from Paris. It was the birthplace of three generations of Braques, who all lived together in a house in the Rue de l'Hôtel-Dieu that belonged to Georges's grandfather. The shabby Braque house still stands. Grandfather Braque had taught the family trade of house painting to his son Charles, who married a local girl, Augustine Johanet. They became the parents of Georges and two daughters. The renown of Argenteuil then consisted of its riparian charms, its modest midsummer sailing regattas, its white-asparagus *primeurs* (of a variety still sold expensively each spring in the Paris markets) and its chance historic service as a painting center of Impressionist art, brought into glory there in the middle 1870's by Claude Monet, whose favorite plein-air subjects then were the town's river, boats and high old stone bridges. Both the older Braques were Sunday painters, and one of Georges's earliest recollections is of his father's telling him with pride that even Paris artists came out to paint their pretty home town—though without mentioning what kind of painting they did there; Charles Braque probably thought Impressionism too scandalous to mention to a child. He himself confected pictures in the early landscape style of Corot, and well enough to show occasional canvases in Paris at the conservative Salon des Artistes Français, where the new art of Monet and his friends was considered offensive and disgraceful. (All they were doing—innocently enough, it would now seem—was trying literally to paint light, in its colored, atmospheric variations; for plein-airist Monet this meant capturing alfresco the bluish sunshine of the Ile-de-France, which looks nothing less than poetic, inspired and true to our eyes nowadays, and for Monet it meant taking his nude

model away from a north-lighted studio and putting her outdoors, in "Le Déjeuner sur l'Herbe," which today has simply the normal appearance of a masterpiece.) Another of Braque's childhood memories is of watching the construction in Argenteuil of Gustave Caillebotte's mansion—a matter of obvious interest to all male members of a building-trade family. This was the elegant dwelling that Caillebotte, a rich young Parisian naval architect, was having built so that he could live in company with his collection of Impressionist canvases, which roused such repulsion when they were later offered —but still too soon to be welcomed as a munificent legacy—to the French state for its Paris museums.

Because the boy Georges Braque of Argenteuil in after years felt the mysterious necessity to help create an equally unwelcome new art style, which turned out to be Cubism, and because Argenteuil eventually became synonymous with Impressionism, the ludicrous and bitter story of the Caillebotte legacy still seems extremely illuminating. It was the first example of the shocked fury and savage conservatism with which academic, official and journalistic French art circles reacted when faced with the iconoclasm of a new, modern way of painting, and it instituted a psychological pattern of major consequence in modern art's history—and prices, too—as Braque and the other Cubists were later to discover. Briefly, then, Caillebotte, a young Maecenas and mediocre amateur painter, was drawn to Argenteuil through a friendship first with Monet, then with Renoir (both of them frequently penniless from unsuccess) and then with their friends. As a rule, he bought their pictures only when they could sell them to nobody else—an unusual aesthetic criterion. In this kindly, haphazard fashion, he collected the sixty-five items he left to the state for a permanent collection on his death in 1894—sixteen Monets, eight Renoirs, eighteen Pisarros, three Manets, seven Degases, nine Sisleys; two stray canvases by Millet, the Barbizon School naturalist, who did not belong with the rest of the collection, and two paintings by Cézanne, still so unrecognized that the state art authorities did not even know he was not an Impressionist. To everybody's surprise, Caillebotte's will,

though it was made as early as 1876, when he was only twenty-eight years old (being delicate, he feared he would die young), turned out to be the most influential testament in modern-art annals. For one thing, he intelligently recognized in it most civilized people's instinctive hatred of the sight of anything suddenly and radically new in art, and the subsequent mollifying effect of familiarity and time. Still thinking of his early death, he declared that his pictures should not be shown prematurely, since he figured that it would perhaps take twenty years before the public could acknowledge—"I do not say understand," he added, rather haughtily —this kind of painting. His will also wisely forestalled any tricks on the part of the Administration des Beaux-Arts, the nation's art authority, by stipulating that his pictures were "to be sent not to the attic or to a provincial museum but to the Luxembourg," then the state museum that radiated glory on living painters, and finally, on the death of the painters, to the Louvre itself, which would mean the official apotheosis of Impressionism. To his surprise, Caillebotte lived to the age of forty-six. The French, prone since their revolution to quarrels hinging on conservatism vs. radicalism in any form, rose to a frenzy of argument over his legacy. The academic painter Jean Léon Gérôme, who was also a professor of the bigoted, ultra-conservative Ecole des Beaux-Arts, threatened to resign if the legacy was accepted, declaring patriotically, "We are in a century of decline and imbecility. The legacy contains pictures by M. Manet and M. Pissarro and the others, doesn't it? For the state to accept such filth would indicate moral blight. Anarchists and madmen! *Eh bien, non!* It would be the end of the nation, the end of France." A well-known portrait painter said that the best way to treat the Impressionists was to "give them a kick in the behind." Egged on by the Beaux-Arts' determination to sabotage the gift, even the French Senate held a solemn, worried debate on Impressionism. But in 1897, twenty-one years after the perceptive young Caillebotte wrote his will, a truncated portion of his legacy was officially put on public view in a new wing of the Musée du Luxembourg, as though in an isolation ward, and, sure enough, the public yielded

to the pictures sufficiently for the opening to be called a success. At least, the public attempted no mayhem, as it had earlier when shown plein-air art. Only forty of Caillebotte's sixty-five canvases had been accepted by the state as fit for the French people to look at. The twenty-five others were refused. Among those taken were eight Monets—including "Regatta at Argenteuil"—their average worth having been officially estimated at 5,750 francs (then $1,150), so that the state could have some idea of what it was unwillingly getting for nothing. Of the Renoirs, only six were accepted, including "Le Moulin de la Galette"—currently regarded as a masterpiece equal to his "Luncheon of the Boating Party" (now in the Phillips Gallery, in Washington), in which the dominant male foreground figure, bare-armed in his undershirt at the luncheon table, is Caillebotte himself. The Renoirs were valued at the equivalent of $1,000 apiece. The lowest value of all was set on the two grudgingly accepted canvases by Cézanne—750 francs, or $150 apiece. ("There's a fellow who will never know anything about painting," one art official declared.) One of the pair was "L'Estaque," a view of the Mediterranean fishing port of that name, which is today worth perhaps $150,000 and is regarded as a gem of the Louvre. Gustave Caillebotte's brother Martial, unwilling that the twenty-five other legacy pictures should remain spurned, fought for their inclusion in the Luxembourg Caillebotte wing until 1908, when he renounced the struggle, leaving the French state triumphant in its loss.

It was time for Martial Caillebotte to stop, for in 1908 there were already three forms of even more modern art for the state, cautious collectors and the public to laugh at and miss appreciating for at least the next decade. It was in 1908 that Braque, following in Cézanne's footsteps, went to the village on the bay of Marseille and painted his "Houses at L'Estaque," depicting a group of hillside dwellings that had lost their domestic character and become brownish cubelike floating forms, levitated by his imagination into new structural creations in the southern air. On its exhibition in November, 1908, this most famous—because most arbitrary and

positive in its geometry—of Braque's prophetic L'Estaque canvases passed into renown as the first Cubist picture ever shown to the public. And Braque's was not the only new talent in ferment. Early in 1907, Picasso had finished a picture he had been working on for almost a year, known only to a few friends. It had no cubes in it, but over the years art experts, who had first called it Negroid, began calling it a proto-Cubist picture. Because of Picasso's indifference to public showings of his work, it was not exhibited for many years. It was a violent, revolutionary composition of five monstrous, archaic-looking females portrayed against shifting planes, as if tilted in space; only the two right-hand females, which were repainted late in 1907, are truly of the Cubist dynasty. The legendary, nameless canvas was later cavalierly dubbed "Les Demoiselles d'Avignon." Its facial dislocations—the first appearance of this technique in modern art—have sporadically appeared in Picasso's work ever since, and, through him, the potent dynamics of this canvas have influenced modern artists and painting generally. Two years before these Braque and Picasso creations, Matisse, at the Salon d'Automne, had led the first group show of the Fauves, including Derain, Vlaminck, van Dongen and Rouault (Braque did not join them until 1907), in the historic, short-lived Wild Beast movement that used colors plastically as a version of form—magnificently brilliant colors, whose unmixed purities struck Parisians as uncivilized and comic.

Behind these three bold, fresh creators stood at least forty years of violent rupture in taste. A kind of class war was being waged between the great late-nineteenth-century avant-garde painters of France and the great French bourgeoisie of the rich Third Republic. On the one side were the average citizens, who thought Parisian Victorianism was up-to-date art—especially the Salon des Beaux-Arts' dainty, well-painted nudes—and on the other was that long line of superior painters who, starting with the Impressionists and continuing with the Post-Impressionists, had gone on, through younger blood, to become Divisionists, Pointillists, Neo-Impressionists, Nabis and Expressionists, fighting the public with

color on canvas, and fighting each other, too, as one theory faded or lost shape or advanced into another theory in the rush of fecund genius and vitality that inexplicably animated and hurried these artists, already ahead of their time, pushing them forward, and eventually depositing their names and paintings in museums all over the world. Impressionism, and particularly Monet's poetic, atmospheric version of it, was stale and *démodé* to these younger painters, who thought it shapeless, facile and unsatisfying. It was as rebels against Impressionism that Braque, Picasso and Matisse, each in his own way, suddenly arrived at inventing twentieth-century art.

Actually, Braque had missed knowing anything about the sensational imbroglio over Caillebotte's will, for when he was only eight years old, his father, hoping for bigger business opportunities, had moved the family away from the neighborhood of Paris and its picture gossip to Le Havre. There he set up his own house-painting firm and indeed prospered. When young Braque was twelve and a student at the *lycée*, his father gave him his first bicycle, a notable adolescent event in those unextravagant days, and after saving his own sous, Georges bought his first box of paints. At the *lycée*, he was poor at books, and in his mid-teens he began attending night classes at Le Havre's Ecole des Beaux-Arts—making charcoal drawings from plaster casts and copying respectable oil paintings. Though his heart was in his work, dull as it was, he showed no aptitude for becoming a painter—at least not along those lines. He saw Toulouse-Lautrec's posters and he copied them. "Never did I learn so much as then," he has always said, with satisfaction. He took flute lessons from an older brother of Raoul Dufy, the only Le Havre boy of his acquaintance who was also trying to paint. His father gave him a small sailboat, and he sailed alone in the harbor and on the river reaches, developing his taste for looking at colors and forms, and for shunning crowds, which, as compositions, always failed to catch his eye. When he reached seventeen, he decided he

could not face the *lycée's* difficult baccalaureate examinations, and quit school. There seemed to be nothing for him to do but follow the family routine and learn house painting and its sidelines, which then extended from painted imitations of woodwork to fancy wall-paper appliqués—a great good fortune, as it turned out, for him and for contemporary French art, because these sidelines, brought like packages from his trade, gave contemporary French art its initial distinguishing decorative elements.

In 1900, at eighteen, Braque became liable for military service, then a lengthy three years that all sensible French families tried to help their sons reduce when possible. He was not called up at once, and his family began surveying the possibilities. Military service could be cut to one year for certain individuals, such as young qualified artists, examined and certified by the Ecole des Beaux-Arts, but Braque's poor performance at the Havre institution gave no hope for this. The reduction was also granted to certified artist-craftsmen, but for this qualification the Braques thought that their son's single year of apprenticeship—he had been handed over to one of his father's former employees in Le Havre, a man named Roney—was not good enough. So they sent him off to Paris on a bicycle, which was his idea of the way to travel, to continue his apprenticeship with another former Braque employee, named Laberthe, who was doing well in the capital. Nineteen-hundred was also the year that Picasso, a few months Braque's senior, came to Paris, also with parental permission. It was, moreover, the year of the Paris Universal Exhibition, which was of wondrous ocular excitement to any art-minded provincial youth but in addition marked a peak in the egregious bad taste running riot in French middle-class homes, perfectly served by house-painter decorators like Laberthe and the Braques, who were carefully trained to produce excellent painted imitations of the richer bad taste in the wealthy bourgeois establishments. In this second year of apprentice-ship, Braque learned to create inexpensively with his brush the costly effects of polychrome marble, mosaics, masonry and cornices, and to paint imitation rosewood or oak panels, false parquetry, ersatz

beams, bogus gilt dadoes with flashing, angled perspectives, and other simulations—all demanding patience, expert manual skill, creative manipulation and impeccable workmanship. These were the house-decorator elements that Braque later incorporated into Cubism and that he continued to use in his paintings, with unfailing elegance of style, throughout much of his career.

Naturally, he won his artist-craftsman's certificate without difficulty. During his single year of military service, he not only was made a noncommissioned officer but was even stationed near Le Havre, close to home. The ease with which his life and career were to unroll had begun. *"Je n'ai jamais imposé ma volonté dans toute ma vie,"* he has repeatedly said, with a kind of mixed pride and personal philosophy, meaning that he has never insisted on having things his own way but, instead, has wisely let events carry him. Everything that he was to have and develop eventually came to him without his lifting a finger, except to paint. When his military service was over and he announced to his family that he was going to be an artist, there was no parental outcry. In 1902, the Braques sensibly sent him back to Paris with a small allowance, to study painting. "He always had a beefsteak in his stomach and some money in his pocket," an old friend said recently, still envious. Braque was never to be a spendthrift with his money—not even on himself, let alone on others. He rented a classically cheap room in Montmartre. He attended classes at the conservative local Académie Humbert, where the director at least tried to teach his pupils nothing, letting them all paint as they chose, and where Braque met his first two artists, Marie Laurencin and Francis Picabia. Soon he decided to give the severe Ecole des Beaux-Arts a trial, and was accepted in the atelier of the then popular Léon Bonnat, but could not stand the dead academic air or the students' pranks, and left. In the autumn of 1904, still working alone, he took a Montmartre studio and occasionally hired models. He studied art by looking at it in the Louvre. At first, Corot was his favorite painter (which must have pleased his father), and he greatly admired Poussin. Braque decided at the time, and still maintains, that the painting

of the Italian Renaissance was decadent—"a period of dispersion and grandiloquence," he calls it, a mere *mise en scène* of decoration. In one way, he showed a sure instinct for his own future development: the Louvre sculptures that excited him were the primitives, the Egyptians and the archaic Greeks. Yet the Louvre painter he most frequently copied was Raphael. His first copies were quite accurate. Then they began to show deformations. Curious as to what was happening to his eye, he made copies of paintings by Corot and van Gogh. The same phenomenon of deformation occurred; he could not copy accurately any more. He decided he could not learn to paint from others but could learn only by painting in his own manner, which still showed oddly little individuality in form or color sense. His general aim in style was Impressionism, then a contagion in the Montmartre air. He had seen his first Impressionist canvases in the shop of Ambroise Vollard. Braque liked Monet, Renoir, Sisley, Pissarro and Seurat and his dot-painting followers, did not like Degas or Gauguin, and was much affected by van Gogh, long dead but now being appreciated at last. As for Vollard's Cézannes, Braque did not even notice them. The first Cézannes he saw, and knew he saw, and was immediately impressed by, were the two in the Caillebotte Collection at the Luxembourg.

It was the Fauves' revolution that gave Braque his first new orientation, pulling him from the nineteenth century into the twentieth, where color took its own pure directions, carrying modern painting forward into new extensions and wildernesses that became historic. "The Fauve painting was a highly enthusiastic kind of painting, a physical kind of painting, that suited my age," he later recollected. "I was twenty-three and had never liked the romantic style." During the summer of 1905, Matisse and Derain had painted together at Collioure, on the Mediterranean, where brilliant colors abounded in the heat, and it was the canvases they created there that helped make the Fauves' opening show so scandalous to the public and so informative, as a violent shock, to Braque when he saw it at the Salon d'Automne. "Matisse and Derain opened the road for me,"

he has always said. Yet the half-dozen canvases he sent in the spring of 1906 to the Salon des Indépendants (where, for a small fee, anybody could exhibit) were again dull-toned, since he was now between two stools—off Impressionism but not yet onto anything else. That summer, he and Othon Friesz, already a confirmed Fauve, went off to Antwerp, and Braque's harbor scenes began showing style and unwonted crimson and purple patches. But he knew that what he needed was fierce, hot light, as if to hatch his own chrysalis. For this, in October of 1906, he made the first of his trips to L'Estaque—a sort of pacing off of the ground for his memorable visit of 1908. He must have known that Cézanne had painted there, but today, in recollection, he thinks that he chose L'Estaque simply for its convenient outdoor painting climate, its stimulating scenery and its remarkably cheap hotel. There, at the age of twenty-four, Braque's talent rushed forth, as if in relief, in adult, stylized landscape paintings that featured pale orange-colored and orange-shaped trees on delicately pink or mauve hills, and scarlet boats in the Estaque port, more temperate than the Wild Beasts' excessive colors but maturely in the Fauve technical manner, which he had now caught up with. He thought his L'Estaque paintings his first good work, sent six of them to the Fauve section of the Salon des Indépendants in the spring of 1907, and had his first success. All his pictures sold, at prices ranging from seventy-five to two hundred francs, one being bought by Wilhelm Uhde, the perspicacious German collector who had been the first professional in Paris to discover the worth of the Douanier Rousseau's paintings. At the Indépendants, in talking with Matisse, Derain, van Dongen and the others, Braque had his impressive introduction to his first painting group.

Braque was late. Actually, Fauvism was already dying, though it had much that others lived on afterward. It had discarded perspective, the sublime technical triumph of the Renaissance, which European painters had taken hundreds of years to arrive at and master, capturing the difficult law of distance as the eye condensed it and confining it, through foreshortening, within the frame of

a painted canvas. Along with perspective, the Fauves had perforce repudiated representational painting—the art of making a ripe peach, for example, by a depiction of volume and by illusionary chiaroscuro, really look like one, and one good enough to eat, if possible. The Fauves had also liberated themselves from imitating nature. They had been the first to discover and enjoy Negro sculpture, in which they found what one art expert called "unhackneyed aesthetic values involving the bold distortion of natural forms." Borrowing from Seurat's vivid palette, they had employed color as a psychological shock, and had gone beyond poor van Gogh in consciously using his mad black outlines. But the vehement Fauves, aiming at too many revolutions at once, had poured off most of their rebellion into violent color, which, to keep their theory going, led only to the need for colors even more violent, and this became an insoluble problem for everyone except Matisse, their chief. It was a year after the visitors' jeering uproar against Matisse that Braque's belated Fauve paintings enjoyed their success.

As the Fauves' theory sagged, their human relations became strained. One Wild Beast insulted another by calling him "a lion that feeds on grass." Derain, who, in hailing the splendor of pure color squeezed straight from the tubes, which he called "cartridges of dynamite," realized that the battle was lost. By midsummer of 1907, even the newcomer Braque understood that what he later described as "the Fauve paroxysm" could not last. "I noticed that the exultation which had at first filled me and which I had transferred to my paintings was not the same," he said recently. Everyone began decamping, and by the year's end the movement had practically perished. Fauvism was like a fiery-colored bridge that, the moment all the Wild Beasts were safely on the other side, burned up behind them. But it had afforded them an unforgettable, illuminating passage. Those who were able to were now free to paint things as they did not look, except in the painter's visual imagination.

By this time, Braque had been identified as a young avant-garde painter worth watching. He spent the autumn of 1907 at L'Estaque

again, painting Mediterranean scenes in some new, provocative, angular browns—a *mea culpa* for his Fauve excesses in pink and orange. Back in Paris, he was hunted up by Daniel-Henry Kahn-weiler, a brilliant, intellectual young German from a well-to-do Palatinate family of international financiers, who preferred collect-ing modern art and dealing in its uncertain values to fiscal infalli-bility. Kahnweiler had just opened a little picture gallery in the Rue Vignon, behind the Madeleine, and was starting what turned out to be his historic career in modern art as the backer and believer in those unpopular young painters who were to become the famed Ecole de Paris. He had already bought some brutal, Negroid-look-ing canvases of Picasso's, which even Vollard, usually a sagacious gambler, had refused, and a few Derains, van Dongens and Vla-mincks. He now bought some of Braque's peculiar, angled Medi-terranean landscapes, and shortly afterward he arranged to take his whole output. This was the first easy upward step on which Braque eventually rose to become a major, famous French painter.

Braque met Picasso in 1907, in a casual conjunction of two major talents. He was taken to Picasso's studio by the poet Guil-laume Apollinaire, whom he had seen at Kahnweiler's gallery. Braque now began frequenting the exuberant group of writers, poets and artists and their mistresses that gathered in a nimbus around the fulgurating Spaniard. Picasso had his studio in a Montmartre tenement—nicknamed the Bateau-Lavoir, because of its resemblance to a Seine laundry barge—in the Rue Ravignan. Others who lived there, off and on, were the impoverished poet Max Jacob, the struggling writers André Salmon and Pierre Mac Orlan (later the art critic and novelist, respectively) and the artists Juan Gris and van Dongen. Outside members of the Bateau-Lavoir coterie were young Marie Laurencin and, above all, Apollinaire, in love with her and soon to be in love with Cubism, for which he became the apostolic writer. They were all poor and dined on credit, when they could manage it, in the Retaurant Azon, down the street, where the neighborhood fiacre drivers ate. Picasso's

mistress of the period, the beautiful, well-fleshed and well-educated model Fernande Olivier (she had been trained as a schoolteacher), described the newcomer Braque in her memoir *Picasso et Ses Amis*, now a nostalgic relic, long out of print. "The powerful head of a white Negro, dark skin, black curly hair," Mlle. Olivier wrote, in her staccato style. "Often a conscious expression of brutality, of coarseness, in his voice and gestures." Now and then, there were grand champagne evenings in the apartment of the third noted German collector of that period, Richard Goetz, where a roast goose was customarily brought in on a wooden drawing board and carved by the artists—"with saws and hatchets," Mlle. Olivier reported, without further explanation. On one occasion, when the noisy party was finally breaking up, Braque fell downstairs, landing inside a flat whose tenant, in a nightcap, had just timidly opened the door to see what on earth was happening. The coterie often gathered at the Montmartre Café de l'Ermitage, where it had its own corner table, from which nobody listened to the excellent string orchestra because, according to Mlle. Olivier, "Braque liked only the accordion, Picasso the guitar. Mac Orlan liked the accordion, especially with a hunting horn."

As was inevitable for a young painter of talent in Paris then, Braque was invited to the Rue de Fleurus apartment of Miss Gertrude Stein. He went with Marie Laurencin and Henri-Pierre Roché, later the art expert who chose many of the paintings for the private John Quinn Collection, in New York. Braque was suspicious, and kept asking, "What do they want us here for?" As usual, to break the ice, the Steins gave the artists a pile of Japanese prints to look through. (A year or so afterward, Braque felt so at home that one evening he pulled out his little concertina, which he usually carried with him, and began to play, while Leo Stein obliged with an imitation of Isadora Duncan—who had just burst over Paris—in a dance he called "The Young Girl and Death.") After his prim first visit at the Steins', Braque and Roché finished up by making a night of it in Montmartre, and Roché woke the next noon in Braque's studio. There was nothing on the

walls except a sinister Negro mask (Negro art "opened a new horizon" for him, Braque has said)—the first Negro art Roché had ever seen and, in his unsteady state, a considerable shock to him. Miss Alice B. Toklas recently said that young Braque, in his picturesque, colorful workman's clothes, reminded her so much of an American cowboy that she always had the impression he could understand English, and so was careful in what she talked about. He also made Picasso and Apollinaire think of the Wild West. They called him *"notre pard,"* a term they had picked up from American adventure stories they were fond of—*Les Histoires de Buffalo Bill,* in which Colonel Cody called a friend "my pard." (In 1911, Picasso did a Cubist painting he called "Buffalo Bill.")

Miss Stein, who had her own ideas about what constituted art, thought of Braque not as a painter, she later said, but as a minor poet with musical rhythm who was able to put these qualities into paint. She bought only two Braques, both after the First World War, and soon traded them for somebody else. Of the earlier days, she once said to a friend, "Braque was tall and big and handsome. It was very handy, his being so tall. Without using a stepladder, he could hang pictures on the top row of my studio wall. He used to do a lot of physical culture with Guillaume Apollinaire." Apollinaire was fascinated by physical culture, then a novelty in France, and wanted to edit a magazine on it. Braque's physical culture took the form of boxing, which had just become popular in Paris. (In the art critic André Warnod's souvenirs of the Montmartre days, he recalls Braque as "a big fellow . . . with a neck like a bull . . . looked like a boxer.") He often sparred with an English professional whom he admired. There has long been a legend in Paris about a boxing match among the three giants of the group: the heavyweight Vlaminck; Derain, who was the tallest; and bull-necked Braque, who was the best. According to the legend, Braque successfully took both of them on, one after the other. The straight of it seems to be that it was not Vlaminck but Roché, six feet tall, who was one of the outsize fighters; he had been coached by Alfred Frueh, who was then studying art in Paris and later became a caricaturist in

America. The match was fought in somebody's Montmartre studio, and neither Roché, who fought first, nor Derain, who was taller and heavier than Braque and a pretty good man with the gloves, ever got inside Braque's defense. In art circles, Braque had a big reputation as a boxer. One night, the rumor spread around the Café du Dôme, in Montparnasse, that he was fighting that evening, under another name, in one of the preliminaries at the Cirque d'Hiver; half the artists on the café terrace hurried over to see, but it was a false alarm.

Tales about Braque's strength and prowess circulated like myths. Roché says that the first time he ever saw him was at the 1907 Bal des Quat'z Arts, which Braque was attending as an ex-Beaux-Arts man. He was attired as an almost naked Roman warrior, and was sitting near the bottom of a staircase with a beautiful girl dressed rather like a statue of Venus. At their feet was a huge decorated float that was being given its finishing touches for the *grande entrée* by some atelier students, who were being very discommoding to Braque and his companion. "If you don't stop bothering us, I'll tip that idiotic chariot of yours over," Braque said tranquilly.

"Just try it," one of the students jeered. "The thing weighs a ton."

Braque crawled under the middle of it, got down on all fours and unsuccessfully tried to raise it with his back. He hurried out from underneath, studied the situation a moment, then disappeared beneath the float again and succeeded in hoisting it a fraction. A crowd had formed, and there were shouts of "Yes, he can!" "No, he can't!" The harder Braque worked, the more interested he became, trying modifications of his attack. Moving under one side of the float and squatting on his hands and knees, he suddenly arched his back. The float began to tilt dangerously on two wheels, scattering the crowd to a safe distance, and the students began yelling "You win!" "Don't tip it over, you'll ruin it for the *grande entrée!*" "Let her down softly, softly!" This Braque did, with such controlled strength that the float settled back onto the dance floor without a shudder. It was a small herculean triumph, and it became the *clou* of the ball.

It was Apollinaire who, in the autumn of 1907, told Braque of the extraordinary painting of the Demoiselles d'Avignon that Picasso had been working on in various versions for nearly a year, and who took him to see it. According to Mlle. Olivier, who was present, Braque, though astounded, refused to be convinced by the picture's explosive, incendiary composition. He protested against its dynamic new style, especially in the two right-hand females, who seemed to have sunk back farthest into some primitive art eon—the pair of females that were proto-Cubist, though neither Braque nor Picasso knew the word, since Cubism had not yet been discovered, unless it was there in the studio. In Mlle. Olivier's memoir, she reported to posterity that Braque said to Picasso, "Despite your explanations, in this picture of yours it's as if you were trying to make us drink petrol to spit fire." Yet in December, Braque painted a "Large Nude," who in her harsh curves, angled bulk and entire manner was certainly a fattened second cousin to the bizarre Avignon family. But though he had grasped her revolutionary style, she was not what he was after, and he dropped her.

In the spring of 1908, he went back to L'Estaque, this time with Cézanne consciously on his mind. A signal event in the 1905 Salon d'Automne had been a room of ten paintings by Cézanne, but the earlier retrospective of van Gogh and his brilliant colors was still blinding most of the younger painters to the sober-toned Cézanne. Ten more Cézannes were shown in the Salon in 1906, the year he died, and then more than half a hundred in a memorial exhibition in 1907, which finally carried the delayed full burden of his difficult genius. Cézanne's cryptic maxim had just been published: "You must see in nature the cylinder, the sphere and the cone." Facing the Midi landscape that Cézanne had painted, Braque now brought his own eyes and gifts to bear, and, in his first frenzy of work, painted "The Road Near L'Estaque," with cones and cylinders and spheres penetrating his perspective of trees beside a bastioned country lane, the result being a beautiful rudimentary Cubist picture. (This historic canvas is now in the New York Museum of Modern Art.) Then, moving on to a fourth geometric shape,

which Cézanne had left unmentioned but which was to give form and name to the style he posthumously begot, Braque used cubes for his precedent-shattering "Houses at L'Estaque"—brown cubes floating among conical green trees. (This even more historic picture is now in Switzerland, in the Hermann Rupf Collection.) While there, he also painted the first Cubist still life, with musical instruments, which were later to become a feature of Cubism's repertory for everyone.

Meanwhile, back in Paris, Picasso, for whom Cézanne had also for some time been an overpowering consideration, was painting "Landscape with Figures" (still in his possession), which like Braque's L'Estaque roadside, was a Cézanne geometrical scene of trees in a conical glade—in this case, inhabited by two human beings of a new, cylindrical race. In stylistic meaning, the two pictures were similar—both of them rudimentarily and geometrically Cubist, both technically brilliant, both beautiful, both young and both Cézannesque—but one French and one Spanish, and in that respect very different. No connection existed between the two painters and the kinds of picture they were inventing in separate parts of France. Unbeknownst to each other, both young artists were moving with their paint and genius toward the materialization of something that was in the art air, something that only they were recording—the dizzying third dimension and the suspension of volumes in space, which was full Cubism, with its special levitation.

Braque, confident that he now had something important to show, submitted seven of his new L'Estaque paintings to the 1908 Salon d'Automne, the members of whose jury were modern painters themselves, this Salon having been founded precisely to give serious new art its chance. His paintings were refused. Each juror had the right to retrieve one refused picture, and two of them chose to save Braques, but he was so angry that he withdrew them all. In November, Kahnweiler gave him a first exhibition of twenty-seven canvases, including the seven rejections. It was also the first Cubist exhibition ever held, and therefore historic. Braque was by then so timid about his new paintings that he went only once to see his

show—at dusk, when there were no visitors left in the gallery. His new-style art was duly derided by Louis Vauxcelles, the Fauve-namer. Of Braque's Kahnweiler exhibition he wrote, "He is a very audacious young man. The misleading examples set him by Derain and Picasso have emboldened him. Perhaps he has been obsessed beyond measure by Cézanne's style and by recollections of static Egyptian art. He constructs deformed, metallic people that are terribly oversimplified. He is contemptuous of form, reducing everything—sites, figures and houses—to geometric schemes, to *cubes*." He italicized the last word to make the novelty clear, but he added indulgently, "Since he is working in good faith, let us not make fun of him. Let us wait and see."

Apollinaire wrote the catalogue preface for the Kahnweiler show, but in his admiration for Braque he said far less than the disdainful Vauxcelles to explain the Cubist L'Estaque series to the small, attentive public, unless there was something to be gleaned from his mysterious phrase "Braque's spirit has voluntarily provoked the twilight of reality," or from his summing up, "This painter is angelic." For nearly half a century, Apollinaire's essays on early Cubism were accepted as dogma, though Braque himself said not long ago that Apollinaire was so ignorant of art that "he couldn't tell a Rembrandt from a Rubens." However, he did very well indeed in retrospectively explaining Braque's "Large Nude." In the *Mercure de France,* several months after the Kahnweiler show, he stated illuminatingly, "He proceeds from a geometric a priori to which the entire field of his vision is submitted. . . . In front of his paintings of women, people have cried in horror, 'Hideous! Monstrous!' . . . Where we think we are about to be confronted with a feminine figure because the catalogue says 'Large Nude,' the artist has seen only the geometric harmonies that, for him, express all nature. . . . No one is less concerned than he with psychology, and I think a stone would be as moving to him as a face. He has created a personal alphabet, in which each letter has universal acceptance." In thinking back on the criticism in general that Cubism received almost fifty years ago, Braque recently said, "I can remember that our pictures

on the whole seemed at first merely to bewilder the critics, whereas
Impressionism, for instance, inspired a feeling of revolt, a desire to
tear the canvases to pieces."

Pushing on after his Kahnweiler exhibition, Braque did a big
"Port in Normandy" in a cubical storm, and the first of his almost
lifelong Cubist series of still lifes with fruit. These he exhibited in
the spring of 1909 at the Indépendants. His friend André Salmon
said they caused a sensation, which was putting it mildly. Vauxcelles
referred to these new Braque canvases as *"bizarreries cubiques"* and
as "Peruvian Cubism"—probably the first time the word "Cubism"
had appeared in print and certainly the only time this modern
French style was connected with Peru. Vauxcelles was a remarkable
Paris critic; everything he wrote was forgotten except his two great-
est misapprehensions, by which he furnished, as epithets, names
that became historic—Fauves and Cubism.

Braque's Indépendants canvases were the last he showed at any
Salon for thirteen years. Picasso had never shown in the Salons at
all. The press moved from its early bewilderment over Cubism to
open hostility. The public, though far less violent than on earlier
historic occasions, was comprehensibly unable to make head or
tail of this new art—for one thing, because it received mostly un-
sympathetic guidance from the newspaper and magazine art critics.
With the memory of the damage done by the hidebound bourgeoisie
and the contemptuous critics to the cause of the Fauves and, before
that, to the cause of the Impressionists (in both cases resulting in an
almost organized delay of aesthetic appreciation, of picture sales
and of humane prices, even for something too new), the Rue
Vignon group decided to stop showing in the Salons altogether and
to exhibit only at Kahnweiler's, in peace and quiet—to renounce
trying to show themselves in the ordinary way to Paris, and to let
that minute fraction of Paris that was interested come to look at
them instead. A few months ago, an American admirer asked Braque
how he explained the fact that the public, which at first had not
understood one iota of Cubism—or liked it, either—had grasped
enough of it within a decade to enjoy it, and even make it popular.

With prompt authority, he replied, "They never comprehended. They endured. That is the history of modern art. Modern art has seen the greatest changes, perhaps, that have taken place in the last four hundred years."

Looking back today on the fully developed beginnings of Cubism in 1909, one can see it as a pictorial preview—years in advance, and in stylized geometric terms—of the space-time continuum that the century later discussed as a commonplace of scientific and metaphysical thought. What Cubism was believed to be at the time is less clear. Braque and Picasso were able to paint it but not to explain it. At any rate, they seem never to have given out any definitions. As late as 1923, Picasso granted a Spanish friend an interview in which he said that Cubism was still generally not understood, adding, surprisingly, "Cubism is no different from any other school of painting," though he did say, more helpfully, that "it is an art dealing primarily with forms." In 1954, forty-five years after Vauxcelles faltered into naming the new style, Braque said, belatedly, that Cubism's main aim had been "the materialization of space, the research in space." Miss Toklas recently told a friend that one day around 1910, Miss Stein, with her hearty curiosity for explanations, asked Picasso to put Cubism into words, to which he replied, "You paint not what you see but what you know is there."

It was Kahnweiler who put down in writing the only authoritative firsthand account of the early intentions of Braque and Picasso. "Their ideas were no doubt clear in their minds," he wrote cautiously, "yet were mentioned in their conversations rarely and then only casually." By 1908, the general goal, he wrote, "seemed to be the representation of the three-dimensional and its position in space on a two-dimensional surface." Being a well-educated Nordic, he went on to explain that in their synthetic Cubism—or the synthesis of the object painted—they successfully followed the postulate of the German philosopher Immanuel Kant (this must have surprised Braque and Picasso) that synthesis itself is "putting together the various conceptions and comprehending variety in one perception."

Unfortunately, Kahnweiler's pointers were no help to Paris art lovers when they needed them most, for this information, too, came late. It was contained in his famous brochure "Der Weg zum Kubismus," which was not published until after the First World War, and then in Munich and in German.

Even today, most people who admire Cubism cannot define it, and amid all the enormous international literature on it and the complex explanations of it, there are few summations that are both evocative and explicit. One is by the New York Museum of Modern Art expert on Cubism, Alfred H. Barr, Jr., who says, in his 1946 volume, *Picasso: Fifty Years of His Art*, that in "Les Demoiselles d'Avignon" "the breaking up of natural forms, whether figures, still-life or drapery, into a semi-abstract all-over design of tilting shifting planes compressed into a shallow space is already Cubism . . . in a rudimentary stage, it is true." Analyzing what caused Cubism or helped bring it about, he says, further, that it was "nourished . . . in various ways by Cézanne, [the Douanier] Henri Rousseau . . . the critic Apollinaire, the dealer Kahnweiler, as well as by popular talk of time-space mathematics and metaphysics," though "Cubism was a matter primarily of sensibility, not science." Finally, in a tentative image that makes Cubism's simultaneity of vision clearest of all to most people today, after the discoveries of Einstein, he suggests of the Picasso head combining both profile and front face, with its implied fusion of temporal and spatial factors, that it "might indeed serve as a crude illustration of relativity."

What are called the heroic years of Cubism extended from 1907 to the outbreak of war in 1914, but its full function and development began only toward the end of 1909, allowing it a scant five years for all it was to do to art thereafter. In those five years, there emerged the two kinds, or methods, of Cubism, which look completely unalike, as museum-goers today know. First, there was what was called analytical Cubism, made of cubes, spheres and planes, often fractionalized, mostly monotone, tilting in space and containing barely discernible geometric likenesses to something or somebody—the original Cubism, which generally carried on through

1912. Second, there was synthetic Cubism, with no cubes left in it, a Cubism of mixed sections of colors, often as bright as artificial flowers, and frequently with some perfectly recognizable objects displayed, a Cubism that was more plane geometry than solid, tending to be perpendicular and often having flat upright surfaces, projecting into space at different levels. Both were startling at the time.

It was not until the summer of 1910 that the real, radical character of Cubism began to protrude from Braque's and Picasso's canvases. Subject matter—Picasso's girl with squarish breasts and with a mandolin, for instance, and Braque's earlier geometric château tower of La Roche-Guyon among treetops—was fully recognizable almost for the last time. By the end of the year, Braque was finishing his first masterly Cubist canvas of space analysis, "Still-Life with Violin and Pitcher" (a legendary picture, now in the Kunstmuseum in Basel). Today, it looks like a magical visionary presentation of balanced geometries, but it must have seemed formidable then, since in it he "broke" the violin's outline (as, thirty-five years later, he "broke" a billiard table). That is to say, he retained the violin's recognizable entity—its scroll, strings and curved bottom—but with its outline disjointed, or broken, at a certain point. The violin—and the pitcher behind it, too—were reassembled by him arbitrarily in Euclidean cubes and sectioned spheres against a background cascade of other cubes, producing an effect of immediate distance, of the surprise of space. As other Cubist masterpieces during 1910, a big year, Braque painted "Still-Life with Guitar," "Still-Life with Mirror," "Woman with a Mandolin" and "Still-Life with Piano," each of them astonishing, each beautiful as a composition, each more illegible than its predecessor, except to Cubism's few initiates—and even then mostly indescribable in words. "Braque thought about his subject deeply and then painted his invention of it," an old friend explained simply not long ago. These startling influential pictures that Braque and Picasso were creating seemed to mark the end of an ancient universe in art—the end of recognizable things and people—which modern art to this day, nearly fifty years later, has not fully rediscovered.

In these pivotal spring months of 1911 Cubism entered so esoteric a stage that it was called "hermetic" Cubism, and it was well named. Few people except the painters knew what their paintings signified. Braque, during his teens, when he was an apprentice with house-painting firms in Le Harve and Paris, had learned to draw letters and numbers, in case one of his firm's customers might want something as simple as a sign painted. He now started putting the alphabet and numerals into his art—with Picasso following suit —and these became an identifying characteristic of early Cubism, second only to its original cubes. The picture in which Braque first used letters and numbers, that spring of 1911, was "The Portuguese" (now in the Basel Kunstmuseum). It was named for a Portuguese guitar player he had heard in a Marseille bar the summer before. The picture displays an impressive pyramidal composition, presumably the guitarist, and in an upper corner, in capital letters, appears the word BAL, clearly taken by the painter from some printed advertisement for a local public dance; beneath it is an ampersand, which must have been included because Braque liked its shape, and below that are the figures "10, 40," which doubtless stand for ten francs forty centimes, a memorably high price for drinks at that time in a Mediterranean bar.

The innovation put random items of reality back into a way of painting that had become dehumanized. As obvious symbols of memory associations, these legible items also introduced an unexpected anecdotal quality into Cubism, from which any such reports on life had been ruthlessly removed. In using painted words, or parts of them, Cubism took on a local, communicative tone, with many of Braque's and Picasso's convases giving a kind of detached shorthand account of what the two painters had been seeing and where, and, in a way, how they lived. They lived inexpensive bohemian lives in Montmartre, taking their relaxation in corner cafés. Their subject matter now turned increasingly to café still lifes, featuring bottles with the names of the drinks spelled out or indicated by enough letters to identify them. One of Braque's café still lifes, now in the New York Museum of Modern Art, has the

word SODA printed on it. Another, titled "Rum Bottle," and now
in the collection of Mr. and Mrs. Joseph Pulitzer, Jr., of St. Louis,
has the word RHUM in its center. At one time or another, Braque
and Picasso painted pictures containing the words ALE, BASS and
VIEUX MARC, the last being one of their specialties, sometimes ap-
pearing only as MARC, or even as VIEUX, and occasionally as MARC
DE BOURG [OGNE]. Picasso did a picture called "Still-Life with a
Guitar," displaying at its top the letters ENNES, possibly to be read as
[H]ENNES[SY], the cognac, but perhaps standing for [R]ENNES, a
street cater-corner from the Café des Deux Magots, on which a
well-known curio dealer had his shop; it was at this shop that both
Braque and Picasso had bought Negro masks from the Congo. The
extravagant Picasso, who painted letters much less well than Braque,
never having been trained as a house painter, used far more of
them. In a rather prolix picture called "Scallop Shells," he used
twenty. He also painted one picture with Russian letters on it. In
their lettered canvases, both men repeatedly used *Le Journal*, their
favorite newspaper—pictorially, anyhow. At first they inserted its
name in full, and then in abbreviations, such as JOURN, JOUR, JOU
or even LEJO, all of which made it the Paris daily with the most
artistic unpaid publicity in newspaper history. Around 1912, they
featured varied smaller café iconography, such as playing cards,
drinking glasses, pipes, cigarettes and package of cigarette papers
or matches, with occasional dice—Cubism having taken what Picas-
so's Fernande Olivier observantly called "a more material form."
The young Spanish Cubist Juan Gris, who in following their sys-
tem of painting had included its paraphernalia, did a masterly café
still life called "The Siphon," perfectly recognizable by its beak-
shaped metal head, with glases of wine floating over and beside it.
What Toulouse-Lautrec, with his romanticism and veracity, had
done for the Montmartre dance halls, Braque and Picasso, with their
reportorial Cubist neo-realism, did in a new way for the corner
cafés, including trivia and truths that no serious European artists
had ever included before. These Cubist still lifes were painted in

a modern vulgate, rather than in the literary tradition that had influenced the previous French painters of the same scenes.

The use of musical instruments had become another Cubist trademark. It was Braque, a music lover, who had introduced them; Juan Gris said that guitars were for Braque what Madonnas had been for Italian primitive painters. Over the years, Braque and Picasso painted an evocative repertory of musical Cubist still lifes, with guitars, mandolins, violins, clarinets and lutes. (Braque even painted metronomes.) They painted sheet music, clefs, music bars, notes and violin scrolls and pegs, and they painted the words DUO, POLKA, CONCERT, RONDO, SONATE and VALSE. Rameau, Couperin and Bach were Braque's favorite composers then, and he played a very passable Bach on his accordion. One of his most renowned Cubist paintings is his 1912 "Homage to J. S. Bach," a monumental architectural composition suggesting the pipes of an organ with the outlines of a recumbent violin and bearing the name BACH, J. S. Around 1930, after figuring in various collections, this canvas came on the market again in Paris. The dealer and collector Henri-Pierre Roché, an old friend of Braque's, took it on loan to the painter's studio and said to him, "I want to buy a Braque that pleases me, but I want to buy one that pleases you, too." Braque unwrapped the picture, balanced it across a chair, drew up another chair a few paces away, sat down with his hands on his knees and said, "It's been a long time since I saw this one." He sat silent and immobile for about ten minutes, with his eyes traveling back and forth across the canvas, stopping in concentration and then ranging again while he steadily observed, explored, remembered, and revalued. Then he said calmly, "Ça va. It's all right. Buy it."

By 1911, Cubism had become a Paris movement among avant-garde artists whose names were to be well known in the future, though not necessarily as permanent Cubists. "One way or the other, either for or against, they were all agitated by it," Braque said many years later, with satisfaction, adding, "All except Matisse, who

was fifteen years older than we were, who had found his own truth for himself, and who altogether missed out on what we were doing." Even by 1910, the list of talented Paris artists practicing some kind of Cubism included Robert Delaunay, the first to paint it highly colored; Fernand Léger, whose Cubism soon became pipe-shaped and was inevitably called Tubism; André Derain; André Lhote; Francis Picabia; Marie Laurencin; Roger de la Fresnaye; Henri le Fauconnier; Jean Metzinger and Albert Gleizes, who became professional Cubists and were soon teaching the style; the Polish engraver Louis Marcoussis; the Russian sculptor Alexander Archipenko; and to a degree, the Rumanian sculptor Constantin Brancusi. Three brothers of the talented Duchamp family joined up: the painter Gaston, known and finally famous under the pseudonym of Jacques Villon; the sculptor Raymond, who called himself Duchamp-Villon; and the celebrated Marcel Duchamp himself, whose "Nude Descending a Staircase" was to be the Cubist scandal of the 1913 New York Armory Show. In the spring of 1911, these new followers of Cubism—but without the two originators, Picasso and Braque—held the first big, spectacular exhibition of the new art in a special room in the Salon des Indépendants. Three years before when Braque had been given a private showing by the German art dealer Daniel-Henry Kahnweiler—the first Cubist exhibition ever held—the Paris press had been bewildered. Now it was ferocious, the art critics being surer than ever that they knew more about art than the artists. The critic of *Le Journal*, which Braque and Picasso had been immortalizing, was especially violent, saying that Cubism's so-called novelty was nothing but a "return to primitive barbarism . . . to a degradation of the beauties of nature and life." After the 1911 Salon d'Automne, crowded with further Cubist works as proof of the movement's popularity, he fell back on prophecy in his review, writing, "May I avow that I do not believe in the future of Cubism? . . . It has said its last word, the swan song of pretentious impotence and self-satisfied ignorance."

But Cubism was much more potent than he thought; it was already penetrating other countries. In 1910, a pair of Picassos had

been shown at the Grafton Gallery, in London, where the critic
Roger Fry was their champion; an English Cubist movement, called
Vorticism, was soon fully under way. In 1911, Delaunay showed
in Munich with the Blue Rider group, led by Kandinsky, on
whom he had a big influence. In New York in the same year, the
first Cubism—again by Picasso—was shown by Stieglitz, in his
Photo Secession Gallery. (One of the first New York references to
Cubism appeared in a Paris note in the *Times* by Gelett Burgess,
the humorist who invented the Goops. He reported on Braque's
"weird productions," including "a woman with a balloon-shaped
stomach.") In Italy, the year before, Umberto Boccioni had
launched Cubism with the Futurism group. By 1912, pictures by
Braque and Picasso were also being shown in Munich with the
Kandinsky Blue Riders, and other Paris Cubism was on exhibition
with the Sonderbund coterie in Cologne and with the Moderne
Kunst painters in Amsterdam. Also by 1912, the Dutchman Piet
Mondrian and the Mexican Diego Rivera, both living in Paris, had
become Cubists. There was such a flood of Cubism in that year's
Salon d'Automne, in the Grand Palais, that an uncouth city coun-
cilor wrote to the Under-Secretary of State for Beaux-Arts, telling
him to go look, "and, Minister though you are, I hope you are as
sick at your stomach on leaving as lots of people I know." Cubism
was denounced in Parliament by a deputy, who declared that it was
intolerable for a national exhibition hall to display an art "so in-
artistic and antinational," and that if such odious sights were re-
peated, the Salon d'Automne's concession at the Grand Palais
should be revoked.

Looking back, years later, on this mushroom spread of the style
he had helped create, Braque was not very sympathetic, either.
"Neither Picasso nor I had anything to do with Gleizes and Metz-
inger and the others," he said. "Their idea was to systematize
Cubism. They started to lay down the law about how Cubism is
like this and not like that and so on. I was hardly the man to start
painting Braques in accordance with their rules. It was all intellectu-
alism. They merely cubified what they painted. To my mind, the

only one of them who conscientiously pursued his Cubist research was Juan Gris." Gris, Picasso, Léger and Braque were members of what became known as the Kahnweiler quartet of Cubists. They were in a privileged position. As a customary thing, their paintings could be seen only in Kahnweiler's gallery and they did not exhibit in the Salons—always a public risk in Paris for any new art form. The flower of the flock of avant-garde painters, they had Kahnweiler behind them, and behind him he had a few collectors who were regular buyers. One was the Swiss Hermann Rupf, whom Kahnweiler had known when they were both young bank clerks in Germany and who still has his magnificent modern-art collection in Bern. The first Frenchman to buy was the well-to-do young Paris financier Roger Dutilleul, who liked only small Cubist pictures, because he chose to live in a small flat. Another buyer was Vincenc Kramar, the Czech art historian. In 1908, the Russian millionaire merchant Sergei Shchukin began buying from Kahnweiler for his enormous collection, which by the First World War had become the world's largest and finest private or public assemblage of French art of the debut of the twentieth century; it is now in an attic of the Hermitage Museum, in Leningrad. Miss Alice Toklas, who knew Shchukin, recently said of him, "He was a rich Moscow gentleman who loved modern Paris art but didn't like it too modern. He preferred it to be a little stale—about three years old, by which time he'd grown used to it. Every year when he came to Paris and saw Picasso's latest work, he would moan, 'What a loss to France!' because every year he thought that Pablo was going too far and that the pictures were terrifying and unsalable. Then he would buy pictures he had thought a loss to France three years before, which made him and Pablo both very happy." He bought fifty pictures by Picasso, thirty-seven by Matisse, and only one by Braque, whom he did not fancy—an omission that unbalanced his collection as representative of the epoch.

In the summer of 1911, Picasso and his model, Fernande Olivier, and Braque and Braque's model, the pretty Marcelle Lapré, went for holiday painting to the village of Céret, down by the Pyrenees.

Braque took his accordion along, and Picasso painted a hermetic portrait of him that he called "Accordionist." (Instead of inscribing the title on the back of the picture, Picasso, as he often did, merely wrote the name of the town, and for years a subsequent owner of the picture enjoyed it as a Cubist landscape from around Céret.) The next summer, Picasso discovered the village of Sorgues, near Avignon, as a new place to paint, and urged Braque to join him there. Braque took a little house, called Villa Bel Air, with an attic big enough to use as a studio. In that year, he and Mlle. Lapré were married, and for the next sixteen years, except during his military service in the war, he and his wife returned to the villa for at least part of his annual summer painting. Once, he even rode down to Sorgues from Paris on his bicycle.

That first summer at Sorgues, he and Picasso were both coming to the end of their analytical Cubism, with its severities and sublimities. It had lasted only about three years. The stupid and prophetic art critic of Le Journal had been right, in a way, though he had been wrong about Cubism's impotence. In that brief time, it had profoundly affected the future of modern art. As a belated obituary of analytical and hermetic Cubism, the final, definitive explanatory words on it were appropriately spoken by Kahnweiler in a remarkable tape-recorded interview published in the first number of the new Paris art review L'Œil, in January, 1955. He said that it had obviously been revolutionary, "a profound break with the accepted habits of painting, in that what was being represented was not only one view of an object—of a bottle, for example—but a view from the side, from above, and from inside as well. In other words, an object was described in terms of what was known about it, and not only in terms of what could be seen of it." Furthermore, the artist painted several aspects of the object simultaneously—the theory of the space-time continuum—according to several angles of vision, and even projected onto it his own personal vision. Analytical Cubism entered the realms of psychology, and mnemonics, too, for, as Kahnweiler said, the artist "was also trying to represent his memory of the many different aspects that the object had assumed

for him." It was an attempt that, in complexity, had no precedent in the history of painting, and, in intention, incorporated many of the interests that society was later going to specialize in as the new spirit of our half century.

Braque and Picasso were generally finished with analytical Cubism in 1912. They carried on its remains, however, into lower, more popular fields. From their corner-café quasi-realities they had already started to progress even further into a serious use of the commonplace, which was one phase of the instinctive democratization of European modern art. They began simulating reality by pasting it on their pictures in what became known as *papiers-collés*, or collages, *colle* being the French word for paste. They pasted paper cutouts onto a Cubist painting or drawing as integral parts of the composition, or even made them the whole composition, and they used cutout squares or strips of all kinds of paper—newsprint, butcher's paper, plain paper, fancy paper, paper patterned in white, black and brown (and later bright-colored paper, since it was color that they were starved for). Once or twice, Picasso, who was the first to do collages, pasted gentlemen's visiting cards on his paintings as exceptionally thick patches of white, because new surface effects, with depth and tactile values, were what both men, in their different ways, were hunting. Braque and Picasso had no intention of being fantastic or humorous. They were impersonal and serious even about Picasso's calling cards.

As a temporary system, collage was a catalyst. During the first summer at Sorgues, Braque found in a shop in nearby Avignon some brown wallpaper that imitated wood-graining, and he later pasted it in simple decorative strips on a Cubist charcoal drawing. He had already been experimenting with paper, folding it to produce sculptured Cubist shapes that must have looked much like biplane flying machines, since Picasso addressed him in a note at the time as *"Mon vieux Vilbure"*—a phonetic reference to Wilbur Wright, then widely talked of in France. Guitars having always been irresistible to both men, Braque and Picasso now repeatedly

represented them, in part, by *papiers-collés* made from the wood-grained wallpaper. Then, in a tour de force of sheer fine painting, they both began doing imitations of imitations; they began painting simulations of papers that imitated reality, such as that wood-grained wallpaper and a marbleized paper they also favored—a perfect example being Braque's "Oval Still-Life (The Violin)," in the New York Museum of Modern Art. Metaphysically, in their conscientious efforts as modern artists to avoid painting reality itself, they could go no further.

Some French art experts now casuistically give almost social or political importance to the two painters' having elevated such a lowly ingredient as paper to a place in art. On the other hand, Alfred H. Barr, Jr., in his book *Picasso: Fifty Years of His Art*, sternly speaks his mind by saying, "Through collage, the Cubists . . . undermined the virtuosity, the academic dignity of painting. 'Look,' said Picasso and Braque arrogantly, 'we can make works of art out of the contents of waste baskets.' " This, in fact, is just about what they did. Their irrepressible genius for form, however, mostly produced compositional results, increasingly abstract, that spiritually excused the vulgar material. One thing seems certain. Their rich, multicolored second style of Cubism (which, in essentials and with variations, was to last Braque, off and on, for the rest of his major painting life) had begun to take its shape with their ephemeral pieces of pasted paper. This was synthetic Cubism. Juan Gris was the first to understand it, and gave it its name. In a study called "The Possibilities in Painting," published in 1924, he described the new process, according to his own experiences, as "a synthesis"—as the road that led from the abstract to the real, from the general to the particular. In an earlier article, he said that this new form of Cubism, compared to the other, was "what poetry is to prose." The new Cubism was explained as a synthesis of colored figurations of objects, seen in single perspective. What this meant, boiled down, was that synthetic Cubism's somewhat deformed objects were perfectly identifiable—that a child could have recognized

the *démodé* clay pipes, for instance, that Braque and Picasso both often featured. Anyhow, people did not need to understand it. They enjoyed it. It gave pleasure, was sensuous, colored, realistic in a new way, and decorative, and was often compositionally great. Its composition changed fairly constantly, but at first, at least, some version of the *papiers-collés* background shapes was usually in evidence, often graphically decorated with bits of pattern. It no longer contained cubes, its geometry by now being discreetly flattened and perpendicular, and its foreground being rich, ornamental and, finally, communicative. This was Cubism's last influential statement—an expressive, rhetorical style, beautifully phrased.

The remarkable human relationship that dominated Cubism between 1909, when it came into full fruition, and 1914—the vital period that has been called its heroic years—was the Braque-Picasso friendship. As a friendship, it was a strange conjunction of natural dissimilarity, of common ideas and of work, youth and shared genius. It is impossible now to know the full compass of that friendship, because it was destroyed so long ago and because neither man has ever publicly explained what ended it. Nor do their friends seem really to know. There is vague talk of a quarrel, which does not appear likely, since the two were together, as usual, up to the last minute before Braque went off to the war. Those of their friends who are now left in Paris think that the war itself probably killed it by bringing their epoch to an end. Today, since both Braque and Picasso are important, masterful old men in their seventies, who rarely see or talk of each other, the early intimacy is naturally not brought up by outsiders. There was a brief period in the mid-1930's when Picasso several times invited the Braques to dine on Spanish rice—when he even seemed to insist on seeing Braque again. And in recent years, too, Braque has made an occasional afternoon summer call on Picasso in his house in Vallauris, in the Midi. But the friendship has been broken like a piece of pottery, beyond repair. Whenever either Braque or Picasso does happen

to speak of the other, he speaks of him as if he had died at the end of those youthful days, instead of producing pictures ever since. The inexplicable exception to the usual silence on their long relationship was a touching reference made by Braque himself in an interview published in 1954 in the Paris *Cahiers d'Art*. What Braque said had a deep reminiscent echo. "At that time," he recalled, referring to *les années héroïques,* "I was very close to Picasso. Despite the great difference in our temperaments, we were guided by a common idea. As our work made clear, Picasso is Spanish and I am French; anybody could appreciate the difference that this involves, but during those years the difference didn't count. We lived in Montmartre, we saw each other every day, we talked. During those years, we said things that nobody will say again, things that nobody would understand any more, things that would be incomprehensible and that gave us enormous pleasure and that will end with us. . . . If Picasso and I hadn't met, would Cubism have been what it was? I don't think so. Even poetry is circumstantial— and how much truer that is of life itself. . . . You know, when I was so close to Picasso, there was a time when we could hardly tell our pictures apart. Later, when they revealed what went deeper, the differences appeared. . . . At that age, ideas counted a great deal with me. In my judgment then, the personality of the painter was not supposed to intrude, and, in consequence, paintings should be anonymous. I was the one who came to the conclusion that paintings should not be signed, and for a while Picasso didn't sign either. Since we were both doing the same thing, I thought that there was no difference in the paintings and that there was no need for them to be signed. Afterward, I understood that this was not true, and I started signing my canvases again. Picasso, too. I understood that without the tics—without the palpable traces of the individual—the individual could never reveal himself."

One day after the First World War, in the Paris mansion of the couturier Jacques Doucet, who had a fine collection of contemporary art, somebody saw Picasso staring in puzzlement at a picture;

he was sure it was one of his own, he said, yet he could not identify it. Suddenly he turned it over and looked at the back; it was signed by Braque.

During this long, famous friendship, with its fecundity in art and its differences of creative and adaptive temperament, Picasso, in a half-humorous domestic metaphor that became legendary in Paris, used to refer to Braque as "my wife," Braque's painting being more tender in line, his colors less harsh and more sedate, his character more conservative, his art more serene. Once the friendship was over, the only reference to it Picasso was known to make, which also became a legend, was his cryptic recollection of the day he saw Braque and Derain off to war. "At the time of the mobilization, I accompanied them to the railway station at Avignon," he said, and added, "I never found them again."

In the early days of Cubism, which the friendship helped to form, the relationship had, paradoxically, been destructive to Braque's reputation as an artist. Other artists took it for granted that his values derived from Picasso. "The better half of Braque is Picasso," one of them said. Because of Picasso's dynamic, dominant personality and fulgurant accomplishments, Braque was relegated to the shadow that Picasso's brilliance cast. Kahnweiler recently said that among the few hundred people in the Western world who early heard of the new art, the general tendency was to identify Cubism with the figure of Picasso—that Braque was considered an imitator, though Picasso always stoutly defended him, invariably saying, in one way or another, "Not at all, he is absolutely authentic, and his painting is his own." This popular misconception, held even by Braque's own artist friends, continued until Braque's personal, independent creations, contributions and speculations became so apparent, around 1912, that his work was revalued in terms of its own authenticity, and he was given his due identity as what Kahnweiler, from the beginning, had said he was—one of the two artists who were "the great founders of Cubism." But the prices paid for his pictures were still overshadowed by the prices paid for Picasso's, and they have remained so over the years. Picasso excited buyers,

and sold better than anyone else. His 1912 contract with Kahnweiler gave him three thousand francs (at that time six hundred dollars) for a large canvas; Braque's contract with Kahnweiler gave him four hundred francs for a painting the same size. It was only their Cubist ideas that were parallel.

Braque entered the war in September, 1914, as a sergeant in the infantry, and in December he was commissioned a lieutenant. On May 11, 1915, he was wounded in the head in the battle of Neuville-Saint-Vaast, in the Artois sector, was left for dead, was found the next day by stretcher-bearers, and was trepanned in a field hospital at Carency. He came back to consciousness on his birthday, May 13—"as if I had been given a second life," he later said. He received the Croix de Guerre and was made a chevalier of the Légion d'Honneur. In June, he was sent to Paris for hospitalization. Juan Gris visited him, and wrote to Kahnweiler that he was still in serious danger; his eyesight had been affected and he was temporarily blind. In April, 1916, he was sent back to his regiment, but was invalided out and returned to Paris, where he and his wife started to wait out the war in a modest flat in Montmartre, in the Rue Simon-Dereure.

Miss Gertrude Stein later said that 1914 marked the end of an epoch even before the war began, and that the war only made the ending official. The aesthetic unities of the Kahnweiler quartet had already run their complete course. Then the war scattered the group itself. As Spanish nationals, Picasso and Juan Gris were noncombatants, and alone continued in their existence as artists. Gris was now the invalid Braque's only contact with what had been their small, private Cubist world. Kahnweiler, being a German, had been forced to settle in Switzerland, and his gallery in the Rue Vignon was shut. The Cubist painter Léger was in the artillery; the Cubist poet Apollinaire, though a Polish subject, was a volunteer in the French Army. Even Cubism itself was in the Army, as camouflage. A well-known French academic painter, Guirand de Scevola, had been put in charge of this new department of art in military affairs,

and upon his utilizing Cubism as its basis, the old journalistic hatred of the new art form sprang up again, with a wartime twist. De Scevola was criticized by the press for using crackpot Germanophile painters in France's defense—a slanted reference to Kahnweiler. In his eventual explanation, de Scevola said maliciously, being anti-Cubist himself, "To deform totally the aspect of any object, I employed the means the Cubists had used to represent it, engaging in my section several painters who were competent, because of their very special way of looking at things, to denaturalize any form whatever."

After spending the summer of 1917 at Sorgues, the Braques returned to the old Montmartre studio, on the top floor of the Hotel Roma, in the Rue Caulaincourt, where he had lived when he worked with Picasso. With Kahnweiler's gallery closed, things were not easy in Paris for his former painters. During the last years of the war, Léonce Rosenberg, brother of the dealer Paul Rosenberg, had opened a gallery called L'Effort Moderne, in the Rue de La Baume, and purchased works by the Kahnweiler Cubists when they had no other market. Rosenberg bought some Picassos and some Braques. They were a risk. He could not be sure how such semi-abstract painting would be received by people after the horrors of the first mechanized war. It was Rosenberg who, in 1919, gave the initial postwar exhibition of Braque's new paintings. It opened in March, only a few months after the armistice, in the early euphoria of peace and of hunger for aesthetic stimulation. For the first time in his life, Braque had an outstanding success—though with a recherché public, it is true. Gertrude Stein said to him, "You're very near glory." He answered, "Well, you know how it is. You are convinced about your work. Then a bell rings—a bell whose ringing you can't either advance or delay. That's the way you know you've arrived."

In 1919, Braque turned out some bad as well as some good pictures, the bad ones being loosely painted. "I have seen some recent works of Braque's that I find soft and lacking in precision," complained Juan Gris, the youngest of the original Cubist quartet and the only one to remain strictly Cubist to the end, which in his

case was his untimely death, in 1927. "He is moving toward Impressionism," he added with melancholy, as if that were the Cubists' hell.

Kahnweiler returned to Paris in 1920, and Braque once again made him his merchant. But Kahnweiler was in an unhappy financial position. Since he was an enemy alien, his collection of close to a thousand pictures that he had bought from his Rue Vignon gallery artists—his whole stock in trade—had naturally been seized by the French government at the outbreak of war. In June, 1921, the government, acting through l'Administration des Domaines, held its first sale of these canvases—about 150 of them, by Braque, Picasso, Gris, Léger, Derain, van Dongen and Vlaminck, among others—at the Hôtel Drouot auction rooms. Kahnweiler scrupulously, if vainly, advised the officials that their government would make more money on his former possessions if they did not flood the market and ruin prices. To make matters worse, Léonce Rosenberg, regarded as an inept businessman, had agreed to be the government art expert for the auction. Braque and the other painters for whom he had acted as dealer were outraged over his connection with this wholesale auction, which was bound to drive down the value of their prewar work. The afternoon before the sale, the pictures were put on public view at the Hôtel Drouot, and attracted a small crowd of collectors and the artists' friends, as well as a number of the gloomy artists themselves. Even Matisse was present—merely out of professional solidarity, since he had no pictures involved, not being a Kahnweiler artist. Miss Stein and Miss Toklas also attended but arrived late and missed the big scene by a minute or so. But Matisse, Miss Toklas remembers, immediately put them *au courant*. He said that Braque had started arguing angrily with Rosenberg, with Matisse himself joining in and saying, "The artistic patrimony of France should be upheld, not robbed." At this point, Braque hit Rosenberg on the nose. In the excitement, someone called the police, and both men were taken to the police station to cool off, but they were back within the hour, Braque still in a rage. As for the picture prices next day,

though they were lower than they should have been, they were at least higher than they had been for the same big pictures before the war. Braque's first large Cubist canvas, "Still-Life with Violin and Pitcher," fetched 3,200 francs, or $237, but his small canvases went for as little as 230 francs, or $17.

There were finally four of these historically famous Kahnweiler sales in all, and they completed the havoc in the prices of the pictures done in the heroic years of Cubism. At the third auction, in 1922, Braque's big "Still-Life with Guitar" brought only 1,600 francs, and small pictures sold for as low as 100. According to Kahnweiler's catalogue, which he marked during the sale, Braque's average price for a big canvas was 880 francs, or $71, and for a small one 150 francs, or $12. French art merchants disdained the sales, for the last time mistakenly ignoring the existence of Cubism. Kahnweiler, of course, was the one exception, but he had so little money that he could by only a handful of his own former canvases, whose seizure had precisely put him in his nearly penniless position. The new buyers were all almost equally unprosperous. They were avant-garde young writers and poets, among them Kahnweiler's brother-in-law, the poet Michel Leiris; Tristan Tzara, who had founded Dada; and André Breton, who in 1924 was going to found Surrealism. Louis Aragon, who would later found the Communist party's intellectual wing, bought Braque's Cubistic "Large Nude" for the equivalent of a few dollars. (It seems worth noting here that last spring a Texas millionairess was offering $30,000 in New York's art circles for a big analytical-Cubist Braque but was unable to lay hands on one.) The foundation pieces of most important private Cubist collections today—especially the English and American ones—and many fine American museum items passed through the pell-mell Drouot sales, at which, unfortunately, the French government did indeed help rob the artistic patrimony of France.

In 1922, Braque was invited to exhibit at the Salon d'Automne, which had refused his pictures fourteen years before. It must have

been solacing revenge; he sent fourteen of his recent paintings, and they all sold. He also had his first success with the ordinary French public. This time, the bell rang not among the intelligentsia in the Rue de La Baume but in the Grand Palais, visited by thousands of average Parisian citizens. It was a new, postwar world with a new, postwar art, which they now recognized when they saw it. Within one year the tide had started to turn. The new art had already been discerned by the members of an exceptional, aristocratic new smart set in Paris, with avid and intelligent fresh tastes, led largely by Comte Etienne de Beaumont. Their private, eclectic appreciation of modern art soon helped launch it internationally, as this smart set itself was boosted to snobbish influence in the unexpected postwar wave of Francophilia and in the opening influx of American tourism and of big money, which made Paris the aesthetic and hedonistic capital of a transatlantic world,with its taste influencing London, New York and points west. Another Paris focal point was the Ballets Russes of Serge Diaghilev, with their aristocratic revolution, which featured *le moderne* generally—the modern artists who became Diaghilev's scene painters and his costume designers, the composers (among them Milhaud, Auric and Poulenc, of Les Six) who wrote his ballet music, and the poets who furnished his ballet themes. It was a revolution that was the talk of the transatlantic world. Picasso had naturally led the way, having created during the war the décor and costumes for *Parade,* a burlesque ballet with music by Erik Satie on a theme by the scintillating Jean Cocteau.

Picasso and various other artists had worked for the Ballets Russes since the last years of the war, but Braque was not invited to join them until 1923. At the end of that year, Braque went to Monte Carlo, the ballet company's official residence, equipped for the social rigors with his first derby hat. There he supervised the completion of his sets, costumes and curtain for the ballet *Les Fâcheux* with music by Auric and choreography by Mme. Nijinska. Braque's contributions having made *Les Fâcheux* one of the popular art productions of the repertory, Diaghilev commissioned him to do *Zéphyr et Flore,* and then ordered a fresh décor for *Les Sylphides.*

Unluckily, he was so pleased with the sketch Braque scrawled ("on a scrap of paper on my knee," he later said), which was a mere suggestion of what Braque meant to paint, that without further consulting the artist he had the scrap made up as an official Braque set. To prevent its use, Braque had it seized by the police. (Other artists also had difficulties with Diaghilev. Juan Gris said, "Diaghilev was an elephant who crushed you so gently you did not know you were dying.") Braque's final ballet creation was *Salade*, commissioned by the Comte de Beaumont in 1924 as part of the seignioral magnificence of taste that marked his *Soirées de Paris* productions, still remembered as unique in Paris theater history. None of this was Braque's world. Behind the scenes, he felt no fraternity with the polyglot dancers, either as workers or as creators, and he sensed even less relationship with the glittering spectators who applauded their artistry and his. His paintings eventually became almost as fashionable as Picasso's, but, unlike Picasso, Braque never became a fashionable personality. Provincial, serious, unworldly, he remained in his studio, painting pictures that entered salons where he himself never set foot.

In the three years, from 1920 to 1923, that Kahnweiler acted as Braque's merchant again, he could pay him only 7,800 francs for a large picture. So in 1924, Braque went to Paul Rosenberg—Léonce's younger brother and far cleverer at business—who offered him much higher prices for his paintings. He had already grown prosperous enough to leave bohemian Montmartre, now become a champagne night-club center, and join the painters who had moved across Paris to Montparnasse, which thereupon immediately developed cheap night clubs. Braque chose the quiet, bourgeois Parc de Montsouris neighborhood, just beyond Montparnasse, where Derain had taken a studio. Here, in 1924, Braque built a house which he designed himself and in which he still lives and paints. It is a sturdy cement-and-brick affair, with his studio on the third floor, and it stands on a silent, dead-end residential street opening off the park. Derain, whose prosperity had come earlier, bought himself a Bugatti racing car. Now Braque bought an Alfa

Romeo, which he drove fast and well—the first of a long series of powerful, expensive motorcars. Being typically French, he was never interested in foreign travel. He went to Italy once, which sufficed. He often drove down to the Riviera—the part of France that had always attracted him, as a northerner. One summer he rented a place in Cassis, and another summer he visited a friend who had a house there. A boatman who made a living by rowing summer visitors offshore in his dory one day asked Braque's advice about how he should repaint his boat to attract customers. Braque suggested simulated black-and-white marble as a striking effect for a boat, and painted it for him. It was a great success, and frequently summer visitors took snapshots of each other in it, for fear that friends back home might think they had made it up.

Braque was forty-two years old when his contract with Paul Rosenberg began assuring him enough money to prove that he had finally and fully arrived. He had arrived, it is true, without anguish or worry, yet certainly without haste. His equally untroubled future career of color, fame and increasing riches lay before him. Now in his seventies, he is regarded as the greatest living master of French painting. (Picasso is always considered a Spanish painter.) The French speak about him differently from the way they speak about any other painter. They speak of his paintings in terms of what they consider his Gallic essences—his sensuousness, his economy in putting his pictures into focus, his infinitely civilized feeling for color and the refinement of line. He has a direct gift for painting, they say. They speak of his measured imagination, by means of which he is able to translate the rich experience of his physical eye into style, and of the ordered grace of pure composition that his serene mind proposes and that he paints with care and knowledge and an inspired hand, all inherited from France's long tradition of great and reasonable painters. He has represented two professions esteemed and revered, respectively, by the French as contributors to their civilization. He has been artisan and he has been artist; he has been worker and he has been genius. Compared to the liber-

tarian abstract paintings of today and to what he himself hermeti-
cally painted in the Cubist discipline when he was young, his
modest deformation of his subject matter over the years has come
to seem to the French merely the masterly signature of his indi-
vidualism, the proof of his meditative effort to control color and
form in one of the major styles of his time—which he, after all,
helped to create. The French also speak with respect of what they
call his aesthetic morality, and of what he himself has spoken of
as "the painter's necessity for conscience and for loyalty to his
material and to himself, to avoid the deterioration of his painting,"
adding, "Good painting is very difficult." For the French, his ulti-
mate popularity comes from his modest bourgeois devotion to the
homely objects of everyday life as being duly suited to art—that
magic domestic world of familiar inanimate objects to which he
has given his major affections. In his art, he has mainly concen-
trated on two rooms—the dining room and the parlor, both French
favorites—which for almost forty years he has furnished, through
his imagination, in hundreds of ways, with a supply of inanimate
objects, in part edible, and with various backgrounds. He has
painted compote dishes, figs, plums, peaches, apples, bunches of
grapes, fish, leeks and fried eggs. He had a period of painting
mussels and plates of opened oysters—their inner pearl hue, their
bivalve gray and their dark outer shell having fascinated him for
years as color contrasts—with a lemon ready at the side as a dash
of yellow. He has painted a toilet table, with hairbrush, soap dish
and bath sponge. He has painted anemones—French painters' in-
expensive preference for bouquets—and sunflowers; he has painted
chairs, books, sugar bowls, cups, platters, spoons, breadbaskets,
bread, fruit knives, kitchen knives, plates, decanters, jugs, pitchers
and bowls, with an occasional guitar interspersed. For his parlor
scenes, he has repeatedly used tables from his own studio, in partic-
ular one that has become almost as familiar to art lovers as a piece
of furniture from their own homes—a bandy-legged, round-topped
pedestal table of the type called *guéridon*—piling it afresh for each
new composition with another artful arrangement of household

objects or strewing it with an exalted litter of sheet music, whose small black notes seem to rise up through space in a regular hosanna of pale color and form. In both parlor and dining-room scenes, he has purified the bad taste of the Braque family's professional-decorator reproductions of wallpaper and bogus dadoes by giving them an imposing neo-classical treatment, making them look like the angles and cornices of minor architecture seen in private perspective at close range. Over the years, his method of painting became more and more concentratedly French, until he was finally compared to Chardin, the supreme eighteenth-century painter of *natures-mortes*. In his divergence from Picasso, their ethnic difference added to the distance between them—the protean Picasso, resident Iberian anarchist of Paris art, and the native Gallic Braque, fulfilling even in quasi-Cubism the aesthetic tradition of his nation. One of the clichés in French art circles is "Picasso's genius astonishes; Braque's mastery satisfies."

Oddly enough for a Frenchman, Braque was already past forty when he painted his first series of female nudes. Apparently Mme. Braque served as his model—at least, the face with the broad, curling features is always her likeness—for a number of semi-draped, impassive antique figures with baskets of fruit or flowers, which he named "The Canephoroe," after the basket-carrying maidens in Demeter's processions. On Braque's canvas they became as depersonalized as caryatids. Late in the 1930's, he tried once again to paint the human form, in a series of modern female figures whose bodies were arbitrarily part black, part light, each thus becoming two figures, perhaps—one substance, one shadow. Himself physically a magnificent model of a man, he had little feeling for painting from a model. Around 1933, he rose to the technical peak of his midcareer, which established him in France as the greatest still-life painter of his time. A rare wave of color had washed his imagination with terra-cotta red, yellow and, especially, a radiant pink, colors he used for tablecloths in a truly extraordinary series of paintings that offered the controlled essence of his genius. The outstanding canvas of this period was "The Pink Tablecloth,"

refined to a perfection of color and line that could not be displaced by a hairbreadth without shifting the composition's place in art. One of the finest Braques in the United States, the picture is now in the collection of Walter P. Chrysler, Jr., of New York; its more elaborate companion piece, "The Yellow Tablecloth," which in 1937 won first prize at the Carnegie International Exhibition, in Pittsburgh, is in the Samuel Marx collection, in Chicago.

In 1931, the Braques began spending five months of the year, from June to November, in a new house he had built outside the village of Varengeville-sur-Mer, a few miles southwest of Dieppe, on the Normandy coast—in the sea air, under the uncertain pearly lights and mackerel skies that had furnished the climate of his late childhood and youth in Le Havre. He could be said to have come back home. The land he chose is a lonely high piece of ground with big oak trees. His architect had naturally proposed something modern in style—a flat-topped house with huge windows. Braque built a comfortable imitation of the typical Norman cottage, with a peaked roof of red tile instead of thatch, and small casemented windows to shut out the sea damp. Because this house by the sea is set far back, the inlet of the sea itself far below is invisible. The Cubists had been trained as indoor men, whose cult was painting objects and who rarely set brush to a landscape. Now Braque, descending to the ocean beneath him, began paintings that showed the little black boats tilted idly on the stippled stony beach, and the chalk cliffs washed by an oyster-colored sea—all exceptionally natural and dramatic for his style and temperament. These pictures are fairly small—as are the blackish seascapes he has lately been painting—owing to the problem of carting the finished canvases back to Paris by automobile.

The Braques were in their house in Varengeville in 1939 when the Second World War was declared. When the Germans broke through the Maginot Line, in the spring of 1940, Braque cleaned his brushes carefully, piled some major canvases in his car, and with his wife and Mariette Lachaud, formerly the Braques' young maid,

who had become his studio helper, managed to drive south to the
house of Mariette's parents, in the Limousin. They found a place
to hide Braque's paintings, went farther south, to the town of
Castillon, in the Pyrenees, and in the autumn, returned to their
house in Occupied Paris. German soldiers had entered his studio
and stolen his accordion, which he had not played for years, but
they had touched nothing else. Across the street, a large residence
was occupied by German officers. Braque remained in his house
for the duration to prevent its being occupied, too, and he was
not molested. He was allowed by the German authorities to hold
one exhibition during the Occupation, but he refused their invita-
tion—which some of his old painter friends mistakenly accepted—
to go to Germany and exhibit. He also refused a request to design
an emblem for Marshal Pétain's Vichy government. As the Occupa-
tion and its hardships went on, some of Braque's pictures showed
what was on his mind. In 1942, he painted "The Blue Washbasin,"
which indicated a lack of hot water in the bathroom, and later he
painted "Kitchen Still-Life," the kitchen being the place the ra-
tioned French thought of most often. After the Liberation, in the
bitter-cold winter of 1944-45, "The Stove"—a potbellied affair with
a coal scuttle—appeared. In 1945, Braque had an operation for a
serious stomach condition, which had been aggravated by war-
time food. In the spring of 1947, walking on the Varengeville cliffs,
he caught a cold that turned into pneumonia. The young painter
Nicolas de Staël, who had become his friend and had American
friends, managed to get him into the American Hospital in Neuilly,
outside Paris, where penicillin—otherwise almost unobtainable in
Paris—saved him, though the illness left him with a permanent
respiratory weakness. Almost ten years later, de Staël came to him
in desperation, asking if Braque's success, when it finally arrived,
had dismantled the previous shape of his life and ruined his paint-
ing, which de Staël felt was his own tragic case. Nothing had
changed his life, Braque told him, because he was a painter and had
continued painting as an answer to everything, even triumph, and
he begged the young man to use this as a truth. He felt that de

Staël's friendship had saved him when he was ill, but his philosophy could not save de Staël, who shortly afterward ended his life in Antibes—a grievous shock to old Braque.

In the summer of 1951, the Abbé in Varengeville asked Braque's advice about three projected stained-glass windows for the village Chapel of St. Dominique, newly sanctified in a splendid eighteenth-century Norman barn after the original chapel had been destroyed in the coastal fighting during the ill-fated Allied Commando raid on Dieppe. Braque offered to design the windows himself, which naturally was what the Abbé had in mind—as did Père Couturier, the modern-minded Dominican friar who was responsible for Matisse's decoration of the Vence chapel, for Léger's windows at Audincourt, and for the contributions of Lurçat and Rouault to the Assy church, and who had long had his eye on Braque for an important churchly art work. In his patient, studious, artisan way, since he knew nothing about colored glass and its light effects, Braque examined the problems and experimented with his designs for over two years, so it was the summer of 1954 before his windows were installed. The main lancet depicts St. Dominique with part of his habit rising above his shoulders, like dark-blue triangular wings, and what looks oddly like a Moslem red fez on his Castilian head; the two smaller lancets show red-and-blue designs on which is superimposed a twisting white rope, which the local Norman peasants regard as a white serpent. The windows radiate a pious, artistic effulgence above the sturdy old oak beams of the former barn. The Braque windows have become such a popular sight for summer visitors that nearby Ste. Marguerite, the historic Roman-esque medieval church perched high over the sea alongside its famous marine cemetery, with its complement of German dead— the Nazi soldiers killed in the Commando raid—has put up a sign over its poor box reading, "The windows by M. Braque are *not* here but in the Chapel of St. Dominique."

Braque lives not far from the chapel, on a shady lane that ends on an empty cliff top after it passes his hedged garden. His house looks like a prosperous, up-to-date Norman farmer's dwelling, with

yellow checked curtains and rampant beds of yellow flowers on the
lawn, which offers a perspective on the sea. Behind the house is
his modern glass studio, built in 1948 and unquestionably the most
carefully planned, efficient and luxurious—and clean and orderly
—of any of the painting quarters of the great artists in France. A
huge, high-ceilinged room, largely walled with opaque milky glass,
it is an elegant, functional shell, filled with extravagant working
conveniences installed by an artisan become a rich artist. It uncon-
ventionally faces south. (Braque says that the northern exposures
required by painters in the nineteenth century ceased to have value
when modern painting came along, since painters now paint not
from models but from memory or imagination, where the outer
light plays no part.) Inside, it has been organized into areas of
use. The largest is alloted to painting; others are given over to
preliminary drawing, to engraving and to water colors; and a final
area is devoted to relaxation, brooding, contemplating or talking.
These areas are set out like parts of a pictorial composition, with con-
centrations of color always furnished by bouquets of red and yellow
flowers, which are the ones Braque likes best, taken from his
cutting garden. All the studio materials are arranged for saving
the labor of hand and eye. Movable suspended louvers of brown
paper control the light for whatever canvas Braque is working on;
the heights of the various tables in the room have been calculated
to the veriest centimeter, according to their function; different
palettes, each with its own color harmonies, are arranged on small
shelves branching out like limbs from a tree trunk that Braque
has cobbled into a palette stand. Former tomato cans—little econo-
mies are part of his practicality—hang from his easel, each con-
taining enough paint, already mixed, for the picture's dominant
coloring, so there need be no interruptions for mixing and match-
ing. All these are the artisan touches of the house painter's ap-
prentice that Braque once was. His current notebook—the latest
in a series he has kept for over thirty years to jot down aphorisms,
philosophic notions, art definitions and, above all, sketches for new
compositions—stands handy on a lectern. For recumbence and

repose, he has an American contour couch. Behind the glass building are a sculpture studio and a carpenter shop, where, as a practical craftsman for whom manual training was the basis of art, he made his palette stands and his worktables. There is a garage for his motor scooter and his latest expensive car (now chauffeur-driven), which has custom Italian upholstery. The milk-glass studio is like the elegant directors' room of a unique one-man organization, consummately equipped with the costly luxuries of privacy, quiet, modern mechanics and utter efficiency—the pluperfect installation for producing painted art.

As his living quarters, his Norman villa offers agreeable charms in the constant pleasure to the eye of flawless compositions assembled from its furnishings; the exact placing, for instance, of a pewter teapot and colored plate on an antique Norman chest, behind which Spanish *fer forgé* curls against the walls, or table-top clusters of sea objects he has carried home from the beach (stones, starfish, a crab shell, a fragment of blue fishing net) become incipient still lifes as arranged by his hand. The living-room walls are of four shades of orange. He has Erik Satie's piano, which he bought after the death of the old composer, one of his first non-painter friends in the early Montmartre days, when Mme. Braque used to cook occasional succulent midday dinners for the two of them and they would spend half the afternoon at the table. Music is still a necessity to him. Daily at Varengeville, he plays selections from his big library of phonograph records, Buxtehude and Mozart being his favorites now—and Mme. Braque's, too, naturally. It has been an unusually successful marriage, friends say. For over forty years, she has tactfully managed, served, cosseted and protected him. Today, she looks like a portly Manet portrait, with her hair cut in a gray bang above her charming old-fashioned small features. She is gay-spirited and tells funny stories. They have no children.

Braque is a night reader. He prefers books on discoveries, voyages and philosophy, along with nonpolitical biographies and books of maxims. He has always liked to talk philosophy, and he

refers to himself as a Cartesian. His reading has produced book decorations, too. Long ago, a translation of that majestic curiosity Hesiod's *Theogony* fell into his hands. Hesiod's tedious classic on the genealogy of the gods, one of the oldest Greek poems extant, somehow fired his imagination, and in 1931 he accepted a commission from Ambroise Vollard to do a series of etchings for a new edition. He pictured the gods in a sensuously thin-lined neo-archaic style, adapted from the antiquities he had loved in the Louvre when young—those kirtled, fragmentary Greek figures, those strained equine heads, those nude Olympian scenes etched on Etruscan mirrors. He has said of himself, "I have a heavy hand for drawing. Whenever I start doing a drawing, it turns into a painting, with crosshatching, shadows and ornamentation." Yet it is this graphic weakness that gives his Hesiod etchings their strong plasticity and complicated charm. Vollard never got around to bringing the book out, but in 1954 it was published by the new Galerie Maeght, which sprang up in 1946. Shortly after the war, Braque came upon a copy of Professor Daisetz Suzuki's *Essais sur le Bouddhisme Zen*, originally published during the Occupation but rather lost to sight at the time, and his interest in that theosophy is reflected in the most recent book decorations he has done. The volume in which they appear is called *Milarepa—Magicien, Poète, Ermite, Tibétain*, contains brief extracts from the writings of this eleventh-century Tibetan mystic, was published by Maeght in 1950 in a limited edition of a hundred copies (now quoted at a hundred thousand francs apiece) and remains probably the most de luxe French bibliophile item that has been printed since the war. It is bound in parchment and has a loose-leaf format of "hand-made paper, dried in the air on a cord" (or so the title page states). Each leaf has a Braque-designed watermark containing the initial "G.B." and "A.M." (for Aimé Maeght). Braque's four etchings in the text (there is also a frontispiece) repeat a swanlike bird in flight, which he has lately used almost as a trade-mark, in four facets of the same composition. The first shows the bird in mere outline, with added inked surfaces seeming to change the creature's aspects until,

in the fourth version, it is darkly dramatic, the whole shifting conception being four states of brilliant *maîtrise* of artisanship.

In 1948, Braque won the first prize for foreign painting at the Venice Biennial Exhibition with his "Billiard Table," one of several in which he "broke" the table's outline—a problem he labored over for eight years, and to most art lovers a mystifying, unpopular deformation. It is now in the Paris Musée National d'Art Moderne, among fifteen of his works, five of them gifts, one made by him; the ten others were purchased after 1932—and therefore at stiff prices—by the French state. (The first Braque, which was also the first Cubist painting the unwilling state ever bought, was purchased in 1919 and immediately expedited to the museum in Strasbourg, the provinces always having been the place to get rid of art horrors the Paris museologists do not want.) Only two Braques in the Musée d'Art Moderne are from the heroic years of Cubism, of which the state once possessed so many examples that it threw them away for nearly nothing in the Drouot-Kahnweiler sales. Another important group of Braque paintings, eleven in number, is now in the Kunstmuseum, in Basel, eight of them a recent gift of the Swiss collector M. Raoul La Roche, who had previously kept his Braques in France, where he lives. Mr. Douglas Cooper, the British authority and writer on Braque's works, whose comprehensive collection of about two hundred modern paintings is now housed in his Château de Castille, near the Pont du Gard, specialized in the original Cubist quartet, and as choice items appeared during the 1930's—usually having passed through the Kahnweiler auctions—he picked them up, with the result that his Braque room now contains the finest selection of Braque's early works of any private collection in France, as well as of his most notable recent work. In the United States, the vast assemblage of modern art owned by Walter P. Chrysler, Jr. (it is so vast that the bulk of the pictures have been kept for years in a New York storage warehouse), doubtless contains a big and choice assortment of Braques. Two large Braque retrospective exhibitions

were organized after the war, the first held in 1949 in the Museum
of Modern Art in New York, which showed 114 items, including
certain of his sculptures, and the other in 1956, in connection with
the Edinburgh Festival, when 87 pieces were displayed in the
Royal Scottish Academy.

After the Second World War, Braque changed his art merchant
again, accepting the high-priced offer of the Galerie Maeght.
Today, a big new Braque there, suitable for museum use, is priced
at ten million francs, or around twenty-nine thousand dollars. His
paintings of twenty or thirty years ago are sometimes less dear, his
characteristic 1929 still life "Peaches" having lately been valued by a
London gallery at seven thousand pounds. However, one great
example of the early Cubist period, now reportedly for sale, is
estimated by the French owner as worth fifty thousand dollars on
the 1957 international art market. Braque has become rich from
his paintings, even though he paints slowly. It took him more
than a year to finish his most recent major canvas, and he finished
it, at a couple of brush strokes a day, during a period last summer
when the explosive Picasso was reported to have painted three
pictures in thirty-six hours.

Braque himself owns very few Braques, and those on his walls
are not necessarily of his best. He is not a collector. Of far more
consequence to him than his finished pictures are his sketches
for picture ideas, scrawled in his notebooks—cheap *carnets* of
square-ruled paper like the ones French school children use—
which he regards as such precious art possessions that he always
takes all of them along with him whenever he leaves home for any
length of time; he carried them with his canvases when he fled
before the Germans in 1940, and, more recently, he would not let
them even leave his studio to be photographed for Tériade, the
editor of *Verve*, who had long wanted to bring out selections from
them. Braque says his notebooks are like private cookbooks to
him; they contain the recipes of his imagination. He finally allowed
Tériade's photographer to do his work on the premises, and parts of
the notebooks appeared in the autumn of 1955 in a de luxe volume

called *Carnets Intimes de G. Braque* in the French edition. (Tériade also edited one in English.) The notebooks' colored pages have been reproduced in lithograph, and heliogravure for the black-and-white gives perfect verisimilitude to the original quadrangular-lined paper. Among the reproduced pages is one with the conceptual sketch of the windows of St. Dominique; one of portraits of Mme. Braque; one of versions of Braque's recently invented white bird, flying on blue (the same bird device, in reversed colors, is now a ceiling panel in the Salle Henri II of the Louvre); and—of most interest to laymen—several sketches for large compositions that have since become familiar museum pieces, which were already so established in his imagination that their coming colors, *jaune, bleu, rouge,* are pencilled in the margins.

The Rue Douanier, where Braque has lived for more than thirty years in his white square cement house, is one of several short residential cul-de-sacs leading off at right angles from the tree-filled Parc de Montsouris. His third-floor studio—it, too, faces south—is flooded with sun (when there is any in Paris), which shines on his philodendra and canvases and brightens his decorations of archaic sculpture and a barbarically colored South Sea shield. Until a few years ago, Braque stood straight as a cypress, as his Norman country neighbors put it. Now he stoops a little as he moves around in his Paris studio, but still in an arboreal way, slightly bent, as if under wind. His linear elegance is notable. His long painter's hands are still handsome and relatively unimpaired by work or age. His feet, small for a man of his height, are shapely, even debonair, in their collegiate polished brown moccasins. His skull is narrow and high and looks very hard, being covered, though not softened in outline, by stiff, thick, milk-white hair. In his French workman's blue cotton clothes—which are as carefully pressed as if made of broadcloth and which he wears like a dandy, with his French complications of a yellow wool scarf, a silk handkerchief and a sweater swelling round his throat below his ruddy face—and with his clear, all-seeing brown eyes, as earthy-bright

as agates, he looks like an artisan become Olympian with age, success and knowledge. The discipline of his picturesque attire perfectly matches the almost eccentric orderliness of his studio. A dozen or more small unfinished pictures, braced against triangular wire supports (made by him in his Varengeville workshop), sit upright on the dustless polished floor like carefully placed pieces of low furniture. Another dozen or more uncompleted large canvases are ranged on an upper level on easels.

He recently told a visitor that he has long had the habit of working on perhaps twenty pictures at a time, sometimes devoting the whole morning to one—he cannot paint all day, as he used to—and sometimes an hour each to two or three of them and perhaps five minutes to a fourth. When he is through with a particular spell of painting on any picture, he puts it aside, later taking it out from time to time to paint some more, with refreshment and familiarity. Then, one day, he will take it out and discover that he finished it the last time—that there is no more painting to be done. He said that the moment he knows he has finished a painting he has no more interest in it; "its idea has been effaced by completion." He also spoke of his curiously physiological conception of the artist, his canvas, and his canvas's resemblance (or not, as the case might be) to the subject painted. He said that the relationship that exists between an artist, his subject and his canvas is like the one that exists between a mother and a father and a child who resembles one parent or the other; the picture's subject, he said, is the mother, the painter is the father, and the painting itself is the child. For instance, he explained, in an early Monet picture of the Norman cliffs of Etretat, the painting, which was realistic, looked like the mother. But in a later, finer Monet, of Rouen Cathedral, which sublimates likeness to art, the painting resembles Monet *père*. As with many active intellectuals of accruing age, unorthodox early conclusions he reached on certain topics have become part of his lifelong mental equipment. Thus, he suddenly volunteered his opinion that the Italian Renaissance, which as a young man he had concluded was aesthetically decadent, had typically pro-

duced painters "like Veronese and his contemporaries, who were only decorators and could not have properly painted a pair of green apples." Facing him as he talked and dominating the room from its easel was the then unfinished huge canvas called "Atelier VIII," the eighth version of a composition he had been working on for almost seven years. The aim of "Atelier VIII" —other painters before him, including Courbet, have used the theme—is to pay tribute to the act of painting itself. Critics have already ranked the canvas as his masterpiece of the past twenty years. His conception is an enormous, bold group of still lifes, taken from his own studio and all placed in intimate connection amid stylized Braque decorations, the whole painted in rich, ripened colors—carmine décors, green table, a basket of purple fruit, a bluish jug and cup, his whitened palette and his brushes grouped in a bouquet, and, above it all, his special large pale false bird, like a paper pattern of flight. (The picture has recently been acquired by Mr. Douglas Cooper for his collection.) He began the painting in 1954, just after finishing with the Varengeville windows. Its originating sketch, reproduced in his "Carnets Intimes," is what "Atelier VIII" finally became as a finished composition. In the meantime he had discarded new versions, which constituted Ateliers I and II, and then had later returned to refinements of his opening sketch in Ateliers III through VII. This assiduous, patient perfectionism, by which he finally arrived at developing his original valid composition, is a manifestation of the incredibly scrupulous workmanship that, after all these years, he still gives to what painters call "resolving the aesthetic problem." Apparently, no other notable painter in France resolves it with such patience and with such steady devotion to technical mastery, to the stabilizing of the grace that his eyes have perceived, to the perfecting of the artisanship that remains the base of his art. Two summers ago, when "Atelier VIII" was still uncompleted, there were corrective white chalk marks here and there over its color (one of his habits of work), as if the painting, perhaps the apogee of his career, were the blackboard for his final chalked problems of equations and summing up.

Like most of the big painters, Braque has a remarkable memory and is a ready talker, conversing with enlightening coherence and recollection, talking without egotism, his ideas emerging intact, like passing authoritative creations, though they are sometimes as unexpected as they are arbitrary. He brings out his ideas in verbal shapes with the same personal, reasoned style that he employs in painting forms. Because he is a highly literate French painter, who uses the French language with the sure precision of one drawing a series of separating mental lines and refinements, his phrases come to him without hesitation. As he talked to his visitor, he kept glancing at the canvas of "Atelier VIII," which dominated the atelier that it celebrated and its painter. Behind and far below the big easeled canvas, in a corner on the immaculate floor, stood a small painting, only just begun, representing two still lifes in classic conjunction— a skull and a bottle. He had not touched it to develop it for a long time—perhaps for months—he said, and he added calmly, "A skull is a beautiful structure, and used to waiting."

4

THE SURPRISE OF THE CENTURY

PABLO Ruiz Picasso began being an artist at the age of prodigy—at about seven—and at seventy-five remains the complete phenomenon he was throughout the intervening years. The excesses of his artistic endowments, of his will, of his life appetites and his character appear to have been idiosyncratic from earliest childhood, so that becoming prodigious and phenomenal was, for him, the only form of being natural. Even the opening report on him comes from an unusual source—his own vivid memory of how he learned to walk. More than sixty years after the event, while watching a child of his own try out his first steps, he suddenly stated in reminiscence and satisfaction to his most intimate Spanish friend, "I remember that I learned to walk by pushing a big tin box of sweet biscuits in front of me because I knew what was inside." What must have early distinguished him as being beyond normal was his unconventionally high state of consciousness. He apparently started his life by being already intact—by being precociously ready and functioning to begin with—rather than by proceeding classically through the tentative, qualifying stage of development customary to the average very young human being. He started

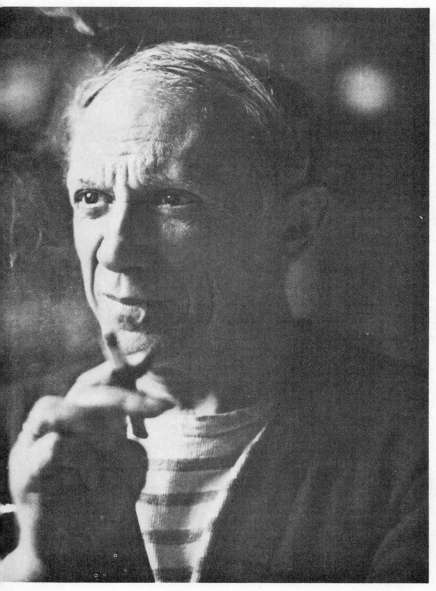

Picasso

drawing as soon as his fingers could grasp a pencil. At school in his birthplace of Málaga, he usually brought with him a pigeon from his father's pigeon cote, which he put on his school desk and drew pictures of during class, as a continuing protest against authority and against being taught anything at all. He later swore that he had not even learned to read and write at school but had taught himself. In any case, he has never been much of a book reader, except for the French poets—Verlaine especially—when he first came to France. He reads newspaper headlines. His juvenile instinct against authority has matured whole. His Iberian spirit of anarchy is still one of his few traditional elements.

During his childhood, he was, naturally, not comparable to normal little boys, but he was also nothing like the other great artists of today when they were small, if one can judge from what is known, reported and recorded of them, which sets them down as reliably ordinary children who merely grew up into astonishing men. From the first, even among artistic geniuses, Picasso was clearly hatched as the white blackbird, the *rara avis*. At the age of seven, his exceptional gift for drawing was so manifest that, shortly afterward, his father, José Ruiz, a teacher in the local School of Arts and Crafts, began giving him highly competent academic art instruction. Young Pablo's specialty was drawing domestic animals —donkeys, cocks and dogs—for his little sister Dolores, three-years younger than he, and for his cousins Concha and María, who, to vary the monotony of his proficiency, would demand that he begin his picture at some unusual point of departure—for instance, with the donkey's tail or the dog's hind legs—and, indeed, he could start a picture anywhere at all without disbalancing the logic of the total likeness or composition. A highly informative new French documentary film, *Le Mystère Picasso,* exhibited in Paris in the summer of 1956, shows the growth of a great many paintings and drawings under his creative hand; it shows him beginning elaborate compositions at inconsequential points of attack (such as painting an alfresco female figure by starting with her foot), then jumping his brush to sketch in part of a surrounding marine scene, then

supplying her with her head or a hand—the effective irrationality
of his procedure being founded on his supreme surety (which, in a
simplified way, he had perfectly demonstrated as a little boy) about
the exact position of those parts of his picture he had not yet visibly
supplied.

When Pablo was still very small, his father patriotically took
him to the Sunday bullfights. The cruel and animated pictorial
qualities of tauromachy seem to have left more than the usual
aesthetic and psychological impressions on his violent little sensi-
bilities, being later summed up in the suffering of the horses and
in the handsome and monstrous traumatic qualities of the bulls
who charged through his canvases, caparisoned with so many vary-
ing symbols and transferred meanings that both animals eventually
constituted his private mythology. In teaching him, his pedantic
father had redundantly urged him to work hard; working at art
seemed to the boy a natural frenzy. He dominated the family as if
he were an outsider. Señor Ruiz had been a gay-spirited Andalusian
wit and artist, had married late and, by the time his son was born,
had become an acrimonious ill-paid art teacher, with his wife, his
mother-in-law, two sisters and his own growing family to support.
(It eventually included another little girl, Concepción, who died
early.) Sometimes he sold a painting of pigeons or lilacs, his
specialities for bourgeois Málaga dining rooms, but as a normal
thing the household was pinched for money. When the boy was
thirteen, his father, as a sign of artistic resignation, handed over his
paints and brushes and never painted his flowers or fowl again.

Pablo painted sufficiently for both of them. At about the age of
eleven, he held his first public art exhibition in the doorway of an
umbrella shop in Corunna, a Galician town ill-famed for its rain,
where his wretched father, who liked sunshine, had a temporary
teaching post. At fourteen, he was painting portraits of his family
in an adult, masculine, Spanish style. He painted an excellent,
still-extant profile of his mother, who was handsome and loving
and his favorite, and a tortured, brilliant, psychological full-face
portrait, also still preserved, of his bearded, middle-aged father,

who is holding his head in his hand and frowning without focus in worry and disappointment. In 1895, Señor Ruiz was promoted to teach at the Provincial School of Fine Arts, in Barcelona, and Pablo, because of his father's position, was exceptionally permitted to take the School's competitive entry examinations when he was only fifteen years old. The elaborate examinations were ordinarily spread over a month (they included drawing a male nude from a life-class model), but he completed them in one day and, furthermore, won first place over all the adult competitors. In Barcelona, Pablo had one of his first poor, cold studios around the corner from the Calle del Aviñó, or Avignon Street, which contained a brazen night-life establishment of considerably more warmth and color. Eleven years later, in 1907, he painted the dynamic canvas that was finally known as "Les Demoiselles d'Avignon" and that marked an epoch in European art. Though he rarely gives names to his pictures unless forced to by his art merchant (and then, he says, titles them "with the first thing that comes into my head"), he did have a working title for this revolutionary painting—"Le Bordel d'Avignon." It was the fastidiousness of art collectors' circles that later supplied the euphemism.

A year after his acquaintance with the ladies of Calle del Aviñó, he repeated his examination prodigies at the San Fernando Royal Academy of Fine Arts, in Madrid, where a doctor-uncle, his father's most prosperous brother, had kindly sent him to study, with, unfortunately, only a pittance to live on. In Madrid, as in Barcelona, he immediately deserted the classes as if they were cemeteries. For him, academic art was dead; he was alive. A few years later, in Paris, when Leo Stein told him almost in reproof that he already drew as well as Rubens, he said, "If you think I draw that well like somebody else, why shouldn't I draw only like me? I would rather imitate my paintings than another painter's." Though extrovert, he could only learn from himself.

Later that same year, an important formative event occurred. He fell ill of scarlatina (it was only a mild attack) and was sent for eight months' convalescence to a village called Horta de San Juan,

in Catalonia, a region that was even then agitating for autonomy. He afterward said that he learned "everything I know" there. His statements have always tended to be extravagant, as if too full either of imagination or of truth. What he learned there, living among the peasants, was the totality of their poverty. He himself, of course, had come from the penurious, semi-intellectual bourgeoisie, and he had roamed the picturesque poor quarters of Barcelona and Madrid with his penniless art-student friends, but this ugly, barren poverty on the Spanish land was his first picture of some men's helpless fate. His recollection of it, added to the misery he himself knew in his early days in Paris (where he had to burn his drawings to keep warm), produced his pathetic and brief Blue Period pictures of social consciousness, such as the portraits of "The Mistletoe Vendor" and "Woman Ironing" and the etching of the bitter-faced, semi-starved couple in "The Frugal Repast." (Together with the pictures of those brightly dressed social outcasts of his Rose Period —the circus harlequins, saltimbanques, and scarlet-clad jugglers— they are still the general public's emotional favorites.) The Catalan experience was also the basic background of his ultimate joining of the French Communist party.

Toward the end of 1898, when he had just turned seventeen, Pablo suddenly ceased signing his pictures "P. Ruiz Picasso," dropped his father's patronymic, and started using only his mother's family name, instead. By Spanish custom, a child's legal name is dual, being that of both parents combined, with the mother's maiden name coming last but the father's family name being what the child is called by. That the young painter should have dropped the paternal surname was irregular—and also inconsiderate, for on his birth he had been particularly welcome in the family circle as the sole perpetuator in sight of the family name of Ruiz, despite his father having been one of eleven Ruiz children. The sire of the clan, Señor Diego Ruiz de Almoguera, a Málaga glove manufacturer, had disappointingly fathered seven daughters, and of José's three brothers, brother Diego, though married, was childless; brother Salvador, the doctor, was a widower with only two girls; and the

late brother Pablo, for whom the newcomer was named, had been a priest, risen to become a canon in the Málaga Cathedral. José's welcomed male infant was born at a quarter past eleven at night on October 25, 1881, and a forthnight later baptized Pablo Diego José Francisco de Paula Juan Nepomuceno María de los Remedios Cipriano de la Santísima Trinidad Ruiz Picasso, the fourth name being for his grandfather Francisco de Paula Picasso, the fifth being the first two names of his godfather—Juan Nepomuceno Blasco y Barroso, a lawyer who was his father's cousin—and the last two being conventional pious Catholic additions. In the recent solemn research dedicated to turn up every possible contiguous fact about the ultra-famous Picasso, it has come to light through professional genealogists set to the task that Picasso's father's family, through José Ruiz's grandmother, can be traced back to include a distinguished holy brother who was called the Venerable Almoguera and who died in an odor of sanctity in 1676 as an archbishop and viceroy in Lima, Peru, in a monastery he had founded. Disappointingly enough, the Picasso side, which Pablo had chosen to feature, yields nothing further back than a photograph of his great-grandmother. Picasso was an unusual and little-known name in Málaga, and reportedly of Italian origin (which the artist himself denies). Pablo's grandfather Francisco de Paula Picasso had been educated in England, for some reason, and afterward, Cuba being still under Spanish rule, ventured out to Havana as the head of the local customs service, and died there of yellow fever—or perhaps in mysterious circumstances. The family never was sure. Possibly because he was more attached to his mother than to his father, possibly because her name was the prettier, and certainly the rarer, of the two, or doubtless because he himself was already violently drawn toward the arbitrary and unprecedented, Pablo, to the chagrin of the Ruiz clan, who were thus lost to posterity (as well as to future world fame), opted to be known and to paint from then on as a Picasso.

The young Picasso made four assaults upon Paris, that dominant, alluring European art citadel, before he was able to enter and

remain. The first was a visit of only two months, in 1900, at the age of nineteen, with the permission and assistance of his parents, who, with difficulty, paid his railway fare. "I later discovered," he once told a friend bitterly, "that this left them with only a few pesetas to live on for the rest of the month." The second was the next year, when he spent from June to December in the city and then was defeated by the combination of poverty, hunger and French cold. A third sally followed, in 1902, and finally, in 1904, he slipped in permanently, like an unrecognized explosive foreign body. He came to rest in the battered old Montmartre tenement called the Bateau-Lavoir (because it looked like one of the Seine laundry boats), and there he stayed maturing for five years, rapidly growing into his first period of importance in France.

More has been written and is known about Picasso's career than about that of any other painter of our time—indeed, of any time. Probably more art lovers today know that he was discovered by the American residents, Miss Gertrude Stein and her brother Leo Stein, in his early Paris period, and that they paid the equivalent of thirty dollars for their first Picasso, "Girl with Basket of Flowers," than know or care that King François I of France paid Leonardo da Vinci four thousand gold florins for the "Mona Lisa," in the Louvre. For the better part of half a century, Picasso has functioned as the unique, dominating art personality of Europe and the Western world—a small, intense man who, like a magnet, attracted, heated and fused intellectual interests and public curiosities into a gigantic core of adulation, admiration, disapproval and some hatred, inside which he has lived and worked. Today, at seventy-five, he still functions in periodic concentrations of his remorseless energy. The black mane of his youth and that "celebrated lock of hair that fell over one eye, like a black currant," as an early friend described it, have long since disappeared. His large head is now an impressive, almost bare cranium, from which his bright, jet-black eyes, rather like the bold eyes of a bull, watch with unabated attention. His strong, short, muscular body hardly looks

middle-aged in its flesh and proportions (recently made publicly visible, since in his film he wore only shorts and sandals). Excessive in himself, he has always inspired hyperbole in others as the only logical method of dealing with his special case, which is that of a phenomenal man. His Spanish secretary, Jaime Sabartés, who has known him for fifty-seven years and has lived with him, off and on, for many of them, recently described Picasso as having a brain like *un incendie cérébral*, a molten mind comparable to a volcano in constant eruption, an intelligence in a perpetual state of susceptibility. With Picasso, Sabartés noted, launching into an assessment as consecutive as a household inventory, "thought and action are paired. He is a stranger to premeditation. His whole entity is restless. Everything ferments in him—his thoughts, sensations, and souvenirs. Nothing stays quiet." He has always expressed himself naturally by extremes and contrasts. He attaches himself only to what is essential; what is minor will follow. He never loses his strength by diluting himself. He does not vacillate, is never discouraged. He uses tenacity, rather than patience. He is the sworn enemy of any and all systems. He has no sense of law; to him the law is something invisible. He is a tireless analyst; he follows the scent of an idea as if it were an intrigue. He is interested in everything and completely absorbed by some things. Discovery is what he deeply cares for and is what alone fascinates him. "He is pre-eminently a sum of curiosities. He has more curiosity than a thousand million women." (This last was an affectionate jibe at the astronomical kind of counting Picasso himself indulges in when he wishes to indicate a sizable quantity of anything. He once said that one of his father's paintings of his modest Málaga pigeon cote showed it filled with "hundreds of pigeons—with thousands of pigeons—with thousands and millions of pigeons.") He has always been abnormally alert. His eyesight is exceptionally quick at seizing and noting details, and he likes to pamper his extraordinarily acute sense of smell; in his early, impoverished Montmartre days, whenever (as rarely happened) he had a hundred francs to invest in pleasure after being paid for a picture, he would buy a big bottle of

Eau de Cologne for Fernande Olivier, the first and most historic of his many public Paris liaisons. His reaction to music, however, has always been nil, aside from a fondness for Spanish gypsy guitar playing and songs. One night at a gathering in his studio, Braque started singing the major themes from one of Beethoven's symphonies; Picasso was the only one present who could not fall in, even stumblingly. To a musician friend he once said, "I know nothing about music. I don't even understand enough to enjoy it without risk of being wrong."

His gestation of an idea for a picture is so rapid that by its very brevity it does not exhaust him. When he starts to work, nothing distracts him and everything disturbs him. Without looking or listening, he sees and hears everything that is going on around him, "and guesses the rest," Sabartés says. When working, he is hyperconscious of what, when not working, he refuses to pay any attention to, such as the doorbell or telephone ringing, or important messages being delivered for him, or quiet questions, demanding immediate answers, being asked in the hall. As a palette for his colors, he is liable to use the wall, or a newspaper lying on his studio table, or the seat of a kitchen chair (he once bought several such chairs at a junk shop, just for this purpose), and he has been known to mix his colors on the windowpane, to measure their translucence. He paints sitting down, bent almost double before the canvas, which he pegs at the lowest level of his easel. According to an artist friend, when he begins a new picture, "his eyes widen, his nostrils flare, he frowns, he attacks the canvas like a picador sticking a bull." This seems a reasonable simile, to judge by Le Mystère Picasso; it showed a half dozen of his paintings being created by him from the first brush stroke on to completion, and developing with such rapid thrust and violence, with such acrobatics of imaginative defense and maneuver that the major compositions seemed to proceed by torture to their final shape.

Of the trio of modern master painters—Matisse, Braque and Picasso—only Picasso is referred to by friends who have known all three as representing what they call "a presence," apparently

meaning a ruling personality, intact in its force and manifestations, that establishes a sense of distance and of difference from all that encircles him. They regard him as a unique man of his time. "He is the surprise of the century," one said. Most of his friends believe that his genius projects far beyond the limits of his art; they measure him not so much as an artist but as an inventor, whose paintings are only illustrations of what he has been unable to formulate in any other way. (Several friends, for instance, think that Matisse was a better painter, in his own terms, and that Braque has never shown the compositional weaknesses that Picasso has restlessly demonstrated.) He has created his own universe, they point out, with his own race of humans, his own forms of beasts, myths and nature, and he has consciously imagined time and space in terms of his own visible composition. Picasso remains unique and a phenomenon because of what Sabartés has oddly described in his psychological inventory as his *déclic créateur*—his creative lever— a supreme mechanism apparently built into him at birth, by which he functionally invents and makes the new that for him takes the place of visual reality. Some years ago, standing in the kitchen of a young friend, he picked up a small trivet off the top of the gas stove and said, "This is first-class Negro art." His profound interest in the repetition of forms, beginning with the magic similarities created by nature itself, has, goaded by his sense of wit, led him to almost a literary appreciation of the humor implied by the resemblance of one thing to another—like a pun visibly performed by objects. Disguise, too, has always fascinated him. In one of his earliest self-portraits, painted at the age of fifteen, he portrayed himself dressed in a white wig and the costume of the eighteenth century; a few years later, he elaborately sketched himself as a Barcelona swell, in a top hat, a white silk scarf and a Chesterfield, none of which he possessed. One of his first sketches of himself in Paris showed him in front of the Moulin Rouge dressed in bicycle breeches, though he also had no bicycle; another showed him in a toga lying on a beach, palette in hand. He painted himself as a Pharaoh wearing an Egyptian crown, and then with various

other forms of headgear—a student's cap, a workingman's cap, a *vie de Bohème* large black hat and a sombrero. In 1905, he painted a beautiful portrait of himself dressed as a harlequin. Braque took a photograph of him wearing Braque's French Army uniform in September, 1914. At Vallauris, for the last few summers, Picasso has staged a mock bullfight, with a real bull but no final death stroke, which has led him to indulge in a wave of the costuming he so violently enjoys. When *The Mystery of Picasso* was recently shown at the Film Festival at Cannes, where for years he has been famous for his negligee dress of shorts, sandals and fisherman's striped shirt, he surprisingly appeared at the première formally dressed—for the first time in twenty-five years, or so he afterward said—in an old bowler hat and a smoking jacket—a variant of disguise. In his studio, he is still inclined to astonish friends by suddenly appearing "in the most unexpected get-ups," as an Englishman among them recently declared. A Paris art magazine not long ago printed a snapshot of him, taken in 1955, in which he looked very unexpected indeed, for he was wearing a white sailor's cap, and false whiskers and a false nose, like a circus clown of his old Montmartre days.

In one way, at least, Picasso fulfills the popular notion of the conventional artist, who is always supposed to work in a studio cluttered by disorder. (The notion is mostly untrue today among the high-priced painters; Matisse's studio, for instance, was as tidy as a rich doctor's waiting room, and the dandified Braque keeps his workrooms as well tended and polished as the shoes on his feet.) Once given a chance to accumulate, the disorder in Picasso's successive studios and apartments has never varied from his first Montmartre days in the Bateau-Lavoir. He has lived and painted on the Boulevard de Clichy; on the Boulevard Raspail, in Montparnasse; on the Rue Schoelcher, near the Montparnasse Cemetery; on the Rue Victor Hugo, in the suburb of Montrouge; and then, for twenty-two years, starting in 1918, in a studio-flat on the Rue La Boétie. In the early 1930's, he bought, near Gisors, the hand-

some Louis XV château of Boisgeloup, with its splendid classic façade of red brick and white stone, and then, because it was far except for weekends, rented a house at Le Tremblay-sur-Mauldre from Ambroise Vollard, his one-time picture merchant, for mid-week evasions from Paris. In every case, he took root where he lived. When he finally broke connections with the Rue La Boétie (he moved out in 1940 but held on to the place, largely as a storage depot for his thousands of pictures, until 1951), a woman friend said that the process was like pulling up a mandrake, which is supposed to scream at being uprooted. He would never have given up the flat at all if he had not been forced to by a postwar housing-shortage law that prohibited any one from possessing manifold dwellings. His situation, as usual, was complicated. It seems that in 1938 he had taken a studio in the Rue des Grands-Augustins for more room, but had continued to live and work in the Rue La Boétie until 1939. Then, after the war broke, in the summer of 1940, he began living permanently in the studio. It is located in the two upper floors of a shabby but distinguished edifice which till the Revolution formed part of the Hôtel de Savoie-Carignan, an elegant private mansion. The stone carvings on the façade around his hand-somely proportioned studio windows are its finest relicts today. His thousands of pictures are mostly stored in his apartment and in his villa near Cannes. Since 1955, he has lived—in his comfortable, impoverished manner—in a costly new mansion, called the Villa Californie, that he bought just above Cannes. It is a large, tastelessly built Edwardian house, with big salons, which are per-fect for studios. The mansion sits in a neglected garden, now ornamented with gigantic figures that he has constructed in ceramics. Scattered about the salons are crates of his belongings, still unpacked after their extensive odyssey from his Paris apart-ment in the Rue La Boétie. His friends use them as chairs and tables. The scarce real furniture is dilapidated by use, by having frequently been moved from house to house, and by his indiffer-ence. He inherited some good Spanish cabinets from his parents,

but they failed to survive. Besides his own canvases, he has some valuable paintings by other modern artists in the house, which are usually posed carefully in a corner, faces to the wall.

The disorder in which he lives is psychologically very informative—a special static organized disorder, mystifying to visitors, touching to his friends. It consists of a confusing, dusty, heteroclite accretion of objects—many of them valueless or ephemeral and kept beyond their time—amidst which he seems to immure himself in order to feel at ease and resident. It is a disarray that he carefully protects—nobody is permitted to tidy up and destroy it—and that both stimulates and comforts him. He saves everything—half-empty boxes of Spanish matches, half-filled boxes of desiccated Spanish cigars; for years he kept an old hatbox filled with super-annuated neckties. In his untidy Paris studio, ordinarily the telephone serves as a paperweight, holding down telephone bills, invitations to art exhibitions, long since past, cards, addresses, notes and stray papers inscribed with special information—all impounded together so they will be handy if he ever chooses to look at them. The mantelpiece overflows with post cards, letters, snapshots, calendars, art-sale catalogues, maybe a box of chocolates, new writing paper and press clippings, ranged in confused mixed piles. There are piles of things on the tables and chairs. Because of his theory that anything not in sight is irretrievably lost, things merely go permanently astray. The pockets of his jackets are frayed by what he picks up in his peregrinations—pebbles of unlikely shapes, shells, bits of promising bone, pieces of deformed wood, sections of metal—discarded fragments of things, which no longer look like whatever they were at first and so are free to look like something new, different and stimulating to him. Around his studios, there has always been a mixture of Negro sculpture, bronze statues, pottery, broken-stringed musical instruments and paintings—like an un-sorted overflow from a provincial museum. He owns half a dozen Cézannes, including a "View of l'Estaque"; two Renoirs, one of which is a fine female figure; and several canvases by the Douanier Rousseau, whom he knew well and who he thought—as nearly no

other painter did at that time—"represented perfection in a certain category of French thought." Picasso has the Douanier's double portrait of himself and Mme. Rousseau with a lamp, and also a landscape. He possesses half a dozen canvases by Matisse, including a "Still Life with Oranges," which he particularly admires, and a fine 1913 *papier-collé* given him by Braque. Everything has always been privileged to lie where he put it down or where chance happened to place it, to mature *in situ*, so that his glance can come to rest on the immobility of these surroundings he has brought to pass. It is a collection caused by nothing being thrown away. In the estimation of his friends, it acts like a memorandum for Picasso, with things recalling himself at other times, recalling other people, recalling events, or perhaps recalling nothing at all except that these objects have become familiar penates, with a patina of dust. Change or organization he restricts to his art, in which he has spent his career ceaselessly reinventing and altering the nature and appearance of life, while immersed in the proved, commonplace reality of his surroundings.

Before the war, when he was more in the city than now, he was for years respectfully stared at by tourists in the St.-Germain-des-Prés quarter as the most famously revolutionary artist of Paris; on the other hand, he was known by certain café waiters and neighborhood habitués as the notable with the most immovable and conventionally regular habits, who invariably repeated the same routine whenever he appeared in the Latin Quarter—lunch at Lipp's, and the Café de Flore and a small bottle of mineral water in the evening. If he walked by night, he usually took the same streets he had taken the night before, and the night before that.

Picasso has always delighted in having people about him, like courtiers. He invites them in numbers, and often lets them wait in his untidy salon until they have grown into a small crowd. Then, instead of talking to several of them at once, he frequently selects one person for a confidence, leading him to one side, or even taking him into an adjoining room, as a mark of favor. Most of his life, he has worked at night, to assure himself of no human

interruption at all, and this has led to his habit of rising late in the morning. In the days when he lived mostly in Paris, his rising—matinal coffee around noon, the morning paper, his first half-dozen cigarettes, the gossip and news from choice assembled intimates, the air of his presence combined with that of the visitors' proximity to greatness—was a notable, informal event, enviously discussed in lesser art circles. "It was something like the morning levées of Louis XIV, only more disorderly and intelligent," an habitué commented not long ago. His powers of attraction, of magnetism, or energy, and of concentration have, on the whole, not lessened with age. His use of his eyes and their quality of searching attention are still striking; when he comes into an unfamiliar room, his rapid black-eyed glance seems to register everything in a sudden exclusive exposure, like a photographer's lens taking a group photograph. Once, when he was looking at some original Rembrandt etchings, the owner said he thought Picasso's staring, intense gaze would burn Rembrandt's lines off the paper, the way the sun's heat dries up the pattern of dark moisture on an old leaf. He is a heavy cigarette smoker who does not inhale, eats simply and without fine taste, possesses incomparably preserved good health, has always been a hypochondriac, who once had a bit of liver trouble and an attack of sciatica, is still proud of his small hands and feet, hates old age and has a horror of death. Picasso is always reported as shutting off his past behind him—as having no nostalgias and living, with almost cruel determination, only in the perpetual present, on which he has seemed to construct his life. Yet the old friends from his youth who are still alive are, in a literal manner, daily in his thoughts. To an English friend of the younger generation he lately confided that he has the habit every morning of repeating to himself the names of these old friends. When Maurice Raynal—the noted art critic, who was for some time a member of the Montmartre group during the impoverished, euphoric Bateau-Lavoir days—died recently, Picasso felt great remorse, he told his English friend. Raynal had died on the very day Picasso had forgotten to mention his name in the morning.

Picasso is ranked as the wittiest artist and best conversationalist since Whistler, if very different. He has become famous for his talk and what could be called his cannibal wit, since it usually eats other people alive. Even his friends, almost with helpless appreciation, write of how his "malicious eyes" scintillate with pleasure while he, like his listeners, enjoys his destructive tongue. He does not converse but talks solo—creatively, decisively and fascinatingly, with wit, ideas and odd images, his ever-present Spanish accent seasoning his phrases, which emerge in bursts. The only attention he pays to anything that may be said in comment or reply is to change it so much, on dealing with it, as to make it unrecognizable to whoever has just said it; moreover, Picasso then holds the other party responsible for what he has not said. As a woman friend of his once remarked, "If he has been in the wrong about something, he always forgives you." He is wittiest when he attacks; if attacked and taken by surprise, his answer is neither quick, apt nor ready. When he has nothing to say, his silence is so profound, moody, Iberian and oppressive that nobody else has anything to say, either. His humor is sardonic, frequently cruel, always deft, never clumsy or brutal; is usually composed of oversharpened truth, penetrating and painful when it strikes. He rarely misses. The oldest, most quoted of his sayings was a characterization of the late Cubist painter Marcoussis, whom Picasso accused of copying his paintings as a way of picking his brains. "The louse that lives on my head," he called him. He described his friend Braque as "one of those incomprehensible men easy to understand." In reference to the *démodé* paintings of his friend Derain, he said, "He is Corot's illegitimate son." To his art merchant Paul Rosenberg, he announced one morning, "I have just made a fortune—I sold my rights to paint guitars," meaning that half the modern artists of Paris at that time were freely imitating his guitar motif. Another morning, he said to the long-suffering Rosenberg, from whom he exacted very high prices indeed for his pictures and whom he had kept waiting a month for a new picture, "I am so rich that I just wiped out a hundred thousand francs," and sure enough, the new

picture, which Picasso did not like, had disappeared from the canvas. Some of his humorous exploits have had unexpectedly factual results. Years ago, when Matisse was at the height of his fame with his haremlike series of odalisques, Picasso, as a joke, painted an odalisque at the telephone, and for this incongruity perfectly imitated Matisse's brush strokes, style and colors, and his background of Orientalism—everything, including an imitation of Matisse's signature. The joke was so authentic that the *Cahiers d'Art,* in all ways the most serious Paris art magazine, on getting hold of a photograph of the telephoning odalisque, solemnly published it as a real Matisse. His generosity, which is fitful, is sometimes as troubling as his humor. During the 1930's when the fabrication of counterfeit Picassos was at its height—his works being the most often falsified because he rated the highest prices—an old journalist friend took a small Picasso belonging to some poor devil of an artist to Picasso for authentication, so the impoverished artist could sell it. "It's false," Picasso said. The friend brought him another little Picasso, from a different source, and then a third. "It's false," Picasso said each time.

"Now listen, Pablo," the friend said. "I watched you paint this last picture with my own eyes."

"I can paint false Picassos just as well as anybody," Picasso riposted. He then bought the first Picasso at four times the price the poor artist had hoped it might fetch. When another person brought him a counterfeit etching to sign, he signed it with so many signatures that the man was able to sell it only as a curiosity to an autograph dealer. There is something so mordant about his humor and about what amuses him that certain macabre types of funny stories that start the rounds in Paris are often introduced as having been told by the artist himself. In the latest Picasso-type story, credited to him by the weekly *Paris-Match,* a cannibal mother and little cannibal child are walking in the forest when an airplane flies overhead. "Good to eat?" asks the cannibal child. "Like lobster," the cannibal mother says. "You just eat what's inside."

The pungency and originality of his talk can be judged by two

of the most famous and stimulating interviews he ever gave on art. Most of the other great Paris painters, when interviewed, have tended to be either technical or uplifting, and have often made sincerely lofty enunciations. Picasso's interviews moved in a fresh, contrary realm, with his most serious verities generally expressed in soaring paradoxes. As far back as 1923, in an interview given in Spanish, published in translation in *The Arts,* in New York, he said, with glittering illumination, "We all know that art is not truth. Art is a lie that makes us realize truth—at least the truth that is given us to understand. . . . People speak of naturalism's being in opposition to modern painting. I would like to know if anyone has ever seen a natural work of art. Nature and art, being two different things, cannot be the same thing. Through art we express our conception of what nature is not. . . . The fact that for a long time Cubism has not been understood, and that even today there are people who cannot see anything in it, means nothing. I do not read English—an English book is a blank book to me. This does not mean that the English language does not exist, and why should I blame anybody but myself if I cannot understand what I know nothing about?" The other highly characteristic interview was published in the noted *Cahiers d'Art,* of Paris, in 1935, at the zenith of Picasso's popularity, and in it he said, "In the old days, pictures advanced toward their completion by stages. Every day brought something new. A picture used to be a sum of additions. In my case, a picture is a sum of destructions. I make a picture—then I destroy it. . . . A picture is not thought out and settled beforehand. While it is being done, it changes as one's thoughts change. And when it is finished, it still goes on changing, according to the state of mind of whoever is looking at it. . . . A picture lives only through the person who is looking at it. . . . There is no abstract art. You must always start with something. Afterward, you can remove all the traces of reality; the danger is passed in any case, because the idea of the object has left its ineffaceable mark. . . . Academic training in beauty is a sham. . . . When we love a woman, we don't start measuring her limbs. . . .

Everyone wants to understand art. Why not try to understand the song of birds? Why does one love the night, flowers, everything around one, without trying to understand them? But where art is concerned people [think they] must understand." Of all the interviews Picasso has given, these were probably the most informative on his style of mind and also on what he thought about art until he became a Communist, following the Liberation of Paris.

Picasso's relation with his own life, like that of many intellectuals, was profoundly altered by the Spanish war. Until then, he had sentiently been only an artist, concerned with no revolution except the ceaseless one of his painting and dissociated from any rising threats or counter-hopes in European politics. When friends talked politics (or even literature), he would sit silent, or perhaps walk out of the café, or maybe leave them arguing on the street, with no explanation of his disappearance except the tacit one that his mind was on something else. Upon the outbreak of the Spanish Civil War, he was fundamentally and doubly roused—first as a Spaniard, and then as an immediate, ardent champion of the Republican side. In January, 1937, he began etching the two plates called "Sueño y Mentira de Franco" ("The Dream and Lie of Franco"), each divided into small panels of symbolical horrors, like a "nightmare comic strip," as an American art critic observed—panels showing, variously, a winged horse, which Franco is killing with a lance; wild-faced weeping women and a mythological bull; and Franco, turned into a centaur, being gored to death by the bull. To accompany these impractical violences, Picasso wrote a full-fledged Surrealist poem, such as he had been writing in his quasi-intimacy over the prior two years with the Surrealist group—especially with André Breton and the leading Surrealist poet, Paul Eluard. Of his incomprehensible poem against Franco, the phrase "his mouth full of the chinch-bug jelly of his words" seemed to non-Surrealists the only clear expression of his loathing for Il Caudillo. He had already been commissioned to paint a mural for the Spanish Government Pavilion at that summer's

International Exposition in Paris, but he did not start it until he was suddenly inspired by a real horror in history—the destruction in April of the Basque town of Guernica by the German Luftwaffe, obligingly flying for General Franco, in a modern experiment to ascertain the combined effect of explosive and incendiary bombs on a civilian population. What Picasso produced by June was his own "Guernica," his gigantic, terrifying illustration of an apocalypse in gray, black and white—the gray of fear, the white of bones and the black of his own violent graphic language. Whether intelligible or not in its horror to many viewers, this is the most famous of his paintings from his late life, with its symbolic bull, its open-mouthed screaming horse, its woman with a lamp, its dead baby, its lifeless, gutted fighter with a broken sword, and its anguished citizen with face and arms lifted toward the heaven from which comes the novelty of a new form of death. Seen in the Spanish Pavilion by the gay Chaillot fountains, the mural, with its agonized political mythology, had only a stupefying effect on most of the Exposition visitors. Sabartés later declared of it "that of necessity even the pictorial expression was horrible, that the outlines wept, that the discolored color was one of sadness, that the whole was a penetrating clamor—tenacious, strident, and eternal." Aesthetically appreciated only by a few visitors (though valued as rare political propaganda by the intelligentsia backers of Republican Spain), it palpably failed to impress or inform the general public, come to the Exposition to have a nice time.

When the next war broke, in 1939, Picasso and Sabartés drove from Paris to Royan, a fishing town on southern France's Atlantic coast, where he eventually took the top of a house called the House of the Sailmakers, which looked out to sea. He spent almost a year at Royan, interrupted by several hasty, all-night drives back to Paris. In August of 1940, he returned permanently to his Rue des Grands-Augustins studio, to sit out the war under the Germans, working. Because he was a special anathema to Hitler—a distinction that tacitly acknowledged Picasso as the supreme chief of modern art—the Occupation authorities forbade him to hold any

public exhibition. But occasionally Nazi officers, sufficiently cosmopolitan to be disloyal to their Führer's art limitations, out of curiosity called at his studio, where a large photograph of "Guernica" was hung. This circumstance led to Picasso's most ferocious bon mot of his career. An especially cultivated Nazi—or one, at least, who had heard of the picture—said on looking at it, "Ah, so it was you, M. Picasso, who did that," at which Picasso flashed back, "No, you did it!" He had post cards made of his "Guernica," and when the occasional Germans continued to call, he would thrust one in their hands, saying maliciously, "Take it, take it! Souvenir!"

Throughout the Occupation, Picasso maintained his spirited, if passive, resistance to the occupants. It was implacable and audacious and, by way of the rumor and gossip on which Paris lived during those long years of blackout, it became a legend. Since everything that touched him was always magnified, the gossip swelled into the belief that, despite his being more than sixty years old, he was secretly active in the underground Resistance, like many of his young intellectual friends. The truth is that during the Occupation years, he remained a kind of immovable, impressive Latin Quarter monument, first inscribed anti-Franco and then anti-Hitler—the outstanding *Kunstbolschewismus* practitioner of the Occupation, who simply went on working at his art, was cold in winter like everyone else, and, like everyone else, fed himself on the black market to the extent that he could afford it. Two days after Paris was liberated, his friend Paul Eluard brought him a Livre d'Or, which was to be filled by writers and artists of the militant Resistance and presented to their triumphant chief, General Charles de Gaulle; as an exceptional honor Picasso had been asked to make the first drawing. Picasso obliged with a pen-and-ink drawing of a girl's head. Attracted by his fame, Allied soldiers who had been artists or writers, or who were just rank-and-file admirers, trooped to his studio, which became the American intellectual sergeants' headquarters. Newspapermen described him and cameramen photographed him like an internationally known

masterpiece portrait feared lost in war and now discovered perfectly intact.

Six weeks after Paris was free, the Salon d'Automne opened in the quai-side section of the Palais d'Art Moderne, across from the Eiffel Tower, with the first big exhibition of France's contemporary art after four years of Nazi domination. For special significance, it was called the Salon of the Liberation, and Picasso was honored by being given a special gallery, where close to eighty of his works were displayed. They did not satisfy the general public. Probably too many French people recalled what they had seen as physical realities of war and occupation; after four years of ugly history, they had forgotten the luxury of what the cerebral inventions of modern art looked like, and they were shocked. To the overemotional—and, at that time, still optimistic—public mind, the Salon was supposed to symbolize restored Gallic culture, the nation, patriotism and a republic, and Picasso, being foreign, was resented as the featured star. Also, just before the Salon's opening, he had announced his adherence to the Communist party. On the Salon's third day, there was a demonstration against him—his bull's head, concocted in the Occupation shortage of material and in his own mordant humor from an old bicycle saddle, with the handle bars as horns, especially angered some visitors—and a few of his pictures were pulled from the wall with shouts of *"Décrochez!* Take them down! Money back! Is this French art?"

At Christmas time the next year, with the war finally ended, about twenty-five of the Picasso art works (along with an equal number of pictures by the great Frenchman Matisse), were exhibited in London, in the Victoria and Albert Museum, and produced a gale of letters, many of them indignant, in the *Times.* Londoners who had been buzz-bombed and V-2-bombed, had had their houses fired, and were still living amid the grotesque wreckage of their great city with their knowledge of horrors that Parisians had been spared, in many cases scoffed at what they felt was a lack of human solace and civilized moral values in Picasso's art, but, being English, they did not lift a finger to his paintings. Instead,

they wrote to the *Times*. "Figures with half a head and three eyes appeal to very few," wrote one man briefly. A letter writer "in a state of utter bewilderment" thought that "the efforts of Henri Matisse seemed tolerable" only in comparison with those of Picasso, which were "unjustifiably brutal"; an angrier correspondent called them "the Belsen horrors at the Victoria and Albert." "This exhibition is an insult both to artists and the intelligent public," the president of the Royal Institute of Painters in Water Colours stated, adding a great deal more. Evelyn Waugh, in his letter, said disdainfully that as an experience Picasso "can only be treated as crooners are treated by their devotees. . . . Do not let us confuse it with the sober and elevating happiness which we derive from the great masters."

Viewed even in retrospect, Picasso's joining of the Communist party still seems incomprehensible to most of his friends—especially, one gathers, to some of his Communist friends. A few years after his conversion, he said that he had become a Communist because there should be "less misery in the world." He hated poverty, he went on; he had seen other men cruelly and unforgettably poor, as in Catalonia, and he had been bitterly poor himself when a young artist. Undoubtedly, his sufferings and humiliations from poverty when he first came to Paris were still active, heavy recollections, sunk to the bottom of all his youthful memories. (At times, he had been in such need that, having refused the villainous price offered by a shyster Montmartre art dealer, he would be forced to accept half of it the next day, because he was too hungry to hold out, to be proud or to bargain. Fernande Olivier once said that there were days they had no food at all; that there was a hungry, miraculous day when one of his rarely practical admirers left outside the studio door a tin of sardines, a long loaf of bread and a bottle of wine; and that there were two winter months when she remained housebound because there was no money to buy shoes for her.) It has been said that his adherence to Communism was also partly founded on his generic sympathy with workers,

since he had always worked himself, but, by the time he joined the party, this explanation had been rendered hypothetical by his having become, in his way, the highest-priced, fastest piece worker in the world, who could paint a picture valued at twenty thousand dollars in one day. By the time he joined, he was a self-made millionaire of eccentrically inexpensive bohemian tastes, who lived in his various dwelling places—in Paris, in his successive houses in the Midi, or even in his château—in disorganized simplicity, since luxury happened not to appeal to him any more than order. It was natural that his announcement of his signing up with the party—a seriously regarded step in France, like taking an ineradicable sectarian vow—should have created considerable stir in Paris in 1944, even though Communism had been temporarily given an almost benevolent, patriotic position by General de Gaulle's initial political opinion as the head of the provisional government that all Resistance parties (and in the Resistance the Communists had been greatly important) must be considered valid in helping govern the new France they had helped to save. In October, 1944, in an interview carried by the *New Masses* of New York, Picasso was quoted as saying that he had long been aligned with the Communists, as his closest party friends, the poets Paul Eluard and Louis Aragon, well knew; that he thought Communists "worked the hardest to understand and reconstruct the world" and that it was among Communists that he found those he most admired— "the greatest scholars, the greatest poets, and all the beautiful faces of the Paris insurgents" of the August Liberation days. In the meagerly lit Paris cafés of that following winter, there was a great deal of talk as to which of the two had made the worst bargain in accepting the other—he or the Communists. The questions of how the toughened, realistic party could digest his unproletarian and intellectually individualistic art, clearly in a class by itself even for the bourgeoisie, and of how he, as a revolutionary artist who had been a law unto himself for sixty years, would be able to swallow obediently the party's academically Marxist bigotry and Stalinist infallibility were argued with relish. In March, just before the

war ended, a woman Communist journalist, Simone Téry, brought
to Picasso's attention an American newspaper story saying that his
Communism was only a caprice, and claiming he had said that
art and politics had no connection, anyhow. Outraged, Picasso im-
pulsively took up a pencil and wrote for her—and for the Com-
munist literary weekly, *Les Lettres Françaises*—a brief statement
on *l'homme engagé,* the most revealing politico-aesthetic statement
he has ever made. In the swift double heat of anger and conviction,
he wrote, "What do you think an artist is? An imbecile who has
only his eyes if he is a painter, or his ears if a musician, or a lyre
at every level of his heartthrobs if he is a poet, or—even if he is
only a boxer—just his muscles? On the contrary, he is at the
same time a political being, constantly alert to the heart-rending,
burning, or happy events in the world, molding himself in their
likeness. How could it be possible to feel no interest in other people
and, because of an ivory-tower indifference, detach yourself from
the life they bring with such open full hands? No, painting is not
made to decorate apartments. It is an instrument of war, for attack
and defense against the enemy."

Picasso served the party well in public, within the limits he must
have laid down to his close friend Aragon, the Communists' most
brilliant intellectual and the *eminence grise* of their French intel-
ligentsia policies. The party used Picasso as it might have used an
exotic golden pheasant, displayed him on its scarlet-hung platforms
at its workmen's meetings in the Vélodrome d'Hiver, the Paris
sport palace. He was, without question, the biggest, most impres-
sive and most illustrious propaganda feather in the cap of any
Communist party in Europe. He thus became a familiar sight to
masses of the Paris proletariat, who shortly knew his name, his
fame and, by sight, his impressive broad-mouthed face, his formi-
dable, large, brainy head, the wool scarf wrapped around his neck
against drafts. They also knew and appreciated his silence. Seated
on the red-decked stage with its background hammer-and-sickle
decorations, and near to Comrade leaders Thorez and Duclos,

whose speeches usually added up to three hours, Picasso rarely said a word.

In 1948, four years after Picasso had become a French party member, Moscow launched a full-scale denunciation of his art. In his notable, lengthy *Cahiers d'Art* interview, in 1935, he had stated, among his other particular verities, "I cannot understand why revolutionary countries have more prejudices about art than out-of-date countries." The Soviet Union's well-known conventional bigotry as regards modern art was suddenly recapitulated in a new fulmination on the subject—and on those decadent foreign artists who created it—written for a Moscow magazine by Comrade Vladimir Kemenov, a government art critic. His attack was a development of his opening derogatory question, "What is the cause of the catastrophic decadence in which contemporary bourgeois art now finds itself?" To this, he then supplied the correct party-line answer. "The characteristic of the imperialist bourgeois era," he declared, "is its anti-humanism, intended to oppress the worker's sense of his human dignity. Capitalism sells its modern art like men's suspenders or Coca-Cola. The sculptor Lipchitz deforms the human imagination. The English Henry Moore cynically derides the human form. Cézanne removed light from painting and resolved everything into still-lifes. Matisse and Braque have refused to admit that there is any conflict between art, as they paint it, and the public. They are all detached from life, deny social realism in art, and are indifferent to subject matter, which they wrongly consider the enemy of painting." As for Picasso, Kemenov said, rising to his peak, "his works are a maladive apology for capitalistic aesthetics that provokes the indignation of the simple people, if not the bourgeoisie. His pathology has created repugnant monstrosities. In his 'Guernica,' he portrayed not Spanish Republicans but monsters. He treads the path of cosmopolitanism, of empty geometric forms. His every canvas deforms man, his body, and his face." Picasso made no public comment on the Kemenov attack. He had not expected the Russians to belatedly

begin liking his art because he had joined the French party any more than he expected to change his art because the Russians' critic suddenly denounced it, so he went on painting as usual. (Privately, however, he said sharply, to a non-Communist friend, "I don't try to advise the Soviets on economics, why should they try to tell me how to paint?")

The next year, his art relations with the U.S.S.R. took a turn for the better through an ironic accident. According to the most popular version of the anecdote, of which there are various forms, like every item touching on Picasso and his work, in the late winter, while living in his villa at Vallauris, in the Midi, he received a neighborly call one afternoon from Matisse, in company with a handsome, lonely, white fantail pigeon Matisse had been keeping as a pet in his studio at nearby Nice and was now donating to Picasso's pigeon cote, where it could find friends. That same day, Picasso made a truly marvelous, naturalistic lithograph of the Matisse pigeon, technically ranking as one of the finest prints of his career—a lovely, lovable, domestic fowl. It was this feather-toed pigeon that, by a Communist propaganda miracle, was turned into the party's peace dove. The magic transformation was achieved by the poet Aragon, since youth an intimate friend and admirer of Picasso, and by now a scintillating party zealot, who, on seeing the lithograph, at once recognized the possibility of the bird's mass popular appeal as art and its potential symbolic significance if viewed not as a simple fantail but as the dove of peace on earth, and its vast possible propaganda value both for the party and for Picasso when coupled with Picasso's signature. It was first used as a poster, and admiringly commented on by the Paris press for its beauty and technical perfection, in connection with the Communist World Peace Congress held at the Salle Pleyel in the spring of 1949. (That autumn, "The Dove" was given the Pennell Memorial Medal by the Philadelphia Water Color Club and the Pennsylvania Academy of Fine Arts.) Since then, the party has had it printed by the million, using it at the 1951 World Festival of Youth and Students for Peace, in Berlin; at the 1952 Peace

Congress, in Vienna; in China, Poland and other Iron Curtain satellite countries; and at all subsequent big meetings in France and Western Europe. The party has sold it as an art item for framing, has reproduced it on dinner plates, has put it out in reduced size on post cards—has, in fact, made it the most widely distributed, familiar, popular work Picasso ever created. His father had painted pigeons, he had drawn pigeons as a schoolboy, and of all the thousands of revolutionary pictures he had created as a world-celebrated artist, it was his pigeon, disguised as a dove, that was his single art contribution of direct use to the Communist party.

There was associated propaganda value, of course, and kudos for the French party in the fact that after the war his newest pictures were often displayed in the Communist-run gallery ambivalently called La Maison de la Pensée Française, or the House of French Thought. It was here, in the summer of 1954, that, despite its damnation of his art, Moscow installed with pride its loan exhibition of thirty-eight precious early Picassos, of the Blue, the so-called "Negroid" and the early Cubist periods, that had never before been allowed to leave Russia (and that the Soviet citizens had not been permitted to see for years). They were mostly pictures bought in Paris before the First World War by the rich Muscovite industrialist and collector, Sergei Shchukin; seized in his palace by the Bolsheviks after the October Revolution, they were later installed as a nucleus of the new Moscow Museum of Modern Western Art. They comprise the biggest collection of pre-1914 Picassos in the world, and they made up a magnificent and rare exhibition, which was melodramatically cut short a few weeks after its opening. The paintings were hastily snatched up by the Soviet Embassy and whisked back home to Russia when Shchukin's daughter suddenly turned up, with her lawyer, from Switzerland, where she lived. She had long since become a French citizen, and now she tried to claim the Moscow Picassos, now worth a fortune, as her dead father's stolen property. The fantastic story and situation were naturally carried as titillating news in the Paris press. Interviewed on the matter while at a bullfight in Nimes, Picasso inquired,

"And what if the Comte de Paris [the present pretender to the throne of France] takes it into his head one day to reclaim the Château of Versailles?"

It was the death of Stalin in 1953 that brought about Picasso's most embittering and humiliating Communist experience—an attack by the French Comrades themselves, especially the working-class members, on the portrait sketch he drew as his tribute to the defunct and at that moment the hysterically mass-mourned leader. It was a hasty crayon drawing of semi-classical realism—an amazing, if unhistorical, likeness imaginatively showing Stalin's face as very youthful and very Georgian, with a surprising, unfamiliar look on it of brooding innocence, coupled with an almost quizzical look of Slavic distress; supporting the head, with its large mustaches, was an overall, thick neck, round as a funnel of steel. Artistically, it was a masterly, minor performance and anyone would have recognized it as a young Stalin he had never known. It was printed on the front page of the March 12th issue of the weekly *Lettres Françaises*, edited by Aragon, along with Aragon's own emotional *in memoriam*, which contained (among other devotional phrases since quoted with jeers by the democratic Paris press in the recent de-Stalinization operation) his sentiments of party gratitude: "Thanks be to Stalin for those men who modeled themselves on his example, on his thinking, on Stalinist theory and practices." Two weeks later, Aragon was forced to print a recantation of his admiration for the sketch and a selection from the flood of shocked, disapproving letters the magazine had received from Communists and sympathizers elegiacally protesting the Picasso portrait. One writer declared, in his disappointment and grief, "No, this is not Stalin's face, that face which was at once so kind and strong, so expressive, so inspiring of confidence in the honesty of our dear, great Stalin. My son, aged fourteen, shares my opinion."

Another letter writer inquired, more sharply, "What is the value of a drawing that is such an obvious betrayel of what it portrays? Where is the radiance, the smile, the intelligence—in a word the humanity—elsewhere always so visible in our dear Stalin's

portraits?" Since the attacks on the Picasso portrait constituted news, as well as proof of a party quarrel and scandal, they were naturally featured by the non-Communist French press. One newspaper interviewer reported Picasso, then in the Midi, as saying tartly, "When you send a funeral wreath the family customarily doesn't criticize the flowers you chose." In the April 9th issue, Aragon, who was a member of the Central Committee of the party and in troubled waters because of the Picasso picture, was also forced by party opinion to give his explanation of why he chose to publish it—and perhaps was forced by the Central Committee itself to print his accompanying *mea culpa*. In this signed editorial, which he courageously titled "A Haute Voix"—"At the Top of My Voice"—he explained that he would never have published the portrait if it had occurred to him that it might offend anyone's *"grande tristesse,"* which he and Picasso had also shared; he pointed out that in the portrait were "none of those distortions that Picasso often uses in dealing with the human face . . . proof that Picasso had tried to put his technique and the validity of his intention at the service of a real image of Stalin." Then Aragon purged himself. His error, "common to people of culture, had been to judge art on its style, rather than on its subject matter," he boldly stated. "Strange that this should have happened to me," he interspersed bitterly—he who, he said, had struggled more than any other over the years against what party doctrine, in an astonishing definition of Soviet aesthetics, had called this "deviation of the critical spirit." Aragon made his confession double-edged by including this oblique reference to his superior, intellectual *anti ouvriérisme*—his conviction that workingmen's standards automatically carried a lowering of taste—which had already been thought heretical. With what may have been a Machiavellian stroke, he inserted in his editorial a letter of militant *pro ouvriérisme,* harsher and coarser than any so far printed, expressing the writer's "stupor and anger" against "this so-called portrait, published on Aragon's responsibility"—an enraging portrait because "it was not he, our friend," the great, good Stalin, whose prestigious renown

Picasso "had made a mess of, insulting our purest sentiments." The letter went on to adjure, in part, "Come now, Picasso, this portrait isn't a question of Madame X!!! Be yourself, and don't try to make fun of those who look at your paintings and drawings. You still have something to learn, such as respect for your model, and also for anybody who tries to find the interpretative meaning of your work. Don't let your pretentiousness run away with you. Your talent is not lofty enough to deal with Stalin." With the party's proletariat in an angry mood over what seemed to them the blasphemous Picasso portrait; with certain of the party's intellectuals deserting Aragon in cowardly alarm, after having first hailed the Picasso sketch; with his having been made the scapegoat for the vagaries of his friend Picasso's genius; and, above all, with his high party position as intellectual overseer in grave danger, the ambitious, overbrilliant Aragon, who by now had caught his second wind after his enforced recanting of the portrait's values, concluded his *Lettres Françaises'* editorial indeed at the top of his voice. In an astute appeal to party pride, and with courage and with a loyalty to amity rare at such moments in Communist practice, he declared that it was to the Marxist party, not to capitalism, that Picasso had chosen to ally himself politically, adding in crescendo that Picasso belonged on the Communist side of the world struggle, "the man who makes the enemy envy us. He is celebrated throughout the entire world. He is a great artist, the painter of 'Guernica' and of 'The Dove'—my friend, our friend, Picasso." Under this vigorous declaration, and because Picasso was too valuble a propaganda property for the party to lose, the rebellion against the Stalin portrait suddenly petered out, probably on orders from the party chiefs. But it left Aragon's position gravely weakened. At the 1956 annual Party Congress, held at Le Havre (where the platform's scarlet curtain featured a new multiple use of Picasso's dove, five of them wheeling, as if in flight, around the hammer and sickle), it was freely predicted that Aragon's place as intellectual chief was finally to be given to a new rival, and that he would not be re-elected to the Central Committee. The surprise which

greeted his last-minute re-election must have been for him the final humiliation in his relation to the scandal of Picasso's ill-fated Stalin likeness.

Shortly after the portrait fracas had died down, it was said by reliable gossips in Paris that Jean Cocteau, a close friend of Picasso's for nearly forty years, felt that the recent events justified his asking Picasso the question that, out of tact, his bourgeois friends had not asked in 1944: Why had he joined the party? Picasso's answer, according to the same reports, was, "I thought it would be a big brotherly family. *Eh bien,* now I hate my family!" Several years earlier, a French friend, who knew far more about totalitarian politics than he did, had asked him what he would do if his Communist party ever succeeded in taking over France as a satellite and, in consequence, could forbid him to continue working as an artist, except along party cultural lines. "If they stopped my painting," he answered, "I would draw on paper. If they put me in prison without paper or pencil, I would draw with spit on the cell walls."

The final ironic turn of the screw in his Communist relations came in the belated aesthetic recognition finally accorded him twelve years after he had joined the party. When Picasso's seventy-fifth birthday came around, on October 25, 1956, it was surprisingly honored by a large exhibition of his paintings in Moscow—the first time since the recent war that the Ministry of Culture had allowed any of his works to be viewed by the Soviet public. The occasion was, moreover, the capital city's first recognition of Picasso himself as a famous member of France's Communist party—which, by this time, many French supposed he had ceased being. The exhibition of about sixty pictures—half from the Shchukin collection, ending with canvases painted in 1914, and twenty-nine, dating from 1915 through 1952, that had been sent up from Picasso's own store of his works, plus five examples of his Vallauris ceramics —opened at Moscow's Pushkin Museum on the night of his birthday. The next day, the Paris party newspaper, *Humanité,* reported with a straight face that "all whom Moscow counts among friends of art rendered homage to Picasso." It did not explain how

this profound appreciation was suddenly projected by Moscow's aesthete notabilities, who had not even seen their own Picassos for almost twenty years, had never laid eyes on his puzzling later works, and had been instructed over the last decade to regard all his paintings as anathema. (According to one British visitor, in 1923, to Moscow's Museum of Modern Western Art, Picasso's pictures were then described by the museum as exemplifying "decadent, bloodless bourgeois art." After the war, when Moscow's modern art was reported lost to view, a visitor to the Hermitage Museum in Leningrad, in 1955, with considerable surprise fell there on what were obviously the great Shchukin Picasso pictures, which by this time were not described by the art authorities at all. Furthermore, the customary labels on museum pictures had been removed, so that his name was not even given, nor was it contained in the museum's official list of the artist shown there.) In connection with the 1956 museum exhibition, *Humanité* also published the amiable greetings that Picasso had sent for the opening, in which he said, in part: "May this message bring friendship from Picasso to all. I said, long ago, that I came to Communism as one comes to a fountain, and also that my work had led me to it. I regret not to be with you at this time, and hope one day to undertake that beautiful fraternal voyage which at present I must empower my pictures to make for me." The night before the exhibition's première, a gala soirée in Picasso's honor was held in the Moscow Academy of Fine Arts, where Ilya Ehrenburg, his friend for over forty years, appropriately gave a lecture on Picasso's historical position in the outside world of contemporary art—obviously to edify those Muscovite connoisseurs who would have to render Picassoan homage the next evening.

Picasso had refused Ehrenburg's personal invitation to be his Moscow guest for the exhibition's opening because it would have interfered with the birthday celebration—"for my centenary," as he called it, with his usual caustic humor—given him by the village of Vallauris. His postwar interest in making pottery and ceramics there had, by happy contagion, revived pottery-making in all the

Vallauris kilns, suffering from depression. Not only did his signed jugs—some bulging like women's bodies—his plates painted with cockfights and bullfights, and his figurines of toads and owls, primitive with natural wisdom, become collectors' items but, through their magnetism, all Vallauris pottery developed a vogue. The village was turned upside down into a tourist center, and, in gratitude, made Picasso an honorary foreign citizen. For his birthday, which occurred on a weekday, the mayor had requested the potteries to let out their workers at eleven o'clock, instead of noon, so that, before going home to lunch, they could be joined by their wives and children in a village turnout for Picasso on the little square called "The Man with the Sheep," in honor of his life-size bronze statue of a shepherd that adorns it. It is near to the deconsecrated chapel that the mayor gave him, so that he could use its walls for large fresco paintings, and that will soon be inaugurated as a Museum of War and Peace, these being his two themes. That evening, in his pottery workshop, he was host to the village potters, who presented their birthday gift—an inscribed bronze potter's wheel for his use. There was also a gigantic birthday cake, flaming with three-quarters of a hundred candles.

In 1955, the French state, not waiting for Picasso's "centenary," accented the great honor it wished to pay him by doubling it—by holding two parallel retrospective exhibitions of his art in the two most famed historical exhibition buildings in Paris. It was the first time that a modern artist has ever been dually celebrated in this manner. A hundred and forty-one of his paintings were displayed in Musée des Arts Décoratifs, which is in the Louvre Pavillon de Marsan, and 282 of his engravings, etchings, lithographs, aquatints and book illustrations were displayed in the Galerie Mansart and the Salle Montreuil of the Bibliothèque Nationale. Together they united the largest combined body of his art ever shown in the fifty-two years of his long career in France. With a due recognition of his personal history, the Arts Décoratifs' exhibition listed among its first canvases his "Self-Portrait" and, second, his "Portrait of

Gertrude Stein," the two signal, strange-appearing 1906 faces that began the gravity of his fame and of hers—his as painter, hers as appreciator. From there on, the pictures gave, more or less, the chronology, in periods, of Picasso's subsequent art life (he says "painting is another way of keeping a diary"), up into 1955, ending with final, typical female portraits in stylized human distortions— perhaps his way of painting fiction. As the first even partially complete record of his art that has ever hung on Paris museum walls, the exhibition was overwhelmingly convincing and concise in its information. His paintings since 1906 seemed to be of the purest twentieth-century invention, as unconnected with nature as an airplane, which only on its own terms flies like a bird. There were the long years of cerebral painting in Cubism, then voluptuous still lifes of pears and other fruit, Spanish and sensual in their created alien style. There was sad and anguished painting— sometimes private, sometimes political—not only in pictures of weeping humanity, with faces charred into broken black lines of grief by war or abandonment, but often in unidentifiable shapes deliberately tragic in their very lines, outraged and outraging. There were paintings of ugliness, of contrived hideosities, further projections of the angry, disillusioned imagination, and paintings of chimerical monsters like necessary illustrations of today's cruel modern legends. The rare bravura returns to classic beauty lay only in the world of make-believe—in portraits of ballet dancers posed as young lovers, of harlequins, of his little son in fancy dress. He has painted thousands of pictures, which, except for the early allied creations in Cubism, are often little alike yet which all are related by the consanguinity of his protean imagination. The preface to the Arts Décoratifs catalogue opened by saying, in part, "It is not impossible that the art of Picasso, like that of the poet Rimbaud, will long remain unassimilated, that it is essentially unlikely to become the conformism of any epoch or society. For it is an art that is refractory, unruly, outside the law. . . . [These liberties] make for its unequalled importance."

Among the significant items in the exhibition were his study for

one of those savage "Demoiselles d'Avignon," still archaic, still ultramodern; the graceful, geometric problem of the Cubist "Girl with a Mandolin," of 1910; the vastly intelligent, unrecognizable portrait of Braque in the hermetic Cubist "The Accordionist," of 1911; the refreshed verbalist Cubism of 1912, with painted words such as the forthright statement "Jolie Eva"; the stimulating, realistic *papiers-collés*, which the Dadaists admired as legerdemain; and his 1914 synthetic Cubism, ebullient in its many forms. By 1917, he had already gone so far in transforming subject matter into shapes of his own invention that he paused to etch some realistic portraits of living writers, drawn in factual life—of Paul Valéry, Raymond Radiguet and André Breton—"to see if I can still draw like everybody else," he said sardonically, as if producing portraits that actually looked like certain men of talent, instead of images begotten merely by the genius of his own imagination, constituted a sort of modern-art charade. (These accurate literary likenesses were displayed at the Bibliothèque exhibition.) In 1923 began a stage of sumptuous, nostalgically Cubist still lifes, and of masked and majestic *commedia dell'arte* figures—modern figures like "The Three Musicians," whose rich angularities led to "The Dance," denticulated in red and blue, which Miss Alice B. Toklas described simply and authoritatively as "one of his most beautiful pictures." She regretted that Miss Stein could not afford to buy it when new, Picasso's success and prices having already put him beyond anything but the ladies' continuing appreciation. The picture still belongs to him. In 1925 began what the catalogue called "his strange, invented human figures, which established new relations between the organs and members of the body—ear, nose, arm, breast, leg, etc." These eventually led to what the public considers his first period of aesthetic horrors, including the so-called bone styles of 1929—at which even many habitual collectors balked and refused to buy—which depicted sickle-jawed females with teeth like machinery. With relief, in 1931, came the first of the fascinating two-faced female portraits, with profile and front view separate yet become one—his most celebrated, mystifying, dis-

concerting and influential invention. The Arts Décoratifs example, one of his earliest, was inconsequentially called, as an instance of the first thing that came into his head, "The Red Chair"—in which the dual-visaged phenomenon indeed sat. It still belongs to him; he is a large collector of significant Picassos, as if such canvases illustrated special days in the painted diary of his imagination. In 1934 began the women with hands and feet like gloves, as in the "Muse," with her pencil in hand, drawing her reflection in a mirror. During 1935, for private emotional reasons, Picasso ceased painting almost entirely. Instead, during that year, he brought to finality what is considered the most important print of his career—"The Minotauromachy." (A perfect example was among the Bibliothèque items.) In this visionary etching, he inscribed a dark allegory around the figures of the chimeric, taurine-headed Cretan man; a bare-breasted woman matador astride a disemboweled, screaming horse; a flower girl with a bouquet and a lighted candle; two girls in a window intent only upon a pair of doves; and an ascetic male figure mounting a ladder—a scene of associations that remains inexplicable, impressive and anguished in its linear poetry and private mythology. It is comprehensible, perhaps, only in its reference to the animalistic death dramas the painter had seen as a little Spanish boy at the Sunday *corridas,* first watching the death of the horses, then the death of the bulls. In 1937, he began his prodigious production of thirty-one aquatints of animals, at the rate of one or more a day, as modern illustrations for a reprinting, originally projected by his art editor, Ambroise Vollard, of France's eighteenth-century masterpiece, Buffon's *Natural History.* (A copy of this remarkable book was on show at the Bibliothèque.) Picasso's beasts displayed a new version of his practical genius. As part of the legend of his multiplicity of knowledge and attainments, he is reported by friends who watched him at work to have drawn all his creatures without recourse to any model—without, for instance, going to the Vincennes zoo, as most artists would have been driven to do. They are realistic creatures in genial black-and-white, each true to his species and the picturesqueness of his outward nature

and seeming to be the very essence of his kind, whether ape, goat, cock or ostrich, and making up in their entire company what ranks today as the supreme contemporary illustrations of any great French classic republished in our time. The Arts Décoratifs exhibition included "Guernica," also still the property of the painter but of recent years on loan to the New York Museum of Modern Art and reloaned to the Louvre exposition. This time, it was the cynosure of the public's attention, being described in the catalogue with the phrase, "No work of the twentieth century is more famous." (Another politically epic canvas shown was his 1951 "Massacre in Korea," with its robots in armor machine-gunning a nude citizenry. His 1952 double panels of "War" and "Peace," in the first of which appears a horned Mars in his chariot, carrying microbe bombs from which bacteria may be seen emerging as big as bumblebees, bats and serpents, were, for various international reasons, not included.) By 1941, he was painting bifurcated faces of a race of women often called *les monstres*, distorted by anguish and invention; by 1942, they had changed to rarefied, triangle-faced females shapes, which looked like effigies. From 1950 through 1953, he painted many black-lined, bright-colored portraits of his youngest son and daughter, born late in his life; some of them, like "Maternity in Orange," which includes their young mother, were hung at the Arts Décoratifs exhibition. After 1910, as a rule, he never painted from living models, except his wife and first-born son, his mistresses and their children, and his friends; in these paintings, likeness, despite deformation, was always devotedly maintained. In other pictures of women, of which the exhibition showed multiple examples, he reduced the faces to what the art experts called "signs," with the human features organized as a picture, not as a reflection of humanity. The final item in this vast exhibition consisted of fifteen canvases painted with concentrated energy and speed late in 1954 and early 1955, when he was seventy-three years old, all of them versions of the famed Louvre painting by Delacroix, "The Women of Algiers"—a harem scene composed of odalisques, servant maid and narghile. Such variations on a theme are natural

practice for musicians but rare for painters except when still very young or else old and ripe enough to impose their style on compositions a previous generation of masters has left behind.

The Arts Décoratifs catalogue contained a startling innovation. In it, for the first time, the French state took official cognizance of the private life—that is to say, the love life—of a modern painter while the painter—and, indeed, several of the women who shared it—is still alive. This sparse, carefully dated and discreetly phrased information—the old-fashioned provincial term *"compagne,"* meaning "companion," was mostly used—appeared in the catalogue's brief Picasso biography and, more expansively, in the catalogue notes on the portraits of those who had been participants in his personal history and had remained illustrations in the chronology of his art. The general information (though not necessarily the details) was already fairly familiar to most Parisians, but it came as a surprise—especially as itemized in an official catalogue bought in the purlieus of the Louvre—to many foreign visitors. As an American lady, who had known Paris modern art circles and Picasso for fifty years, said, "All the important painters had a private life of some sort—frequently so private that no one ever discussed it, because it was dull. But Pablo's private life has always been public. Everyone has known about it, everyone has conversed about it, including Picasso himself, and everybody has written about it. He always painted the women's portraits, recognizable or not. They became part of his art and legend, and it was all extremely fascinating and worth talking about." The most picturesque, as well as the best-known of his early companions—probably because she wrote a book, called *Picasso et Ses Amis,* on the seven years she spent with him and his art circle—was the handsome, almond-eyed Fernande Olivier, whom he met in 1904 in a corridor of the Bateau-Lavoir, where they both lived; he was carrying a kitten, which he offered her, laughing, and would not let her pass. The catalogue mentioned her mostly only in connection with her subsequent travels with him (three times to Spain) or with Braque to their holiday painting center in Ceret. The well-educated, observ-

ant Fernande, who never became the schoolteacher she had been trained to be, had exquisite diction and an angelic voice when reciting poetry, and during the eighty sittings that Miss Gertrude Stein had for her portrait by Picasso, Fernande read aloud to her all of La Fontaine's *Fables*. Picasso wanted to marry her, but she had married earlier, to get away from home, had been separated from her husband, and at that time was unable to trace him to obtain a divorce. It was not until almost forty years later, after the Liberation of Paris, that she learned by chance that he had died just after she and Picasso first met. Her book's verbal portrait of Picasso as he looked then is still historical: "Small, dark, thick-set, unquiet, disquieting, with sombre eyes, deep-set, piercing, strange, almost fixed. Awkward gestures, a woman's hands, ill-dressed, careless. A thick lock of hair, black and glossy, cut across his intelligent, obstinate forehead. Half bohemian, half workman in his clothes, his hair, which was too long, brushing the collar of his worn-out coat." The morbid side of his work both bothered and charmed her. It was the end of the Blue Period, and "his studio was alive with work, in the midst of such a disorder—great God!" One canvas particularly affected her—"a lame man, leaning on his crutch, with a basket full of flowers on his back . . . emaciated, gaunt, poor, with a look of lamentable resignation. . . . What was behind it all? Was his work completely cerebral, as I later understood it, or did it reveal a profound, desperate love of humanity, as I then thought?" Then, in 1912, came Marcelle Humbert, whom Picasso called Eva—meaning that she was almost Eve to him, the first woman of creation—in whose honor, the catalogue said, "at the moment when she took her place in his life," he began painting nine analytic Cubist portraits, all containing the inscription "Ma Jolie," a refrain from a then popular song, which he printed on the pictures. At the time, he and Braque, painting together at Avignon in the summer, were using words as *trompe l'oeil*. "I love her very much and shall write it on my paintings," he told Daniel-Henry Kahnweiler, his picture merchant, and he did so—"J'aime Eva" appearing on two, both historically celebrated but neither

shown at the Louvre. In 1918, as the catalogue biography stated, he married Olga Koklova, a *petit sujet* dancer of Diaghilev's Ballets Russes, with whom he fell in love in Rome in 1917, when he was making the décors for the ballet *Parade;* as Diaghilev, who knew his female compatriots, had warned him, "Russians marry." Their son Paolo was born in 1921. (He has had an uneventful life, for years was his father's chauffeur in the Midi, is married, and recently became the owner of the château of Boisgeloup, which Picasso, who associated it with his own marital unhappiness there, years ago, gave to his son in order to remove it from his own life.) With the devoted artistry that painters over the ages had used to formalize the intimate, plastic relations between mother and child in their Madonnas, Picasso created those dozens of neoclassic pictures and drawings he tenderly called "Maternity." It was when his marriage to Olga came to its breaking point in 1935, that, in complete disorientation, he deserted painting almost entirely for a year. It has been reported that Mme. Picasso blamed the destruction of their marriage partly on his involvement with the Surrealist movement—an aesthetic line of reasoning that perhaps only a Russian dancer of the French epoch could have given domestic application. As the catalogue said, though divorce was envisaged (they were instead legally separated), their marriage ended only on her death in 1955, in southern France. In connection with a portrait called "The Mirror," of 1932, it stated, "this year marked the opening of his relations with the future mother of his daughter, Maïa," whose 1938 portrait was also exhibited, with the explicit information that her birth had inspired "no maternity pictures, doubtless because the mother did not share in Picasso's life." One lovely portrait—"Seated Women," ribbed in pastel colors, almost like a Chinese paper lantern—was shown of Maïa's mother, however, a handsome young blonde matron whose name is well known in France but is never printed in this connection, not even by the French state catalogue. The catalogue added that "in 1938, Mlle. D. M. had already taken her place in the artist's life . . . as a new companion, whose features are frequently found in the faces he

painted until 1944." Of the many women in his life and art, Mlle. Dora Maar was the most esteemed as an Egeria by those left among his old friends—a highly intelligent, dignified, brunette Yugoslav, with a rich, quiet voice and laughter and with elegant narrow hands and feet, her fine, long, handmade shoes being a rare sartorial touch in the bohemian crowd at the Café de Flore in the prewar and Nazi Occupation period. Educated during her girlhood in the Argentine, where her father, an engineer, had accepted a post, she first entered Paris art circles as a photographer, then became a painter, influenced by Picasso's style. Until 1944, hers was the familiar art face of his pictures—in particular, in some of his famous double-visioned portraits. (He also painted a realistic portrait of her, doing justice to her normal, high-cheeked beauty—a painting never exhibited and still in her possession.) After the break in their relations, she abandoned painting, but has recently started again, in her own style and with her own subject—scenic views that are like small mirrors reflecting the prisms of sunset lights over the empty, pre-mountainous hills surrounding her remote summer home in southwestern France.

In 1946, the catalogue announced, "Françoise Gilot, met the previous year, became his companion," and many Arts Décoratifs portraits and Bibliothèque lithographs were displayed as part of "his homage" to her. (She, too, turned painter, and exhibited in Paris in the Surindépendant Salon, in 1956.) He also painted portraits of his second son, Claude, born in 1947, and of his fourth child and second daughter, Paloma, born in 1949, and numerous pictures of Françoise and her children all together. The Arts Décoratifs catalogue then recorded that "Françoise Gilot and Picasso separated in 1953." Paris newspapers reported her as saying at the time, in the Midi, where they had made their life together, that she could no longer stand "living with a historical monument." The exhibition's final portrait, of a handsome new face, dated 1954 in the catalogue but otherwise uncommented on, was significantly titled by Picasso "Portrait of Madame Z," as if his amorous alphabet had come to its end at last. Actually she is Madame J. R.—Madame

Jacqueline Roque, formerly of Vallauris, a handsome dark woman, no longer young, who serves excellently in his portraits of her and has for the past two years been his companion in his Villa Californie life.

"Probably no painter in history has been so written about—attacked and defended, explained and obscured, slandered and honored by so many writers with so many words—at least in his lifetime," wrote one of the most internationally admired writers on Picasso, Mr. Alfred H. Barr, Jr., of the New York Museum of Modern Art, in his *Picasso: Fifty Years of His Art*. Published in 1946, it even then listed 522 substantial works on the painter, including 40 monographs. The single humble book written on Picasso, containing uniquely intimate human observations made of him, off and on, for over fifty years, usually from such close range as the other side of the room, is that by his compatriot, Jaime Sabartés. It is called *Picasso—Portraits et Souvenirs,* was published just after the Second World War, and was begun as a private production, to fill in the empty hours. Only afterward was it modestly offered as "a guide for whoever seeks forgotten or unknown details" on the painter. It does not pretend to vie with other books on Picasso, to which it is in many ways superior as an analysis, but merely presents "what I know of his life when mine followed the same course—a sort of chronicle, but only of the periods I directly observed, when I was in close touch and continually saw him, listened to him, watched him." Sabartés first knew Picasso in 1899 in the artist cafés of Barcelona, and early called on him in the poor studio room Picasso had rented from a family who used the rest of the apartment for their trade of making corsets. In 1901, Picasso painted the Blue Period, romanticized portrait of him (handsomer and without his spectacles), which is now in Moscow, and in 1939, after the war broke out and they were in Royan together, he painted a portrait of him as a medieval Spanish intellectual, in a white ruff and plumed hat, with his modern horn-rimmed glasses perched upside down across his cheek.

In his book, Sabartés furnishes the backdrop of Picasso's youth, as the artist recalled it in adult reminiscences, and in a second volume, *Picasso: Documents Iconographiques,* published in 1954, he provides more than two hundred documentary photographs— of Picasso's birth certificate, of his birthplace, of all the places where he has lived in France, and so on. The particular quality of Sabartés' information, which alternates in its intimacy between the interesting humdrum events in the life of a genius and the exceptional psychological peaks he reached in his art, is that it deftly inventories Picasso's character ingredients, as well as private movements of his mind when brooding, chatting and painting. In certain letters, Sabartés offers hitherto unknown alternates to Picasso's biting public wit—his harmless, capricious and affectionate good humor, and even whimsey, as in a letter he wrote to Sabartés from the Midi in 1936, when his painting was still dissatifying him after his previous year's vacuum. In it, he said, "I announce to you that as of this evening I am giving up painting, sculpture, and engraving to consecrate myself entirely to singing. A handshake from your entirely devoted friend and admirer, Picasso." One a few days later, referring to his continued black mood, added, "Let's say no more. . . . Receive, fresh as a letture, the ancient amity of your old friend."

Years ago, Picasso said, "I should like to live like a poor man with a great deal of money." This characteristic diversity he has long since perfected as a millionaire. He lives in what one French wit called *"une faste miserable*—a kind of destitute grandeur, like champagne drunk at the kitchen table." When he himself was young he said, "Art is a saleable commodity. If I want as much money as I can get for my art, it is because I know what I want to do with it." What he wanted to do—or even what he has done —with the fortune he has earned nobody seems to know, beyond totting up the obviously calculable parts he has given over to renting or purchasing his various studios and dwelling places and to supporting his various paternal relatives. (It is reported that if

anyone does know what he has done with his fortune, it is an old
Spanish banker, who for years has lived in France. He is a
financier in whom Picasso has placed his confidence, and with
whom he has possibly placed his moneys.) It is known that he gave
a very great deal of money to the Republican cause in the Spanish
civil war, and for years afterward to the refugee organizations that
cared for the defeated Republicans who had fled into France.
Today, he gives to Montmartre and Montparnasse. He gives to
painters he has known who are slipping downhill—who had talent
and have become failures—and even to some who only thought
they had talent but whom he chooses to spare from knowing their
mistake.

In June, 1956, at an auction in the Paris Galerie Charpentier,
a little Picasso painting, nine and a half by thirteen and a half
inches, Cubist in style, and called "Mask and Gloves" fetched
1,750,000 francs, the equivalent of $5,000—about as high a price
for so small a contemporary-art surface as has ever been paid. His
various Cubist periods, which offered the mystery of a concrete,
calculated new invention, were in many cases (as far as the general
public was finally able to follow with great pleasure and without
worried perplexities, once it grew used to the idea) his most popu-
lar periods, along with his earlier realistic reports on human beings,
such as the poor in his Blue Period and the romantic jugglers in
his Rose epoch. Many of his succeeding aggressive or tragic or
distorted periods have excited public curiosity—at least in Paris—
but have certainly had no general popularity. His styles have been
so multiple, and the public reactions to them so varied, that Picasso
himself is supposed to have launched the sharpest summing up of
his work in the imaginary dialogue: "I don't like Picasso." "Which
Picasso?" In the postwar inflation of international moneys that has
raised modern-art prices to astronomical heights, Picasso's prices
have always been the highest, and at the same time his output has
always been the largest. Recently he told a friend that he had
taken some of his pictures to the Louvre, presumably after it was
closed to the public, and had hung them on the wall, "to see how

they would look there after I am dead." And how did they look, the friend wanted to know. *"Ils se tenaient très bien*—they held up very well," Picasso said, with his indecipherable air of farce and fact, and the friend later remarked, like most of his more incredible yarns, it was possibly true.

The possibility that profound oblivion may one day be the fate of his horrendous, most unpopular styles is one, according to friends, that he would neither believe nor be concerned with. "Everything is sorted out in art in time," he has said. "Pictures live only by their legends"—by what men differently think and say as they look at them, now or later. (What the complete legend may be in the twenty-first century nobody today can even imagine.) To him, the way the world looks is a travesty, dressed up in a limited and customary reality, of a truer world that exists in his own imagination and that he records in color and line. Sabartès commented that before Picasso, artists isolated an object so as to imitate it; but Picasso regards an object as a point of departure toward an infinity of combinations and permutations, so varied and far-reaching that the object has become something re-created and different from its original truth when he has finished with it and laid down his brush. Painters of his generation have thought him a dangerous man to emulate. Yet it is he— not they, not Matisse, not Braque—who has been emulated by the younger generation of modern European artists. Many painters today believe that if one does not accept all of Picasso one has lost him; he has his own special, unique entirety. He was born and has lived as a phenomenon. "What is a painter?" he once asked, and then answered, "He is someone who founds his arts collection by painting it himself."

5

THE BEAUTIFUL SPOILS

I.A.H., Linz—Adolf Hitler's Collection

For several thousand years, the looting of art by the victors from the vanquished has been the most civilized sideline of war. From time immemorial, war has given to the conqueror the privilege of plundering whatever art treasuries have not been demolished. This last European war was the most immoral on modern record because of the Germans' pillage of portable art as an elaborate, highly organized psychological policy; and the most calamitous ever known since the invention of explosives in the chance destruction of big-scale beauty such as buildings or even whole towns bombed into floating dust. This war also produced history's greatest, most delicate military traffic problem: the portage of the transferable loot, of which the art-hungry Nazis assembled thousands of tons and myriad trainloads of the classic, from bronze Apollos to stone saints, and of the cozy, from gold Empire soup tureens to a portrait of Mme. de Pompadour in her boudoir. The physical act of carting pillaged beauty off to the homeland is older than the hills of Rome, which are peopled with marble mythology stolen from the temples of Athens. But the Germans did something new this time; they

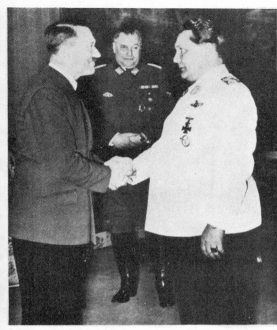

Hitler paying Göring a birthday visit, in Carinhall, where Göring stowed some of his stolen art

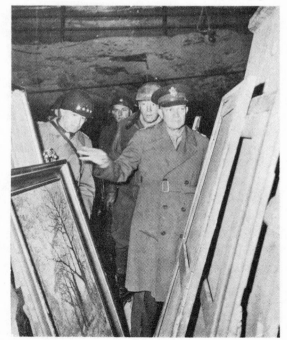

General Dwight D. Eisenhower, accompanied by General Omar N. Bradley and Lieutenant General George S. Patton, Jr., inspecting art treasures stolen by the Germans and hidden in a salt mine

looted art on an ideological basis—almost all the victims were French, Dutch, Austrian and Belgian Jews, and Poles and Russians of any faith. The fact that the Nazis considered their looting of art a protection of art was also a novel touch.

The German organization that did the bulk of the looting actually started out as a high-powered unit in search of material for political propaganda. It was formed directly after the blitzkrieg in Poland, in 1939, and began operations in France, the richest plunder center of Europe, in July, 1940, a few weeks after the Nazis marched in, by setting up its elaborate Western European headquarters in the Hotel Commodore, in Paris. It soon became known as E.R.R., after the first three initials of its full name—*der Einsatzstab Reichsleiter Rosenberg für die Besetzten Gebiete,* or the Reich Leader Rosenberg Task Force for Occupied Territories—and turned into a complex, hard-working, enormously specialized bureau made up of fanatics, administrators, art experts, art crooks, art restorers, art packers, art appraisers, stenographers, secretaries and cataloguers—a greedy group that by mid-war had practically completed the most efficient art-robbery enterprise of all time. At the Nuremberg Tribunal, Dr. Alfred Rosenberg made cowardly denials of his feverish racism and of his Task Force's pillaging, but it is a fact that in January, 1940, he had received specific orders from Hitler about his initial duty, which was to carry out what was considered a vital ideological mission—the looting of all Jewish and Masonic archives, libraries, temples and places of worship, and so on. Hitler later ordered the Paris Kommandantur to help Rosenberg in this idealistic Nazi labor. From the time the philosopher Rosenberg became Germany's Deputy of World Outlook, in 1937, his *Weltanschauung* specialties had been anti-Semitism and anti-Freemasonry. Now his plunder was to be gathered in anticipation of a strange academy he was to found for Hitler after Germany won the war, an academy at which, with the E.R.R. material as a curricular base, future young Nazis were to be educated to hate Jews and Freemasons—if any were left. In September of 1940, Hitler suddenly enlarged the assignment of the Paris Kommandantur. He ordered it to note that private

Jewish art collections—such as those in the Rothschilds' mansions —were technically ownerless, because all Jews had been made stateless by Nazi decree and therefore had no property rights, and that, along with the synagogue booty, Rosenberg was to be assisted in transporting "cultural objects" belonging to the Rothschilds and other Jews to Germany, where the Führer himself would decide what should be done with them. That was the beginning of the wholesale anti-Semitic art plunder in France. Then, in November, beauty-loving Reichsmarschall Hermann Göring, who was in residence among the treasures of Paris, added some fanciful twists of his own to this new program. In a military order, which he oddly declared would be operative until Hitler should affirm it (Hitler never laid eyes on it, and it thus remained in force until E.R.R. fled Paris in 1944), Göring decreed that five categories be established for the "safeguarding of Jewish art." Category No. 1 was to consist of those art objects that the Führer would safeguard—i.e., seize. No. 2 was to include the art that was to be safeguarded by being put into the Göring collection. No. 3 was to include the temple and archival items good enough for Rosenberg's Nazi school, but not good enough aesthetically for Hitler or Göring. No. 4 consisted of objects appropriate for German museums. The specifications of No. 5 were the most hypocritical of all: that Jewish-owned art not up to museum standards, or too decadent and modern for Nazi ideology, was to be seized and auctioned off in the commercial market, at a date to be fixed later, and the proceeds were to be given to the children of dead French soldiers. During the four years of German occupation, no date was ever fixed.

In the spring of 1946, when Göring was reminiscing on the Nuremberg witness stand, he confided, with his easy, vulpine smile, "I fully admit that I had a passion for collecting things. And if they were to be confiscated, I wanted my small part." He even cheerfully confessed he had looted loot that had been intended for his Führer. This was the piratical spirit that animated the big Nazis in their free-for-all pursuit of beauty, which extended over the whole of conquered Europe, which swelled social reputations and

which led to power intrigues, E.R.R. love affairs and even to three E.R.R. suicides, debasing whatever art it touched.

With the beginning of the struggle for art began the unequal contest between Göring, Himmler, von Ribbentrop, Frank, Bormann, Rosenberg himself and, at the head of the line, Hitler (when he could take time from the war) for the domination, direct or indirect, of the miserable Rosenberg's Task Force, which actually was principally under Göring's thumb. Owing to the orderly German habit of maintaining records of everything, including disorder, the Hotel Commodore in Paris became a huge E.R.R. library of filed letters from, and reports on, everybody involved in the art rush —one of the most complete and candid catalogues of Nazi freebooting methods that came to light after the war. According to these documents the first work of art the Nazis pirated in France was one of the world's greatest paintings, "The Astronomer," by Vermeer, informally removed in the summer of 1940 from Baron Eduoard de Rothschild's palace by the Gestapo and handed over for safekeeping to the High Commissioner of Occupied France, Otto Abetz. After Hitler's order to the Kommandantur that September, one of the Gestapo's official pastimes was the searching out of art in Jewish mansions, apartments and shops. As fast as it was found, E.R.R. sent trucks to transport it to the Jeu de Paume Museum, on the Place de la Concorde, used as the clearinghouse for all stolen French art. There E.R.R. packed it for shipment to the Reich. By the spring of 1941, the first rush was over and a shipment of the very finest of the French booty had started for the Reich in thirty carefully heated baggage cars. But the larceny of minor loveliness continued until July, 1944, when, just before fleeing in rout from the Allies, E.R.R. tidily totted up the figures on its French campaign: 29 shipments, consisting of 138 freight-car loads, or 4,174 cases of art, containing 21,903 objects confiscated from 203 Jewish-owned collections. Of these, 5,009 objects had come from the various Rothschilds, 1,202 from the Alphonse Kann collection, 2,687 from David-Weill, 989 from Levy de Benzion and 558 from Seligmann

Brothers, the art merchants. According to E.R.R.'s conscientious figuring, the 21,903 art objects included 10,890 paintings, etchings, engravings, pastels, enamels and other pictures; 583 sculptures in bronze marble, wood, terra cotta and other materials; 2,477 pieces of furniture; 5,825 objects d'art; 583 textiles, including Gobelin and Aubusson tapestries and carpets; 1,286 Asiatic articles, including rare Chinese items; and 259 Greek, Roman, Egyptian and Assyrian antiques. This vast heteroclite accumulation, except for the precious elements subtracted by Hitler and Göring—the greedier and more cultivated Reichsmarschall seized nearly a thousand fine items—was triumphantly destined to enrich the museums of the German and Austrian Reich. It was largely because of E.R.R.'s ideological art thefts that its obscure-minded director, Dr. Rosenberg, a member of the sacred Leadership Group of the party, was sentenced to be hanged, after being judged guilty of "crimes against civilization and humanity" with which he was charged by the Allied prosecution at Nuremberg. As head of the official Nazi art-collecting organization, Rosenberg did not even like art. He was a semi-educated philosopher who liked to talk Nazi ideology, regarded by the rest of the leadership group as true but dull, as conversation.

Though a very amateur art collector among a bewildering wealth of free riches, Hitler, despite competition from Göring, dutifully took most of the best, because he was the Reichsführer (and because of the advice of his art counselors) but not because he knew beauty even when he saw it plain. Hitler's first bag of pictures came almost entirely from the four finest baronial Rothschild collections in Paris —from those of Barons Robert, Henri, Maurice and Edouard, the last of whom had the best canvases; Hitler's first assortment of objects d'art came from Baroness Alexandrine de Rothschild, who had the greatest treasury of fine furnishings in the family. There is no record that Hitler's compliment to Jewry in choosing what they had chosen ever became apparent to him or to other Nazis. It is known that he relished robbing the houses of the Rothschilds because their name was a symbol of the worldly success of some members of the unhappy race that he and his Germans aimed first to

humiliate, then to destroy. During the Nuremberg trial, Rosenberg spoke of fifty-three pictures which Hitler "purchased" through E.R.R. The truth is that Hitler never paid a pfennig for the lot, and that Göring, who actually filched three of these same paintings for himself, paid nothing either. Hitler's first haul from the rich elegant Jews included "The Astronomer," and he went on to other superb portraits—Rubens' court-dress portrait of Hélène Fourment and a child, who is probably her little son, carrying her train; Frans Hals' "Lady with a Rose," perhaps the loveliest, least gross of his female likenesses; and Fragonard's cynical "Comédien." Hitler also seized a noble Luini, "Madonna with Jesus and St. John as Children," as well as the more worldly Soria children by Goya, and Maurice de Rothschild's famous "Mme. de Pompadour in her Boudoir," by Boucher. Göring, taking second choice, got a Paris Rothschild's Goya of "La Belle Bourbonne," plus the three Rothschild pictures he stole from Hitler, among them Fragonard's "Girl with a Chinese Doll." Though Hitler detested French art, especially the amorous palace type, he graciously accepted from E.R.R. an exquisite, fleshy Boucher, "A Spring with Waternymph." He not only took the Rothschilds' best but had such faith in the Rothschild sense of values that he also absorbed some near-Watteau drawings and some not quite authentic old masters that had apparently fooled even the Rothschilds themselves.

Hitler's second largest unit of French spoils was the cream of the Schloss collection, comprising 262 great small pictures, mostly Flemish and Dutch masters, rare in that they are both dated and signed. Hitler acquired them, through a forced sale, for fifty million francs —equal then to a million dollars, the Nazis having cut the franc to two cents—of which the Schloss family received no part. The money was paid to the Vichy Commission for Jewish Affairs by the Germans, who simply drew the money from the funds paid by the French to defray the German expenses of the occupation. In this way Hitler thereby received a million-dollar swag of Flemish art for nothing, and had besides the pleasure of knowing that the French people were footing the bill.

Because of Hitler's thefts from the Rothschild and Schloss col-

lections, there grew up the legend that the Führer personally looted Western Europe like a kleptomaniac. This was only partly true. Unlike Göring, he appeared to lack the aesthetic sensuality necessary for savoring art obtained gratis. Hitler did a certain amount of outright stealing, but he also had his art advisers and agents buy for him prodigiously, usually with money his government had picked up in occupation payments or had frankly stolen in the countries occupied. Under his influence, art became one of the means of demoralizing occupied Europe. For example, since art was the one thing that the *Herrenvolk* would sometimes pay big money for, art was taken from hiding by collaborators and sold to them. E.R.R. art looting, and the art buying done for the Nazi *Bonzen,* or big shots, as American gangsters would have called them in admiration, each with his own dealer, provoked the greatest turnover of art in Europe's history, in which by being head of the hierarchy, the essentially unaesthetic-minded Führer automatically became the largest, hastiest collector of art, at least in tonnage, in modern times. Quite apart from what he stole, his purchases during the first five years of the war—he lacked time and heart for art during the last, losing nine months—totaled the fantastic sum of 163,975,000 reichsmarks, the equivalent of $65,590,000, the greatest individual outlay for beauty ever recorded, especially for a man who knew and cared nothing about it.

It must be noted that the scheme of Nazi art buying and stealing in occupied Europe varied according to the local German pattern, and did not make much sense anywhere. In a country under German military government, such as France, art belonging to Jews and Christian anti-Nazis could be confiscated by E.R.R., but art belonging to other Christians or to state museums could not be touched. In Holland and Belgium, which were under German civil government, and where E.R.R. had only branch offices, most of the art belonging to Jews or Christian anti-Nazis was confiscated by another German agency, the Enemy Property Control, and disposed of at forced sales, from which the wretched art owner, even if not already dead or in a concentration camp, received nothing. As a

rule, the receipts from forced sales went into the coffers of the Devisenschutzkommando, or Foreign Currency Control—minus a 15 per cent rake-off to the Nazi sales agent, and often minus the other 85 per cent too, which the German Enemy Property Control had pocketed. In Holland, Artur Seyss-Inquart, Nazi High Commissioner for The Netherlands, pocketed 5,000,000 guilder, equal to $3,400,000, from the forced sale of the banker Frits Mannheimer's fabulous collection of *preziose,* which included a life-size bird carved from one huge emerald, dozens of gem-eyed Renaissance cupids, a gilt bronze miniature of Houdon's statue of Voltaire, and other special items. The Currency Control's main task was to take over mints, public funds and bank deposits in occupied lands, the cash to be divided up and distributed among the top Nazis. Hitler and Göring received the largest cuts, which they promptly paid out to buy more art at another forced, or even voluntary, sale. This cruel rigmarole was repeated over and over again. In Belgium and Holland, the Nazis also seized private collections that had been by arrangement sent to museums for the safety of anonymity—a precaution which, since it looked as if the collectors had not quite trusted the Nazis, was regarded as unfriendliness and was punished by confiscation. On this plea of unfriendliness, Hitler obtained the magnificent collection of Terborchs and Breughels belonging to the Dutch Aryan collector and art expert Frits Lugt, whose valet, desiring a nice job with the Gestapo, informed them that his master intended to disseminate his treasures among friends. The Lugt collection was seized and given to Hitler, and, as reward, the valet was given a good job. In Austria, that poor relation of the German family, art was treated more contemptuously than it was anywhere else in Western Europe. It was stolen, or seized for forced sale, not only from Jews and Christian anti-Nazis but from anybody else the Nazis did not like, including monks in art-rich monasteries.

Buying or stealing art for the Reichsführer was a rousing big business. His favorite, if least competent, agents were a pair on his own modest aesthetic level—his old friend Heinrich Hoffmann, the Nazi party official photographer, who collected photographs of

available European art, which Hitler then thumbed through as though he were choosing from a Sears, Roebuck catalogue; and Hoffmann's associate, Frau Maria Dietrich, a Munich side-street art dealer. Under Hitler's sponsorship, she became a nimble traveler, especially in France and Holland. Her accounts showed that the Führer bought nearly six hundred of the discoveries of this pair, mostly Hubert Robert ruins and inferior Dutch interiors. Hoffmann's biggest success as a Hitler agent was in Leiden, where, at a forced sale, he bought up Dr. Alfons Jaffe's collection of seventy-seven Dutch masters, including Van Loo's canvas "The Lovers." Hoffmann also retained from this sale some tidbits for himself— minor exotic pictures of parrots and marmosets, a form of art which the Dutch, early world travelers, specialized in, and for which Hoffmann had a pretty taste.

Hitler's most important art agent, both before and during the war, was Karl Haberstock, who also worked for Göring. He was Germany's most powerful, most ruthless art dealer, owned a Mercedes-Benz bigger than that of most generals, and fearlessly put the screws on everbody. During 1942 alone, his purchases for Hitler, on which he took a 10 per cent rake-off, totaled millions of dollars. The Nazis expected not only that Jews should donate art but that royalty, even German royalty, should sell it. One of Haberstock's deals on Hitler's behalf was with the German ex-Crown Prince, for the Hohenzollern family's "The Dance," by Watteau, which was an inheritance from Frederick the Great and which had gone to Doorn with the Kaiser. The Prince valued the canvas at 900,000 reichsmarks, or $360,000. Instead of being paid in cash, the Prince was, with Hitler's permission, given an immense tract of Reich hunting forests, which, after all, his father had once owned and for which he himself yearned. Haberstock tried, and failed, to persuade the Grand Duke Ludwig von Hessen to sell his magnificent Holbein "Madonna of the Bürgermeister Meyer," but he did manage to extract from him a nice Cranach for Göring, which the Reichsmarschall never paid for. After dubious dealings with an Italian attaché in Vienna, Haberstock spent the equivalent of $360,000 in reichsmarks to ac-

quire, through a forced sale, the famous von Mendelssohn Rembrandt portrait of Hendrickje Stoffels. In confused and ambiguous circumstances, he gave 1,650,000 reichsmarks ($660,000) for the Czernin Vermeer of "The Artist in His Studio," the greatest self-portrait in all Austria and one for which Andrew Mellon had reportedly once offered $2,000,000. Of all the things for which Hitler paid cash, it was one of his few bargains. He later paid the equivalent of $1,200,000 to the Parisian collector Etienne Nicolas for two Rembrandts—"Portrait of Titus" and "Landscape with Cattle." Haberstock even led the anti-Semite Führer into purchasing Old Testament subject matter, such as Poussin's "Finding of Moses," along with sensual or fanciful mythological pieces, quite foreign to his taste, such as Van Dyck's "Jupiter and Antiope" and "Hercules and the Lion," by Cranach the Elder, whom the Nazis considered *echt Deutsch* and of whom they made a national fetish. In his last will and testament, made when the Russians were entering Berlin, Hitler declared that all his pictures had been intended for public collections, but during the war, when he thought he was going to win it, not lose it, he earmarked 534 pictures—partly thefts and partly purchases—for his mountain home, built on the heights overlooking Berchtesgaden, where the public was kept out at the point of S.S. guns. Another 209 canvases were intended for a castle the Führer had captured in Posen, where he planned to set himself up in extraordinary pomp, like a new Polish king.

The amount of money Hitler spent on art in Italy was incredible —40,179,742 lire and 45 centesimi, or $2,114,723.29, to be exact, which, however, included freight charges. Prince Philipp von Hessen, ex-King Victor Emmanuel's son-in-law, was Hitler's elegant agent in Italy, and he did himself proud. He bought for Hitler the "Spiridon Leda," a hypothetical da Vinci, for 10,500,000 lire—next to what Hitler laid out for the Czernin Vermeer, the tallest price the Führer ever paid—and he persuaded the princely Corsini family to part with its lovely Memling "Portrait of a Man" for a mere fortune of 6,900,000 lire. Only once did Hitler obtain something for nothing in Italy—Makart's "Plague in Florence," which was called

a "gift from the Duce" but actually had been stolen by the Italians from some French relations of the Rothschilds.

 Hitler's, Göring's and, indeed, the entire Reich leadership's Austrian agent was Kajetan Mühlmann, before the war a popular Salzburg booking agent from whom tourist Americans bought their train and music-festival tickets. His war career was spectacular. He became the one-man Dienststelle Mühlmann, or Nazi party art-confiscation agency, operating pitilessly among Jews and Christian anti-Nazis in Austria, Holland, Czechoslovakia and Poland. From Poland, he appropriated 30 Dürer drawings for his Führer, and his Führer was so fond of them that throughout the war he always had them hung in his headquarters wherever it might be. Mühlmann also furnished the martial leader with 1,294 items of medieval armor, principally confiscated in Vienna and Prague, and he took 32 cases of rare coins—one case contained 2,200 gigantic gold coins —from the outraged monks of Austrian monasteries. From the Lobkowitz collection in Prague, he obtained for Hitler Breughel's "The Haymakers," one of the 5 completed panels in a series of seasonal subjects projected by the painter and one of the most beautiful, informative reports on sixteenth-century rural life that exist. For himself, Mühlmann took a 15 per cent commission on all his Dienststelle forced sales, which were ruthless and frequent, and became bloatedly rich.

 By far Hitler's most inept art buyer and dispenser of his funds was not an agent at all but an internationally famous museum director who acted as a personal employee of his—Dr. Hermann Voss, who, being a professional art historian and career bureaucrat, should have known better on both counts. Voss was so expert an art scholar and administrator that in April, 1943, he was appointed director of the Gemäldegalerie in Dresden, in normal times one of the most important museum posts of the kind in all Europe. Shifted to the Führer's service, the irritable, didactic, bureaucratic-minded Voss actually outspent the tough traveling Hitlerian art agents ten to one, which was quite an achievement. According to Voss's sworn state-

ment, made to SHAEF's G-5, Operations Branch's Monuments, Fine Arts, and Archives men in Munich, he had, as Hitler's chief art buyer in 1943 and 1944, spent 150,000,000 reichsmarks, or $60,000,000, for about four thousand paintings, of which, in 1945, he could remember only three—not three thousand paintings, simply three canvases. This is indubitably the smallest amount of recall for the greatest investment ever put on public record. The three pictures he remembered having bought were a Rubens family portrait (he could not remember which family), a Frans Hals portrait of a man (he was not sure what man) and Jordaens' canvas of "Neptune and Amphitryon," whose antique names had somehow stuck in his head. Voss had just possibly developed an authentic memory block. He was such a specialist on sixteenth- and seventeenth-century Italian art that some of the young American Monuments men whose prisoner he became in Munich had earnestly studied his *Late-Renaissance Painting in Rome and Florence* in their university days. However, Hitler had also set him to buying nineteenth-century German art. Since he was a good Dresden cinquecentist, perhaps Voss's whole memory process went blank in the end, to aid him to forget the mediocre Teutonic pictures for which he had squandered part of the $60,000,000.

Voss was one of Hitler's art advisers for nearly three years, but he was consulted face to face only once by the Führer and then was not permitted to speak one word of advice. After his capture, he said that, though Hitler unfortunately did not appreciate Italian Renaissance or even his own land's gay triumph, Austrian baroque, he had been violently recalcitrant only about modern French art, which he declared degenerate and which he forbade E.R.R. to ship into the Reich for fear of aesthetic pollution. When somebody showed Hitler a saintly, metaphysical Puvis de Chavannes to make him change his mind about France's decadence, he only laughed at it, very loudly. Though Voss had forgotten what he bought, he remembered what it was bought for. When captured, he was curator of a nonexistent Hitler museum. While Göring was looting like a *grand seigneur* to obtain splendid additions to his pri-

vate art collections, housed in his various country mansions, Hitler was piously stealing and purchasing art all over Europe for a dream-project museum he intended founding, in his mother's honor, in the Austrian town of Linz, near which she was born and where he spent part of his youth with her. Psychopathically, this Linz idea must have been important to him, since in those last, infernal, bombastic, early-morning hours in Berlin just before he killed himself, he cited it in his will as the sole project that he asked to have carried out posthumously—by the Allies, presumably. Hitler had earlier drawn a pencil sketch of the façade of his dream museum, featuring stiff, ungraceful Greek pilasters straight as plumbers' pipes —his Nazi version of Attic grace. The sketch, though not much to look at, was kept locked in a safe in the Monuments men's head-quarters in Munich. The official Nazi architect, who, carrying out Hitler's ideas, constructed a model of the Linz city project—the model was the size of a large room—did not dare change anything of its bad proportions because Hitler, as far as his own art was con-cerned, was known to have the memory of an elephant and the eye of an eagle and flew into a rage if anything was improved.

According to Voss, Hitler had evolved a strong geopolitical theory about Linz. His basic notion was that Vienna, farther south in Austria, had become swollen after Budapest, its Hungarian counterbalance to the east, had been divorced from it by the unjust Treaty of Versailles. He planned, as part of the scheme for vic-torious Germany's New Order, to de-congest Vienna by attracting trade to Linz, where he had already established the Hermann Göring Steel Works and where, he strangely figured, stolen Jewish art, taken mostly from private millionaire collections, and thereto-fore almost never seen by the public, would attract tourists from everywhere to turn Linz into a popular, thriving North Austrian capital city. His project embraced a complete city plan, including a library of a quarter-million rare volumes and even rarer medieval manuscripts raped from Austrian monasteries, a theater, and an art museum containing old masters and his beloved German modern mediocrities.

The whole filial Linz museum idea, before the magnificent booty taken from the Rothschilds and other knowledgeable collectors agreeably deformed and improved it, had been to set up a museum containing merely a *gemütlich* collection of banal nineteenth-century Teutonic canvases such as Hitler and his mother both would have liked and which, unguided by any advisers at all, he had actually started assembling before the war. Hitler's taste in pictures ran to costume items. The only good canvases he acquired before the war were the early romantics, such as Waldmüller and Spitzweg. Many of his pictures were the kind usually hidden in museum basements—jolly monks quaffing beer; coy, dirndled maidens; goats and cows against an Alpine background; and a morality study by his favorite, Grützner, called "Behind the Wings," showing an opera Faust leering backstage at one of Marguerite's village *Mädchen*. Hitler's moderns were mostly of the questionable Munich School and included the genteel morbidity of the Swiss "Isle of Death" artist, Arnold Böcklin, for whose sickly "An Italian Villa" Hitler had paid the equal of $270,000, possibly the most preposterous price in art annals. When Hitler was buying, rather than stealing, art, he primly insisted on paying high prices, a practice that drove Göring, a seasoned haggler, nearly crazy. Hitler boosted prices to ten times the market on Grützner's daubs and on some unimportant Dutch artists whom he fancied. Paying these prices was, of course, an inexpensive pleasure for the Führer. The German Reich was footing the bills. The mysterious Martin Bormann, who became Party Minister and a top Nazi after Göring was ousted, came prominently into the archives of the Nazi inner circle for the first time when he was recorded as paying out government funds for some of Hitler's wartime art purchases.

When, early in May, 1945, officers of the United States Third Army reached the small salt-mining town of Alt Aussee, high in the spectacular mountains near Salzburg, they discovered, after voyaging a horizontal mile inward among the vast, gleaming white galleries, a fantastic underground community of marble statues and thousands of magnificent portraits and other pictures, all standing

unclothed and unwrapped in the benevolent saline atmosphere.
Many of the items were tagged "A.H., Linz." They were surrounded
by hundreds of sealed cases, also labeled "A.H., Linz." This same
tag appeared on baskets heaped with art objects as casually as if they
were vegetables, and on gold-and-silver Renaissance armor, piles of
folios of prints and drawings, rare books and breviaries, bales of
rich tapestries, and a complex arrangement of furniture, arrayed on
the mine flooring almost as formally as if in a salon—the finest of
chairs and tables, carved and gilded for French and Italian kings.
The Third Army had discovered the cache of art treasures for
Adolf Hitler's someday museum. Of the 6,755 paintings in the
mine, 5,350 were by old masters, and of these 3,922 were marked
for Linz. Shortly before the Army arrived, S.S. men prepared to
blow the mine up with dynamite hidden in boxes labeled "Marmor,
Nicht Stürzen" ("Marble, Don't Move"), to prevent the treasure
from desecration by barbaric American hands. A German counter-
plot against the S.S. prevented their carrying out their plan. Accord-
ing to legend, the mine was worked three thousand years ago; since
1300 A.D. it has been continuously labored in by a tribe of what
now look like gnomes, suitable for Wagnerian opera scenes—men
dwarfed by working underground and by centuries of inbreeding,
still speaking their medieval tongue. For over two years, the A.H.,
Linz cache had been operating like a museum, unvisited, sunken
in the earth, with curators and restorers living like moles, with floor-
ing and racks ready for 14,000 pictures, if need be. The mine had
been chosen because of its climate's kindness to art: ideal humidity
and a steady 40° Fahrenheit in summer, oddly warming up in win-
ter by another seven degrees. However, the armor—among it some
belonging to Archduke Franz Ferdinand, of Sarajevo fame—suf-
fered from oxidation; the curators had to grease it carefully.

There was such a congestion of magnificent art in the Alt Aussee
mine that the Monuments men, cheerfully aided by the guttural
gnomes, spent two and a half months bringing it out to the light
of day. Of the wealth of famous beauty there, surely the most pre-
cious to Hitler was the van Eyck brothers' masterpiece, the altarpiece

called "Adoration of the Mystic Lamb," from the Church of St. Bavon in Ghent, obtained by putting pressure on the Vichy French government, to whose predecessor, the Third Republic, the church had hastily confided it during the invasion. By the Treaty of Versailles, as part of the penalty for invading Belgium the first time, Germany was forced to surrender six of the St. Bavon altar wings, which the Kaiser Friedrich Museum in Berlin had acquired long before by legitimate purchase. Now, in what must have been for Hitler his most crushing victory in his war, he had got back not only what had been Germany's own but what had been enemy Belgium's as well. To him, this must have seemed his great artistic revenge for the loathed Treaty of Versailles.

Only in Italy did the Nazi art collecting for Hitler turn out to be comical, because of the Germans' clumsy pretense, after the collapse of the Duce's regime, that they were not stealing from their former partner, and the Italians' conviction that they were. According to official American Army reports, however, the art that was stolen from Italy after the fall of Rome, when Italy became a cobelligerent of the Allies, was certainly no laughing matter: 532 masterpieces from Florence's Pitti and Uffizi galleries, including Raphaels and Botticellis, and 153 cases of the city's superb statues, among them Cellinis and Michelangelos. To these were added three other precious Tuscan state collections and four other Florentine collections— that of the art collector Conte Contini, who had been Göring's art agent and must have been surprised at being robbed; that of an expatriate French banker, which had been discovered by a German parachute unit down in somebody's cellar; that of the Duke of Bourbon-Parma, which had been liberated by an S.S. Panzer division and which Himmler wanted to use to decorate his S.S. training school at Wewelsburg; and a collection that already belonged to collector Hitler. This last was the Gordon Craig theater archives, assembled for the Führer in Florence and intended by him for his theater in Linz.

The German Kunstschutz—whose professed task was to save

Propaganda by Germany to get Italy to "sell" their works before the Allies appeared

Italian art from "barbarous Anglo-Saxon terror bombing" and, later, from greedy American art dealers, whom Nazi radio propaganda declared the United States had included in its invasion forces to pick up Italian bargains as quickly as possible—was headed by a Prussian S.S. colonel, a professor whose specialty was typography. He was aided by two majors—one an Egyptologist, the other an Orientalist. None of the three knew anything at all about Italian art. Ten days before Florence fell to the Allies, in the summer of 1944, the Kunst-schutz, quiescent until then, was stirred into action. The colonel professor, who knew a thing or two about German art, at least, opened up by personally stealing Cranach's "Adam and Eve" from the Pitti Gallery and carting it off to his hotel in a German Red Cross ambulance. Then sufficient gasoline was suddenly supplied by the nearly fuelless German motorized units to send off the nine collections in a series of convoys, which all vaguely headed north.

It is significant that almost simultaneously with the belated move to rob Italy, the Nazis in France, on Himmler's orders, tried to steal the famous Bayeux tapestry from the Louvre—which had been placed there for safekeeping and had theretofore been left un-touched—and that Nazi Navy men in Belgium highjacked the Michelangelo "Virgin and Child" and fourteen important paintings from the Bruges Cathedral. A desperate, last-minute optimism—based, according to some Kunstschutz men, on a belief that the Nazis had finally perfected their secret weapon, atomic or otherwise—must have animated Berlin into commanding these synchronized, extra-illegal acts of vandalism, so tardy and so close to Judgment Day in their losing war. For a month, the Florentine-art convoys wandered through Northern Italy, occasionally pausing for lack of gasoline, while the Nazis tried to put the Italian government's Belle Arti curators off their track and the curators snapped at their heels. The Nazis pretended, alternately, that they were going to safeguard the Italian art in Verona, in Bologna, in Modena, in Venice and in the Borromean Isles. Bolzano was also considered, but the Nazis feared that Mussolini might rush up there, seize some of the pictures and hurry them into nearby Switzerland, and swing a badly

needed personal loan. Another spot the Nazis contemplated as the site for a cache was one of their own ammunition dumps. In September, Hitler bluntly ordered the convoys to stop roaming around and to store their art—in the Alto Adige district, near the Austrian border, and in two mountain hamlets on the Brenner Pass, leading into the Reich. All pretense of merely safeguarding the art was cast to the mountain winds later in the year, when Himmler suddenly ordered all of it moved over the Austrian border and into the Alt Aussee mine to join Hitler's Linz Museum collection. But he spoke too late. There was not enough gasoline left in the German Army to transport even the revered Führer's stolen treasures. The Italian loot for A.H., Linz never left those rocky Italian outposts.

The Nazis' first mass of loot naturally came to hand shortly after the invasion of Poland, in 1939. Acting on his theory that Poles were subhuman, Hitler commanded that no documentation be made of what the Nazis stole from them, as if they were illiterate beasts. The order given to the German armies in Poland made it clear that the property of Christian Poles and even of the Polish God was to be treated as if it belonged to stateless Jews: all homes, all churches, all museums could be burned or despoiled. The largest single work of art stolen during the war was Polish. It is one of the wonders of the world, a relic of medieval Christianity—the twenty-five-foot-high, multicolored polyptych altarpiece, carved in linden wood, by Veit Stoss, for the Church of Our Lady in Cracow. The altar's peregrinations under the Nazis read like the plot of a detective story. In 1938, on the five hundredth anniversary of the death of Stoss, who the Poles have long claimed was Polish and the Germans have claimed was a German from Nuremberg, Dr. Goebbels published a pamphlet logically declaring that Stoss was obviously a German artist because there was no such thing as Polish art and therefore no such thing as a Polish artist. In this same Teutonic spirit, the Nazis, in 1939, sent the twelve-foot apostolic figures of the altarpiece to the Berlin Reichsbank, for deposit as German National treasures. In 1940, a Nazi archaeologist and some S.S.

helpers began melodramatically dismantling the altar itself by night and spiriting it away bit by bit from Cracow. The nocturnal task demanded weeks of work and dozens of trucks. For two years after its removal the priests of Our Lady did not know where their treasure had gone. Then they received a message from Spain, via Switzerland—sent by a sort of altar underground group of Polish exiles, with members all over Europe, whose express mission was to find and restore the altar, which they considered the heart of Cracow—that their treasure had been taken home, as the Nazis put it, to Nuremberg. There it had been hidden beneath Nuremberg Castle, in the deepest *Bunker* in the Reich—a series of chambers sixty feet underground, hewn out of the solid rock. The Nazis, with their usual sadist jocularity, had forced Polish slave laborers to do the work. One of the slave laborers had been a member of the altar underground group. He finally succeeded in getting out a message by a roundabout route. In the summer of 1946, the Stoss altar was returned by the United States Army Monuments men, traveling in von Ribbentrop's private railway car to Cracow.

Rosenberg's Polish branch of E.R.R. did not start operating efficiently until early in 1940, when thirty art historians from the universities of Berlin, Breslau, Königsberg and so on were sent in to rifle what the Nazi soldiery had not looted or burned. One of the younger of these E.R.R. aesthetes, who became Kommissar of the Cracow district, had written his university thesis on "The High Ideals of the Cranach School." He soon resigned as Kommissar, transferred out of art and became an S.S. officer at the concentration camp of Auschwitz as more to his fleshly taste. The Munich University art lover who replaced him fastidiously took only non-Polish pictures when he looted the Cracow National Museum. The Polish pictures, not being considered art, were cut from their frames and nailed across the museum windows as blackout curtains. E.R.R. lacked men to do all its exacting ideological work in Poland. Hitler *Jugend* had to be brought from Berlin to help the E.R.R. forces collect the incredibly large stacks of precious Polish manuscripts, tomes and archive material in the Polish libraries, cart them to St.

Michael's Church, in Posen, which was being used as a dump, and there make bonfires of them, which the lads tremendously *enjoyed as great fun. Hitler's avowed plan was to leave absolutely no Polish historical works in Poland, because Poles had the effrontery to pretend that such things as Polish culture and history existed. Yet the Nazis were careful to ship to their Berlin libraries the most valuable proof that they *had* existed—the contents of the great Cracow Historical Library, Warsaw's Library of the Parliament and Senate, and the famous medieval Codex Suprasliensis of the Zamoyski family's private library in Cracow. Naturally, Warsaw's Synagogue Library, one of the richest repositories on earth of Jewish culture, was carted to Germany for Rosenberg's postwar Nazi academy, as future proof that Jewish culture had never been.

Rosenberg himself was finally sent from France to Poland on E.R.R. business, but he was not much use in safeguarding art because, in a supplementary new post, which was Minister of Eastern Occupied Territories, he was too busy, from the moment he arrived, in 1942, organizing slave labor in Russia and arranging for the extermination of ten thousand laborers at Minsk to putter about with Polish pictures. The Nazi Governor-General Frank took charge of that. In the spring of 1946, in the Nuremberg Court, Frank denied that he had plundered Polish art. Yet in 1945 some American Monuments men discovered a de luxe, privately printed book that Frank had fulsomely dedicated to Hitler and that contained a list of 521 major Polish items he was supposedly offering as a choice and multiple gift to his Führer. The list included such treasures as Cracow Castle's Gobelin tapestries and the most famous trio of paintings from the Museum of the Princes Czartoryski—da Vinci's "Young Women with the Ferret," Raphael's "Portrait of a Man," and Rembrandt's superb crepuscular "Landscape with the Good Samaritan." Included also were the 25 exquisite "Views of Warsaw," painted there by Belotto Canaletto. These had been pilfered from Warsaw Castle, which the Nazis then blew up, after Polish Jews had been forced to drill the holes for the dynamite. The telltale book and the three Czartoryski canvases, worth millions of marks, were

found by the American Monuments men in Frank's Bavarian chalet, where he had tucked them away appreciatively with a great many other Polish treasures. /

The Russian prosecution at Nuremberg presented a ninety-page document listing examples of art seized or destroyed by what it officially called the Hitlerian burglars. Russian art was treated as savagely as Polish art. Rosenberg's E.R.R. had quickly, as usual, made its appearance in Russia on the heels of the invading Nazi army. It set up headquarters in Smolensk, where experts went to work looting the town's four museums, one of which contained the exhibits the Soviets had shown at the International Exposition in Paris in 1937. The Nazi troops also helped conspicuously by burning the twelfth-century Petropavlovsk and Archangel churches, by stabling their horses in other churches, by dressing up in rich ecclesiastical vestments to make each other laugh, and by building sleeping bunks out of icons.

Both the German Army and E.R.R. bore a loyal Nazi grudge against the homes and towns of notable Russian intellectuals, even though pre-Bolshevik. In the town of Klin, the Nazis demolished Tschaikowsky's house and established a motorcycle garage in the Tschaikowsky Museum, where they kept things snug—until driven out a week before Christmas, 1941—by burning Tschaikowsky's scores in their stove. In the village of Mikhailovskoye, the Nazis burned or sullied the manuscripts in Pushkin's house, a Soviet memorial, where he wrote *Boris Godunov* and four chapters of *Eugen Onegin*. In Kaluga, they set up a hen roost in the Tsiolkovsky Aeronautic Museum honoring the great Russian aeronautical scientist. In Tagenrog, they looted and burned the home of Chekhov, and in Tikhvin they destroyed the home of Rimski-Korsakov. In Kharkov, they used the books in the Korolenko Library as paving bricks to ease the passage of German camions carrying bigger loot along the muddy streets. In Novgorod, they blew up St. Sophia, built around 1050, one of the oldest ecclesiastic architectural curiosities in Russia and a treasure house of twelfth-century frescoes and

icons. E.R.R. gave even more delicate attention to former noble and Czarist domains. With the aid of Foreign Minister von Ribbentrop's Special Purpose Battalion, E.R.R. shipped to Germany all the precious inlaid eighteenth-century furniture from the Pavlovsky Palace in Pavlovsk. It also removed the amber walls of Catherine the Great's amber room in the Ekaterinsky Palace in Pushkin and sent them to Berlin, along with the eighteenth-century painted Chinese silk hangings of Alexander I's bedchamber in the Alexandrovsky Palace. In the town of Petrodvorets, built by Peter the Great with a mixture of Russian, Italian and French taste, E.R.R., in 1941, stole 34,214 art items and 11,700 luxuriously bound old books. From the Petrodvorets palaces of Marly, Mon Plaisir, the Hermitage and the Cottage, it took 14,950 pieces of furniture, much of which Catherine the Great had used. It cut up the enormous ceiling painting "Fete of the Gods on Olympus" in the Hermitage and sent it in bits to the Reich. The Nazi transportation unit that helped E.R.R. and the von Ribbentrop Specials had its own sort of artistic fun. Some of its members set up a latrine and stable in Mon Plaisir's west wing and an artillery emplacement in the Hermitage with shooting galleries in the ballrooms and with statues and portrait canvases used as targets. Others took joy rides in the royal museum-piece rowboats, amid the famous Samson fountain and lagoons, until they sank the pretty little boats. And, as they evacuated the palaces in January, 1944, the Nazi officers and soldiers had the final pleasure of knowing that a delayed-action mine would blow up Marly.

After Germany's collapse, United States Army Monuments men discovered in Bavaria a collection of thirty-nine deluxe photograph albums, the first of a projected series of three or four hundred volumes. They were filled with photographs of the art stolen by E.R.R. from all over occupied Europe for Hitler's Linz collection. These albums were to have been a 1945 birthday present to Hitler from E.R.R.'s faithful Dr. Rosenberg, whose humble note of presentation expressed to his Führer the hope that "your

brief contemplation of these beautiful things of art which are nearest your heart will send a ray of beauty and joy into your revered life."

This dedication furnished in advance the perfect epitaph for Adolph Hitler's art collection.

II. Collector with Luftwaffe—Hermann Göring's Collection

Hitler's corrupting effect on European art was the result of his anti-Semitic fanaticism and his organizing power as the Führer. His wartime preoccupation, however, was war, not pictures. It was Hermann Göring's real passion for pictures—so strong that it repeatedly attracted him away from the battle zones—that led to whatever special contributions he made to the demoralization of European art during the Nazi occupation of Europe. According to Göring, he came by his fondness for art collecting naturally. His Rhineland family had owned a highly prized collection of ecclesiastical garments, which he inherited. His own collecting tastes turned out to be quite different. Göring collected nudes— whether Dianas, Lucretias or Eves—and triptychs and portraits. He was fondest of the great French and Flemish periods, was indifferent to landscapes, and had a weakness for what Europeans call the Mannerist school, which included his favorites, the gourd-bellied Cranach Venuses, and his second favorites, the fashionably melancholy shepherdesses of the Ecole de Fontainebleau. As a connoisseur, he had gusto. On his opening day in the Nuremberg Court, he described himself with arrogant satisfaction as a Renaissance *condotierre*, a historical figure born out of his proper time. His aesthetic taste was sumptuous and eclectic, embracing anything from Roman fragments to Cartier emeralds; it was in the grand manner, and somewhat second class. He had a collector's passion for possession and an art merchant's aptitude for buying cheaply. After the war began, his methods of acquisition became dis-

honorable, ruthless and usually devious: sometimes he stole out-
right and at other times he bought dishonestly, employing
magnificent and legal pretenses that apparently hid the truth
more from himself than from others. Before the war, he had an
art collection of fewer than 200 paintings. When he gave him-
self up to the United States Army's 36th Infantry Division in
May, 1945, near Berchtesgaden, it contained 1,375 paintings in
an accumulation totaling 2,243 items, almost 1,000 of which had
been passed along to him gratis, though not always willingly,
by Alfred Rosenberg's "art-safeguarding" E.R.R.

Göring owned eight consequential German establishments, in all
but one of which—the luxurious hunting lodge Rominten, on the
former East Prussia-Russian frontier, in which he kept only books
—art of some sort was housed. Until, in 1942, the deadly bombing
of Berlin persuaded him to stow his most opulent house furnishings
in the Kurfürst air-raid *Bunker* near Potsdam, they were kept in
his Leipzigerstrasse town house, even though for five years he used
it only for dinners and receptions. At Schloss Veldenstein, a
sixteenth-century castle near Bayreuth that he was restoring, he
kept some of his Gothic tapestries and modern German paintings.
At Mauterndorf Castle, near Salzburg, he kept sixteenth-century
ceiling paintings and his family ecclesiastical vestments. At his
summer place in Berchtesgaden, he specialized in sculpture and
less heroic tapestries. At Gollin, his model farm near Berlin, he
inappropriately stored French furniture. At Ringenwalde, a neigh-
boring eighteenth-century manse, where he invited his bombed-out
Berlin friends to roost, he deposited his 1,200,000-franc Bagatelle
ceiling, reputedly by Fragonard and Greuze. As for his pet property,
Carinhall, which was in the country sixty miles southeast of
Berlin and became his official residence after 1937, it looked like
a country club but was actually a treasure trove. To judge by his
217 deluxe photograph albums, which after the war came into
the possession of the United States Army—the Nazis had an
adolescent passion for photograph albums—Carinhall was abso-
lutely crowded with elegant art, practically none of it German.

Some prewar photographs of the Führer, sheepishly dandling Edda, the Göring infant, robed in long, lacy garments for her baptism, gave that pious domestic ceremony the appearance of having taken place in the vestibule of an auction room. Also in the albums were wartime Carinhall photographs of Göring himself, in white uniform and his hair freshly marcelled, with clusters of medals as big as dahlias on his breast, posed in understandable admiration before a wall covered by his superb eighteenth-century Beauvais tapestries. Then there were snapshots of him in a white dinner jacket, champagne glass in hand, standing in one of his many salons before his gothic tapestries, companion pieces to some Tournai hunting scenes he acquired in France for twenty million francs at the forced sale of the de Sèze collection. There was another snapshot, taken in yet another salon, showing Göring in Luftwaffe regimentals, his large sensual hand lifted like a white signpost to point to an "Adam and Eve" by Cranach the Elder. There was a picture of the Carinhall library, lined with beautiful old books the Nazis stole from Jews all over Europe. His favorite writing desk had once supposedly belonged to Cardinal Mazarin. Another item of the house furnishing was a supposititious Velàsquez which had prompted one of his Paris art representatives to write him, after viewing it, "I inspected the pictures of the Baroness Alexandrine Rothschild, which you have not yet seen, and which the Devisenschutzkommando [Foreign Currency Control] has safeguarded. *This certainly was a sensation*," he underlined with enthusiasm. "Among other things is an enchanting 'Portrait of the Infanta Margarita,' by Velàsquez [as a matter of fact, it was only of the Velàsquez school], which *by all means*," the agent frankly underlined again, "you must acquire. The Devisenschutzkommando office will safeguard these pictures until you come to Paris. This collection also comprises the voluminous collection of modern family jewels, which naturally has been put under seal, pending your decision." Göring and Hitler ended up by splitting the loot between them, which must have been a disappointment to Hermann.

It was the same outside Carinhall as it was inside. On the lawns

was a welter of carved French cupids, Greek satyrs, busts of blank-eyed Roman matrons and marble *amorini* lolling incongruously among the northern shrubbery. There were alabaster vases, Renaissance sundials, porphyry columns, set-piece balustrades and verd-antique hemicycles encircling nothing but the cool Prussian air. Göring and his agents bought, during the war, such a tonnage of weathered antiques and classical garden trimmings in Rome alone that the Italian Minister of National Education made a pointed speech, in 1942, mentioning art and Göring, and later decreed that nobody, meaning the Reichsmarschall, could take any more art out of Italy. Göring thereafter had to ask for a helping hand from the German Ambassador, who was able to sneak out some smaller things by diplomatic courier. One photograph taken at Carinhall showed a stony-faced, spraddle-legged Nazi guard on duty beside what looked like the splendid, long-limbed Fontainebleau bronze of Diana but was really a copy that had been made for Göring by the obliging collaborationist French Minister of Education, Abel Bonnard, who after the war hid out in Spain and was finally sentenced *in absentia* to death as a traitor. He also presented Göring with a reproduction of the Louvre's "Victory of Samothrace." These copies gave rise in France to a rumor that Göring had stolen both of the originals. Göring planned, after the Nazis had won the war, to run occasional cut-rate tourist trains from Berlin to his estate, to give art-loving Berliners a treat and also to give his private loot the air of being practically public, at least several times a year.

When Göring reached the apogee of his looting organization, dozens of people—in E.R.R., the Luftwaffe, the German Red Cross—participated directly or indirectly in his art hunt. Some were on salary; others were collecting commissions or graft. Some worked out of greed; some, who had Jewish blood in their family, out of fear. Some worked with brutal ambition; some for the mere flash of kudos. Göring's most trusted helper was a woman, his private secretary, Fräulein Gisela Limberger, a hard, efficient, knowledgeable blonde, who was manager of a Paris art office he

established on the Quai d'Orsay in 1940. Until early in 1944, she looked after his art, kept his records, administered all his finances, both in connection with art and with other business, and was in charge of a staff of librarians, photographers, art restorers and so on. Because Nazi ideology did not permit a woman to be boss, a man was employed in her office simply to pass her orders on to the other males. Behind his blue-eyed jollity, Göring was on the whole a distrustful and secretive employer. He had to see all except the smallest bills, he demanded receipts, he wanted to know petty office details and he forbade his staff to discuss anything that went on. Soon there were such thrilling scandals in his office that they all gossiped constantly.

The Reichsmarschall's chief art adviser, who in March, 1941, became the titular director of the Göring collection and early in 1944 took over the supervision of the Paris office from Fräulein Limberger, was Walter Hofer, a second-rate Berlin art dealer who was clever enough to know experts who knew more than he did and to pay rock-bottom prices. Hofer refused to accept a salary Göring offered him, but he enjoyed several other advantages: his living expenses were paid by the Reichsmarschall; he had the privilege of keeping any art he bought for Göring that Göring then refused (usually on the ground that it was too dear, and—with the benefit of the Reichsmarschall's cachet—of offering it at a still higher price to others; dealers sometimes padded their prices to Göring, giving Hofer the difference; and, with Göring behind him, he could travel wherever he wished (usually in a Luftwaffe plane), compare markets, meet the bigwigs and, above all, promise Nazi protection to those wretches who were willing to exchange art for safety, always cruelly cheap. It was Hofer who worked out the heartless, shifty, pseudo-legitimate, semi-blackmail technique that characterized Göring's wartime art deals, as distinguished from Göring's wartime art thefts. Hofer was probably responsible for three of Göring's most noteworthy French acquisitions—a pair of Boucher erotica depicting shepherds and shepherdesses in antic delight (painted for Pompadour's boudoir

by order of Louis XV) and a very fine Burgundian primitive entitled "Student with Book," the soberest item in the Reichsmarschall's entire collection.

Another of Göring's agents in Paris was Sepp Angerer, his sculpture-and-tapestry specialist and a smooth international type, with long-established contacts in France, Switzerland, Italy, Spain and Iran. On one occasion, in a loyal effort to obtain a famous Maximilian court tapestry for Göring from a Munich dealer, Angerer distinguished himself by threatening to set the Gestapo onto the dealer. Still another Göring agent, and apparently the least dishonest one, was Walter Bornheim, of the Munich Galerie für Alte Kunst, who had suggested many of the Reichsmarschall's noted birthday presents. Each year, before his birthday, January 12, rolled around, Göring would tell Bornheim what he had his eye on and obsequious admirers would foot the bill for it, hoping he would feel grateful to them. One year, Göring acquired an 8,500 reichsmark ($3,400) South German Madonna this way; another year, a Nazi businessman put up 38,000 reichsmarks ($15,000) when Bornheim had picked out something extra nice. Bornheim was not, of course, a participant in all the Göring birthday tokens. For one birthday, Hitler himself donated one of his own early art efforts, a pastel accurately entitled "House with a White Fence Around it," and in 1942, Mussolini made him a birthday gift of four panels from the Stertzing Altar, a Tyrolese item the Reichsmarschall had hinted he would like to own. A whole *Gau* once chipped in and bought him a battle picture for his birthday, and his Luftwaffe usually remembered him. In 1936, it gave him the 280,000-franc ($5,600) beautiful sixteenth-century French "Portrait of a Man with a Hawk," and in 1938 the 18,000-reichsmark ($7,200) Cranach "Fountain Nymph." Despite all the trouble Göring went to, to be given such fine selected birthday presents, he was not always so sentimental as to keep them; he sold or traded some for other art, often enough.

A so-called Parisian named Gustav Rochlitz seems to have been Göring's worst agent. He was a German-born art dealer, reputedly

a morphine addict and a swindler, who was subsequently taken into custody, like all dedicated Göring men who were caught after the German collapse. He furnished the Reichsmarschall with dubious old masters and exchanged other faked old masters for "degenerate," meaning modern, French E.R.R. pictures with other Nazi bosses who, imitating Göring, had taken up art collecting. In his wake there followed a sinister crowd of collaborationist French middlemen and discreet Parisian gentlemen who acted as contacts for certain high-class French who would not speak to the filthy Nazi Fritzes but were eager to sell them art straight out of their châteaux.

Göring's earliest, most significant acquisition of the war came from Holland, where art sold as freely as tulip bulbs once had. Göring sent Hofer in five days after the lowlands surrendered, and hurried in himself a week or so later. Rosenberg's E.R.R. was then operating only in Poland; in the West, art, as well as other property belonging to Jews, was being seized by Germany's Enemy Property Control and had to be bought at forced sales and paid for, even by Göring, since things were not yet being given away. Much of the art Göring acquired in Holland was sold to him by Aloys Miedl, a German banker turned speculator who—which indicates the sudden importance and increase in the value of art—had taken over the reputable, old-established Amsterdam art shop of an internationally known and trusted Jewish dealer, Jacques Goudstikker, after the frightened dealer died in an attempt to flee to England. Miedl ran the Goudstikker business as a bizarre syndicate, its pictures, or even parts of pictures, owned by frantic shareholders, some of whom were Jews in hiding or other enemy nationals, including the owners of a London gallery. After Göring arrived on the scene, owning part of a Goudstikker-syndicate picture was almost like having a piece of the glittering Reichsmarschall himself. For two years, Holland's art market had been frozen by fear of war, but once the war actually occurred, under Nazi heat it thawed out and had its biggest boom in modern

times. Göring enjoyed first pick of the Goudstikker stock. He enthusiastically bought six hundred of its original three thousand items for two million guilders ($1,360,000) and had to be dissuaded by Hofer from buying everything in the shop, the shop itself, and the land it stood on. This was Göring's first big plunge. Though his purchases included some trash, he nevertheless obtained not only Rubens' "Diana at the Bath," which had been painted for Cardinal Richelieu, but three other nude Dianas, all in the one greedy swoop. He took Rembrandt's "Two Philosophers," which he later gave to Hitler as a present; a lovely Cuyp, "Portrait of a Girl"; Hals' "Portrait of a Young Man"; a rare double-sided Stephan Lochner, a "Nativity" with a "Crucifixion" on the back; and four wondrous, intimate little Memling altar panels, "Musician Angels," which straightway became four of his passions. Miedl, knowing Göring's reputation as a bad debtor, made him put down a million and a half guilders in hard cash when he signed the purchase contract, and promise to follow it by a 500,000-guilder balance within fourteen days. But even though the Air Marshal had to pay something for them, the Goudstikker pictures were a bargain after Göring's heart; Hofer first had figured their real value, then priced them at a fourth of it, as the Marshal's price. What Göring bought for $1,360,000 was actually worth over $5,000,000. After the rest of the Goudstikker collection had been snapped up, the Miedl syndicate acquired, and sold, other items, often inferior but now bearing the famous Goudstikker label, until more than six thousand Goudstikkers were careering around occupied Europe. Experts knew the difference, but gullible Nazis did not and bought them so as to be able to brag that they had the same art merchant as the Reichsmarschall.

When the war moved through Belgium, the second victim on the Nazi's western list to surrender, Göring moved in behind it, as if holding a basket ready to catch the loveliest debris. By intervening for Miedl in the officially closed Brussels stock market, Göring enabled him to obtain some specific securities Miedl needed in order to buy the great Renders collection, the largest group of

Flemish primitives in private hands. Göring then acquired seven of these—an inspiring purchase, which contained five Madonnas, including two by Memling and one by Roger van der Weyden. By now he had warmed to the pleasures of ownership and collecting. His vast buying power came from German victories; he dominated the market and rigged his payments—most of the time he finished by not paying a penny—and managed to satisfy a greed which surpasses the imagination, along with his more rarified sensual aesthetic appetites.

Then came the fall of France, the richest, most succulent and final victim in the West. When Hitler made his single visit to Paris, as its peasant conqueror, what he was most interested in seeing was the Eiffel Tower. Göring, who prided himself on being of country gentry, made thirteen visits to Paris—where E.R.R. maintained its Western European headquarters, in the Hotel Commodore—and what he went to see there, like a gentleman, was art. He not only dominated E.R.R.; he demoralized it. The Führer, preoccupied with his war and doing his hierarchical collecting only through his art factota, received, as was considered his due, the most and the best of the E.R.R. plunder, but Göring, who carefully decided in advance what he would steal, and who, in at least two instances, even stole what had been stolen for the Führer, received really passionate pleasure from his art and acquired a far more interesting and individual collection. A few weeks after Göring's initial visit, in November, 1940, to the Jeu de Paume Museum, E.R.R.'s Paris clearinghouse for its loot, E.R.R. sent an alarmed report to Rosenberg, at that moment in Berlin, prophetically declaring its fear that the Reichsmarschall would override Hitler's basic directive establishing E.R.R. as a looter of Jewish art treasures for essentially national propaganda purposes and turn it into a looting outfit operating for Göring's benefit. A second directive from Hitler, ordering that the more elegant cultural objects, such as the best in the Rothschilds' collections, be sent to him for disposition rather than to an art depot for various national museums or even for Rosenberg's pet project, his postwar anti-Semitic academy, must have pained Rosenberg. However, since

the Führer could properly be considered the personification of Nazism as well as of the Reich, Rosenberg and his E.R.R. fanatics felt that the aim of his and their looting was still ideological and national. But when Göring began muscling in—gangsters' terms described him perfectly—E.R.R. knew that what he took was destined for his private collection and that the academy and national museums could, as it were, kiss it good-by. E.R.R.'s intention, from Göring's first move, was to resist him. Yet, for two whole years, Göring dominated E.R.R. by his brute political weight, by his enormous lust for art, by his willingness to go, like an inflamed lover, long distances to visit it, and, above all, by his having the means to carry it away. Göring had four private trains—one de luxe passenger unit for himself and his staff, two express trains of two cars each, and a private freight train—plus a Luftwaffe fleet of trucks and the Luftwaffe itself to carry packages for him. Against all that, Rosenberg was helpless. He was merely a fuzzy-brained, philosophizing, anti-Semitic dreamer, a weak, unpopular figure in inner-ring Nazi politics, a nitwit about art, and powerless to prevent what Göring was doing, since much of the time he could not even be in Paris to try to stop him, being first compelled to stay in Berlin, in his Office of World Outlook, as it was seriously called, and then to assume other duties in occupied Poland and Russia. Furthermore, when Hitler's second order suddenly turned Rosenberg's Paris office into a big-scale picture-, statuary- and furniture-moving business, it was not provided with adequate transportation to handle the task of shipping the choice portions of the loot to Hitler, as Rosenberg had been told to do. Göring, by occasionally giving E.R.R. his planes, trains and trucks—mostly to transport loot that he wanted for himself—posed as a kindly benefactor and lender of a helping hand until he had established himself as a beneficiary on the inside track.

To make his art operations easier, Göring had a couple of henchmen at the source, inside the Paris E.R.R. itself, to raid for him. He obtained them simply by spotting the two most ambitious men in E.R.R. and making them his personal representatives. One of them, top man at the extremely important Jeu de Paume clearing-

house and for two years E.R.R. chief for all France, is still a legend among Paris museum folk. He was Baron Kurt von Behr, a handsome, unscrupulous, middle-aged Mecklenburg aristocrat who was an ignoramus about art, an Oberführer in the German Red Cross, a lavish entertainer in chic Nazi circles and a lady killer with an attractive, masochistic English wife. His liaison with a plebeian E.R.R. secretary, Fräulein Ilse Pütz, their *scènes galantes* in the Tuileries Gardens, and his black-silk-hung private apartment amidst E.R.R.'s offices in the Hotel Commodore provoked such a scandal in Paris that Berlin finally withdrew Fräuline Pütz from view. The end of the legitimate baronial couple was even more picturesque—perhaps the most elegant of all of Germany's postwar suicides. As Allied agents, bent upon arresting the Baron for his complicity in the E.R.R. rape of French art, closed in upon his castle in Germany when the Reich began to collapse, he and his still devoted English wife drank vintage champagne mixed with poison. Another casualty of E.R.R. was Dr. Hermann Bunjes, who, as director of the Deutsche Kunsthistorische Forschungsstätte, or German Art Historical Institute, in Paris, worked as liaison officer between the Nazi Kunstschutz (the Nazis' "art-protective" agency, which kept an eye on state museums and monuments in the occupied countries) and the French museums. Bunjes, who posed as an adorer of French art, was almost the nastiest piece of goods in the game. His reply to the Louvre's stern protest against the German plundering of Jewish-owned art is a classic in Nazi insolence and illogic. He said that the Nazis had seized no Jewish-owned art because Jews had no property rights and therefore owned nothing: that whatever the Nazis had seized from the Jews was disappointing in value and taste: that certain French Jews were continuing the war against Germany in the United States, and that anyway the French were not showing the proper gratitude for the Germans' safeguarding of French art in France generally. Trailed by American Army secret-service men after Germany's fall, Bunjes hanged himself in Trier, his art-loving, once elegant home town.

Von Behr had started working for Göring in November, 1940.

He was soon assisted by Göring's second E.R.R. man, the art historian Dr. Bruno Lohse, who was the son of a musician in the Berlin Philharmonic. Their mutual work was simple; whenever the Reichsmarschall was expected in Paris, they arranged a private exhibition of the latest pillage to his taste at the Jeu de Paume, and, when he had departed, they shipped after him what he had chosen. With all the E.R.R. treasures to choose from, even the ignorant von Behr could work up a superb exhibition in forty-eight hours, complete with new nudes, tea, champagne and potted flowers—the regular program. Sometimes Göring arrived at the Jeu de Paume in full dress, carrying his Reichsmarschall's baton and surrounded by his retinue, who laughed loudly if he smiled and frowned industriously if he scowled. Sometimes he arrived straight from the front in boots and a stained raincoat. Between the Novembers of 1940 and 1942, ten such shows were staged for him. In each instance, he made a list on the spot—known as "the G. List"—of what he wanted, and it was all immediately delivered. "The A.H. List," of what Adolf Hitler ought to have, was made by the Führer's art advisers in Germany. By deliberately inscribing A.H. items on his G. list when in Paris and having his henchmen ship them to Carinhall, Göring picked off what he considered three of the finest pictures from the Rothschild collections—a Prud'hon "Bathing Girl," Fragonard's delicious "Girl with a Chinese Doll" and the so-called Velásquez "Infanta." Later, Hitler's chief art adviser, the director Voss of the Gemäldegalerie in Dresden, wrote him a letter timidly and vainly complaining that twenty-five French masterpieces on the Hitler list had somehow gone to Göring. Among Göring's more normal E.R.R. booty were Chardin's "Little Girl Playing Battledore and Shuttlecock," six lovely Italian panels by the Frenchman Hubert Robert, and a Clouet, a Holbein, a Boucher, a Rubens and two Fragonards. One of Göring's most famous pirated objects d'art was an enormous, perfectly preserved limoges enamel portrait of Catherine de Médicis, surrounded by fancy court figures. The booty that reportedly gave him the grimmest political satisfaction was a copy of Germany's 1919 peace treaty

with France, from the library of the late French bibliophile and statesman Louis Barthou. Bound in with it are pages in the handwriting of Poincaré, Clemenceau, Joffre (his order for the Battle of the Marne) and Foch (his order for the Battle of Amiens), as well as the last communiqué of the First World War, signed by the then victorious Pétain.

Through 1941, E.R.R. was never able to do anything against von Behr and Lohse because of its own administrative confusion, to which this precious pair contributed a good deal. They bustled Göring's loot out so fast and surreptitiously that the E.R.R. card indexes, which were supposed to show where everything was, fell into a temporary muddle. Besides, Rosenberg had set up in Berlin such a labyrinthine organization, with a Rosenberg Chief Office, and, within that, the Reich Leader Rosenberg Task Force for Occupied Territories (E.R.R. itself), an Office for Pictorial Arts, a Foreign Political Office, a Central Office for Art Administration and several others, that he probably never did know exactly what the Reichsmarschall's two men were concocting, being too preoccupied with his own multiple affairs. Finally, even if he did know, he was not on a high enough bureaucratic level to be able to eject them, as long as Göring stood behind them. Rosenberg was an unattractive, solemn, ineffectual creature, helpless against the popular gangster, Göring.

Göring paid for his art, when he paid for it at all, through an Art Fund account (with an average balance of between a million and two million reichsmarks, maintained by Hitler principally out of state funds) at the Preussischer Staatsbank. As Economic Director of the Reich, and as head of the Finance Control Kommando and the Foreign Currency Control, Göring was in a position not only to favor himself by pilfering from Hitler's art funds to pay for his own acquisitions but to declare foreigners' art a form of *valuta* and freeze it until he could get around to paying for it. In France, he was further aided by his friend General Ministerialrat Michel's Military Government Financial Section, which obligingly

froze the contents of Jewish-owned safe-deposits boxes for him—
if they contained interesting art, jewels or foreign currency—in
Paris banks, among them the Banque de France, the Credit Lyon-
nais, the American Chase National and the British Westminster
Foreign Bank. In other ways, too, Göring seized a lion's share of
the currency captured in the occupied countries. To top it all off,
during the war years this good-natured darling of German big
business received the equivalent of around a million dollars an-
nually through a kind of good-will slush fund contributed by
industrialists, intelligent, rich and corrupt enough to butter up the
Air Marshal to be sure of his protection.

In the prisoners' box at Nuremberg, Göring disarmingly told
the Tribunal that early in the war he had inquired whom he
should pay for his E.R.R. art loot and that the Reich Finance
Minister had advised him that he need pay no one; it was thus
that Göring indicated it had always been his gentlemanly intention
to pay a little something or other, to someone, some day. His testi-
mony was a characteristic mixture of lies and face-saving. He not
only had tried to avoid paying for any of his loot but he had used
E.R.R. art, especially modern French art, to conduct a shoddy
financial operation, apparently concocted by his agent Hofer,
which Göring finally forced E.R.R. to announce, in a directive,
as its official policy. Even Hitler's agents, also operating under this
directive, swapped and sold old masters in a remarkable traffic that
Hitler clearly knew nothing of, probably because, being a tyrant,
he was ignorant, on his heights, of what was going on below. Gör-
ing's new scheme involved chiseling on his own men. The opera-
tion went like this: not only did he keep for himself the best of
the nineteenth- and twentieth-century French art that E.R.R.
seized—so-called degenerate art, which good Nazis were forbidden
by Hitler to collect—but he foisted some of the modern pieces he
cared least about on his own art merchants in lieu of money to pay
them for the old masters they furnished him. He was at least
liberal in these transactions; he rated his French moderns at only
a fraction of their value. Rochlitz, the first Paris art dealer the

trick was tried on, refused the proposition—which promised huge
profits eventually but would have left him temporarily stripped
of funds—until Lohse threatened to denounce him as an enemy of
the Reich. So for a sixteenth-century portrait of Titian's daughter,
attributed to Bordone, Rochlitz finally had to swallow as payment
from Göring eighteen French moderns—two Renoirs, two Degases,
two Sisleys, a Cézanne, a Toulouse-Lautrec, a Monet, a Manet, a
Boudin, a Berthe Morisot, a Signac, a Utrillo, a Bonnard, a Picasso,
a Matisse and a Braque. Göring acquired seventy-two Dutch,
French, German and Italian old masters by this painless method.
Working an even harsher variant of this system, he forced Miedl
to accept his valuation of 675,000 reichsmarks ($270,000) on five
E.R.R. moderns which were worth, according to E.R.R. appraisal,
about $25,000—pictures that Miedl profoundly did not want,
especially at such a price, and that, naturally, had not cost Göring
anything. Miedl had to be graceful about it. After all, Göring
had just helped him get his Jewish wife to safety in Switzerland,
and besides, the paintings were to be delivered to Miedl in Switzer-
land, where he could sell them for the Swiss francs his family
needed to live on. Humanity from the Reichsmarschall came high.
On another occasion, nine E.R.R. Paris moderns turned up in
Florence; there Göring traded such gems as Sisley's "The Seine at
Argenteuil" and "The Thames at Hampton Court" and a Renoir,
"Woman Dressing," for Tuscan bric-a-brac. His racket was par-
ticularly successful when carried on for him in Switzerland, where
French moderns were prized and were accepted at face value,
as a useful ersatz for the dollars and pounds that Swiss art mer-
chants coveted and that even Göring could not lay hands on. He
extracted from Switzerland a Rembrandt, the excellent Lucas Cra-
nach the Elder "Portrait of a Young Man with a Beard" (evaluated
at 45,000 Swiss francs), and two tapestries designed by van Leyden
by trading E.R.R. canvases by Courbet, Degas, Daumier, Seurat,
Manet, Corot and others. Giving up so many fine moderns must
have hurt Göring, for he admired some of them, no matter what
his strict Führer said about their degeneracy. At the end of the
war, it was found that Göring had saved for himself, among many

others, Corot's "Southern Harbor," a Cézanne called "House," Berthe Morisot's "Madame Lucy" and, inevitably, a pair of Degas ballet girls and a couple of Renoirs. Van Gogh was Göring's favorite modern, and he had two fine ones, "Houses in a Garden" and "Two Sunflowers." His largest modern nude, Picasso's "The Giantess," escaped him at the last moment. She was an old Rosenberg Gallery girl, who, belatedly seized by E.R.R. and then tagged for Göring, was in the last carload of loot the frantic, fleeing E.R.R. tried to send out of Paris by train as the French and Americans liberated Paris. At the Nazis' insistence, the helpless French packers at the Jeu de Paume entrained the giantess, right enough: but they entrained her in a car on the Paris belt railway, on which she slowly circled the city till the Liberation saved her.

These sequestrated French moderns that Göring sold, shyster fashion, in 1941 and 1942 were pictures that in 1940 he had proposed, in his *grand-seigneur* manner, be auctioned off for the benefit of French war orphans. In 1946, he told the Nuremberg Tribunal all about this noble proposition but nothing of his evil practices with this modern art, and the Allied prosecution, though fully documented on his traffic by SHAEF's Monuments, Fine Arts, and Archives men, for some reason failed to say anything to him about it in cross-examination. Considering what a robber and dishonest, cruel collector he had been, the court let him off very easy indeed in those cross-examinations. For instance, they let him complacently state that the valuations on the French moderns he disposed of had been set by a French art expert, Professor Jacques Beltrand, formerly of the Beaux-Arts, without making him add that the professor was his collaborating dummy, who had, for example, lumped a Modigliani, a Renoir and two Matisses together for a hundred thousand francs ($2,000), which would have been too cheap for any one of the four, and that the whole deal, which was delightfully convenient to the Reichsmarschall personally, was only a small part of the great, cold plan he had devised, as Economic Director of the Reich, to debase values in France.

Göring's last triumph in the Nuremberg courtroom concerned

Gregor Erhart's "La Belle Allemande," a life-size, *echt Deutsch*, painted wooden statue of a blond-haired, fat-buttocked, naked, sixteenth-century *Hausfrau*, which Paris had taken for granted that he somehow filched from the Louvre, in whose polychrome collection it belonged. The Nuremberg Tribunal allowed Göring to protest righteously that he had not stolen this beauteous German but had obtained her in an exchange for two works he had purchased, without forcing him to add that another, finer Louvre work, a triptych entitled "Presentation of Christ in the Temple," had been exchanged principally for a fine Coypel canvas he had really stolen from one of the Paris Rothschilds. When, in his final confidence about art to the Tribunal, in his effort to legitimatize his devious, shady art deals, Göring indignantly said that whenever he had tried to pay real cash for art in Paris, the Parisians had invariably doubled the price on him, the two French judges were seen to smile for the first time since they had taken their places on the bench.

Göring's demoralization of the Paris E.R.R. reached its climax in 1941 when, following the bad example of his Baron von Behr and la Pütz, the entire office turned into a love nest. Two out of Rosenberg's five male art historians, Doktors Scholz and Schiedlausky, and a business manager named von Ingram, became involved with four of the E.R.R. Fräuleins, and E.R.R. seethed with recriminations and rendezvous. Frau Doktor von Ingram, an E.R.R. art historian herself, forced her husband to discharge both his inamoratas—his secretary and Fräulein Doktor Eggeman, another lady historian. Lohse, in love with nobody, forced Scholz to reinstate Eggeman, who had meanwhile found part-time employment with Otto Abetz, by then Nazi High Commissioner of Occupied France. When Lohse insisted that she give E.R.R. full time, she ungratefully quarreled with him and so successfully intrigued with Dr. Walter Borchers, his nominal boss, that Borchers sacked him. Lohse, being a Göring special, naturally stayed right on. Other dissensions also shook E.R.R. Both Goebbels and Martin Bormann maintained feeble feuds with Rosenberg. Bormann and Göring

had a hearty feud of their own over E.R.R. matters. E.R.R. was buffeted by everybody's power quarrels. Bormann, who ganged up with Himmler, dealt a blow at E.R.R.'s authority by claiming that since Jews were state enemies, his friend Himmler's S.S. police, not Rosenberg's art gentry, should confiscate Jewish documents. Then Himmler did his bit to hinder E.R.R. by influencing the Occupation Wehrmacht units to refuse to give it supplies, including gasoline and motorcars. (Rosenberg's stock eventually dropped so low that for nine months he could not obtain an interview with Hitler, and everybody knew it.) There was also a squabble about Rubens' "Venus and Adonis" when it was put up for sale in Paris. A Göring agent claimed he saw it first, but a Hitler agent got it by ordering an Embassy attaché and two Gestapo officers to seize it in the sacred Führer's name. Göring furiously ordered an investigation of this pre-emption and, before he was through, won it, thus gaining his nth naked Venus. While greedy, ambitious Nazi chieftains tried to fasten like incubi on what seemed E.R.R.'s sinecure of handling art, the old-guard Junkers denounced the whole E.R.R. organization and their Reichsmarschall's part in what they described as a vulgar and even felonious performance. Count Wolff von Metternich, elderly scion of the distinguished diplomatic family and almost the only respectable German art man in Paris (he represented the Kunstschutz), also decried E.R.R. and all concerned.

Even severer observations on the conduct of E.R.R. were being made and compiled by Mlle. Rose Valland, one of the few women curators in France, who was in charge of art conservation at the Jeu de Paume Museum when the Nazis moved in on it. She thus had them, their stolen French treasures, their Göring exhibitions and their quarrels right in her lap. Though repeatedly threatened with arrest by the Nazis, she was never ousted by them, perhaps because they needed someone French to blame when their own men or plans went wrong, which was not infrequent. Mlle. Valland, being what the French call *une femme de tête*, intelligently and courageously accepted all the blame in the hope that she could

stay on and thus perhaps discover where the Nazis were sending the loot. It was a dangerous undertaking, but, before 1942 was over, she had found out what she wanted to know, even though the addresses of the Nazis' art caches were in cipher and were top secret. She discovered that E.R.R. had been shipping whatever plunder survived Göring's raids to five famous castles—Neuschwanstein, Chiemsee, Kögl, Seisenegg and Nickolsburg—and to one monastery, Kloster Buxheim. It was this information of hers, eventually transmitted to the Monuments men, that enabled them to find the stolen treasures.

The struggle between Göring and Rosenberg to control E.R.R. matured in 1942. Göring, aware of Rosenberg's growing rebelliousness, sent him a couple of letters, first suavely reminding him of the private trains, trucks and planes he had occasionally lent E.R.R., and then claiming that his organization had helped E.R.R. seize a great part of its acquisitions. At this, Rosenberg must have appealed to Hitler, now deep in Communist Russia and hopeful again that Nazi propaganda would have greater value than any trumpery art. In March, 1942, Hitler repeated his fanatical order of January, 1940, that the Paris Kommandantur aid Rosenberg in collecting his propaganda data, adding hysterically that "the ideological fight is now a military necessity. It is the Jews, Freemasons and ideological enemies who are responsible for the war now being waged against the Reich." Then Rosenberg, slowly summoning his courage, struck his first and last vengeful blow against the Reichsmarschall. In June, 1942, he wrote Göring a letter, servile in tone but precise in content. He told Göring that he could have no more E.R.R. loot and that what he had already taken should be turned over to the National Socialist party—one day, he added tactfully. He declared that, according to Hitler's E.R.R. directive, all Jewish-owned goods had been seized for Rosenberg's postwar anti-Semitic, anti-Masonic academy and that in any case it belonged to the Nazi party, which "has paid for the battle against the Jews for twenty years. Art confiscations can no longer be considered measures of safeguarding or of seizure but only a kind of booty, acquired

through the triumph of the German people over the Jewish people, who have been declared outside the law." Göring did not deign to answer the letter. Instead, in November, he attended his final private Jeu de Paume exhibition and selected his final clutch of plunder. He never returned. There was nothing much left for a connoisseur like himself to covet.

One year later, to Göring's enormous annoyance, he was compelled to refuse the greatest birthday present of art ever dangled before the eyes of contemporary man. In October, 1943, his Hermann Göring Division, then operating in Italy, stole and trucked off to its headquarters, a villa near Spoleto, the bulk of the treasures of the Naples National Museum and of two other museums, which the Italian government had hidden in the subterranean passages beneath the soon-to-be-embattled Monastery of Monte Cassino. Since the Axis powers were still allies, and since the Führer had issued a firm order about the sacredness of Italy's art, this was not lighthearted looting of an enemy but plain, insubordinate stealing in the eyes of the German Headquarters Army Group, which however did not dare say so, because the sky was the limit for the unruly, privileged Göring flyers. It was the Division's plan to present the theft to their chief in Berlin, as a surprise, on his approaching fiftieth birthday. The real surprise was that Göring officially refused beforehand to accept the dubious gift, since it had already become a hilarious scandal even in solemn German Army Group Headquarters circles. For the next two months, his fliers were repeatedly asked, please, to turn in their swag, if not to the Italians, whom they laughed at, or to the German Kunstschutz, which they despised, or to their own Headquarters Army Group, whom they ignored, then at least to the Pope. The Hermann Göring Division obligingly began taking bits of the booty back to Rome, in part to Vatican protection and in part to Il Duce's office, in the Palazzo Venezia, where he was still doing business. Then, after Rome fell, the Kunstschutz, which had at least nominal charge of the art treasures of Italy, discovered, but only by listening to the Allied radio, that Göring's warriors had held back fifteen

cases of the Naples plunder. It heard that the fifteen missing cases contained at least three of the Naples National Museum's greatest works of art—Breughel's masterpiece, "The Blind Leading the Blind," which seemed wonderfully appropriate to the matter at hand, the splendid Roman copy of a Greek life-size bronze statue of Mercury, and, best of all, Titian's "Danaë," naked in her shower of celestial gold. When it presently heard that the lost cases were safe at Field Marshal General Kesselring's headquarters at Monte Soratte and ventured to ask questions, it was sharply told to mind its own business. The next thing it overheard was that the three great works had arrived in Berlin a few days before Göring's birthday. Göring heroically refused to accept even this small fraction of the haul and passed the three great purloined works along, rather like three hot potatoes, to Bormann, who shipped them to the cache in the Alt Aussee salt mine, where the American Monuments men found them in the spring of 1945.

The last of Göring's princely art acquisitions furnished the final touch of grotesque comedy. In February of 1944, through his agents in Holland, Hofer and Miedl, he acquired "Christ and the Woman Taken in Adultery," a fantastic Vermeer fake, fresh from the brush of a brilliant Dutch counterfeiter named Hans van Meegeren, along with seven lesser, though genuine, pictures (valued at 550,000 guilders, or $374,000) in exchange for 150 paintings worth 1,650,000 guilders ($1,122,000). Nazidom's prime connoisseur had achieved a notable art record. He had lost about three quarters of a million dollars on legitimate pictures for the dubious privilege of giving the third or fourth highest price ever paid for a Vermeer, real or false. And his was famously false. He and Hitler, who both itched for it, at first refused to buy it for fear it might belong to a Jew, who they thought might then blackmail them for the Nazi crime of having bought rather than having stolen from the scorned race. Göring, warmer in his passion for what he erroneously believed was fine art than his Führer, took the ideological risk. It was typical of the *condottiere* fractional element in his nature.

The most interesting and cruelest development of the final historical months of the Reichsmarschall's collection was that Göring, from February, 1945, until his capture in May by the Americans, was more concerned with trying to save his art than he was with trying to save the Nazi Reich, to which he owed everything including his magnificient treasure trove. As Germany crumbled, his fear for his art became almost a panic. He made decisions only to change them. By conflicting orders and counter commands, he threw his railroad staff, his art advisers, his henchmen and even the art itself into a perfect mare's nest of confusion and danger. During the holocaust of February, after the terrible bombing of Berlin had commenced, he decided to move everything important from Carinhall's main air-raid shelter and from the Kurfürst *Bunker* to greater safety. Between bombs, he and Hofer waded feverishly through his collection to choose what should go first. Göring wanted to ship all his purchased art out in the first load and send his E.R.R. loot later; Hofer advised first sending out the best of E.R.R. and pure Göring combined. Göring, taking Hofer's advice, decided to ship the cream of each group to his Schloss Veldenstein, and then a second caravan to his new air-raid shelter in Berchtesgaden, which he promptly learned was not finished yet, necessitating a fresh change of plans. Shortly afterward, he was reminded that the doors of Veldenstein were too narrow to admit large objects. In desperation, he decided to ship only the smallest and finest of the two groups to Veldenstein, which meant that the Bagatelle ceiling at Ringenwalde, among other things, had to be abandoned. One shipment finally left Berlin in February, in one of his private trains. After another feverish session of choosing and calculating, a second shipment got off in March. An April shipment, which emptied the Kurfürst *Bunker* and nearly emptied Carinhall, was loaded and ready to leave from Göring's private Carin station when he sent the train commander an insane stop order and instructed Hofer to go to Veldenstein and pack up everything already arrived there for a further move. After a week of waiting on the tracks, the April load was routed to a point near

Bad Reichenhall, where the first two Veldenstein loads met it, by appointment. Then the three loads, containing the most valuable elements in all his collections, proceeded together to Berchtesgaden, where, since his *Bunker* still was not ready, the trains, with their incalculably priceless and fragile freight, huddled in the Berchtesgaden station tunnel for safety from Allied bombers, with Hofer and the guards aboard. One or two days later, eight carloads of the most precious valuables were, on inexplicable orders from Göring, sent to a shelter at Unterstein, near the Königssee. There remained in the tunnel the cars containing his finest furniture, some fine canvases, his art library and his art records. He himself soon arrived at Berchtesgaden to choose further among the art left in the tunnel, and there, busy with beauty, he was arrested, with one of his liaison officers by Hitler's S.S. on April 30. Even with the terrible charge of treason in the air and the Marshal under guard, his art dominated the scene, was more important than disgrace, than the highest tottering affairs of state or the imminent crumbling of the Nazi Reich. The following day, on Göring's frantic insistence, the liaison officer was released, with orders to bring back the cars that had gone to Unterstein and to sort out the collections for the absolutely last time, putting Göring's art in a Berchtesgaden shelter for his personal staff that did happen to be finished, and leaving, if necessary, the E.R.R. booty in the tunnel. This was done, as far as possible, but the shelter proved not ample enough for such voluminous treasure, and the magnificent leftovers had to be confided to a local Nazi official who ran a grocery shop, in which, greatly honored, he hid some of Göring's paintings among his miserable, dwindled supply of edibles. The awe-inspiring, ill-begotten, fabulous and magnificent collection of art that Göring had raped from Europe was now close to its final indignity.

A day or so afterward, the U.S. Seventh Army arrived at Berchtesgaden and in the battle machine-gunned Göring's art train in the tunnel. Lancret's "Hunters at Luncheon" and several other pictures were shot. On May 4, the 101st Airborne Division fol-

lowed the Seventh Army into the town. After inspecting the air-raid shelter and finding Göring's art inside, the Americans started shipping it back to Unterstein. There they set up a sign, "Göring Art Collection, courtesy 101st Airborne." This was the ultimate humorous humiliation which beset it.

As the American troops swarmed almost like tourists over the area, the two sites most visited by the soldiers and officers were the Führer's former eyrie, bastioned on the heights above the village of Berchtesgaden, and Unterstein, with the Air Marshal's art, double proofs to the Army that with these two captured properties of the two leading Nazis, the Nazis had lost their war. The Marshal's collection was a sensational success with G.I.'s who had never seen an art exhibition in their lives but who had all heard of the fat Göring and his fancy uniforms and wanted to take a look at his private possessions as one of the most satisfying spectacles in Europe. When they began streaming by jeep into Unterstein it had already become one of the most conglomerate, revelatory art shows in history, for by this time the collection, on view upon the castle floor, included the Reichsmarschall's gold dinner plates from his country home in the meadows outside Berchtesgaden and his gold hairbrushes. The exhibition had been added to as the Airborne men collected further Göring possessions which had been picked up by Berchtesgaden peasants and by the souvenir-loving American Army. After it all came under the guardianship of the 101st Airborne, only two small Memlings, one small Cranach and a couple of pocket-size Dutch masters disappeared—a remarkable record for the American armed forces.

Around the middle of May, Hofer, having decided to carry out his final order from his chief, who had meanwhile been rescued from the S.S. by the Luftwaffe, reported to the Allied Military Government in Berchtesgaden and said that he "wished to help" take care of Reichsmarschall Göring's valuable art collection. To the scandal of some Americans and of all of the Allied chiefs who heard of it, Hofer's offer was accepted with alacrity. For several months, he was *persona grata,* but then his waning

utility, and the growing criticism of the American folly and lack
of dignity in having made such speedy use of him, an enemy agent,
combined to put him in jail, at least for a brief period.

When Göring finally turned himself over to the American Army
authorities, he had with him no riches beyond his confident smile,
his jeweled Reichsmarschall's baton and his costly array of medals.
But when Frau Emmy Göring was put under guard at Mauterndorf
Castle, near Salzburg, one of her husband's favorite pictures,
Memling's "Flight into Egypt," was symbolically enough, found
among her luggage. Indeed her bags were loaded with art works,
which an officer of the 101st Airborne relieved her of. As the art-
loving Reichsmarschall's proxy, the Reichsmarschallin had his
Roger van der Weyden Madonna from the Renders collection in
Brussels, a Madonna from a Rothschild collection in Paris, the
Dutch Goudstikker quartet of tiny Memling "Musician Angels"
that were his four little passions, the French Burgundian primitive,
"Student with Book," and the great fake Vermeer.

III. The Monuments Men

At the height of its war effort, the United States had
almost three million men under arms in the European Theater of
Operations. Exactly one dozen men out of these millions were
functioning, under G-5, Operations Branch, SHAEF, as a *raris-
simo* group known as Monuments, Fine Arts, and Archives. Up to
almost the end of the war, it was the modest task of these very few
American Monuments men, and their two or three British col-
leagues, to try to check on and protect, over an area of thousands
of square miles, what was left of the Continent's art and historic
monuments. And when peace came in Europe, it was the aim of
this group, then swollen to some twenty-five members (officers,
sergeants, and pfc's, mostly Americans), to collect a few hundred
thousand items of displaced art—French, Dutch, Belgian, Czech,
Russian, Polish and even German—to be returned to or held in

trust for the proper people in whichever country they had been owned before 1939.

In 1942, the American Defense-Harvard Group and the Committee of the American Council of Learned Societies, two groups interested in the protection of works of art in the war zones, had drawn President Roosevelt's attention to the unavoidable probability that Europe's beauty would suffer martyrdom when the Allies invaded the Continent. As a result, Roosevelt created, in 1943, the American Commission for the Protection and Salvage of Artistic and Historic Monuments in War Areas, more conveniently known as the Roberts Commission, because Justice Owen J. Roberts, of the Supreme Court, was its chairman. The Roberts body acted as intermediary between the War Department and scholars from Columbia, Harvard's Fogg Art Museum, the Metropolitan Museum, the Frick Art Reference Library and other erudite centers that supplied the Army with information for what was called the *Supreme Headquarters Official Lists of Protected Monuments,* a vast, military guidebook of historic lay buildings, churches and museums that were to be saved during the activity of invasion, if possible. That is, they were not to be targets, or be slept in, or be looted. Monuments, Fine Arts, and Archives, operating in the field, took up where the Roberts Commission left off. The optimistic prospectus set forth early in 1944 for the M.F.A. & A. envisaged a bang-up Allied advisory staff, topped by a lieutenant colonel, with sixteen majors, more than half to be American, aided by a number of predominantly American field outfits, each containing a minimum of twelve junior officers; plus an officer attached to the H.Q. G-5 of each army, and three more officers under him at the front, assisted by six enlisted men. All of them were to be kept scurrying around Europe in trucks and jeeps, with cameras and typewriters, so they could send to the rear "a constant flow of reports and information," under fifteen subheadings. That, at any rate, was the official dream.

Eleven days before the Normandy invasion, General Eisenhower issued a letter to field commanders that began, "Shortly we will

be fighting our way across the Continent of Europe. . . . Inevitably, in the path of our advance will be found historical monuments and cultural centers which symbolize to the world all that we are fighting to preserve. It is the responsibility of every commander to protect and respect these symbols whenever possible." On June 6, however, art preservation must have been the last thing the field commanders thought about as they battled for an invader's toehold in the Atlantic Wall, blasting Gothic spires and billeting their tired, dirty men in any Norman château, full of art or not, that they were lucky enough to find intact. In any case, no Monuments men were present to make suggestions. About a fortnight later, two American Monuments officers, Captain (afterward Major) Bancel LaFarge, A.U.S., and Lieutenant George Stout, U.S.N.R., and one Englishman, Squadron Leader J. E. Dixon-Spain, R.A.F., arrived in Normandy—without typewriters, cameras or trucks— and were turned loose to hitchhike toward their goal, the salvation of art. The situation the trio found themselves in was novel. They had to explain, practically in the heat of battle, who they were, what they were trying to do, and why. Their task was to give first aid to badly injured art (though they had no supplies to repair with), to prevent improper billeting in historic buildings (though the field commanders were supposed to have the *Protected Monuments Lists* with them, even if they did not read them) and to inspect and report on the state of the monuments to be protected (though they had no machines to inspect in or to type with). Whether the whole Monuments project was to continue or be scrapped—the latter was greatly favored by some brass hats before the scheme was even tried—depended on the kind of show these three (and three other Americans and two other British, who were added before the summer's end) were able to put up. The amazing accomplishments of these eight men, who at first had to make their way by riding on anything from regimental laundry trucks to liberated bicycles, resulted in the piecemeal arrival of the Allies' full wartime art group, which—the early ambitious plans forgotten —was maintained at an average strength of fifteen, and which,

up to the end of hostilities, with unbelievable efficacy and
ubiquity, scoured France, Belgium, the Netherlands, Luxembourg
and Germany and actually inspected 3,145 monuments and ar-
chives, or what was left of them.

The M.F.A. & A. was probably the smallest outfit, and was cer-
tainly the most recherché one, in the Allied armies. Once, in the
autumn of 1945, shortly after the German capitulation, it swelled
to eighty-four officers and men, but while the fighting was on,
no such number, it was felt, could be spared for mere art. About
half of the Americans in the M.F.A. & A. had been recommended
by the Roberts Commission for transfer to Monuments on the
basis of their highly distinguished and knowledgeable civilian
backgrounds. They were largely youngish art professors, museum
curators, sculptors, painters and architects, and occasionally talented
dilettantes. Their chief adviser to SHAEF was the Slade Professor
of Fine Art from Cambridge University, Lieutenant Colonel Geof-
frey Webb. Some of the luminaries among the earlier American
Monuments men were—in addition to LaFarge, who had been a
New York architect, and Stout, who had been an expert on con-
servation at the Fogg Art Museum—Lieutenant Lamont Moore,
National Gallery, Washington; Lieutenant Sheldon Keck, Brook-
lyn Museum; Lieutenant Calvin Hathaway, Cooper Union
Museum for the Arts of Decoration; Captain E. Parker Lesley, Art
Professor, University of Minnesota; Pfc. Lincoln Kirstein, art
patron; Captain Robert Posey, architect; Captain Walker Han-
cock, Prix de Rome sculptor; Lieutenant James Rorimer, Metro-
politan Museum; Captain Walter Huchthausen, Art and
Architecture Professor, University of Michigan; and Captain Ralph
Hammet, architect.

The first of these professional art experts were sent off to their
Normandy-invasion tasks carrying directives sprinkled with such
helpful hints as "A castle is usually defined as a large fortified
building and a palace as an unfortified stately mansion or residence
of royalty," of which latter element republican France had long

since had none. The Monuments men's own definition of a palace, according to one of them, sharp-tongued and young, was "the local honey on the Supreme H.Q. protected list, where the blasted colonels will certainly billet their troops unless a wandering Monuments man gets their first with an 'Off Limits' sign and his neck stuck out." In their billeting-overseeing job, the Monuments men were like frantic boardinghouse keepers, trying to put thousands of lodgers into the right rooms and out of the wrong ones, and, above all, trying to prevent them from pocketing everything pretty that belonged to the house. "Off Limits" signs were tried and did not work, so "Protected Monument" signs were put up to discourage the U.S. Army souvenir hunters from liberating art items to send home to Mom and their girl friends. And the cynical Monuments men marked off really attractive debris and important buildings with white tape, falsely indicating the presence of unexploded mines. It was the worry of our State Department, especially after the Liberation idyll began to fade, that the prestige of the United States Army and the American idea would decline still further if the U.S.A. troops and officers manhandled or lawlessly occupied the western democracies' historic properties. As long as the American armies remained in Europe, "the greatest single" M.F.A. & A. problem, an official report declared, was saving the Continent's art "from spoliation and damage by the U.S. Armed Forces." A great deal of minor damage was, it seems, done to châteaux by billeted Americans who nailed pinup girls to highly valued, highly carved antique *boiseries*. This was, however, literally only a pinprick among all the wounds art suffered.

The worst billeting jam occurred in the autumn of 1944, while the war was still on, in the Paris sector—the part of France that is richest in palaces and châteaux—when American troops were pouring toward the front. Improper billeting became almost as big an M.F.A. & A. anguish as the unwarranted demands for fancier billets by outfits that were already billeted. One colonel of a replacement group aspired to billet his fifty officers in Mme. de Pompadour's historic mansion at Fontainebleau—a demand that was easy to refuse because another outfit had accidentally just

set fire to the Henri IV wing of Fontainebleau Palace. The Monuments people also received endless intimate requests from the French; that a Quartermaster trucking battalion billeted in the Château de Celle please respect the collection of stag antlers belonging to its owner, the Duc de Brissac; that the room in which Cardinal Richelieu once slept in the Château Fleury-en-Bière be marked "Off Limits"; that an Air Force unit near Chantilly abandon its project to practice-bomb a camouflaged hunting lodge on an island where the Vollard art collection was hidden. There was a claim that all the furniture of the Château Voisenon had disappeared with a certain distinguished bombardment group, famous also for liking comfort. There was a protest that American troops billeted in the Château de Frémigny, built for a friend of Napoleon, had done more harm in the two months they were in residence than the Germans billeted there had done in four years. However, the M.F.A. & A. report on the gutted Château de Chamerolles, where Germans had also been billeted for four years, noted the owners' complaint that the Boches had carted off 700 valuable paintings and drawings, 147 sixteenth- and seventeenth-century Oriental rugs, some seventeenth-century tapestries and masses of rare silver—the most Herculean cleaning out accomplished by any unit in Europe in the entire war.

The Battle of the Bulge produced a great number of front-line billeting disasters. Surprise, confusion, danger and bitter cold drove the American fighters into any shelter, no matter how artistic; those who were not freezing in foxholes were sweating it out in Belgian châteaux almost as fine as those in Touraine. The Château de Pailhe, the finest Louis XV structure in Belgium, was burned to the ground when the Americans used gasoline cookers on a parquet floor. Chimney fires and ruined marble mantelpieces were frequent. Most of the men had had no experience with elegant, ancestral open fireplaces; they had been brought up on comfortable common steam heat.

An unexpected secondary war duty of the Monuments men consisted of acting as an ambulant lost-and-found department for art. In 1940, as the Germans started invading, Western Europe

frantically began hiding the treasures it loved, burying them in gardens the way dogs cache bones, or hiding them in haylofts, in church steeples, in slaughterhouses, in bank basements or lunatic asylums, in any place of concealment that seemed logically safe or so absurd that it was unlikely to be discovered. City people sent their valuables to the country for safety and country people carted their stuff to town. The first reaction of the populace in the Liberation, after the cheers, was to hunt for their things. As the Monuments men moved around, they made lists of lost-and-found art, sent reports to one another, dispatched inquiries and filed good news of discoveries and clues.

They also took notes on the gigantic, yawning destruction of the architectural face of war-struck Europe—of those now lost features of beauty, art and picturesqueness, of housed history or charm, whose disappearance made the profile of the Continent sectionally unrecognizable and necessitated the partial rewriting of all the Baedekers. The first handful of Monuments officers, by thumbing rides and not standing on professional dignity, covered a tremendous amount of territory and compiled, often on borrowed typewriters, reams of notes that could have served the guidebook editors all too well. They did not see everything, but they saw a great, great deal, most of it tragic and terrible for Western civilization. In the twelve weeks before Christmas of 1944, one man traveled 13,000 miles in France and inspected 224 monuments. The M.F.A. & A. notes showed that in the most badly injured regions of the occupied countries, damage ran to about 45 per cent. In Germany, inventor of the blitz, 90 per cent of the great historical monuments were struck and 60 per cent were blitzed to nothingness, a kind of boomerang destiny the Nazis had not thought of, with all their planning. The Monuments men also observed a fact that would have gratified the medieval building trades: the fragile-looking Gothic constructions, with their airy, resilient flying buttresses and broken surfaces, resisted the shock of bomb concussion better than the solid, unbroken surfaces of the Renaissance constructions, which—being built on the modern, four-square principle—were bashed flat by modern blast.

The Monuments reports were brief and melancholy. Of Boulogne, after Patton's Third Armored had fought its way in, the summarizing note read, "On M.F.A. & A. requests, engineers scraped 14th-century cathedral ruins from street functioning as Red Ball highway between Omaha and Utah beaches." A British note read, "Antwerp, Musée Plantin-Moretus, world's most famous printing museum, 18th century façade struck by buzz bomb." Major the Lord Methuen, Royal Scots Guard, the M.F.A. & A. officer in the Brussels region, kept a diary in the best traveling-Englishman manner, with appreciative observations on art ("Aerschot, inspected Béguinage, pleasant building dated 1636, badly damaged by bombing. Thielt, inspected charming Renaissance Belfry with tower and spire shot up in '44") as well as notes on whom he had lunched with and the latest difficulties with his sinus, which was troubling him in the Lowlands climate. In Holland, the notes of Major Ronald Balfour, Fine Arts Officer for the Canadian First Army and former Fellow at King's College, Cambridge, were also personal, but they had a severer tone: "To appoint an officer for a whole area and to expect him to cadge lifts is not only faintly ludicrous but gives the Netherlands authorities a clear and perhaps accurate impression that we are not interested in their monuments at all."

The M.F.A. & A. men who followed the Allies into Aachen and the Rhineland became simply obituary writers, since dead art lay in every direction: "Cologne, circa 80 per cent of monuments and churches destroyed, including St. Maria in Capitol, famous Romanesque landmark . . ." "Kleve, Stiftskirche, mid 14th century, air bombed Oct. '44, again Feb. '45, an eliminating operation. Church shattered." After completing his mortuary report on Kleve, including a two-page epitaph on architectural details of the church alone, Major Balfour, the Canadian First Army Monuments officer, was killed by Nazi shellfire. From the town of Xanten came this note: "St. Victor's cathedral, rated most beautiful Gothic complex of buildings in the Rhineland, is wrecked. Shot, shell, blast." Another note recorded: "Münster, remarkable for assembly of fine buildings 14-18th century, is gone for good.

Aerial bombardment Sunday March 25, 1945." A Münster post-
script, written by an M.F.A. & A. archivist, said, "Münster city
records on methods of Nazi treatment of Jews as well as future
plans in that regard reported intact in Schloss Nordkirchen." From
Trier: "Dom, 11th century, oldest church in Germany, heavily
bombed Xmas week, '44. Karl Marx House, birthplace, used as
Nazi newspaper H.Q., direct bomb hit, destroyed." Near the
Ruhr pocket, Captain Huchthausen, the peacetime Professor of
Art and Architecture at the University of Michigan, was killed
by machine-gun fire on an *Autobahn*. Like all Monuments men,
he felt that his work was concerned not only with the death of
art but occasionally with its resuscitation. He was killed in a bor-
rowed jeep while answering a hurry call to come inspect a newly
found art cache. The Monuments, Fine Arts, and Archives men,
dead or alive, were mostly heroes who received little attention, and
were highly civilized—a mere handful of specially educated men
who made the first tragic reports on what remained of the cultural
monuments, styled or beautified over centuries in Western Europe,
where the most destructive armies the military genius of man had
ever invented had been efficiently destroying them in its long-
drawn-out war for possession of the battered Continent itself.

It was the discovery of one underground art cache after another
and the unexaggerated reports that they were worth millions of
dollars that presently gave European art its place on the front
page, along with the battles, and made it unnecessary for the
Monuments men to go on being apologetic about their work. The
first underground cache the U.S. armies encountered was a
specially constructed art air-raid shelter in a deep subterranean
sandstone chamber outside the Dutch town of Maastricht. There
the Dutch had stored their most valuable museum pictures, with
Nazi approval. The fact that the art had been hidden by our
Allies decreased the excitement of the discovery for the G.I.'s,
though they took sightseeing tours underground to stare at some
Rembrandts—once it had been explained who and how important

Rembrandt was. For the next fortnight, every Dutch daub found by a G.I. in a farmhouse attic was called a Rembrandt, and the nearest Monuments officer was sent for, posthaste, to authenticate it.

Then, in April, 1945, in the mountains of Germany and Austria, our armies made the first of a series of spectacular, melodramatic discoveries of enemy-hidden subterranean treasure troves, which turned out to be the most dazzling, rich, compact underground depots of art in history. The first buried cache was found on April 2 by elements of the 8th Infantry Division, in the Westphalian copper mine at Siegen. As a matter of fact, Lieutenant Stout had already discovered it, at long distance (and had tipped off Headquarters to be on the lookout for it), while studying an annotated Nazi art catalogue he had come on in Aachen, whose rich cathedral treasures had been hidden at Siegen. He had also borrowed the cathedral's curate as a sort of unwilling guide. When the Monuments men finally entered the mine with the curate, its corridors were without light and reeked of the mine's sulphur and the stench of a vast, departed German civilian population, which had hidden there in semi-suffocation for two weeks, first from the *Amerikaner* bombs and then from the incoming *Amerikaner* soldiers, who butchered children, the German radio had warned. Deep in the mine, behind a locked door, the Monuments men found the German caretakers and the art they took care of—among other things, more than four hundred great pictures.

Later, when the 8th Infantry turned the mine into an exhibition place, it posted at the mouth a sign, bearing its insigne (a golden arrow), that read, "Golden Arrow ART MUSEUM (Siegen Copper mine). Europe's Art Treasures RESTORED. Paintings of the OLD MASTERS, Rembrandt, Rubens, Van Dyck, Delacroix, Van Gogh, Holbein, Bones and Crown of CHARLEMAGNE. Original Music of BEETHOVEN. Discovered and Guarded by the 8th INFANTRY DIVISION." The manuscript of Beethoven's Sixth Symphony, taken from the Beethoven House in Bonn, was indeed in the mine; the Charlemagne crown there was only a modern exhibition copy, which the American officers and troops tried on as happily as if

it had been the real thing: Charlemagne's bones were merely a part of his skull, imbedded in a silver, jeweled, life-sized bust. And Delacroix and van Gogh had never been more than modern, not old, masters. The mine had been equipped with a dehydrating plant, but American bombs had wrecked it in January, and in the interim some of the damp pictures had become encrusted with a green, plushlike mold that made the people in the portraits look as though they were suffering from a novel skin disease. The art—much of it still carefully packed in boxes sitting comfortably on floor boards, since the Nazis never spared labor in fitting up their underground art repositories—was again somewhat disappointing to the G.I.'s, because it had not been stolen from one of our Allies. It was merely Kraut riches, which included the Aachen Cathedral's tenth-century gemmed cross and twelfth-century crosier and enameled gold shrine; canvases by Stephan Lochner; church and museum treasures from Münster and Alsatian Metz (which the Germans had always rated German); and the best of the contents of the Rhineland's wealthy museums, including the Essen Volkwang Museum's collection of French moderns, which was among the finest in Europe.

On April 6, four days after the Siegen find, the American Army uncovered its second German cache—the Kaiseroda salt mine, at Merkers, in Thuringia. This discovery satisfied everybody and definitely put art on the war map. The Merkers art received a high ranking because it was mixed with the colorful personality of General Patton and with a new type of treasure that really made sense to the American troops—millions of dollars' worth of gleaming, solid gold. The Merkers mine was a lucky discovery of the 347th Infantry of Patton's Third Army. An M.P., Private Mootz by name, in itself a wondrous monicker, had been told by a couple of French deportee women that what looked like a sawmill on yonder hill was the entrance to a salt mine filled with gold and other treasures so vast than when, a few weeks before, they had arrived from Berlin, it had taken scores of slave laborers seventy hours to carry the stuff into the place of hiding seven hundred

meters underground. The first visit by one of the M.P.'s officers, to whom Mootz had related this fabulous tale, disclosed that the mine also contained a Prussian State Collections curator and a British war prisoner, who had helped to tote the gold and knew exactly where it was. Before many hours had passed, the mine was bristling with extra M.P.'s, a tank battalion to guard the mine head, a reinforced rifle company thrown around its four other entrances, and jeeps everywhere, armed with machine guns. The area also boiled with excited reconnaissance parties, special details, and Intelligence and Counterintelligence. When a number of officers, accompanied by a Franco-American banker and gold expert who had been hastily flown in from Paris, descended into the mine and reached the cache, they saw a breathtaking sight: 550 canvas bags, each containing a million reichsmarks in gold; 400 smaller bags, containing brick gold; and, to one side, sordid boxes of gold fillings from Jews' teeth and their gold wedding rings, which the Nazis had thoughtfully saved from the concentration camps at Auschwitz and Buchenwald. On second glance, the officers also noticed some art. According to German bankers, with which Army Intelligence seemed to find the countryside teeming, Patton's Third had discovered the entire gold reserve of the Nazi State's Reichsbank. This was the first instance in modern military annals of the belligerent's capturing his enemy's every red cent. The Franco-American banker appraised the gold at $250,000,000. It was known that Germany started the war with a gold reserve of $50,000,000, so the Nazi conquests had truly paid. Part of the Merkers bullion was identified as belonging to Belgium, which in panic had passed it to France in 1940, which had later passed it to Dakar, from which Vichy later ordered it passed to the insistent Germans. Cash money by the millions, no less than art objects by the thousands, had been treated to the same political treacheries, it appeared, as the more secret history of the war began coming to the surface.

The American Army's first report—an unofficial one, since no Monuments men had yet been invited in to have a peek—said that

the Merkers art treasures were not masterpieces. Actually, the Merkers art was so masterly that it was worth at least twice as much as the Merkers gold. Two hundred and two of its German pictures, once the pride of Berlin's now wrecked Kaiser Friedrich Museum and later cached in the Washington National Gallery, were alone valued at $80,000,000. The lovely polychrome head of the Egyptian Queen Nefertiti, found in a wooden box labeled *"Die Bunte Königin"* ("The Multicolored Queen"), was only one extremely valuable item in the Merkers trove of art from fifteen Berlin state museums. On the sixth day after the discovery came the distinguished visitors—Generals Eisenhower, Bradley, Eddy and Patton. All fourteen stars, representing the top brains and valor of the United States Army in Europe, descended into the mine in the same elevator, operated by a grim German. Soon after that, the gold was removed—rapidly. Protected by fighter planes, ack-ack guns and anti-tank guns, the gold was trucked to Frankfurt and its only slightly bombed Reichsbank vaults, where, for an undisclosed period of time, it remained, the most heavily guarded cache in Europe. For nine months before the Merkers find, Monuments men had been disparagingly known in the Army as "those guys with their so-and-so art." The Merkers gold and Patton's glittering personality had made art itself important. An art cache was thereafter known as an "Art target," and all Patton's rivals itched to strike one too. Clearly, art targets meant publicity to any outfit's public-relations officer. Capturing towns was valorous and still the aim of the war, but capturing art became for the impressionable American fighter a glamorous new idea.

Patton's lucky Third made the next strike, too, with the discovery, in May, just before the European war's end, of the art cache in the salt mine of Alt Aussee, up in the mountains near Salzburg. Among its sixty-seven hundred paintings was the great Hitler Collection for the museum he planned to set up in memory of his mother at Linz, in Austria, plus the art stolen in Italy by the Hermann Göring Division as a present for its chief's 1944 birthday, which to the Monuments men were already historical anec-

dotes by this time, for which they now received occular proof. Especially to two of the Third's Monuments men, Captain Posey and Pfc. Kirstein, Alt Aussee's cache was far from a surprise. Months before, in Trier, they had extracted a tip about it from a German who had been connected with the French headquarters of the infamous E.R.R., *der Einsatzstab Reichsleiter Rosenberg für die Besetzten Gebiete.* These two Monuments men had been impatiently waiting ever since for their outfit to fight its way to the mine. Once the Allies entered Germany, there was a steady trickle of tips about art in the Allied Intelligence reports. These were assembled in England by British and American Monuments officers and passed back to the proper authorities on the Continent. German prisoners also added tidbits of news, and from interrogations of the German population, then anxious to please, came an incoherent but informative mass of facts, clues and rumors about hundreds of German art hideouts. There had been to start with, the list, filched from the E.R.R. exhibition rooms in the Jeu de Paume in Paris, by the intrepid French woman curator, Mlle. Rose Valland, of the six German aboveground hideouts, at Neuschwanstein, Chiemsee, Kögl, Seisenegg, Nickolsburg and Kloster Buxheim. This list had been compiled in secret and in danger by her, as far back as 1942, when the Monuments men were still miles and years away from their goal. The major art, however, had been moved by the time the Monuments men caught up, in 1945. The terrible success of the Allied bombing had driven art, considered by the Nazis more valuable than their people, to safety in new hideouts, often unknown to the Allies, underground.

The fourth big German cache was discovered by the United States First Army in the twenty-four kilometers of underground passages of a salt mine at Bernterode, in the Thuringia Forest. At first view, it was perhaps the most startling of all. It featured the caskets of Feldmarschall von Hindenburg and his wife; of Kaiser Friedrich Wilhelm I, his bier decorated by a wreath and red ribbon bearing the name of his admirer, Adolf Hitler; and of Prussia's

most revered king, Frederick the Great. Using Scotch tape, the methodical Germans had attached to each coffin lid a paper label bearing the name of the occupant scribbled in red crayon. The effect of this morbid scene was enhanced by an array of 225 German battle banners, the relics of centuries of Prussian campaigns. Around Frederick the Great's coffin lay those of his Sans Souci Palace treasures that he had loved most—dozens of his paintings by Watteau, Chardin, Lancret and Boucher, and boxes containing his library, most of the books in French and all of them bound in scarlet leather. Mixed in with swastika-marked flags were the sparkling insignia of earlier German greatness—the Hohenzollern crowns fabricated for Friedrich Wilhelm I and Sophia Dorothea in 1713 (with the jewels missing, these having been "removed for honorable sale," as an accompanying German note stated); a gold *Totenhelm,* or death helmet, dated 1688, for dead kings lying in state; a blue enamel royal orb, or *Reichsapfel*; two magnificent royal swords, dated 1460 and 1540; and an 1801 Hohenzollern sword and scabbard, the latter a terrific, yard-long, tawdry blaze of diamonds and rubies.

The French, Italian and Russian slave laborers milling about the neighborhood when the liberating troops arrived said that the caskets had been carried in a few weeks before under the supervision of the highest German military men and had been walled up in such secrecy and so quickly that they, the slaves, had not known what was being hidden away. It was the presence of fresh mortar in the main mine corridor that had led four sergeants and two corporals of the 330th Ordnance Depot Company, an art target hopefully in mind, to start digging through five feet of still damp masonry. What they had discovered were the sacred elements of Germanic revivalism—in readiness if and when Hitler failed. Bernterode was the most important political repository in all the Reich. By coincidence, the Monuments men brought the caskets out of the mine on V-E Day, while their radio was dialed to the Armed Forces' network, over which London's celebration of the great event was being broadcast. To the tune of "The Star-Spangled Banner," Frederick the Great, in a bronze coffin so vast that there

was only a half inch to spare, rose majestically on the mine elevator, and, just as he reached the free air, there sounded the monarchial strains of "God Save the King."

In a brick kiln in the town of Hungen was the most insultingly housed cache of all. Here were hidden the most precious Jewish archives, tomes and synagogue vessels from all over Europe, including the Rosenthalian collection from Amsterdam and that of the Frankfurt Rothschilds. In the kiln, the repository for the Jewish material Rosenberg planned to use in his projected postwar academy, where anti-Semitism was to be taught as an exact science, priceless illuminated parchment torahs were found cut into covers for Nazi stenographers' typewriters or made up into shoes. Here, too, were thousands of Jewish identity cards, marked with a yellow "J," all that remained of Jews who had perished in Nazi crematories. There was no blaze of aesthetic beauty here, no emblems of dynastic Teutonic history. There was nothing in the ugly rooms except the rubbish and mean utilities to which these remnants of Jewish lives, identities and God-loving faith had been finally reduced.

Having located thousands of items of despoiled and pillaged art, far from home, and of German-owned art, displaced from its bombed-out museum habitat, the Monuments men, after V-E Day, were faced with the final two problems of their arduous war-and-peace tasks. The first was the physical act of removing this art— either heaving it up, sometimes heavy and sometimes light, but always valuable and breakable, from the bowels of the earth or carrying it down staircases or out of attic windows from the castles in which it had been stored and transporting it along ruined roads and across streams without bridges. The second problem was to find safe places in which to store this art. The first was the harder. The terrible technical difficulties were made quite clear in a rhetorical question one American Monuments officer put to a friend: "How would *you* go about hauling up a close-to-life-size Michelangelo marble statue of the Virgin and Child from the bottom of a salt mine, in a foreign country, with the mine machinery *kaput* from our bombs, with nearly no help from our Army, since

it was authorized to give nearly none, without proper tools, without trained handlers, and without even the tattered bed coverlets of the moving man's trade to use as padding?" Monuments men used what they found in German military stores for padding and protecting the art they had to remove and preserve, in all kinds of weather and awkward situations. Gasproof Nazi boots were cut into wedges to use as buffers between paintings. Gasproof capes made ideal waterproofings. The full-length German sheepskin coats, tailored for the disastrous Russian campaign, which were never delivered to the freezing Nazi troops driving toward Moscow in cotton summer uniforms, had their ultimate utility at last. They were perfect to wrap around sculpture which the Nazis in their European campaigns had ravaged from other European peoples. For labor, the Monuments men, in their desperation, used any willing human being they could find—Polish, French, Russian, Belgian, Dutch and Baltic slave workers, male and female, all grimly delighted to help pry loose Germany's loot, and minor German jailbirds, in the jug for stealing U.S. Army rations and lent by petty German officials eager to curry favor with the conquerors. Some of the newer Monuments men were young curators from rich American museums who had never moved anything heavier than a Degas pastel. During the first summer, autumn and winter following the peace, the Monuments men—under the supervision of Lieutenant Stout, the Fogg Art Museum Expert, as Monuments chief for all the evacuations in the 12th Army Group area, which comprised the German-Austrian mountains and took in six hundred big and little depositories—spent months in red-tape-bound, wearying, exciting, maddening and often incoherent work, and by the time they were through they had removed a large percentage of the Nazi-hidden art, much of it with their own hands.

After viewing Germany's ruins in their search for dependable receptacles, the Monuments men chose the Verwaltungsbau, in Munich, as the central collecting point for pillaged E.R.R. art, for the Hitler and Göring thefts and purchases, and for any other art from the occupied countries. This had been the Nazi party's ad-

ministration building for South Germany, one of a solid, tasteless, white-stone pair of party edifices—the other being Hitler's head-quarters building, the Führerbau, next door—which also had oddly escaped destruction in the bombed ruination of Munich and which, in their dual, matching ugliness, now dominate the Königsplatz, of whose earlier architectural charm little but the battered façade of the Glyptothek Museum remained. The central collecting point, soon known as the "Bau" to the Monuments men, was inaugurated and run by Lieutenant Craig Smythe, U.S.N.R., of the Washing-ton National Gallery; Lieutenant Commander Hamilton Coulter, U.S.N.R., a New York architect; and Captain Edwin Rae, art in-structor, University of Illinois. The Verwaltungsbau had been par-tially gutted, and its tons of secret, sacred Nazi documents—includ-ing lists of party members as well as of anti-Nazis scheduled to be shot, as a result of denunciations, as the party began tumbling from power and treachery became rampant—had been scattered by post-V-E Day German mobs. The huge building had to be repaired, cleaned, lighted, staffed and guarded at a time when a broom was a rarity, when coal was lacking, and glass for smashed windows and skylights had to be scrounged. Furthermore, veritable and use-ful anti-Nazis had to be discovered among the German curators to aid in the colossal task. Finally, the Army, with the war over, with half a country to patrol, and with the art-target game only a memory, was naturally indifferent about lending good, strong G.I. guards to sit up night and day eying fine pictures.

The Verwaltungsbau actually served not only as a collecting point but as a repatriation point. It was in this building that all the reports from the field Monuments men were collected and filed. It was typical of the poor equipment given to them that there was not even enough paper for them to type their reports on. Being used to makeshifts, upon discovering in the building piles of yard-square military maps, some German, some American, all printed on decent solid paper, all now headed eventually for the trash bin, the Monu-ments men cut the maps to folio size and typed their reports on the back. Behind their words referring to the destruction by bombing

of a Romanesque chapel near Cologne, or the rumored discovery
of a sculptured Gothic Virgin in the hayloft of a barn outside
Aachen, could be seen at the same time the faint dominant color-
ing of the military map on the other side of the paper, sometimes
a contour map consisting only of the lay of the land and its moun-
tains or streams, sometimes a road map with towns or cities in-
dicated only by numbers, not names, as if identities and nomen-
clature had been ignored by the military minds. It was from these
field reports, which consisted of what the Monuments men had
seen, whether in the German underground art caches or elsewhere,
as well as the gossip they had heard from local people they had
talked with, that the general whereabouts of sequestered art had
been established and an over-all tabulation was made on which the
Verwaltungsbau operations eventually proceeded. As the repatria-
tion point, all Allied art which the Nazis had pirated came to roost
temporarily in this building, brought in by military trucks. The
treasures assembled there were inestimable in value. The canvases
were filed, standing upright and face to back, in rows, in storerooms.
On the walls of the Monuments men's offices usually hung a few
favorites, a Bronzino portrait, a Breughel group of peasants, a
Titian banquet scene, a Madonna, all waiting to be claimed. As the
art arrived, usually in bulk, it was then carefully parceled out, on
signed receipt, to the Allied countries to which it had belonged
before the Germans got hold of it. To facilitate the work, repre-
sentatives of the Allied governments also functioned at the Bau.
As art items were tentatively identified, through catalogues or often
by the Nazis' own tags, they were placed in storerooms—each
nation had its own—for further checking of ownership. When the
identification was verified, the art was trucked off home, at the
concerned nation's expense, after a receipt had been signed releas-
ing the Allied authorities from further responsibility. Art that had
actually been bought by the Nazis from private owners was, as a
rule, simply put into government custody, when it got home, on
the principle that unless the former owner could prove that the
property had been sold under duress, it should become the property

of the state. The wrangling over ownership was still going on, years later, long after the Bau was finished with its paternalistic task.

To complete their knowledge of the Nazi looting, it was necessary for the Monuments men to do considerable detective work, establishing—by interrogation and by locating and studying Nazi, collaborationist and other documents all over occupied Europe—exactly how, by whom, and for which Nazi bigwigs this massive spoliation of art had been organized. On this complicated information was based one phase of the "crimes against civilization" with which some of the Nazi war criminals—especially Göring, Rosenberg and Frank—were charged at the Nuremberg trials. Lieutenants Theodore Rousseau, of the National Gallery in Washington, and James Plaut, of Boston's Institute of Modern Art, both of the Navy and both speaking fluent German and French, and Navy Lieutenant S. L. Faison, art professor of Williams College, made up a roving secret service for the Art Looting Investigation Unit of the Office of Strategic Services, which worked with the Monuments men. The only full-time Monuments detective was Lieutenant Walter Horn, a Hamburg-born anti-Nazi who for years had been art professor at the University of California. By the repeated use of his most effective phrase, in German, "If you are not telling me the truth, you will pay for it with your head," he successfully encouraged Germans to tell him the truth. It was by this method that he obtained from a Nuremberg city councilor information as to the whereabouts of five of the greatest insignia of the Holy Roman Empire, including the real eleventh-century crown of Charlemagne, pipped with raw sapphires, emeralds, rubies and amethysts and tipped with a jeweled cross, and the St. Mauritius thirteenth-century sword. Nazi propaganda had carefully spread the rumor, after V-E Day, that a certain S.S. officer had sunk these relics deep in the waters of the Zell-am-See. Actually, on highest Nazi party orders, the insignia had been secreted in an aperture in a false wall, eight stories underground, in the bottom basement of an apartment house built on the rocky slope of the Nuremberg Paniersplatz. In

1946, the sufficiently interested visitor to Nuremberg could walk down (and later up) eight flights of stairs, accompanied by a slovenly janitor, to see the visible evidence of this ingenuous-looking, completely unsuspected hideaway—a jagged hole, such as any plumber might have made, leading into what appeared to be a flue, such as any furnace might possess, just large enough to contain the five sacred relics, each fitted into its own beautiful locked, sealed, engraved, rustproof copper box. This cache of Holy Roman Empire relics was second in national sentimental and political value only to the royal and martial caskets at Bernterode. Ideologically, these two were the most important of all the German caches, laid by in a desperate hour against the already envisaged German revival.

While the Bau was functioning as the collecting point for looted art, a collecting point for the E.R.R. loot from Jewish libraries, synagogues and private documentary collections was set up at Offenbach in an unbombed I. G. Farben building. Some German-owned art, mainly from the Rhineland, was installed in still another collecting point, at Marburg, in the Staatsarchiv building. The major collecting point for German-owned art, including that from the great Berlin museums, was settled at Wiesbaden, in the old Landesmuseum. Captain Walter Farmer, of the M.F.A. & A., took over the building, considerably the worse for wear, from the Army service troops, who had been using it as a joint clothing and D.P. center. There was a giant D.P. Russian who attached himself as a doorman, complete with a Tartar coat and high fur hat even in summer weather, who gave mysterious *cachet* to the dilapidated museum façade. Here, after the Captain had overcome the customary difficulties of getting brooms, soap and window glass, seventy-five rooms were filled with Germany's most valuable art, usually still packed in the carefully labeled boxes in which the Germans had embarked it toward safety and hiding. There were hundreds of boxes, containing pictures by Cimabue, Mantegna, Dürer, Hieronymus Bosch, Bellini, and all the other great artists of Europe for centuries back. The Landesmuseum also housed hundreds of neat, sliding-paneled, annotated cases containing the Ger-

man museums' fine print and engraving collections—all packed
as carefully as if they were food, awaiting the great day when the
Reich would be victorious and could once again savor its art pub-
licly, in its huge museums. The Landesmuseum's so-called Treasure
Room, kept under special guard, looked like the delirious dream of
a private collector. Crowded into it was every kind of particularly
precious art, piled in corners from floor to ceiling, spread on tables,
ranged from the locked doors to the barred windows—objects in
gold, in silver, studded with diamonds, festooned with pearls, bloody
with rubies; objects once held by kings, worn or collected by dukes,
or revered by bishops, and all finally become the public property
of the wealthy, powerful German State, under its Kaisers. An im-
portant part of the Landesmuseum task was to demonstrate to the
Germans the Monuments—War Department idea that art had
nothing to do with war or race; that it belonged first to everybody
and second to the people who legally owned it; and that German art
was simply being held by the Monuments unit in trust until re-
sponsible German authority could offer the guards and the housing
such treasures required. As illustration of this theory, the Landes-
museum staged two exhibitions for the Germans of their own
magnificent property—a superb painting show of early, rare Gothic
paintings, including some by van der Goes and Bouts; and a fine
engraving show, with the catalogues in both German and English.

Unfortunately, it was also at the Landesmuseum that the Monu-
ments ideal was, in the opinion of the Monuments men themselves,
betrayed. The 202 German-owned pictures which were in 1946
on view in the Washington National Gallery came from the Landes-
museum collection. In December, 1945, the Monuments officers,
acting on unwelcome orders received in November from Berlin to
select—which they conscientiously did—a representative collec-
tion of German art, finished the job, tragical and treacherous to
them, of packing it for transportation and sent a Monuments officer
to accompany it on its hegira to the national capital. This painful
project, utterly contrary to the principles on which the Monuments
men had worked, and had talked in the ethical propaganda to the
Germans, had been unanimously disapproved of by Major LaFarge,

then chief of M.F.A. & A. in the U.S. Military Government for Germany, by the section's other officers and its men, as well as by most museum officials in the United States. Ironically enough, some of the pictures selected—paintings by Botticelli, Rubens, Rembrandt and van Eyck—had in June, 1941, been reproduced in an article in the Nazi Paris propaganda magazine *Signal*, contemptuously denying an alleged Allied report that fourteen of Germany's museum masterpieces had gone out to the vulgarian United States in exchange for millions of dollars in cash to aid in financing the Nazi war. The facts about what the Monuments men bitterly called the Westward Ho Plan for sending this collection of German art to the States, in complete violation of the ethics basic to the whole M.F.A. & A. conception, were never made clear publicly. What was known, however, is that, as far as Europe was concerned, the idea was first heard of in Berlin in July of that year, when President Truman was attending the Big Three Potsdam Conference. In a private meeting with certain chiefs of our American Military Government, in Potsdam, the suggestion to send the art was made, reputedly, by General Clay, Deputy Military Governor of the United States Zone. It was further reported that President Truman, perhaps thinking he was doing art a good turn, had agreed to the suggestion. On the other hand, it was also reported that the idea originated in the minds of non-museum men back in Washington, who later decided not to identify themselves when the plan was bitterly criticized by the American press and museum people everywhere. Only two important American museum directors, one in New York and the other then in the Monuments group in the field, openly stated their approval of the Westward Ho Plan.

The protest by the Monuments men themselves did not carry any weight. In November, twenty-eight of the Monuments men operating in Germany sent a letter to their chief, Major LaFarge, deploring the fact that the United States was violating its concept, unique in military history, that the conquerors would leave conquered art untouched. What was even worse, they argued, was our government's adopting the Nazis' hypocritical line that the art was merely being taken into "protective custody." Some of the

Monuments men asked to be transferred out of their unit, because they wanted to have nothing to do with carrying out the order. They were cautioned that anyone who attempted to impede the shipment would be court-martialed, their requests for transfers being regarded by the military as implied sabotage of a duty to be performed, the duty being packing up and sending off the German art in the Westward Ho Plan. The end of the quarrel about it, though not the end of the Monuments men's feeling of having been betrayed in the high ideals they had given to their work, came when the office of Secretary of State Byrnes, in public answer to all the criticism at home and abroad, told the press that the decision to transport the German art to Washington had been arrived at "on the basis of a statement made by General Clay that he did not have adequate facilities and personnel to safeguard German art treasures and that he could not undertake the responsibilities of their proper care." The White House also told the press that the pictures would be returned to Germany "as soon as possible." It was also understood that they would not be exhibited. It may be recalled that they were nevertheless exhibited on tour in the United States and, public curiosity having been roused by all the discussion on them, were viewed by crowds, the entrance fees paid for the privilege being collected as a sentimental fund for German children. Since the pictures, valued at $80,000,000, were removed from Germany without the American officials having consulted their three Allies in occupied postwar Germany, it was feared that the United States might have set a precedent for the removal of valuables, but England and France did not imitate the United States. However, the Russian Fine Arts officer in Berlin significantly enough failed to give to the U.S.A. Monuments chief there any statement of his government's attitude toward the disposition of German-owned art in the Russian zone. Shortly after, it became known that certain masterpieces from the Dresden Gemäldegalerie, including the Raphael Sistine Madonna (and its pensive little cherubs), had been taken to Moscow. There they were eventually displayed in the museum in a room reportedly called, with candor, the Dresden Art Room. In the spring of 1956, Dresden having

long reclaimed the return of its art, the pictures were returned by the Russians in a popular conciliatory gesture much commented on by the European Communist press. The Russians and the Americans were the only two countries who removed any German art. It is, of course, known that the United States eventually returned the Westward Ho pictures. Whether the Soviets returned all the art they took is naturally not known.

By 1947 the M.F.A. & A., aside from its offices in Berlin, was practically inoperative in Europe. The work of returning the looted art from the Verwaltungsbau, which it had been estimated would take six months from V-E Day, had been finally completed, in two years. The Führerbau, twin of the Verwaltungsbau, by this time also stood useless and empty. Between these paired, pompous buildings had once stood the two small Greco-Nazi Honor Temples where the bodies of those who died in Hitler's Munich *Putsch* reposed as public heroes of the Nazi State. The bodies were removed by the American Army after that State fell, and given a more modest burial elsewhere, and as a last gesture in 1947 the Army demolished the temples themselves. Inside the stripped Führerbau, at that time, Hitler's workroom still contained recognizable elements of its former impersonal, tasteless luxury; the brown carpet on which he used to pace, though stained and torn, still covered the lengthy floor; the green marble mantelpiece before which his impressive desk stood, like an altar before the sacred fire, was intact; the dull wall covering retained its autumnal tint. The rest of the building was a void. This was the site where, in 1938, Prime Ministers Chamberlain and Daladier had accepted from the exulting Führer and his Reichsmarschall the terms of Munich. Almost a decade later, after war and defeat had passed by, the only furnishing left in the Führerbau's long, once elegantly filled marble foyer, at the bottom of the grandiose staircase—which those two visiting plenipotentiaries had climbed and descended between stiff lines of Nazi guards, while the democracies everywhere waited in suspense—was a large scarred globe of the world, slashed by the knives of passing G.I.'s.

INDEX

Abetz, Otto, 223, 258
Action, 7
All-Union Congress of Soviet Writers, 36
American Commission for the Protection and Salvage of Artistic and Historical Monuments in War Areas, 267
American Defense-Harvard Group, 267
André Malraux and the Tragic Imagination, 29
Angerer, Sepp, 247
Apollinaire, Guillaume, 83, 130, 132, 134, 136, 139, 153
Aragon, Louis, 10, 102, 156, 197, 198, 200, 202, 203, 204
Archipenko, Alexander, 144
Arland, Marcel, 11
Art of Henri Matisse, The, 98
Auric, 157
Autobiography of Alice B. Toklas, 83

Bach, Johann Sebastian, 143
Balfour, Ronald, 273
Barnes, Albert C., 74, 94, 98, 99-100, 116
Barr, Alfred H., Jr., 139, 149, 216
Barthou, Louis, 254
Barthoux, Jules, 32
Bas-Reliefs aux Grottes Sacrées, 64
Baudelaire, Charles, xiii, xvi
Beltrand, Jacques, 257
Benzion, Levy de, 223
Berthelot, Philippe, 9
Blasco y Barroso, Juan Nepomuceno, 179

Blum, Léon, 39
Boccioni, Umberto, 145
Böckel, Pierre, 47
Böcklin, Arnold, 233
Boisdeffore, Pierre de, 59
Bonaparte, Napoleon, xiv
Bonnard, Abel, 245
Bonnard, Pierre, 81
Bonnat, Léon, 126
Borchers, Walter, 258
Bormann, Martin, 223, 233, 258, 259, 262
Bornheim, Walter, 247
Borodin, Mikhail, 14, 21
Bouguereau, Adolphe William, xiii, 80, 96
Bradley, Omar, 278
Brancusi, Constantin, 144
Braque, Augustine Johanet, 119
Braque, Charles, 119
Braque, Georges, xii, xvi, 73, 74, 76, 96, 97, 106, 117, 118-73, 182, 187, 189, 199, 209, 219; appearance, 118-119, 170-71; birth, 119; boyhood, 119-20; education, 124-26; First World War, 153-54; marriage, 147; military service, 126; Picasso and, 148-53; Second World War, 163-65
Breton, André, 10, 156, 192, 209
Brissac, Duc de, 271
Bunjes, Hermann, 252
Burgess, Gelett, 145
Bussy, Dorothy, 112
Byrnes, James F., 289
Byron, Lord, 56